Pictured in My Mind

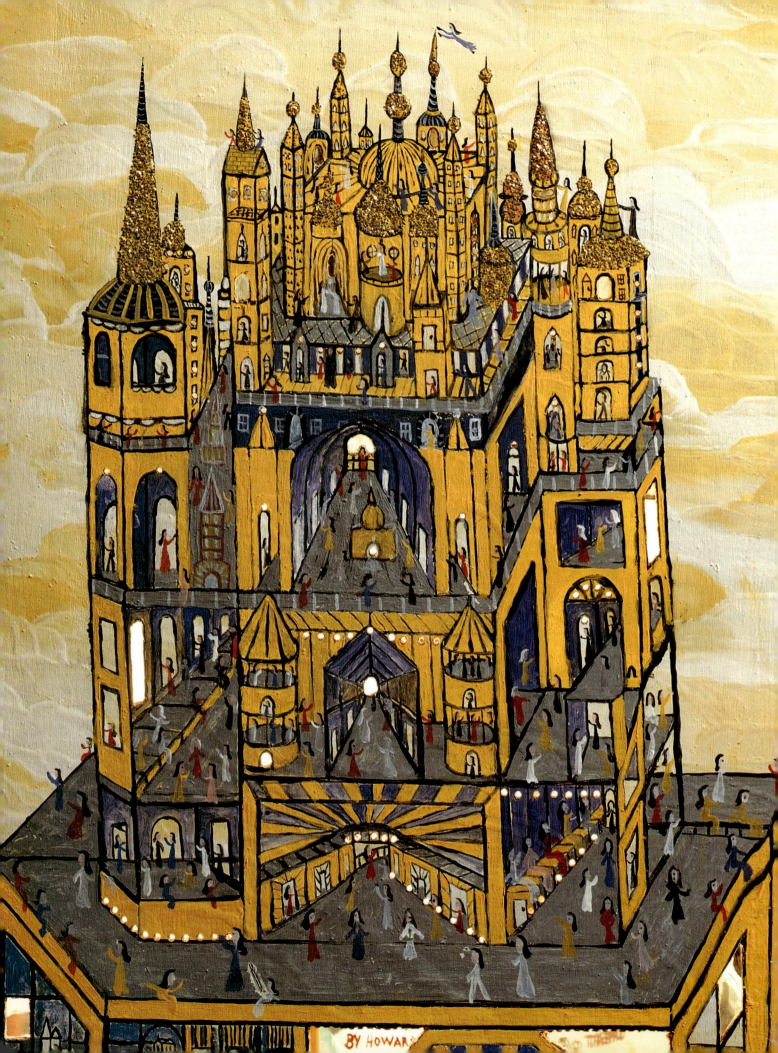

BY HOWAR

Pictured in My Mind

Contemporary American Self-Taught Art

from the Collection of

Dr. Kurt Gitter and Alice Rae Yelen

edited by

Gail Andrews Trechsel

contributions by

Roger Cardinal

Lee Kogan

Susan C. Larsen

Tom Patterson

Regenia Perry

Deborah Gilman Ritchey

Gary J. Schwindler

Thomas Adrian Swain

Gail Andrews Trechsel

Birmingham Museum of Art

Distributed by University Press of Mississippi

This book has been published in conjunction with the exhibition *Pictured in My Mind: Contemporary American Self-Taught Art from the Collection of Dr. Kurt Gitter and Alice Rae Yelen.*

Partial funding for the publication and exhibition has been provided by the Hackney Family Foundation, Birmingham; The Comer Foundation, Sylacauga, Alabama; RICH'S; the Alabama State Council on the Arts; and the City of Birmingham.

ISBN 0-87805-877-x (cloth)
ISBN 0-87805-878-8 (paper)

A catalogue record is available from the Library of Congress.

Jacket/cover front: Detail of *Athlete* (cat. no. 145), by Jon Serl
Jacket/cover back: *Untitled* (cat. no. 116), by Edward Mumma
Frontispiece: Detail of *Cathedral in Heaven* (cat. no. 33), by Howard Finster
Page 6: *Mr. Oliver* (cat. no. 161), by David Strickland
Page 10: Detail of *Poppies* (cat. no. 43), by Victor Joseph Gatto

Edited by Brenda Kolb, Norma Roberts, and Sharon Rose Vonasch
Designed by John Hubbard
Produced by Marquand Books, Inc., Seattle
Printed and bound in Hong Kong

Distributed by
University Press of Mississippi
3825 Ridgewood Road
Jackson, Mississippi 39211-6492
1-800-737-7788

Contents

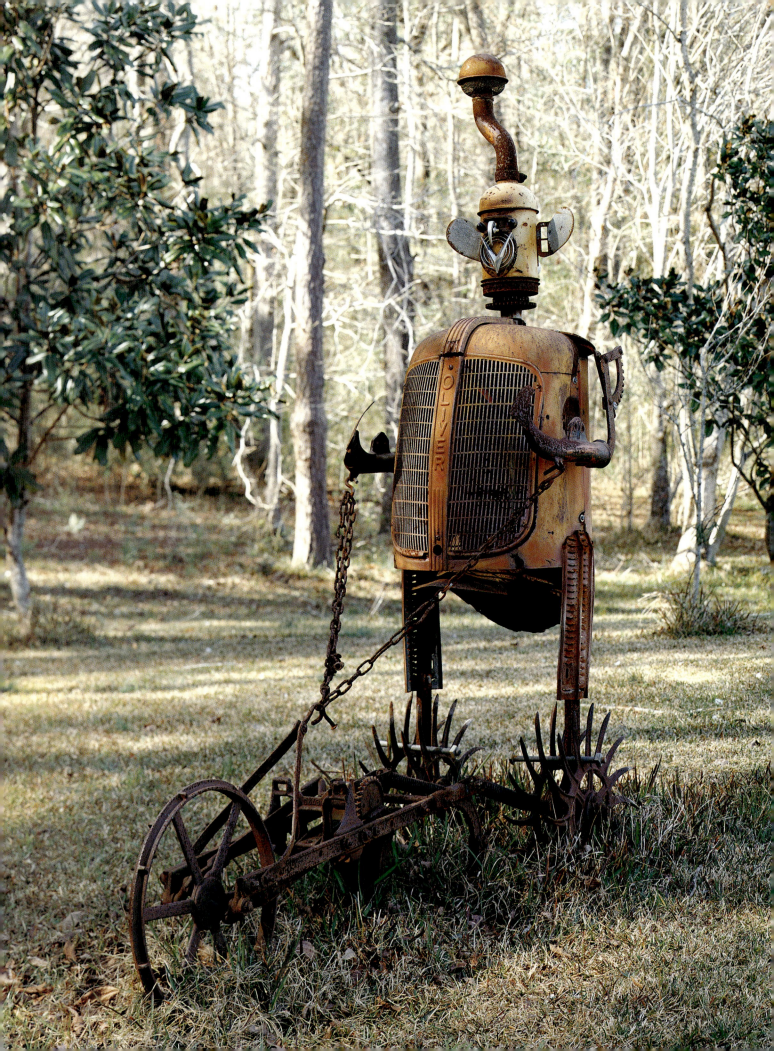

Foreword

Contemporary collectors of folk art view the artists and their work with enthusiasm and reverence. They are passionately involved in their search for art, and they pursue collecting as a mission that consumes their life and overshadows their professional interests. Such fervent devotion would puzzle a generation of collectors like Abby Aldrich Rockefeller. Distanced from the collecting process, these earlier collectors had little connection to the artists or the artists' worlds. They gathered their collections through dealers, who in turn worked with "pickers" who scoured homes for early American art that they perceived as "folk."

Though they were shrewd, these pickers were sometimes outwitted as they sought to buy pieces for dealers. In one tale, a picker in Massachusetts approaches an elderly widow who lives in an old home surrounded by a yard filled with cats. As the picker approaches her house, he pauses in the front yard and pets a cat drinking water from a tarnished metal bowl. He lifts the bowl, rubs its underside, and sees the inscribed initials "PR." Recognizing the piece as an original Paul Revere bowl, he smiles and gently places it back on the ground.

After looking through the woman's home, he confesses, "There is nothing here I want to buy except that cat."

"That old cat. Land sakes, you can have him for free."

"No. I couldn't do that. I want to pay you fifty dollars for him."

"Well, if you say so. But I would gladly give him to you."

He gives her fifty dollars, and as he is about to leave with the cat under his arm, he bends over and lifts the bowl. "I think I'll take his bowl so he won't be homesick."

The woman grabs the bowl from him, saying, "My Paul Revere bowl! How would I get rid of my cats?"

The picker, the savvy old woman, her cat, and her Paul Revere bowl provide a humorous glimpse at the process of folk art collecting in an earlier generation. Both the collector and the artist are absent from the scene.

In sharp contrast to the above tale, the contemporary folk art collector often works with an artist and develops a personal relationship with her or him. The artist's life becomes interwoven with that of the collector, who discovers that both the art and the artist who creates it offer a rich experience. The collecting process becomes a journey into a different culture, a voyage of discovery.

Among contemporary folk art collectors, none are more dedicated and enthusiastic about their pursuit than Alice Yelen and Kurt Gitter. I first met Alice and Kurt five years ago when they traveled to Oxford, Mississippi, to talk with me about an exhibition of southern folk art they were planning. While I was impressed with the scope of their plans for the exhibition, I was even more impressed that they drove through a December snowstorm with their two-month-old child, Manya, to meet me. When Alice, Kurt, and Manya arrived at my door that cold day, I knew they were on a mission for folk art. We sat around a fire, drank tea, and talked about folk artists and Alice and Kurt's plans to celebrate southern folk art in a comprehensive show. Their dreams were realized in *Passionate Visions of the American South*, the first major exhibition of southern folk art.

To avoid any conflict of interest, Alice and Kurt decided to curate *Passionate Visions* without including any works from their own collection. They carefully reviewed pieces from museums and private collections throughout the nation and selected a truly stunning show that presents the full range of southern folk art. The exhibition traveled around the country and, along with its magnificent catalog, focused the attention of both the art world and the general public on the rich contributions of southern folk artists.

The long-awaited sequel to *Passionate Visions* is this moving exhibition of Alice and Kurt's private collection. *Pictured in My Mind: Contemporary American Self-Taught Art from the Collection of Dr. Kurt Gitter and Alice Rae Yelen* reflects both the range and the quality of folk art they have collected over a relatively brief period of eight years. Their personal collection contains works not just by southern artists but by artists working in other areas of the United States as well. With an unerring eye, they have selected images whose colorful worlds are both beautiful and haunting. From Minnie Adkins to Malcah Zeldis, the fifty-three artists whose paintings and sculptures are shown here represent the very best in contemporary American folk art.

Pictured in My Mind is a fitting tribute to each of the artists included, and we are most grateful to Alice and Kurt, who made the show possible. Thanks are also due to Gail Trechsel and her fine staff at the Birmingham Museum of Art, who, like Alice and Kurt, have long championed folk art. Together they have assembled an exhibition that tells us how profoundly folk art may enrich our lives.

—William Ferris
Director of the Center for the Study of Southern
Culture and Professor of Anthropology
University of Mississippi

Director's Statement

It is an honor and a pleasure to introduce Dr. Kurt Gitter and Alice Rae Yelen's collection of self-taught art to the public. While individual objects have been included in numerous exhibitions and catalogs, this is the first time the general public has been able to see in one place such an extensive selection from this remarkable collection.

Unlike curators at public institutions, private collectors can make their own rules about what and how to collect. They can systematically focus on one artist or region, or they can respond eclectically to a wealth of visual material created by a wide range of artists. Although Kurt and Alice's collection is large—over three thousand objects—it is not an overview of contemporary self-taught art. Their choices were prompted first by a pure, emotional response to the objects and then by a more thoughtful, studied focus on the works of artists they consider masters in the field. Dr. Susan Larsen has ably summarized their approach and collecting philosophy to help us understand the commonality of vision that built the collection.

Kurt and Alice's decision to concentrate on selected artists gives the collection a depth and range usually associated with museums. They have attempted to obtain the best examples, while including a variety of media and works produced over a period of time to represent as much of an artist's body of work as possible. To accomplish this they have bought from dealers, collectors, and the artists themselves. Not many collectors are comfortable in all of these worlds, or able to successfully navigate all three.

Their passion for collecting has led Kurt and Alice to intensive study and travel. With open minds for what is new and challenging, they pursue an active schedule of visiting artists, exhibitions, galleries, and seminars. Their collection is marked by quality and commitment, and also by a sense of fun and adventure. The pleasure they take from visits with artists and scholars, and from the objects themselves, is evident. These works are not warehoused; rather they are hung in their homes and offices, to be shared and enjoyed with others. What a treat it is to spend a day with these connoisseurs, and to be caught up in their infectious enthusiasm.

In organizing the exhibition *Pictured in My Mind: Contemporary American Self-Taught Art from the Collection of Dr. Kurt Gitter and Alice Rae Yelen* and its tour, the Museum continues its commitment to exhibit and to collect the work of contemporary American self-taught artists. In 1978, the Birmingham Museum of Art organized one of the first exhibitions of paintings by Alabama artist Jimmy Lee Sudduth. We hosted the Corcoran's seminal *Black Folk Art in America, 1930–1980* in 1983, organized *Voices in the Wilderness* in 1987, and have added significant works by self-taught artists to the permanent collection in the last decade. *Pictured in My Mind* is the first major traveling exhibition and catalog on this subject organized and produced by the Museum, and we are pleased to be able to bring this significant collection to a greater audience.

The Museum is extremely grateful to the Hackney Family Foundation, Birmingham; The Comer Foundation, Sylacauga, Alabama; RICH'S; the Alabama State Council on the Arts; and the City of Birmingham for their support of this project. Their generous assistance enables us to publish this catalog and sponsor related educational programs.

I am grateful to Kurt Gitter and Alice Rae Yelen for sharing this collection with us and to the staff of the Birmingham Museum of Art for their hard work on this exhibition. I especially want to thank Gail Trechsel, whose enthusiasm and knowledge has opened my eyes to the beauty of self-taught art and whose perseverance has brought this important show and catalog to breathtaking reality.

—John E. Schloder
Director

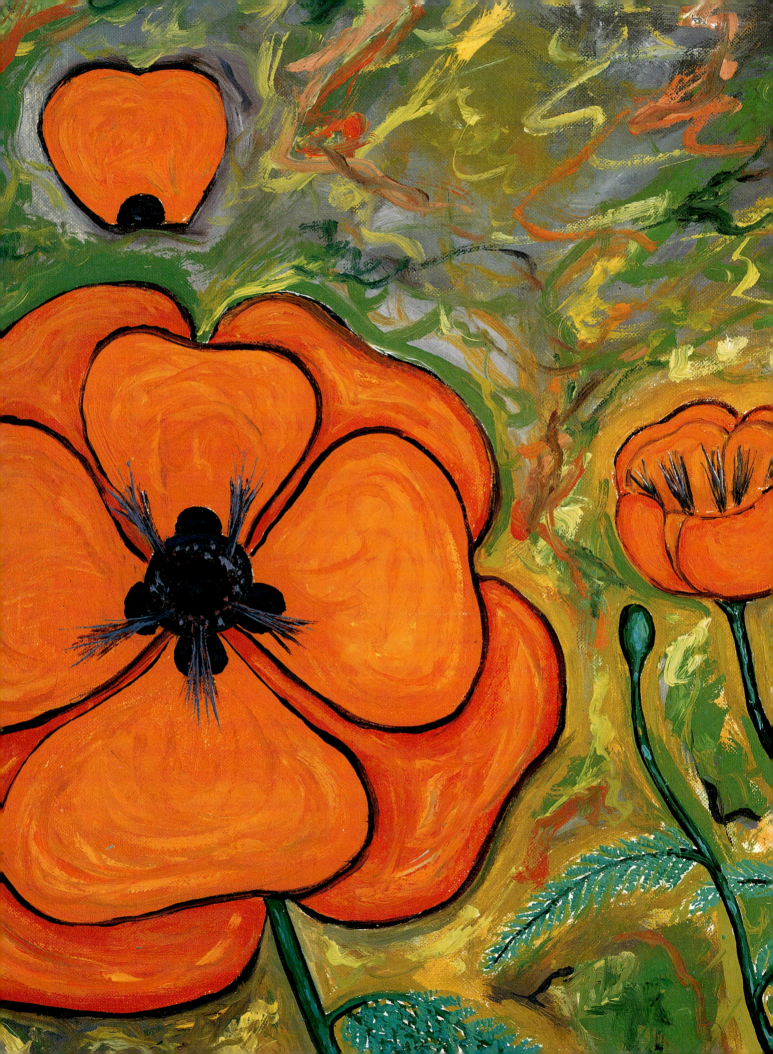

Preface and Acknowledgments

In the summer of 1992 Kurt Gitter, Alice Yelen, Gary Schwindler, Lee Kogan, and I gathered in New Orleans to look at the Gitter-Yelen collection and to begin formulating a plan for this exhibition and catalog. We all agreed that the exhibition should reflect the collection, its strengths and uniqueness, and that it should offer new insights about the artists. Guided by instinct, extremely strong visual sense, and powerful intellectual curiosity, Kurt and Alice have built a collection weighted toward the artists they viewed as masters in the field of self-taught art. Moreover, they have achieved significant breadth in their holdings through the addition of representative examples by other acknowledged masters whose works are no longer available in abundance and through works by emerging artists. As we examined the collection those few days we were together, it seemed natural to focus on its strengths by exhibiting multiple examples by artists such as Raymond Coins, Sister Gertrude Morgan, Jimmy Lee Sudduth, Jack Savitsky, Jon Serl, William Hawkins, Purvis Young, and others—twenty-four artists in all. It was also clear that in order to reflect the range of this outstanding collection we needed to include works by important artists such as John ("Uncle Jack") Dey, Clementine Hunter, and David Butler, who were represented

by fewer works; stellar works by some of the major figures in the field, such as William Edmondson and Bill Traylor, whose works are no longer available in abundance; and examples by artists such as Eddie Kendrick and Archie Byron, who to date have received less exposure.

Thus we would take a dual approach, exhibiting both the depth and breadth of the collection. Nearly half of the fifty-three included artists are represented by six to eight works apiece, giving the contributors to the catalog an opportunity to write about these artists in depth, to consider a broad range of their works, and to discuss changes in their art over time; it also allows visitors to this exhibition to gain a sense of the range and vision of each artist. On the other hand, including one or two examples by twenty-nine other artists enables us to highlight both major and emerging artists. The goal we set in New Orleans was to assemble an exhibition showing the highest quality of work while faithfully characterizing the "collector's eye" and the full scope of the collection. The exhibition is therefore a selection, not an overview, and our desire is to show not only the key pieces in Kurt and Alice's collection but also the best examples by each artist. Thus, in essence, while the exhibition reflects the collection, it equally serves the artist and the art.

As the difficult process of selecting the artists and formulating the checklist got under way, we saw that the project would not be a regional survey. Although the collection is indeed weighted toward artists from the South, it is also rich in material from the Northeast and Midwest (Jon Serl is the only example from the West Coast). We decided that the catalog would be a collection of essays on the artists, and we sought as contributors those known for their knowledge of a particular artist. We agreed to focus on the works themselves and to discuss these in relation to others in the exhibition and within the broader scope of the artist's lifetime work. The backgrounds and biographies of the artists, as these pertain to their art making, would be interwoven in the essays. In most cases those asked to write about the artists and their works knew them and had had an opportunity to talk with them directly about their art making. A contributor's relationship with an artist, while not essential to the understanding of the works, nevertheless enriches the discussion. This personal approach is also in keeping with the style of collecting followed by Kurt and Alice, whose friendship with many of the artists fueled their enthusiasm for the art. The scholars selected have worked diligently to weave together careful research, inspired

insight, and clear writing, and to each of them I am extremely grateful.

I also wish to thank Dr. Douglas Hyland, former director of the Birmingham Museum of Art, who in 1989 introduced me to Kurt while he was visiting Birmingham. The three of us drove to Joe Hardin's apartment, providing Kurt with his first opportunity to see Hardin's remarkable paintings. About a year later, Douglas, Kurt, and I began discussing the possibility of organizing an exhibition of Kurt and Alice's growing collection for the Birmingham Museum of Art. I am grateful to Douglas for introducing me to Kurt and for the idea of mounting this show. When Dr. John Schloder became director of the Museum, he enthusiastically embraced the idea and helped us move forward with the project. He has continued to be supportive throughout this endeavor, for which I am extremely appreciative.

Every staff member of the Museum has worked in some capacity to bring this large exhibition and catalog to completion. In particular, I would like to thank Portia Stallworth, administrative assistant, who has worked tirelessly with the manuscript and dealt with the innumerable details of this project since its inception; and Holly Booyse, development director, who was key in raising funds in support of the exhibition and catalog. I'm grateful to Frances Caldwell, public information officer, and her assistant, Merianne Kimmel, for their extensive efforts in publicizing the exhibition and catalog; and to Joan Kennedy and Jenny Kimbrell, for their assistance with printed material. Suzanne Stephens, exhibition coordinator, has handled the myriad logistics of packing, shipping, and handling the objects. Terry Beckham, the exhibition designer, and his staff, including Lisa Stewart, Hallie Henley, Robbie McClendon, and George Snyder, have carried out all aspects of the instal-

lation to ensure that the exhibition is beautifully displayed in our gallery. The education department staff, in particular Suzy Harris and Stacey Merren, have been enthusiastic supporters of this project and have worked diligently to provide creative programming and teacher initiatives to bring this work to as many schoolchildren and adults as possible.

Owen Murphy of New Orleans has once again brought his skills as a photographer to this museum. He produced all of the photographs for this volume and his sensitivity and expertise are evident in the color plates. I would especially like to thank Brenda Kolb for her meticulous editing and thoughtful comments regarding catalog format; she managed to bring a consistent flow to the essays without losing the unique voice of each scholar, a difficult task that she handled with consistent humor and enthusiasm. The beautiful design of the catalog is the work of John Hubbard under the direction of Ed Marquand at Marquand Books. Each member of the Marquand staff has been available to offer advice and to assist in the preparation of this handsome volume; I am especially grateful to Marie Weiler and Marta Vinnedge for managing production details, and to Norma Roberts and Sharon Rose Vonasch for final editing and proofreading.

I would also like to thank my husband, Haydn, and my children, Julia and Andrew, for their patience and support during the long process of bringing this project to fruition. Their understanding of the time necessary to coordinate this exhibition and catalog made the long days and evenings much easier.

We are grateful to the Hackney Family Foundation, The Comer Foundation, RICH'S, and the Alabama State Council on the Arts for contributing to this project and for their understanding of the

exhibition's importance. The Museum Board of Trustees, the Members Board of the Museum, and the City of Birmingham have our sincere appreciation for their support.

Finally, I would like to thank Kurt and Alice for allowing the Birmingham Museum of Art to be the first institution to share this superb collection with a larger community. Their patience, guidance, and generosity have been constant throughout this process, and they have made this endeavor a joy and an honor.

—*Gail Andrews Trechsel*
Assistant Director

Dr. Kurt Gitter and Alice Rae Yelen

Collectors' Statement

In early 1988 we visited a compelling exhibition at the New Orleans Museum of Art. There we saw the vibrant, apocalyptic paintings of self-taught artist Sister Gertrude Morgan. Awestruck by their expressive power, we returned to the exhibition again and again. Inspired by this experience, we set about to become well versed in the art of American self-taught artists. From the beginning, we consulted a wide array of curators, scholars, collectors, and dealers, but our chief resources always have been the art and the artists themselves.

We decided to restrict our collecting to the art of twentieth-century American self-taught artists. Because a good number of these artists were still living, we determined to meet as many of them as we could. These meetings were the most memorable and engaging of all our experiences as collectors, and in retrospect we realize how fortunate we were to enter the field when we did. For the most part, self-taught artists in the late 1980s were still little known, and many were not represented by dealers and galleries. We enjoyed a friendly access to artists that is not possible today, and the time we shared with these exceptional individuals deeply enriched us. Jimmy Lee Sudduth, for example, whom we first met in early 1988, joyfully combines a zest for life and a passion for art.

We have enjoyed his persona, art, and music, and our visits further enhanced our understanding of him as a painter and a friend. We recognize the gift of all such encounters with the artists, especially when we realize that eleven of the artists we had met have died since we began collecting: Ralph Griffin, Joseph Hardin, Bessie Harvey, Eddie Kendrick, Charles Kinney, Willie Massey, J. B. Murry, Jack Savitsky, Jon Serl, Mary T. Smith, and Johnnie Swearingen. Knowing them was a special privilege.

Our visits to the artists, usually weekend jaunts, relied on serendipity: The artists often did not read and some did not have telephones, so advance appointments were the exception. But with surprising luck, we succeeded in seeking out these intuitive, enterprising artists in their own environments—rural locales, middle-class urban neighborhoods, and ghetto streets.

Our collecting process evolved rapidly and naturally, informed by our varied backgrounds—Kurt's as an accomplished collector, and Alice's as a museum curator and educator. From his decades of experience as a collector of Japanese Edo-period paintings, Kurt developed the ability to make rapid aesthetic judgments and the drive to seek the best objects possible within a predetermined framework. Alice intuitively seeks to understand an artist's work within its artistic and cultural context, and she possesses an innate inclination to carefully document and conserve artworks.

Intensive learning along with constant looking at all available art—at the homes of artists and collectors, and in galleries and museums—sharpened our eyes. We began to exchange information with others. This enabled us to assess which artists we preferred, who we wanted to meet, and what and from whom we would buy. We bought what we liked, either sole works by an individual artist or in-depth representations of an artist's work over time. In general our tastes coincided. Sharing information with early specialists in the field, other collectors, and museum curators was an enriching part of our education.

Among our earliest and most important professional mentors was the late Robert Bishop, former director of New York's Museum of American Folk Art. Bob gave freely of his time and thoughts, and his enthusiastic support was an exciting stimulus. It was Bob who encouraged us to respond affirmatively when Douglas Hyland, then director of the Birmingham Museum of Art, first approached us about mounting an exhibition based on our collection. The current director John Schloder enthusiastically endorsed the project and carried it forward. Gail

Kurt Gitter, Alice Yelen, and
their daughter, Manya Jean

Andrews Trechsel, assistant director, who organized the exhibition for the museum, has long shared our interest in this material and has been actively committed to self-taught artists in the Birmingham community. The private time we have spent with Gail and other contributors to this book—Roger Cardinal, Lee Kogan, Susan Larsen, Tom Patterson, Regenia Perry, Deborah Ritchey, Gary Schwindler, and Thomas Adrian Swain—has increased our knowledge and understanding of the artists whose works we treasure. Museum professionals who have generously helped us include Adrian Swain, Morehead State University Museum, Kentucky, and David Steel, North Carolina Museum of Art, Raleigh, who introduced us to artists in their home states. Collectors like Beth and Jim Arient, Gertrude and Ben Caldwell, Ellin and Baron Gordon, Bert Hemphill, Barrie and Alan Huffman, Sylvia and Warren Lowe, Ann and William Oppenhimer, Dorothy and Leo Rabkin, Jan and Chuck Rosenak, John and Stephanie Smither, Dot and the late Sterling Strauser, and Sue and George Viener generously shared their collections and experiences, often aiding us in locating difficult-to-find artists, sometimes providing detailed maps and descriptions. We also were positively influenced by dealers from whom we purchased artworks, among

them A. J. Boudreaux, Shari Cavin and Randall Morris, Janet Fleischer, Carl Hammer, Jimmy Hedges, Justin Massingale, Roger Ricco and Frank Maresca, Leslie Muth, and Jo Tartt. Many warm relationships developed from these early contacts.

As galleries and auctions began to offer the work of self-taught artists, we turned to them to find works by artists who were deceased when we began collecting: Steven Ashby, John William ("Uncle Jack") Dey, Sam Doyle, William Hawkins, Clementine Hunter, Justin McCarthy, Sister Gertrude Morgan, Morris Ben Newman, Elijah Pierce, Ironsides Pry, Nellie Mae Rowe, Bill Traylor, and Philo Levi ("Chief") Willey. Nonetheless, if a commercial source had a striking work by a living artist, we would acquire it. Our ultimate goal was to obtain what we believed to be the best objects available to us from any source.

In an everyday sense, American self-taught art permeates our lives. We live with it in our home; it adorns the walls of our work spaces. We continue to study the work and document the lives of the artists, and we are absorbed in ensuring that our collection is inventoried and properly cared for through professional cataloging and conservation.

The process of living with this art and knowing these artists has trans-

formed us in significant ways. The aesthetic strength of self-taught artists challenges our traditional notions of what art is and who can be considered an artist. Our view of art everywhere in the world around us has expanded. Likewise our close relationships with the artists have afforded us a personal view into their lives and deepened our appreciation for the vision and spirit of Americans who struggle with hardship in their daily lives.

Since we entered the field, awareness of self-taught art has grown dramatically in the minds of the public and within the museum community, as attested by a plethora of exhibitions and books. The rapid escalation of interest in this material raises questions regarding its survival: Will it continue to be produced? Will it hold its own aesthetically?

For us, the answer to both questions is a resounding yes. We continue to marvel at the strength and proliferation of work by contemporary American self-taught artists. In our opinion, this work has already stood the test of time. By exhibiting our collection in *Pictured in My Mind*, we enthusiastically pursue our commitment to helping the work of contemporary American self-taught artists take its rightful place in the history of the art of our country.

Susan C. Larsen

Conversations with
Dr. Kurt Gitter and Alice Rae Yelen

Collectors have always been influential in the history of American art. They have supported and encouraged artists, shaped tastes, contributed to the scope and quality of museum collections, and set an example of enthusiastic patronage, which is vital to the cultural life of any great nation.

Some have gone beyond the traditional pursuits of connoisseurship, public donation, and the responsible care of important works of art. Two such collectors are Dr. Kurt Gitter and Alice Rae Yelen. Through their private collection, scholarship, donations of works of art, and creation of important exhibitions and catalogs, they have encouraged the serious study of the art of the self-taught. With a special loving emphasis upon the art of the South, Dr. Kurt Gitter and his wife, curator and educator Alice Rae Yelen, have done much to define and shape a growing field of American art in our time.

When one arrives at the Gitter home in New Orleans, one immediately perceives that the family has had a long and serious involvement in the visual arts. Kurt has been a collector and a student of Japanese art since 1963, when he began two years of military service in Japan. He has focused on the art of Japanese Edo Period painters of the sixteenth through nineteenth centuries. The Gitter

home is enlivened by subtle ink paintings vertically mounted on silk, grand screens covered with bold calligraphy, and small handheld folios of an intimate scale. The rough textures and calligraphic painted surfaces of Japanese ceramic art create a sensuous counterpoint to the elegance of the screens and hanging scrolls. A library containing Japanese, German, French, and other European and Asian scholarly volumes represents a virtually complete bibliography on the subject of Zen painting. Some of these works are original translations commissioned by Kurt himself.

Kurt's focus on Japanese Zen and scholarly paintings was an unconventional choice among American collectors of the 1960s. His commitment was prompted in part by his fascination with an art created for private pleasure and enlightenment by a group of painters who often lived apart from the opulent culture of the regional and imperial courts. It is an art of directness and seeming simplicity, which nonetheless requires extraordinary concentration and discipline.

The spontaneity of Zen monk painters captured Kurt's affections very early in his career as a specialist in the medical and surgical treatment of diseases of the eye—a field requiring precision, accuracy, and enormous compassion. The

complementary qualities found in Japanese Zen and literati painting provided a philosophical outlet and a great deal of aesthetic pleasure. Years later, Kurt said of these painters, "Even when they are doing something they have done many times before, a fresh, raw spirit emerges."[1]

As Kurt's collection of Japanese art grew, he and his first wife began lending, and soon donating, important works to the New Orleans Museum of Art. Acquisition of specific works was then driven not only by a desire for an object but also by their understanding of the long-term needs of a growing institution whose Asian collections were small but prized by local artists and art historians. Thus a connection between private and public collecting informed Kurt's life in art, and in time it led to several exhibitions of the Gitter private collection throughout the United States.

In the mid-1980s Kurt Gitter was divorced and entered a period of study and reflection upon the role the art collection played in his intellectual and emotional life. He remained involved as a trustee of the New Orleans Museum of Art and with other art institutions locally and nationally. Kurt is currently a member of the Smithsonian Institution's Sackler Museum Visiting Committee and the Museum of American Folk Art's Advisory

Committee. He met and married Alice Rae Yelen, the assistant to the director of the New Orleans Museum of Art and an art historian, educator, and curator. Also an enthusiast of Asian art, Alice studied Japanese art history at Columbia University and later curated the important exhibition *Zenga: Brushstrokes of Enlightenment,* which opened in 1989 and traveled nationally through 1991.

Among the landmark exhibitions at the New Orleans Museum of Art in recent years was an exuberant, captivating show of the works of Sister Gertrude Morgan, a painter, preacher, and New Orleans native. This 1988 exhibition, curated by the museum's assistant director for art, William Fagaly, profoundly affected Kurt and Alice. They watched the show go up on the walls of the museum, lingered at the opening reception, came back to see it day after day, and realized that work such as this was being created in their own community by people they might come to know and understand. They had seen other exhibitions of American folk and self-taught art, but they were moved by the power of this eloquent, spiritual African American woman. "What wonderful, exciting material," Kurt recalls. "It had the flair of German Expressionism. It had honesty and truth. It was made by someone who had to create and wasn't doing it for the money. She had been part of our community, although we never met her. That show really set it off. Finally, one day I said to Bill Fagaly, 'Where can you get this kind of material?'"

A remarkable opportunity presented itself soon. The most comprehensive collection of the works of Sister Gertrude Morgan was offered to Kurt and Alice by art historian Regenia Perry, but they had to agree to purchase all fifty works. They would in effect have an important collection with their first major purchase in the field. This unusual opportunity to acquire an artist's work in depth proved to be prophetic, as Kurt and Alice agreed to emphasize the work of artists they deemed most important while selecting just a few examples of the work of many other artists.

The negotiations were lengthy, but in 1988 Kurt and Alice acquired the collection along with a significant group of Morgan's poems and letters, essential accompaniments to her art. Perry had known Morgan for many years before the artist's death in 1980. Her collection contained several masterworks and other smaller pieces characterized by the preacher's original adaptations of biblical passages and hymns as well as by the visionary spirituality, wit, and sincerity that are the hallmarks of her work. These qualities set the tone for the coming years as Kurt and Alice embarked upon building an important collection of American self-taught art with a special emphasis upon the South, and they were immediately called upon to lend works from their collection of Sister Gertrude Morgan's paintings and to aid scholars who needed access to her papers. Thus began a pattern of financial commitment, generous lending, scholarly study, and ongoing investigation in contemporary American folk art.

Kurt and Alice set their sights on artists who have become the acknowledged masters in the arena of self-taught artists. Kurt recalls, "The more we looked, the more we realized who some of the masters were, like Sam Doyle, Sister Gertrude Morgan, William Hawkins. We realized that this work was wonderful on a purely aesthetic basis. It is American. It is honest. It is really art. In terms of the art world it was also inexpensive. There was an abundance of material on the market in those years." Gitter had the advantage of his experience in the market for Japanese art and could foresee developments in the mar-ket for the art of the self-taught. "I had already gone through this with Japanese art. I had seen the days when you could buy great Zen paintings, sometimes thirty available at one time through one of the great dealers. I had come in fifteen years to find that there were none on the market. So, with Alice's approval, I decided to acquire the best things we could get."

A wide range of scholars and dealers active in the field helped Kurt and Alice in their newfound passion as they acquired works by David Butler, Sam Doyle, Raymond Coins, Mose Tolliver, Jimmy Lee Sudduth, Clementine Hunter, Willie White, and many others. Alice's contacts in the museum world led them to curators and other private collectors who became part of a network most often characterized by a friendly spirit of sharing and openness. "That first year, 1988, was so intense," Alice recalls. "We bought the Sister Gertrude Morgan collection, and then there wasn't a day that went by we didn't have some exposure to the field and learn something new. . . . Every place we went—whether for medical reasons, for art reasons, or for family reasons—this took priority. We went to every gallery, every artist, every collection. We were constantly meeting new people. Through Bill Arnett we acquired a group of Thornton Dial's works and also some by Charlie Lucas, whom we came to know very well. Charlie is now a good friend of ours. Robert Bishop [former director of the Museum of American Folk Art, now deceased] introduced us to his own collection, which included Clementine Hunter and William Hawkins. We were at Bob Bishop's home when we saw our first Hawkins and said, 'Wow! Who is that great artist?'" Sometimes the excitement of discovery was reciprocal. Kurt remembers, "Bob Bishop found out about Thornton Dial at our farm, where he saw the work *Atlanta Con-*

vention [1988, cat. no. 21]. It led to the Thornton Dial show at the Museum of American Folk Art in 1993."

While this is a story about the creation of a great collection of art, it is also a record of mutual delight and growth, and the partnership involved in the building of a marriage. Kurt and Alice were highly appreciative of the level of excitement in this field during the 1980s, partly because they knew it was a unique moment to be seized and enjoyed as it unfolded. Kurt recalls, "Finding any art that excites you is a thrill, especially if it is new to you. Maybe we were just ready, having been collecting Japanese art for as long as I had. Also, Alice and I were embarking on our own lives together and wanted to create something together. The folk art was totally shared. We bought every object together."

Creating the collection also became a passage to a new understanding of the South. "As two transplanted northerners, between us we have resided here for more than thirty-five years. You ask yourself, 'Why am I here?' Well, life is great here. Great food. Nice people, wonderful architecture; it's easy to get to work. Yet there are a lot of aspects of northeastern life that are not the same here. When we decided to pursue this collection, we said to one another, 'Let's really get to know the South!'"

Kurt and Alice used an old Toyota truck and learned how to pack works of art, tools, equipment, and food in its open bed. The tricky task of arranging tarpaulins to protect art and gear on rainy weekends was initially frustrating but ultimately conquered. "We figured out how to do new things we had never done before, . . . how to be on the road, . . . how to handle a truck. People along the way were really nice to us because our truck looked just like theirs." Kurt and Alice dedicated most weekends to

the pursuit of art and artists, and the trips were frequently long and full of surprises. They went along a southern route through Montgomery, Alabama, a trip that brought them into contact with the works of Mose Tolliver, Bernice Sims, and Charlie Lucas. They traveled throughout Louisiana, Alabama, Arkansas, and North Carolina and then extended their range north to the Middle Atlantic states and New England. Alice recalls, "I remember one Fourth of July weekend telling my sister that we had traveled 2,500 miles. We went up to North Carolina, then down to Alabama and Georgia, driving seven to eight hours to see a single artist. The cab of our truck had just a little space for one bag of clothing, and we had food because we didn't want to waste time stopping."

As compelling and enlightening as their independent investigations became, they took every opportunity to see showings of the work of new artists. In late 1988 Kurt was invited as a board member to the annual meeting of John Hopkins University Institute of Advanced International Studies in Washington, D.C. During a break, Kurt and Alice walked to the Tartt Gallery, where Jo Tartt, Jr., an Alabama native, was making a name for himself as a prominent dealer in photography and folk art. His exhibition of the work of Jimmy Lee Sudduth and the Reverend Benjamin Perkins, both Alabama artists, was a wonderful surprise. As a former reverend, Tartt had a unique perspective on the field of religious folk art and enjoyed Kurt's and Alice's strong reactions to the works of Sudduth in particular. Kurt says, "It was the first time I had seen Jimmy Lee Sudduth's work. I just completely flipped over it. I couldn't leave the gallery. I wanted to have the whole show but selected quite a few and purchased them right then. However, I wanted to meet the artist, which Jo Tartt arranged. The very next

weekend we were visiting Jimmy Lee Sudduth."

The extraordinary group of paintings by Jimmy Lee Sudduth in the Gitter-Yelen collection reflects the core of the two collectors' sensibility. Many are large and dramatic, possessing strong architectural elements and vivid emotion, irony, and humor. They span the entire range of Sudduth's preoccupations, from the varied faces, bodies, and customs of working people to pastoral landscapes, anthropomorphized farm animals, and magnificent and moody architectural paintings. That initial encounter led to a treasured relationship: "We have visited Jimmy Lee at least twenty times or more because we love being around him. We love the stories, his joy of life, of work, of being. He has such a wonderful outlook on everything."

Kurt observes, "Jimmy, unlike many of these artists, has supported himself with art for most of his life. For years and years he would make little paintings on small boards and go to all of the county fairs. He would always sell out. He has never come home with paintings. So Jimmy is probably the best-known Alabama folk artist among Alabama people."

Alice has always been fascinated by Sudduth's use of natural materials like native clays and vegetable pigments as well as his fluid adaptation to the increasing availability of paint and brushes. "Jimmy works with chalk . . . [and] kaolin. While driving to his home, we saw a mound of natural kaolin and filled up a big box we had in the truck to take it to him. It was such a joy to see the source of his colors. He also uses the natural pigment of colors that come directly from flowers in his garden. He did not use paint in any great quantity until about five years ago. Now he is very adept with it and combines mud and paint so very well. We have adored him and his late wife, Ethel."

Kurt Gitter with the artist Jimmy Lee Sudduth

Kurt and Alice have observed that the growth of interest in the art of the self-taught has led to a different kind of social life for Sudduth. "Now when we go to visit Jimmy we don't spend more than two hours before a truck drives up from any and every part of the country. He might say, 'They are doing a movie of me today.' Or, 'Someone is coming from Germany.'" Kurt and Alice understand the gradual evolution of a field of artistic activity, study, and collecting, so they try to enjoy an easygoing relationship with artists when they can. Kurt says, "It has always been simple to relate to the artists because they are soulful, wonderful people. Because I'm in the medical profession and I deal with a wide range of people all the time, salt of the earth people, you can tell in two seconds that they are wonderful. We have formed close bonds with many of the artists whom we visited and still visit."

Another artist whom Kurt met in his travels was J. B. Murry of Sandersville, Georgia. The meeting was arranged by Murry's physician, Dr. William Rawlings, who along with Andy Nasisse had recognized the importance of Murry's work. Kurt remembers, "I had heard the stories about his reading spirit writing through a bowl of water. I was very skeptical. I drove there into the middle of the state on the most gorgeous autumn day in late

September or early October. Dr. Rawlings took me to the house. I met this most humble, dignified, gentle man, deeply religious, absolutely genuine, not one iota of falsehood in him. This is not to mean that everything he said was true, but he, at least, believed it.

"He got up and talked with me about his work. I spent half an hour alone with him. He was a moving, spiritual human being. He died only six weeks after I saw him. I came home and said to Alice, 'You know, there really are people in this world who are deeply spiritual and put their feelings down on paper in some manner to express their spirituality. This man was one of them.' It was a privilege to meet him. We acquired some very good work, and we went back to Andy Nasisse and selected more. We introduced Murry's work to Bill Fagaly, who included him as the only self-taught artist in the Corcoran biennial in 1989."

Another important encounter began a long and productive relationship with the late Sterling Strauser, the well-known scholar, dealer, and collector who had been active in the field of American folk art since the 1930s. Strauser lived in East Stroudsburg, Pennsylvania, less than an hour from Alice Yelen's Pennsylvania hometown. Strauser's knowledge was vast and full of the kind of insight only years spent working in a field could pro-

vide. He is credited with the discovery and promotion of the work of Justin McCarthy, Ironsides Pry, Victor Joseph Gatto, Charles Dieter, and many others.

"Sterling was a wonderful raconteur and an artist of major accomplishment—self-taught, by the way," Kurt remarks. "He helped to educate us about the northeastern artists and to acquire some major pieces."

Alice found a strong sense of cultural commonality among artists living near her childhood home. She observes, "When we met Jack Savitsky, it confirmed for me the real authenticity of these individuals. I understood the culture in which he operated, the way he spoke, his accent, the way he lived, his mannerisms, even his gruffness and directness. I came from this area of the country, so his behavior was not so enigmatic. . . . He was from a culture of immigrants, a coal-mining culture with a strong work ethic. He had a clarity and directness. I saw that in the art. When I met Savitsky, something clicked for me. I understood the relationship of the paintings to his town. It was very special to me."

Kurt appreciated the dignity Savitsky possessed even in the midst of a painful illness. "At first he was extremely gruff with us, not interested in talking to us. Eventually he sat down and told us his whole life story, . . . how he got black

lung disease, how he couldn't work in the coal mines anymore. So he started making paintings during the early 1960s. He wouldn't sell us any paintings because his son ran a gallery and handled the paintings. But he did sell us drawings on our visit. We also acquired many Savitsky paintings through Sterling Strauser."

The Gitter-Yelen collection also contains a generous amount of the work of Mary T. Smith, who lived in Mississippi, only two hours from New Orleans. Alice found her sense of style, her innate beauty, and her expressiveness compelling, despite the fact that a stroke had left her with little ability to speak. Their communication had to be conducted through gestures, a few words, and the unspoken but obviously mutual enjoyment of her art. Alice remembers, "Mary T. lived in a lovely home where she had cleared the yard to make a place to display her work. She had difficulty speaking, and it was often impossible to understand her speech. She was a beautiful and gracious lady who wore marvelous outfits made of combinations of bandannas, kerchiefs, and shirts. Mary T. Smith was remarkably elegant. I could see that her clothes were really worn with use, often torn, and pinned together, yet I was mesmerized by the magnificence of her appearance. Mary T. was always cheerful and positive. It is unusual to feel so enriched by an experience with someone with whom you can't speak."

When Kurt and Alice returned home to New Orleans, late on Sunday nights, they faced busy schedules, telephone messages, and professional responsibilities the next morning. However, the works of art just collected demanded curatorial care and attention. Late into the night they recorded titles and dates, prices paid, dimensions, and details of the artists' biographies; then they had to find safe places around their home to store the work. As the collection grew

to one thousand works and then to over three thousand, they faced an enormous task: keeping an accurate record of their growing collection and its vital attendant material. They have recently sought additional curatorial help and computer expertise to organize the collection's records for future uses, such as the current exhibition and eventual donation of the collection.

Happily, a new person entered their lives and demanded a large part of their hearts and loving attention. Manya Jean Gitter was born to Alice and Kurt in October 1990. Weeks after her birth, she was traveling with them to the opening reception of *Zenga: Brushstrokes of Enlightenment* at the Los Angeles County Museum of Art and to the first discussions that eventually led to the monumental survey *Passionate Visions of the American South: Self-Taught Artists from 1940 to the Present.* Somehow Alice saw to the care of Manya Jean while organizing a 270-work exhibition drawn from 110 public and private collections and featuring the work of 80 artists. She outlined the text of an ambitious catalog with the help of Kurt and a wide range of scholar-specialists, art historians, curators, and collectors. The New Orleans Museum of Art agreed to sponsor the exhibition, which soon had substantial commitments from several national foundations and the participating museums that became stops on the national tour. The exhibition opened in October 1993 at the New Orleans Museum of Art with a large symposium that brought together experts and enthusiasts from all over the world and served as an introduction to people just becoming aware of this field of American art.[2]

The creation of *Passionate Visions* involved Kurt, Alice, and often Manya Jean in extensive travel to private collections, art galleries, and museums throughout the country. They saw much that was new and were made aware of the fast-

paced evolution of the field. Alice recalls, "When we finally did *Passionate Visions,* . . . so many of the artists we knew, included, and wrote about were already dead. Insights came from those moments grabbed on our trips. Kurt also recalled objects we had seen in artists' homes when we saw them in collections in various parts of the country." Thus this practically nascent field was already acquiring a past.

During the organization of *Passionate Visions,* Kurt and Alice focused on the exhibition's need to establish a balanced and inclusive picture of the work of southern self-taught artists. The exhibition gained from Kurt and Alice's familiarity with many of its major artists, but as a matter of principle Kurt and Alice used no works from their own collection and included many artists who do not appear in their collection. The exhibition was thematically organized to explore various aspects of southern life in the twentieth century: autobiography, daily life, religious and visionary experience, social commentary, patriotism, and nature. Works were chosen first for their beauty and quality but also for their ability to clarify or dramatize important aspects of southern life.

In contrast, the relative freedom involved in acquiring a private collection is a privilege known to few curators. It allows the free play of one's own values and loves, and offers a rare place in a busy life to exercise control over one's environment. There is a definite character about the Gitter-Yelen collection that is apparent when one sees the works displayed in their home: "We like very expressive art. We both like painterly things. We are not into deeply obsessive, compulsive, very detail-oriented work. Not that it isn't important, popular, or widely written about, as in the example of Adolph Wolffli, . . . but we are excited by a type of raw expressivity,

the content of a Jon Serl, a William Hawkins, a Jimmy Lee Sudduth. These are artists who, trained or untrained, belong in the contemporary setting and are important artists."

A hallmark of many artists in this collection is their ability to come to terms with their lives—often, but not exclusively, through their art. Kurt observes, "These people were wonderful people who lived their lives within society—perhaps on its fringe, by design or desire—but they were part of society and lived in it. They function well, they often have families, they do the standard things people do to sustain a life."

An example of the ease and intimacy Kurt and Alice have with their extensive collection is seen in their relationship with the work of Mose Tolliver. From the artist's easel paintings to his unusual and often elegantly elaborated pieces of simple furniture, his works in their collection are both extensive and indicative of the bond the collectors have with the artist and the impact he seems to have had on their choices and sensibility. Throughout their New Orleans home and in their country house, Tolliver's exuberant abstractions of trees, flowers, people, and animals fill and animate the environment. In fact, Manya Jean is growing up in a room warmed by Tolliver's colors, textures, and fantasies. His humor and his delight in the natural world have been touchstones for Kurt and Alice, who have sought out artists who find the world a beautiful, if at times puzzling, place and who manage to see the best in man and nature.

Kurt and Alice note that many of the artists they admire, especially in the South, are African Americans who express a great deal of their experiences and heritage in their work. Alice observes, "At least fifty percent or more of our collection was made by African Americans. In Bessie Harvey's work, for example, a direct consciousness of black origins comes out in the work, and this is also true of Lonnie Holley. We find something noble, beyond the political, something human that we all can understand and share in their art. . . . When we went to visit them we weren't treated as outsiders; we were taken in at a human level."

Responsible stewardship of their large and ever-growing collection is a continuing issue in Kurt's and Alice's lives. They have enjoyed lending works to museums for extended periods of time, and they have given examples to many institutions, such as the Birmingham Museum of Art and the New Orleans Museum of Art, to encourage the scholarship and exhibition of American self-taught art from every region of the country. They do not foresee a time when they would lose interest in new acquisitions and certainly do not pass up any opportunity to see the work of an artist new to them. Meanwhile, they are aware that such a massive collection is destined for a public institution where many eyes and many minds can benefit from their commitment to artists whose work is often seen only in thin survey exhibitions. Ambitious endeavors like *Passionate Visions* demonstrate that a large exhibition featuring many artists can have significant social, historical, and artistic content. Kurt believes that the next phase of scholarship in the field will produce detailed monographs on the figures who have earned critical acclaim in recent years.

Even as this beautiful exhibition of beloved works from their collection is on display, Kurt and Alice have acquired a new perspective on the field through their years of work on *Passionate Visions* and their awareness that they have contributed to the recognition of a wonderful aspect of American art. Kurt's eyes sparkle with humor and pleasure when he ob-

serves, "It's a lot easier to go into a gallery and buy if you have sufficient funds. But it's not the same experience, forgetting the money. You might get beautiful pictures. But you don't have the experience of knowing the artist. That has made all the difference for us."

NOTES

1. Quotations from the collectors are from interviews conducted by the author in August 1994.

2. The American branch of the International Art Critics Association awarded *Passionate Visions* Second Place for the Best Regional Art Exhibition in the 1993–94 season. The American Association of Art Museums 1994 film competition acknowledged the related video, coproduced by Alice and Kurt, a film of merit.

Roger Cardinal

Touchstones of Authenticity

Mud, sand, cement, sawdust, burlap, worn brushes, wire, driftwood, seashells, household paint, flour, sugar, glitter: Why should self-taught artists choose to grapple with improvised materials that appear wretched, tawdry, or irksome, when they could enjoy the fluent, refined, industrial products of the art-supply shop? Whence springs that perverse impulse to apply colored paints to such incongruous and inconsistent surfaces as chunks of porous timber, twisted roots, driftwood, buckled panels, old tabletops, ripped metal sheets, torn scraps of cardboard, and the like?

The straightforward answer is that artists whose daily experience proceeds without any reference to our refined and self-conscious academic culture will, more or less instinctively or commonsensibly, reach out for whatever comes to hand. To these unsubsidized creators, "making do" is self-evidently preferable to laying out cash on expensive supplies. The recourse to "unsuitable" materials among contemporary self-taught artists may indeed be as innocent as this—yet it is so widespread a phenomenon as to have become a conservator's nightmare,[1] and its aesthetic implications merit closer attention.

Of course, any student of modern art knows that the cultivation of supposedly improper materials is not unique to

the self-taught creators with whom we are concerned. Indeed, a strong case can be made for seeing this practice as the strategy par excellence of the twentieth-century avant-garde. Picasso and Braque with their tobacco wrappers and newsprint; Kurt Schwitters with his streetcar tickets and broken toys; Jean Dubuffet with his tar, glue, and anthracite; Antonio Tapies with his sand and grit; Julian Schnabel with his smashed ceramics; Christian Boltanski with his cast-off garments; Richard Long with his buckets of river mud; Damien Hirst with his animal corpses—these modern professionals trade on the *frisson* that arises when the tacky and the unhygienic are smuggled into an otherwise pristine aesthetic domain. By and large, the strategy can be defined as a flouting of an etiquette of seemliness, a deliberate indiscretion calculated to sharpen the sense of novelty.

However, it is by no means certain that the nonacademic artists represented in this exhibition have any real complicity with the sophisticated gesture of provocation of an avant-gardist who deliberately posits and then refutes the academic standard. For one thing, it is doubtful that the self-taught operate with any real consciousness of the criteria that we tend to associate with the well-lit, well-swept spaces of our public

galleries. When he set about portraying a sailing ship in *First Passenger Line from Frogmore to Savannah* (cat. no. 24), the folk painter Sam Doyle seems to have made do with a section of flat tin without grumbling about its irregular shape, adapting the stern and foresail of the vessel to the available field and laying down his image in bold strokes of bright enamel paint. There is a kind of genial stubbornness here that seems integral to Doyle's creative stance.[2]

Hence, when we notice a contemporary folk artist infringing academic rules, the explanation may simply be that the natural site for the creation and reception of his or her art is more the backyard and the local neighborhood than the downtown studio or gallery. In any event, a creator who is self-motivated has really no reason to conform to external stipulations. A wood-carver like Clyde Jones would, I think, see no point in having a consignment of expensive, pretreated timber delivered to his door. I don't suppose a stone-carver like Raymond Coins would feel comfortable with a set of state-of-the-art steel chisels, nor can I imagine Jimmy Lee Sudduth having any truck with camel-hair paintbrushes since he can use his fingers. Insofar as the self-taught tend to be totally engrossed in the activity of making their art, the secondary impulse of consciously

communicating with other people, and the tertiary impulse of soliciting their approval are bound to carry less weight. If indeed it is the physical business of coming to grips with concrete substances that is the decisive issue, then the fact that the finished work so artlessly confesses the ordinariness of its constituents may prompt us to identify mud, driftwood, and the rest as clues to a specific aesthetic attitude—in effect, as touchstones of authenticity.

An academic purist might expect that the reliance on degraded substances salvaged from the immediate environment would lead to mediocrity: To apply low-quality enamel paint to a nondescript fragment of roofing tin could seem the very recipe for aesthetic disaster. Yet recourse to base materials should not be equated with artistic illiteracy or a stunted imagination. On the contrary, the artists in this exhibition prove once and for all that it is never the fine frame that makes the picture. An untrained painter like Mary Tillman Smith seems almost to defy the curator to fit a proper frame about her unevenly shaped and boisterously daubed images, while Purvis Young revels in slapping his colors onto sections of old doors and cupboards whose flatness is disrupted by tacked-on slats and other jutting extras. (Young often incorporates incomplete lengths of framing material into his pieces, as if to spell out his disdain for curatorial standardization.) To such artists, suggesting that the substances they are manipulating may be improper or inadequate to their expressive purpose would seem preposterous or simply beside the point.

One way of defining a work of art is to see it as the record of more or less controlled gestures of wrist and hand that seek to articulate a particular vision. In effect, the physical articulations of contemporary folk art are of a piece

with the intellectual determinations concerning media and materials; and it is arguable that once an artist begins to manifest expressive intensity and formal eloquence, then these qualities must be a function of the constraints he or she has tacitly accepted. This is surely the case with each of Ralph Griffin's root sculptures, where the original shape of a piece of found wood is the whole point of a work and where the artist evidently adheres to a rule of not interfering with that shape other than to daub it with paint (Griffin is quoted as saying, "I look at a piece of wood and it tells me what it is"). To limit one's creativity to the finite range of adaptable materials within easy reach is to commit oneself in some fundamental way to an expressive register that is vernacular, unassuming, and without guile.

Of course, even here, nothing is absolutely neutral. Mud, house paints, roots, and remnants from the sawmill are not in fact unmarked or inert materials, nor is their expressive potential as narrow as the purist may suppose. For one thing, their very everydayness ensures they convey an unmistakable weight and texture, just as they transmit clues to the wider environment of which they are a kind of representative sample. Furthermore, their very unobtrusiveness and familiarity tend to hasten our recognition of and sympathy toward the emergence of an individual's mannerisms. It is in this sense that we can posit a connection between a down-to-earth approach and an evolution of artistic eloquence, insofar as the self-taught artist works toward more and more satisfying acts of self-expression against a background of unpretentious self-reliance.

The point is underlined once we consider the intimate relation between creative work and everyday living in practically all the cases we encounter

here. Most of the artists in this exhibition execute their art in the same spaces where they eat and sleep. Some set aside a designated area for their work—a corner table, the attic, the porch, the garage, the yard—but none has what could be considered a formally appointed studio, and few maintain a separate establishment secured exclusively for their work, as mainstream professionals typically do. The self-taught tend not to insulate their art making from their other concerns. Consequently, theirs is an art imbued with a sense of the here and now.

Of course, it would be wrong to place the intricacies of good art making on a par with everyday chores and pastimes, as though making a picture were like making a bed or baking a pie. However closely the creative process is connected to and conditioned by ordinary circumstance, its distinctiveness must ultimately shine through—as is made plain by an artist's characteristic concern for the way his or her work is treated after its completion. (I say this even while recognizing such exceptions as Clyde Jones, who manifests a sublime carelessness by exposing the carved "critters" in his yard to the ravages of frost, rain, and wind.) What I want to stress is that here the shaping activity we call art making is so integrated with the general rhythms of daily life as to suggest that the artists' aesthetic criteria are not far removed from the criteria they apply to all the other areas of ordinary existence. Thus, in the vernacular context, the value one places on a well-made bed or a decent pie may indeed have some bearing on one's taste in art.

For all that the Western fine-art tradition has insisted upon art's autonomy and superiority, it is clear that the wider history of human creativity testifies to a host of contexts and cultures where it has been thought perfectly proper to

align the aesthetic with the common-place. Across rural Europe, the application of ancestral artistic designs to such functional artifacts as spoons, jugs, plates, baskets, blankets, and carpets has been a hallmark of what we might broadly term the peasant aesthetic, an aesthetic that has always blithely ignored any attempt to separate its "arts" from its "crafts," to divorce beauty from function. The objects we now see as typifying early American folk art were obviously produced not only to be admired but also to be put to practical use. It is only nowadays, under the artificial regime of the collectible, that the duck decoy and the weathervane are brought indoors out of the rain. We know that, in classical Japan, a seamless union of artistic and ordinary behavior was cultivated in order to invest ritual or transcendental meaning into activities as ordinary as tea drinking. Age-old tribal traditions across the globe blur the boundaries between the aesthetic and the commonplace by making artworks fulfill a practical purpose. For the Kwakiutl Indians of the Northwest Coast or the Sepik peoples of New Guinea, for instance, it would be unthinkable to shape a spear or a canoe without also adorning it with artistic devices relating to the hunt. Within the history of human culture, the evidence is that the unadorned artifact tends to be simply ineffectual, invalidated both in aesthetic and in functional terms. The implied intersection of different scales of worthiness should offer us food for thought. And though we would have to admit that James P. Scott's ramshackle river-boats look less than watertight, we might easily be proven wrong if we judged Willie Massey's birdhouses to be too much like art to be capable of housing birds.

When we look at a work that declares its affiliation to the everyday through its use of mundane materials, we may well suppose that several of the artist's neighbors had an equally sharp sense of the resources of the shared environment and that this colored their aesthetic response. The recycling of machine parts in the sculptural assemblages of Charlie Lucas and David Strickland represents a process of do-it-yourself adaptation that attentive neighbors are likely to understand and appreciate. It may even be that the local mechanic from whose garage dump such a sculptor scavenges his materials not only enjoys the artistic statement but also analyzes the technical derivation of the object's components. The practice of artistic *bricolage* corresponds to an important expressive paradigm whereby elements from lapsed ensembles are reorganized as new ensembles; these novel correlations attract us when their disparateness is balanced by the cohesion of the maker's vision. In the case of the makeshift improvisations of Lucas and Strickland, our response is hastened by our sense of the irony that inheres in the duality of literal and metaphoric forms. (The Mad Hatter might have asked, "Why is a human arm like a car's exhaust pipe?")

As for the self-taught painter who sets out to construct a visual transcript of some everyday experience, the point is that his or her work will not only reflect an idiosyncratic view of time and space but will also open up a dimension of collective perception and memory. The arresting simplicity of Minnie Adkins's painted animals, Jon Serl's wry portrayal of cotton pickers, the Reverend Johnnie Swearingen's sketch of a baseball game in lively progress, Victor Gatto's visual news flash of the Johnstown flood: All of these images establish a sense of personal participation while transmitting to a local audience on the wavelength of shared experience. Such works articulate what is in effect the central truth of self-taught art of this homespun kind—the kind sometimes called memory painting —namely, that it speaks simultaneously of the particular and the general, the personal and the social. A nonelitist humor and a workaday bluntness of reference confirm the impression that such art is inseparable from the sensations and situations of the artist's home environment, to which we, as viewers, can only aspire to belong by proxy.

The twinning of private and public registers of expression is well exemplified in the architectural paintings of William Hawkins and Jimmy Lee Sudduth. Though each possesses an unmistakable signature, each approaches the task of portraying a given building in the same way, aggrandizing and memorializing it as a supreme entity, as something massive and authoritative, which dominates the wider setting within which hundreds of lives have taken shape. A prime function of such art, which takes place without public sponsorship, can be to corroborate and emblematize communal experience— the artist being inspired, as it were, not simply to speak of familiar things to those who already know them but also to promote those things to a heightened level of consciousness. Both Hawkins and Sudduth can be called expressionists in the sense that they invariably project their own personalities into whatever images they choose to make. Again, both command respect as imagemakers when their delightful idiosyncrasies are in turn eclipsed by a kind of aura of the monumental, of the mythic, conjured up by their garrulousness, hyperbole, and gestural dynamism.

I hope it will not seem perverse if, having placed my emphasis on the here and now as the foundation of this art of the vernacular, I also point to the

very opposite as a reciprocal aspect of the truth. Tribal art is again a helpful comparison: Across the world, it also thrives on the recurrence of those privileged moments in the calendar when, in setting aside the normal balance between art and life, a community suddenly propels its art out of the realm of the commonplace and demands that it mediate those invisible spirit-forces that resist assimilation to daily routine. Yet even as we picture this contrast, we should bear in mind that the sacred and the mundane are not necessarily antagonistic categories: The paradox of so-called savage thinking is that it equivocates between what our Western mentality constitutes as irreconcilable poles. We can learn much from the comparison if we realize that tribal art is associated both with ordinary communal activities, such as cooking and hunting, and with extraordinary ones, such as religious festivals and initiation rites.

Without equating wholesale the approach of the tribal creator and that of the Western self-taught artist, I suggest that both enjoy a similar sense of the simultaneous ordinariness and magicality of human existence. In her cyclical images of rural life in her native Louisiana, Clementine Hunter seems to insist, in her naive yet arresting way, that we not only look at the literal surfaces of the everyday but also absorb the latent values those surfaces project. "Is this Paradise?" asks the painter Mark Anthony Mulligan, referring us to an urban environment seething with a thousand facile signs, from the "Garlic Fresh Bread Company" to the "Low-Seat Pic-Pac Supermarket." Oh, yes, we may want to reply, sensing that his point is to get us to see that there is something marvelously exotic about this very banality. There is perhaps an "elsewhere" hovering within the here and now.

Now it is that my commentary begins to falter, overtaken by a vaguer, more abstract vocabulary—the symbolic, the mythic, the sublime, the metaphysical, the sacred. Yet I hope there is no idle mysticism in the suggestion that, in whatever terms we choose to define it, contemporary folk art does typically call up some sort of spiritual dimension. I believe we should acknowledge this dimension as contributing to the resonance of any artwork, and we should try to be alert to its bearing upon the work's final meaning. It is in this spirit that we may contemplate the uncanny calligraphies of J. B. Murry, seeing in them the traces of a ritual invocation that is at once religious and artistic, just as we may discern in Sister Gertrude Morgan's painterly revelations something like a transfiguration of the earthly-visible into the celestial-visionary.

As long as variations in individual tastes continue to flourish, an evaluation of any folk artist must remain provisional. Many argue that it is healthier to avoid a setting up of folk masters, since it would muffle our sensitivity to less emphatic messages, including those by anonymous creators. What I have tried to highlight is acknowledgment of an existential location and a material base for the aesthetic event. As human communications, these unkempt expressions are irreducible memorials to the authenticity of individual effort, both physical and intellectual. The fact that, as museum exhibits, they have shifted into a secondary phase of circulation should disallow any exclusive rights of possession or interpretation. I believe we only lose if we efface the self-taught creator from our consideration of the work he or she passes on to us. No criticism can be complete if it ignores the fact of the maker's exposure to the dreariness and the drama of circumstance, of existence

both murky and magical. And if we aspire to a more sensitive appreciation of contemporary folk art, we must become more adept at surveying our own sensations, as well as the ideas and values which those sensations help to situate and define. Such marshaling of our perceptions can only heighten the sense of marveling, as we learn to construe the rare visions formulated in mundane materials.

NOTES

1. The Wisconsin-based conservator Anton Rajer has told me some hair-raising and hilarious tales of his commissions to stabilize objects composed of cow dung or turkey bones and to rescue works marred by soot or bird droppings.

2. Rather than comparing the self-taught to contemporary professionals in the West, we may find more instructive parallels among creators of other cultures—such as the carvers and mark-makers of European prehistory, or the dreaming-painters of aboriginal Australia—who simply *get on with the job*, applying the most convenient pigment or sharp tool to the nearest firm surface, be it a piece of bone, a rock, or a strip of bark. Though their art is so often universalized, these are essentially local artists, working in a specific location with local materials and a local audience.

The Artists and Their Works

Minnie Adkins

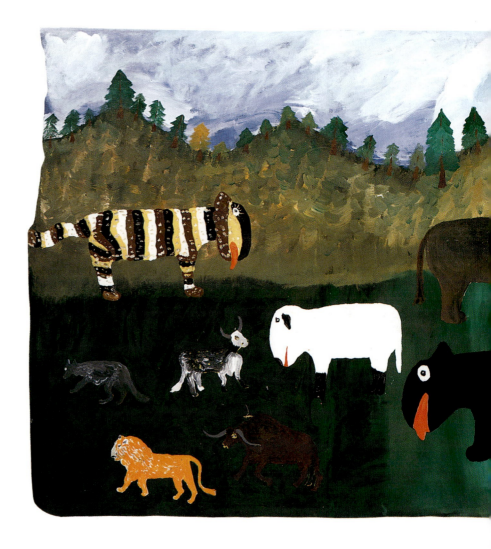

Minnie Adkins, born in Kentucky, where she still lives, is most familiar to me as a wood-carver. Working with her husband, Garland, she has gained a following for her remarkable painted sculptures of animals. These productions express the artist's respect for and love of these creatures at the same time that they preserve signs of their basic animal nature. The sense of humor that pervades these works is also one of Adkins's artistic signatures.

An important exception to Adkins's preference for sculpture is a remarkable, mural-like painting, *The Entangled Wood no. 1*, 1989 (cat. no. 1).[1] A horizontal composition painted on a black fabric window shade, *The Entangled Wood* imitates some of the conventions of landscape painting and at the same time takes liberties with them. The setting, for example, is divided into three horizontal registers. A more or less conventional foreground takes up fully half of the composition, and it represents the grassy green meadow in which Adkins's animal subjects stand. Above this, the artist painted in a line of hills marked with trees. The upper quarter of the painting is a blue sky with white clouds. All three sections are rendered in a rudimentary manner: The foreground is little more than a scumble of unmixed pigment (my guess is that it is phthalo green straight out of the tube); the hilly area is represented using rough mixtures of ochers and touches of green on which are superimposed tree motifs indifferently distributed and perfunctorily represented by green triangles with short brown "stems"; the sky, equally rudimentary in execution, is a thickly brushed simulation of white clouds against a blue background. There is no evidence that the artist sought to suggest space through atmospheric perspective; the subjects are

simply placed against a flat surface suggesting a theater's backdrop.

It seems clear that Adkins felt no compulsion to expend much time refining the setting; it is the animals that inspired her deepest interest, and she seems to have wanted to "rush on" to get to them. And they are a curious lot. An even dozen, they represent a variety of types found in the barnyard and in the wild. They also vary greatly with regard to scale and how they are placed in their environment. Unlike academic artists, Adkins is not concerned with arranging her subjects according to relative sizes of species, establishing their optically logical placement in their setting, or composing her subjects into "interesting"

groups or lines of movement. The message seems to be: "These are animals that interest me. They are creatures of nature. Here is how I imagine them."

Considering the relative scale of individual creatures, it appears that the largest are those that interested Adkins the most; it is almost certain that she has seen these types in the rural area where she lives. Thus, in the right part of her painting, there is a wonderfully lively depiction of a fox, its highly stylized silhouette a direct translation of Adkins's wood carvings. The body is a brilliant red-orange, with paint applied in flat areas (there is no modeling); the face and the tip of the tail are pure white; the lower halves of the legs are black; and

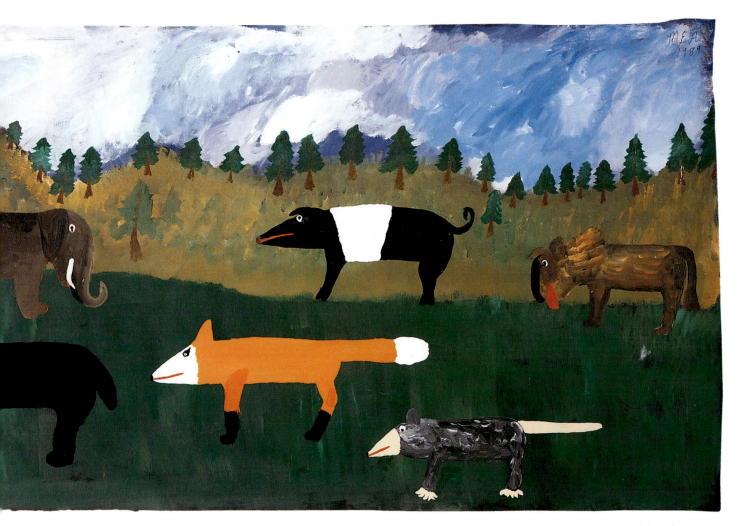

1. *The Entangled Wood no.* 1, 1989

the expression on the face seems to be a self-satisfied smirk. One is reminded of the cunning and mischievous Renard the Fox. Similar treatment is noticed for other common animals, such as the pig, the sheep, and the large black creature in the center foreground. Only the simplest internal details are found in the bison and the opossum painted at the right of the picture.

An interesting conceptual shift occurs among the more exotic creatures Adkins has included in this painting. For example, both the lion and what I believe is a musk ox, located in the lower left corner of the composition, are much too small in relation to most of the other animals; with respect to pictorial space,

they should be among the larger subjects of the foreground. Because Adkins seems less sure of their form, they are also more self-conscious, even labored renderings. My guess is that instead of proceeding directly toward conventionalizing them from personal recollection, as she might have done more easily with, say, the fox or the sheep, Adkins turned to printed illustrations of the exotic animals for guidance.

I do not see these "irregularities" as real problems in this painting. In fact, what is striking about Adkins's *The Entangled Wood*—and this seems true of many productions by self-taught artists—is that it documents directly and candidly the artist's private world with-

out the intrusion of academic standards of pictorial representation. It is a compelling, surrealistically evocative composition, as unnerving as it is charming.[2]

—G.J.S.

NOTES

1. An inscription appears on the back of the painting: M. E. A. / 1989 by Minnie Adkins The Entangled Wood no. 1.

2. In preparing this commentary I have referred to the entry on Minnie and Garland Adkins in Alice Rae Yelen, *Passionate Visions of the American South: Self-Taught Artists from 1940 to the Present* (New Orleans: New Orleans Museum of Art, 1993), p. 296.

Steven Ashby

The figural assemblages of Steven Ashby are classic examples of transformative recycling, a favored practice among self-taught artists. One of many such artists who grew up in a large, economically disadvantaged family, Ashby learned at an early age how to "make do" and turn scrap materials to practical use. It wasn't until much later in his life that he began applying these skills to the creation of art, and in that respect, too, he was like many other self-taught artists who didn't begin their art-making activities until after they reached an age at which most people in our society have retired from working.

Ashby spent his entire life in Fauquier County, Virginia, where he was born in 1904 in the town of Delaplane.[1] His grandparents were most likely slaves on one or more of the large plantations that existed in that part of Virginia during the nineteenth century, and his parents were farm workers who labored under conditions only marginally better than those endured by the slaves. As the second eldest of twelve children, Ashby followed in his parents' footsteps, eschewing the opportunity to attend public school in order to work in the fields to help support the family. He later worked for a while as a waiter in a hotel in nearby Marshall, Virginia, but he spent most of his adult years doing farm chores for various landowners in and around Delaplane.

When Ashby was in his early twenties, he married Eliza King, who was considerably older than Ashby and who worked as a cook at a girls' boarding school. They set up housekeeping in a small, abandoned schoolhouse they rented from a local landowner and lived there, along with a son they adopted, until they died.

Like many rural youngsters, Ashby had learned to carve as a child, but for the first three-quarters of his life this was at most an occasional pastime. Only after his wife's death in 1960 did he begin making the slapdash figures he called "fix-ups" and displaying them inside and outside the old schoolhouse. Perhaps they were substitutes for the company he longed for in Eliza's absence. Pieced together largely from scraps of timber and lumber he modified with a saw and augmented with paint, old clothing, cutout images from magazines, and various found objects, these makeshift representations of people and animals are lively and animated. The humanoid figures are often equipped with arms nailed on at the shoulders so that they appear to be movable, like those of string puppets, and it doesn't take much imagination to envision the figures suddenly becoming ambulatory.

Standing Woman with Purse, 1972 (cat. no. 2), is a good example of such a piece. Ashby has incorporated the irregularly angled natural shape of a slender tree trunk to form this woman's legs and torso in such a way as to suggest that she is in motion, walking—or, more appropriately, sauntering—along an imagined sidewalk and staring ahead wide-eyed, as if in a trance. The head, cut from a slab of milled lumber, and the body, consisting mainly of a roughly hacked log, seem to represent two contrasting aspects of her personality. In his handling of the head Ashby has portrayed a woman of apparent grace and refinement—an impression reinforced by the simple, no-nonsense purse she carries daintily in her left hand. The body, however, seems to be that of an archetypal "loose woman," sashaying around barefoot and swinging her hips, clad only in a short, lacy half-slip and a wisp of a bra that barely covers her protruding breasts. This could be Ashby's rendition of a streetwalking prostitute, but it could just as easily be a fantasized portrait of his wife, who had been dead for more than a decade when he made this piece. In any case, he made a number of similar sculptures of scantily clad women, including some that might be classified as erotic or pornographic, depending on who is choosing the terminology.

Standing Woman with Purse dates from about the time Ashby's work was formally introduced to the art world in a 1973 exhibition titled *Six Naives*, at the Akron Art Museum, which drew the attention of some of the few collectors who were then actively interested in the art of the self-taught. But Ashby died in 1980, a few years before a groundswell of public enthusiasm for such art made his work far more widely known. Particularly important in drawing posthumous attention to his sculptures were two major traveling exhibitions that included several examples of his work and that began their national tours in 1981 and 1982, respectively: the Milwaukee Art Museum's *American Folk Art: The Herbert Waide Hemphill, Jr., Collection* and the Corcoran Gallery of Art's *Black Folk Art in America, 1930–1980*. —T.P.

NOTE

1. The biographical information included here is drawn from two sources: Jane Livingston and John Beardsley, *Black Folk Art in America, 1930–1980* (Jackson: University Press of Mississippi, 1982), pp. 58–63; and Chuck Rosenak and Jan Rosenak, *Museum of American Folk Art Encyclopedia of Twentieth-Century American Folk Art and Artists* (New York: Abbeville Press, 1990).

2. *Standing Woman with Purse*, 1972

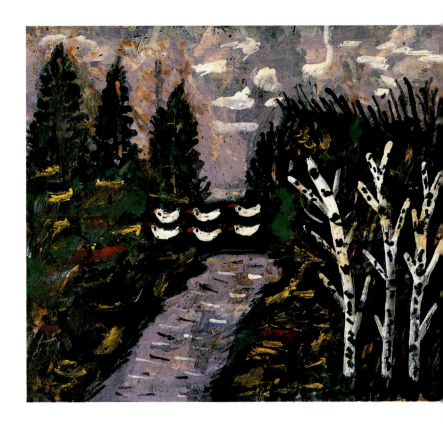

Aaron Birnbaum

In July 1995 Aaron Birnbaum was honored at the Museum of American Folk Art with a mini-exhibition of his works and a birthday party to celebrate his one-hundredth birthday. In good spirits and good health, Birnbaum greeted seventy-five people, including many friends and family who came in a chartered bus.

The artist was eloquent in reminiscing about his life. He spoke of his motivation for painting as a hobby to fill his time after his retirement as a tailor and the death of his wife. He recalled that to quell his loneliness friends encouraged him to buy a dog or raise canaries, but he did not wish to be tied down. Finally, in 1960, he turned to painting, and to this day he continues to paint pictures. He believes that painting helps keep him alive. His early paintings were given to his family; he then painted for his friends, and now his works reach a larger audience. Birnbaum's eyes twinkled as he related his experiences.

Untitled (Landscape), 1993 (cat. no. 3), a traditional memory painting that the artist calls a "remembering" picture, is an Edenic scene composed of two related landscapes. On the right is a house and a contented family, surrounded by birds, flowers, butterflies, and animals. The left half of the painting contains a birch and evergreen forest divided by a stream, the idyllic setting suggesting an area near Birnbaum's birthplace in eastern Galicia, then a region of Austria-Hungary where he "roamed and fished." With its representational yet abstract modernist style of composition, the painting simultaneously encompasses two of the artist's painting techniques. The house-and-flower scene is crisply linear and strongly graphic; the view of the forest is more expressionistic, looser, and more painterly. Created from materials at hand, the cardboard work is painted on the back of a painting on velvet the artist found. He has also painted on mirrors, old fruit-crate tops, and other recycled materials.

The peaceful narrative evokes an optimistic, idealized view of the world, which is not reflective of Birnbaum's early life experience of loneliness, struggle, and hard work. The artist expresses a remarkable attitude toward life: "If you are durable, your resistance can overcome a lot of trouble. . . . It is not the strength you got, it is the durable you got that [helps] you overcome all your troubles."[1]
— L.K.

NOTE

1. Quoted by Ann Mai in *Folk Art Magazine* 20, no. 3 (fall 1995): 48.

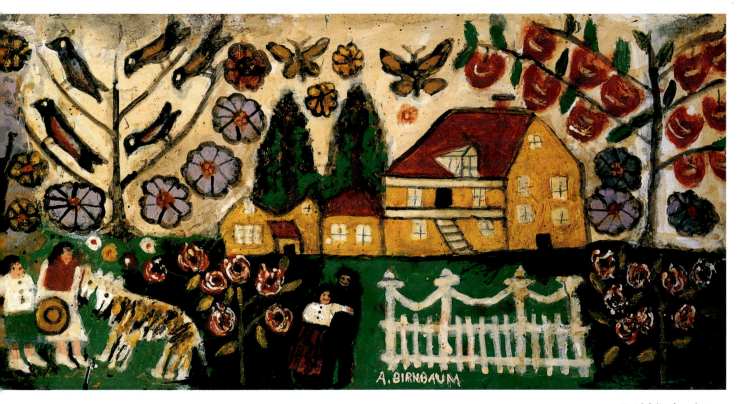

3. Untitled (Landscape), 1993

Minnie Black

Gourd craft is a popular hobby in the American South and other parts of the world where gourds thrive. Its simplest manifestations are functional objects such as bowls, ladles, birdhouses, and rattles. But Minnie Black of Laurel County, Kentucky, has taken this simple craft to new levels of artistry in the figural gourd sculptures she began making some thirty years ago.

Born Minnie Lincks, the eighth of twelve children, in 1899, Black grew up on a farm not far from where she lives now. When she was nineteen she married William Black, a railway agent who later ran a grocery store, and they raised four children to adulthood before she developed the singular art form for which she is now widely known.

Black started growing different varieties of gourds during the late 1940s, soon after she and her husband moved into the rural stone bungalow that is still her home. She recalls that, after several years of cultivating these oddly shaped fruits, "I began to see things in them gourds—little animals and things—and I wanted to see if I could make something out of them."[1] She made her first gourd sculptures in the late 1960s, not long after her husband retired and closed the small grocery store adjoining their front yard. This small cinderblock building later became Minnie Black's Gourd Craft Museum, a low-profile roadside attraction that continues to serve as a repository for many of her distinctive works.

Black's basic technique is related to that of other artists represented in the Gitter-Yelen collection, notably Bessie Harvey, Ralph Griffin, and Clyde Jones. Just as they work by elaborating on animal or humanoid features they perceive in the contours of tree stumps and roots, Black creates her sculptures by highlighting the "little animals and things" that she finds suggested in the natural forms of her gourds. To do this she employs a variety of materials, among them wire, paint, shellac, wig hair, chicken feet, fabric scraps, false eyelashes, plastic googly eyes, and a puttylike substance called Sculpta-mold. Her earliest creations were small, fanciful lizards and birds, most of which she gave away to friends and relatives. As she gained confidence in her artistic abilities, she grew more ambitious and eager to experiment with new forms, and she began creating pieces that were larger and more complex. A 1970s gourd-sculpture portrait of her sister Myrtle was her first attempt at depicting people. "Myrtle was kind of plump and fat," says Black, "and that thing looked a lot like her. She didn't like it, but she took it home with her anyway." Since then she has made self-portraits and gourd-based sculptures of other family members and acquaintances as

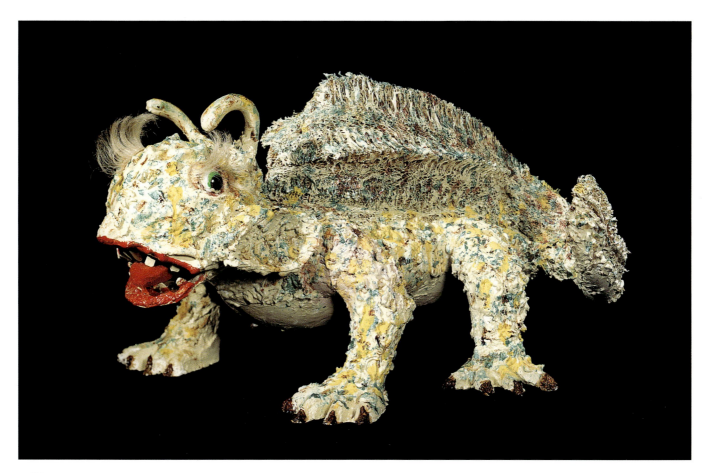

4. *Critter*, 1990

well as "cavemen," United States presidents, and such pop-culture figures as Elvis Presley. Most of her work still consists of quirky bird and animal pieces, although recent ones are generally larger and far more elaborate than her earliest attempts.

Critter, 1990 (cat. no. 4), is a good example of the new pieces. This amusingly grotesque quadruped looks like the giant mutant offspring of irradiated horned toads. Its bulging plastic eyeballs are topped with absurdly long, blond lashes, and its open mouth reveals widely spaced teeth of white-painted cardboard and a blood-red tongue made from a loofah, or sponge gourd. Its facial expression suggests that it's as startled as viewers are likely to be on first encountering the creature.

Black has also created musical instruments from gourds, and these are used by a musical group she organized

with friends and likes to call "the world's only all-gourd senior citizens' band." She is also one of the celebrated members of the American Gourd Society and has faithfully attended its annual conventions in Mount Gilead, Ohio, since 1972. Her appearances on popular television shows, most notably *The Tonight Show* and *Late Night with David Letterman*, have made her a nationally known figure even among those who don't normally follow the field of self-taught art. —T.P.

NOTE

1. Quotations are from an interview the author conducted with Minnie Black at her home on June 11, 1994.

David Butler

Born nearly a century ago, in 1898, in the southern Louisiana hamlet of Good Hope, David Butler demonstrated an early propensity for art making in the drawings and carvings he made as a child and adolescent.[1] He may have inherited his skill in working with his hands from his father, a carpenter. His strong spirituality and deep respect for religious tradition were instilled in him by his mother, a missionary. These traits, combined with an eye for color and beautiful form, were important in shaping the singular artistic vision that Butler began to manifest later in his life and that has made him one of this country's best-known self-taught artists.

Before he began making the art that earned him this reputation, Butler spent much of his adult life working at menial jobs in the timber and pulpwood industry. He was sixty-two years old when a work-related accident left him partially disabled and forced his retirement from full-time wage earning. It was then that he turned to art as a way of passing the time and livening up his home. In this respect he is like many other self-taught artists, who began their creative careers only after becoming disabled or otherwise forcibly retired from more mundane employment.

Working with readily available materials that cost little or nothing, Butler started fashioning lively, kinetic assemblages such as *Whirligig*, 1975 (cat. no. 5), which he installed on wooden posts around the outside of his house in Patterson, Louisiana, only a few miles from where he was born. Using a knife and a hammer, he cut distinctively fanciful silhouettes of animals and humanoid figures from old slabs of roofing tin. He then painted these in bold colors and loose geometric patterns, nailing or otherwise affixing them to scrap-wood supports that had attached movable wheels or propeller blades made of the same cast-off materials. In addition to these freestanding whirligigs, he made decorative scrap-tin cutouts that he nailed over the windows of his house, enhancing his privacy while also creating lively patterns of sunlight and shadow on the floors and walls inside. He reportedly told one friend—the academically trained sculptor John Geldersma—that these window coverings were "spirit shields" intended to protect him from harm. He evidently believed they could deflect the negative forces to which he felt vulnerable following the death of his wife in the 1960s, only a few years after his disabling accident.[2]

This tends to support some scholars' suggestions that Butler's art contains visual and symbolic components rooted in African tradition. In addition to the protective charms that have long been used in western and central Africa, his work also appears to be related to sacred Kongolese cosmograms and grave embellishments, as well as to aspects of Haitian popular art and Vodun (voodoo) religion that are similarly derived from African sources.[3]

A number of professional artists and other individuals involved in the contemporary art world learned of Butler's art and began visiting him during the 1970s, just as the work of self-taught artists was beginning to attract a mass audience. His work first drew national attention when several of his painted assemblages were included in *Black Folk Art in America, 1930–1980*, a twenty-artist traveling exhibition organized by the Corcoran Gallery of Art in Washington, D.C. Largely as a result of this show, art collectors began buying what work he was willing to part with, but he was ambivalent about selling pieces he had made for his own use and amusement. "I can make things because God gave me a gift," he said in 1983. "But God don't want no one selling what's a gift. If you have a gift, then you shouldn't be taking no money."[4]

Butler continued to produce and occasionally sell new work for a few more years, but beginning in the mid-1980s, repeated incidents of vandalism and increasing crime in his neighborhood left him discouraged and fearful, and he stopped making art altogether.[5] These problems, combined with his declining health, eventually led him to move out of his house. After living with relatives for a while, he entered a nursing home in Morgan City, Louisiana, not far from where he grew up, and that is where he remains at this writing.

—T.P.

NOTES

1. In addition to the other sources on Butler listed below, information contained in this essay was drawn from the following: William A. Fagaly, *David Butler* (New Orleans: New Orleans Museum of Art, 1976), no pagination; Jane Livingston and John Beardsley, *Black Folk Art in America, 1930–1980* (Jackson: University Press of Mississippi, 1982), pp. 64–66; *Baking in the Sun: Visionary Images from the South* (Lafayette, La.: University of Southwestern Louisiana Art Museum, 1987), p. 60; and Chuck Rosenak and Jan Rosenak, *Museum of American Folk Art Encyclopedia of Twentieth-Century American Folk Art and Artists* (New York: Abbeville Press, 1990), pp. 65–67.

2. Calvin Harlan, "John Geldersma and David Butler," in *Shared Visions, Separate Realities* (Valencia, La.: East Campus Gallery, Valencia Community College, 1985), no pagination.

3. Maude Southwell Wahlman, "Symbolic Dimensions in the Art of David Butler," in ibid.

4. Artists' Alliance, artist's statement in *It'll Come True: Eleven Artists First and Last* (Lafayette, La., 1992), p. 56.

5. Warren Lowe, letter to the editor, *Folk Art Messenger* 7, no. 3 (spring 1994): 5, 12.

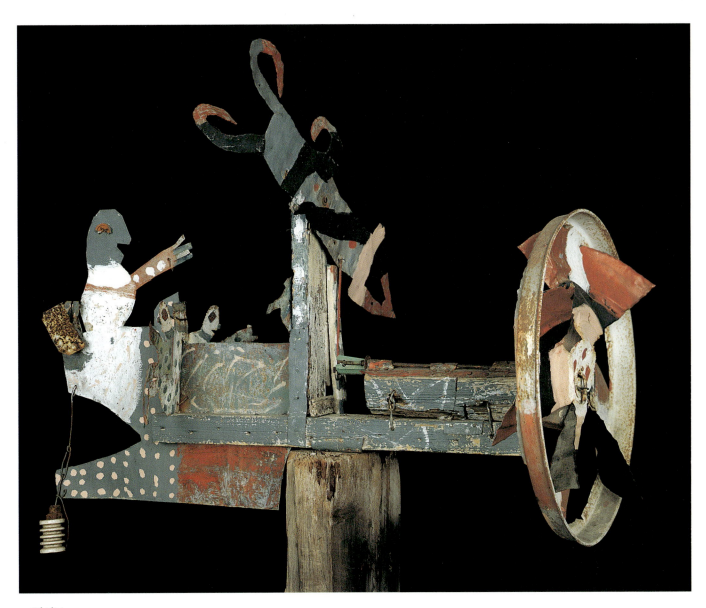

5. *Whirligig*, 1975

Archie Byron

The amazing diversity of Archie Byron's art reflects not only his fertile imagination and his keen observation of human behavior, but also his own richly varied life experience. Born on Groundhog Day, 1928, in the black Atlanta neighborhood known as Buttermilk Bottom, Byron is of African American, Native American, and Euramerican ancestry. After a stint in the U.S. Navy at the end of World War II, he returned to Atlanta, attended a technical school, got married, and went into the construction business, which enabled him to support his wife, Joyce, and the four children they had during the early years of their marriage. But in 1961 Byron embarked on a new and very different career path, joining forces with two partners to form what he says was "the first black-owned detective agency in the United States."[1] Four years later he left to form his own detective agency, which occupied much of his time in the 1970s. During this period he also opened a gun shop adjacent to his office and began training professional security guards in the use of firearms. His increasing involvement in community politics led him to run for public office, and in 1981 he was elected to the Atlanta city council, where he served two full terms before retiring from politics in 1989.

It was early in his first term as a city councilman that he began to gain recognition for a previously hidden talent. In 1975 Byron had begun to make sculptural forms from found pieces of wood, and these led to further experiments in figural art. His works attracted the attention of a few collectors and curators in Atlanta during the early 1980s, setting the stage for his first exhibitions.

Byron refers to his early sculptures as "tree limb art, or nature's art," and explains his working method in simple terms: "I would see various life forms in the tree limbs, and I would complete what I saw." These works are formally related to those of several other artists in the Gitter-Yelen collection—notably Bessie Harvey and Ralph Griffin—who independently discovered the same mode of creation at around the same time. "I started making things with these tree limbs," he recalls, "and that became so interesting that I hardly wanted to do anything else. I almost became a hermit."

Then in 1977 he developed a unique sculptural material that opened up a whole new range of artistic possibilities. He remembers that, while cleaning sawdust out of the workshop where he repaired guns, "My mind said, 'You should do something with this sawdust.'" What he did with it, after some trial and error, was mix it with water and Elmer's Glue-All to form a wet, malleable substance with a consistency similar to that of bread dough. He began using this material to create bas-reliefs and in-the-round sculptures that didn't have to follow the angles and contours of found tree limbs but could instead take any shape his imagination dictated. "I call it sawdust art," he explains, "and I've done it almost exclusively since I discovered it. It's messy to work with. You've got to layer it on one layer after another, and you've got to wash your hands about fifty-six times a day. It takes so long to do a piece. But that stuff is really durable. One collector I know researched it, and he said it would stand up for over four hundred years."

After the material hardens, Byron sometimes allows its natural shade of medium to pale brown to remain, but at times he paints parts of the pieces. His freestanding sawdust sculptures are formed on molds he constructs from scrap lumber and metal. His range of imagery is extraordinary: In addition to sculpting religious icons, historical figures, and ordinary people, he sculpts landscapes and plant forms, green Martians and other fanciful creatures, and surrealistic bas-reliefs of bizarrely combined human body parts. Several years ago in an interview with Judith McWillie, he cryptically observed, "I've made some pieces that give you some weird thoughts. I wouldn't destroy them. If you've got something that has powers

in it, I think you can overcome that. You've got to have enough power or will within yourself to overcome it—especially if it's something I create myself! I'd rather overcome it rather than tear it up."[2]

Even Byron's sculptures of ordinary people seem imbued with a special kind of power, as exemplified by his *Man in Overalls*, c. 1992–93 (cat. no. 6). The most remarkable thing about this roughly life-size figure—one of the largest he has made—is the sense of individuality Byron has evoked in the nameless man's face. His furrowed brow is accented by a large forehead and bald pate; his mouth is turned down at the corners; and his eyes are fixed in a penetrating stare. His expression suggests at once bitterness, suspicion, and deep sadness. The man looks angry, perhaps weary of a socio-political system that still treats him as less than a first-class citizen. It could be a portrait of a dissatisfied constituent whom Byron remembers from his days as a city councilman. —T.P.

NOTES

1. Unless otherwise indicated, quotations and other information on Byron and his work are from the author's telephone interview with the artist on February 12, 1995.

2. *Another Face of the Diamond: Pathways Through the Black Atlantic South* (New York: INTAR Latin American Gallery, 1988), p. 62.

6. Man in Overalls, c. 1992–93

Raymond Coins

Raymond Coins lives in a remote section of rural North Carolina where the most prominent natural landmark is the Sauratown Mountains. Stretching from east to west between the Dan and Yadkin rivers in the northwestern counties of Stokes and Surry, these craggy volcanic ridges are millions of years old, and they've been the source of myth and legend no doubt since they were first encountered by human beings more than ten thousand years ago. Their highest points—between 2,500 and 3,000 feet above sea level—are Moore's Knob, Hanging Rock, Sauratown Mountain, and Pilot Mountain. Pilot Mountain is capped by a dramatic, treeless dome of quartz, slate, and mica that can be seen for many miles in all directions, and the Saura Indians who once inhabited this territory called it *Jomeokee*, or "great guide." Early white explorers in this part of the Appalachian Piedmont named it Mount Ararat and circulated the legend that it was the island on which Noah landed his ark when the great flood began to subside. The lore of our own era identifies Pilot and its companion mountains as cosmic energy centers that attract extraterrestrial spacecraft.[1]

During the early Mesozoic era the ridges were submerged undersea and collected thick deposits of sand that hardened into vast sheets of sandstone. One variety of sandstone is usually flexible and is known in these parts as "wigglygrit." Another is scientifically classified as itacolumite and can be found only in the Sauratown region and in certain parts of Brazil, where it invariably occurs near diamond deposits. This coincidence may account for one more legend, which tells of an old diamond mine located somewhere in Quaker Gap, the low saddle between Moore's Knob and Sauratown Mountain. There may or may not be diamonds in these hills, but there is

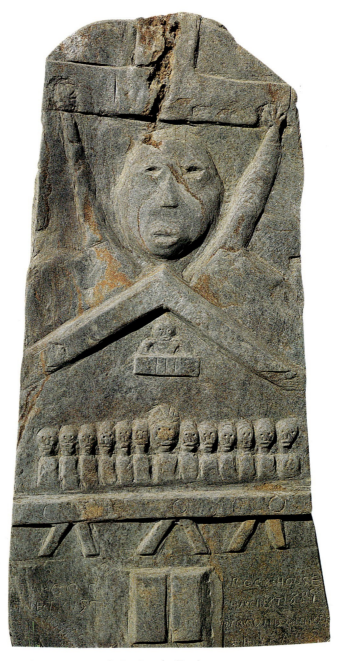

8. *Stele Commemorating the Founding of a Church,* c. 1975

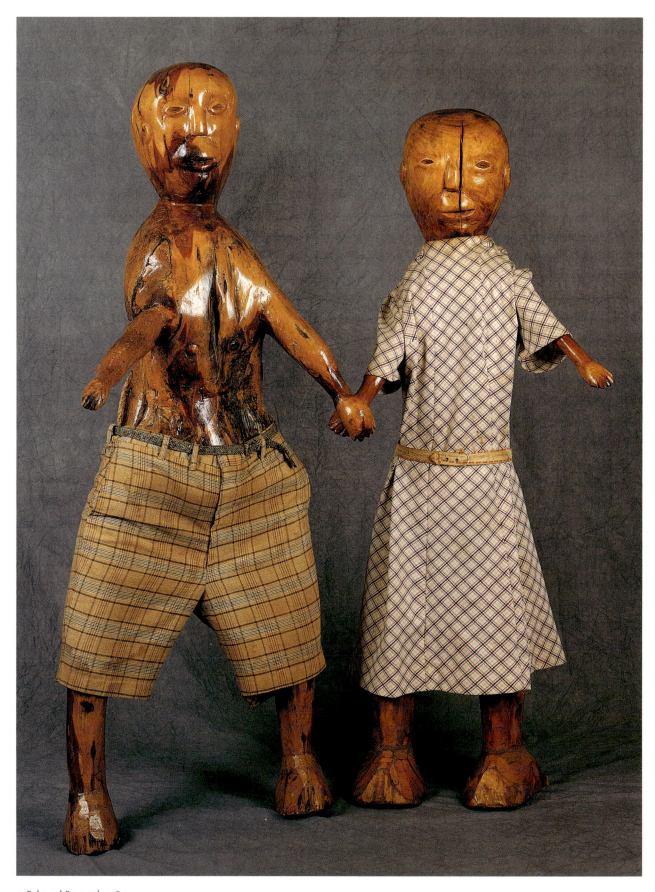

7. *Ruby and Raymond*, 1982

certainly a wealth of volcanic and sedimentary stone.[2]

The Saura Indians for whom the mountains are named were a Siouan people who originally lived in the coastal plain of what is now South Carolina and who migrated north in the seventeenth century to escape the disease and social problems that European traders had brought to the Carolina lowlands. Before the Sauras arrived, the territory had been explored and hunted by the Catawba Indians from further to the southwest, and artifacts from both groups can still be found in the creek bottoms below the mountains.[3] It was these relics, simply but expertly carved in native stone, that provided the impetus for Raymond Coins's art, which itself has become the stuff of legend.

Now in his early nineties, Coins can't remember exactly when he took up stone carving except to say that it was sometime after his retirement in 1968. He does recall the circumstances that got him started. A young neighbor, the son of Coins's longtime friend Harvey Lynch, had found some Indian artifacts in a plowed field. Coins describes them as "a tommyhawk and a little Indian bowl," both made of stone, and says he bought them from the boy for fifty cents each.[4] Something about them inspired him. He took them home, found a couple of stones roughly the same size, and used a few of his farm tools to carve replicas. Soon afterward he showed the copies to the owner of a café in the nearby town of Pilot Mountain; the café owner bought them for three dollars—three

times what Coins had paid the Lynch boy for the originals. This was encouragement enough for Coins to begin what soon became a postretirement career— "my hobby," as he calls it—and brought him the national acclaim he so easily shrugs off.

Long before he became a sculptor, Coins was a farmer. Born January 28, 1904, he spent the first years of his childhood on a small farm near Stuart, Virginia, about twenty-five miles north of where he now lives. When he was seven years old his family moved to Stokes County, North Carolina, where his father bought a small farm. He was married in 1927, and to support his wife, Ruby, and the three children they subsequently had, he labored as a field hand for rural landowners in the area. It

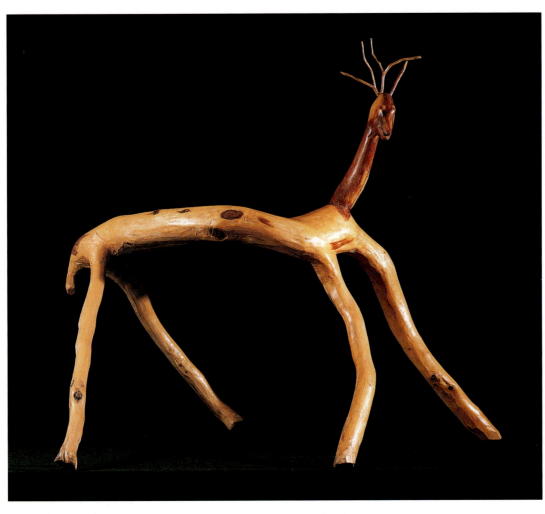

10. *Deer*, c. 1982

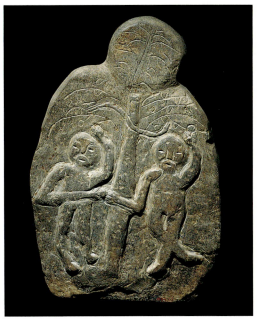
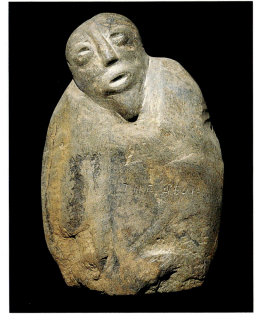

11. *Adam and Eve* (recto), *The Devil* (verso), c. 1982

wasn't until 1950 that he was able to afford a farm of his own. That year he bought a small house and a little more than one hundred acres in a quiet valley a few miles north of Quaker Gap. He has since sold off some of this land, but he still has eighty acres and still lives in the simple one-story farmhouse he shares with his wife. During the 1950s and 1960s Coins used much of his land for cultivating tobacco, the Piedmont's staple crop, but he also grew corn, rye, wheat, and oats. To supplement his farming income, he worked during the winters as a floor manager in a tobacco warehouse.

While his work and family responsibilities occupied much of his time until he retired in 1968, they didn't completely dominate his attention. Long before his artistic talent emerged, he began cultivating a deep spirituality, which manifested itself in his devotion to his church—a Primitive Baptist congregation where he remains active—and in the vividly symbolic dreams he began having as a young man and continued to experience through middle age. Although he says it has been a long time since he has had such dreams, he has recently recorded several of them in the form of carved

stone reliefs, and he still enjoys recounting them in as much detail as he can remember. During an interview in late 1994, he seemed disinclined to talk much about art, but as he exclaimed five or six times in an hour, with an almost boyish eagerness, "Now, I don't mind telling about my dreams!" And he proceeded to do just that for most of the interview.

As a devout Primitive Baptist, Coins strongly believes in divine guidance and revelation, and he claims to see evidence of these miraculous forces in his waking life as well as in his dreams. "I was showed everything to do," he insists—meaning he was inspired directly by the will of God—"and I've stuck to everything I've been showed." As is the case with more than a few self-taught artists in the Bible Belt, Coins's religion is the core of his life. He still gets excited describing the inner conflict he experienced more than sixty years ago when he had his first taste of heavenly admonition. "When I was first showed to join the church," he recalls, "I fought it for a year and a half." But he gave in and began attending services at Rock House Primitive Baptist Church, and soon afterward he heard in the church sanctuary

a disembodied voice that said, "God has give you us for a deacon." Coins obediently followed the directive and became a deacon, at which point he began to involve himself in the politics of the Fish River Association, a regional confederation of Primitive Baptist churches. It was around this time, during the 1930s, that the unusual dreams started. They were remarkably real to him, sometimes involving intense physical sensations. Coins figured the dreams were God's way of conveying special information, including suggestions about how the Fish River Association should be governed. Believing it was his duty to report these divine messages to his church and his fellow officers in the association, he did just that, and as he tells it, he was then ostracized by the entire congregation.

> The folks at the church wouldn't even talk to me about my dreams. Everyone turned against me, and it hurt me so bad I could hardly stand it, but I didn't vilify 'em, didn't hold nothing against 'em. I suffered so much I thought I'd go to preaching to relieve my feelings. But I had a dream that I was standing there in front of the church, and everybody in the church was coming around to shake my hand and telling me how good a job I'd

done preaching, and I hadn't preached a word! So I quit thinking about preaching right there. But I tell you, I went through something in Rock House Church.

Despite the pain this situation brought him, Coins remained devoted to his church and endured the hostility of other church members until the unpleasantness surrounding his dream-inspired pronouncements was forgotten. He learned to avoid discussing his dreams with certain people, but the memory of the dreams remained with him. One that made a particularly strong impression and that is repeatedly depicted in some of his later stone reliefs is a dream in which he and the pastor of his church travel to "the Valley of Dry Bones." As Coins tells it,

> Me and Preacher Martin stopped at this little house at the head of the valley, and we looked down into the valley, and there was skeletons laying there in rows and rows as far as you could see. And then this gospel sound started coming out of that little house, and those skeletons just started rising up one after the other and coming to the house to hear that gospel sound.

In another dream that he has illustrated numerous times in stone, he made a prophetic visit to the house he would later buy, seeing it as it would look fifty years later.

> I didn't plant those two maple trees and that crabapple out yonder till after we moved into this place, but in that dream they were already there, and they looked just like they do now. And this white road come right down out of the sky by that crabapple tree, and I stepped up on that white road and just kept walking. I kept going higher and higher till I come to a road that turned off to the right, and there was a little boy standing there who smiled at me, so I turned to the right. And I kept on that road till I come to another road that turned off to the left, and there was that little boy smiling at me again, so I turned off to the left. And I followed the road on till there was a place where there was two turns—one going off to the right and the other one going off to the left. Then I heard this voice that said "Turn neither to the right nor to the left," so I didn't turn neither

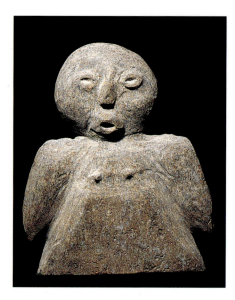

12. *Angel,* c. 1982

to the right nor to the left. And the next thing I know there was a big moccasin wrapped around me.

He pauses to explain that he's normally afraid of snakes, even those no bigger than his little finger, but that he felt unusually fearless while wrestling the giant moccasin entwined around him in his dream. "That big moccasin was bound to have been the devil, but I wasn't afraid of him because I had that gospel feeling."

Coins tells of another dream: "I was setting at the head of my table, and right there at the other end of it was a truckload of hundred-dollar bills. Then the awfulest feeling come over me. I wouldn't take the feeling for all the money, so it went away." And in the dream that his fellow church members found so offensive they temporarily stopped speaking to him, he received what he took as a divine warning about a candidate for president of the Fish River Association. This dream began with Coins and his wife going to visit two preachers who weren't home.

> The door to the house was open, so we went inside. My wife sat down at this table with a great big moccasin on it, and I went on in the next room and sat down at this big round table, and there was a great big old bowl on that table full of

the yellowest grease you've ever seen. I sat there and looked at that old yellow grease, and I stuck my finger in it and touched it to my tongue, and it just about tore me all to pieces! That was the worst feeling I ever had in my life. So after that dream I went to my church and told people about it, and I told them James Hill would bust the Fish River Association. They wouldn't even talk to me about it. But sure enough, after he got in as president, he split the Fish River Association in two.

Those who give credence to Pilot Mountain's reputation for attracting extraterrestrial craft will no doubt take special interest in a dream Coins remembers having more than fifty years ago —one that sounds strikingly similar to widely published eyewitness accounts of UFO abduction. In this dream Coins was standing under a grape arbor outside a small log cabin on the farm of his neighbor, Thornton Smith, when he noticed "balls of fire coming down from the sky." Instead of fearing the danger posed by this fiery rain, he says, "I come out from under that grapevine and walked out in it." Like his struggle with the snake, the walk in the rain of fire inspired not pain but "the best feeling I've ever had." But just as he was beginning to savor the exhilaration, he says,

> I was picked up off the ground just like I'd been shot out of a big gun. I was moving so fast, and I mean I just kept on going way on up till I came to a white building in the air. And there was a kind of a door in the side of it with the top part open, and I was hanging on that door by my arms, looking in where it was open there like a window. There were two people wearing white robes inside this white building. I didn't see their faces. Then a voice spoke and said, "Let him come in. All he's ever done he didn't know any better." And right there's where that dream stopped.

This period of intense dreams ended long before Coins retired and took up stone carving—or "cutting rock," as he says—and it wasn't until relatively late in his art-making career that he began to illustrate these experiences in stone relief. First he made simple pieces, usu-

ally in the round. His replicas of Indian artifacts were followed by a series of small, bulb-headed humanoid figures that he calls "baby dolls." At first he sculpted the life-size or smaller sculptures of infants and very young children from soapstone and other sedimentary rocks that he found near his farm, but he later took to making them in wood as well. He was still carving variations on this form when I first visited him in the mid-1980s. The mass-produced soft-sculpture Cabbage Patch dolls were wildly popular at the time, and Coins greeted me with the announcement that he was almost finished "cutting" a Cabbage Patch doll of his own. "Looks just *exactly* like a real Cabbage Patch doll," he boasted just before bringing out a small stone figure that looked nothing like a Cabbage Patch doll. Its stubby arms and legs were splayed out like those of a gingerbread man, and its irregularly rounded head lacked any detail save for two tiny eyes shaped like cowrie shells and a similarly shaped mouth carved in relief. This piece and Coins's other sculpture figures invite loose comparison to the work of various artists—from self-taught African American stone-carver William Edmondson to the early Olmec sculptors of pre-Columbian Mesoamerica —but they ultimately look like nothing other than Raymond Coins's sculptures. They are as stripped-down and stylized as ancient Cycladic effigies, but they are almost brashly crude and awkward, qualities the artist has cultivated ever since he began cutting rock. Coming as he does from a culture that eschews unnecessary frills and ornamentation, he clearly takes pride in the directness and simplicity of his art, which he has described as "rough stuff."[5]

The most ambitious examples of Coins's in-the-round figural sculptures are his life-size or nearly life-size depictions of adults, carved from the trunks and branches of mature trees. Two such works in the Gitter-Yelen collection are the portraits of Coins and his wife, Ruby, created in 1982 (cat. no. 7).[6] Even on this scale the artist dispenses with all but the

most basic details: roughly stylized eyes, mouths, and ears. And he certainly can't be accused of glamorizing either himself or Ruby. Instead, they look like bald, squinty-eyed, dog-armed mutant bipeds from outer space. Coins's amusement in presenting such a boldly unflattering view of himself is evident in these sculptures and in his gesture of dressing them in articles of his and his wife's old clothing. Good Primitive Baptist that he is, he seems to welcome this opportunity to demonstrate his utter lack of vanity.

His other in-the-round sculptures depict various wild and domesticated animals found in the forests and on the farms of northwestern North Carolina. Often these are even more formally reductive than the "baby dolls" and larger humanoid figures, sometimes to the point that they lack articulated legs. But *Deer*, c. 1982 (cat. no. 10), from the Gitter-Yelen collection is an unusually lively piece. It was clearly inspired by the shape of the single piece of wood that forms its torso and all four legs—a slender tree trunk with two pairs of forking branches. The natural configuration of these interconnected parts suggests a rambunctious animal, and Coins has simply highlighted this resemblance by removing extrane-

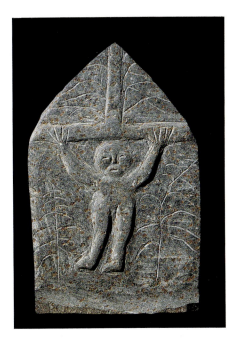

14. *Crucifixion*, c. 1988

ous branches. He has given it a more specific identity by carving in the appropriate place, if on a considerably smaller scale, a football-shaped, antler-crowned head at the end of a long neck. Indeed, its deerlike head and horselike body look as if they belong to two different animals. Its tiny, close-set eyes give it a nearsighted appearance that contrasts with its apparent physical strength and energy.

A third category of Coins's work is composed of bas-relief stelae such as those on which he has recorded the vivid dreams discussed earlier. He reserves this format primarily for his spiritual subjects, including the dream narratives as well as material from the Bible and references to his church. Among several strong examples in the Gitter-Yelen collection are the small *Crucifixion*, c. 1988 (cat. no. 14), *Stele Commemorating the Founding of a Church*, c. 1975 (cat. no. 8), and an ingenious double-sided piece in which a large portrait of Satan appears on the reverse of a vignette of Adam and Eve in the Garden of Eden (cat. no. 11). The figures strongly resemble those Coins sculpts in the round, with the same bald heads, small ears, and inscrutable faces. Fourteen such figures appear in *Stele Commemorating the Founding of a Church*, a particularly fine, autobiographically significant piece.[7] The incised text at the bottom acknowledges the 1889 founding of Rock House Primitive Baptist Church, where Coins has worshiped regularly and served as a deacon since the Great Depression. At the center of this soapstone relief is a small figure standing before an altar or pulpit, but this portrait of the church's founding pastor is dwarfed by the image of the crucified Christ surmounting the peaked roof that apparently represents the church building. Also given greater prominence than the pastor's portrait are a vignette of the Last Supper and an emblem of an open Bible, which share the lower half of the composition. Coins uses relationships of scale to stress the overriding significance of Christ, the Crucifixion, and the Scriptures in the Primitive Baptist worldview. Many of the artist's works in stone have

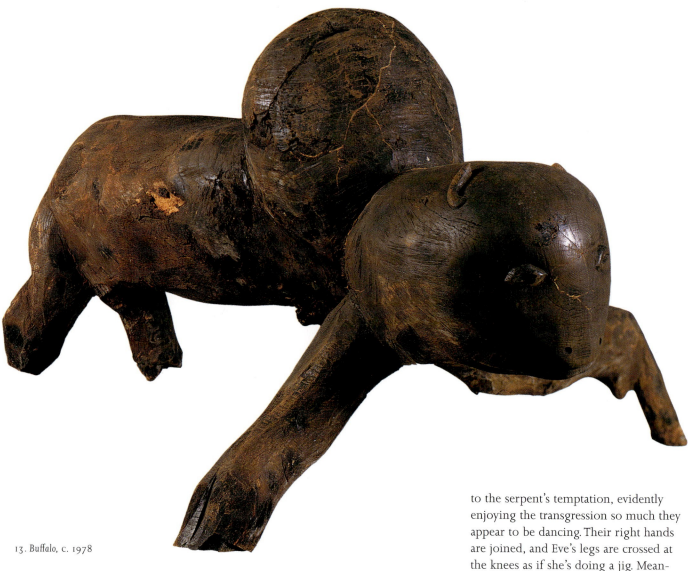

13. *Buffalo*, c. 1978

an aged, time-worn appearance, but this one looks positively ancient. Were it not for the inscribed date and the modern English text, it could almost pass for an early Celtic ritual site marker.

The content and composition of the unusual two-sided stele was in part determined by the shape of the rock from which Coins carved it. The size and shape of the bulbous protrusion at the top of the stone slab suggest a human head tilted to one side of a broad torso formed by the slab's larger lower section. Using his rasp, handsaw, sander, and other "cutting" tools, Coins has articulated the head's features, emphasizing

the pointed chin that represents a goatee, a traditional mark of Satan in popular illustrations. On the opposite side of this diabolic portrait, the head-size stone protrusion becomes the crown of the "tree of knowledge of good and evil" in an exceptionally animated version of the temptation of Adam and Eve. The devil portrayed in human form on one side of the piece here appears in his serpent guise, undulating across the tree's trunk and just above the heads of the original man and woman. Instead of standing stiffly in the Garden of Eden, as in many other artists' renditions, Adam and Eve are depicted in the moment of yielding

to the serpent's temptation, evidently enjoying the transgression so much they appear to be dancing. Their right hands are joined, and Eve's legs are crossed at the knees as if she's doing a jig. Meanwhile, their left hands are gracefully raised above their heads to pluck the tree's forbidden fruit. Despite his abbreviated, "primitive" style, Coins has envisioned this archetypal scene as vividly as he does the compelling dream that he had so many years ago. For him, the Genesis story and all of the other stories in the Bible are no less real than his dreams, which are themselves no less real than the hunks of stone and fragrant cedar from which he has carved his distinctive body of work.

At this writing, in late 1994, Coins hasn't produced any new sculptures for three or four years, and he attributes the lapse simply to a lack of interest or inspiration. The audience and market for his

work are larger than they have ever been, so he stands to profit handsomely from the sale of any pieces he might be moved to create. But he isn't one to fake it, and lacking the proper inspiration, he will no doubt remain inactive. "I have to feel something," he says. "The spirit's got to be there." He compares the situation to that of a preacher: "Can't just no man get up and preach the gospel any old time. There's got to be a feeling to it." But he hasn't forgotten what it's like to be singlemindedly immersed in the creative process. "When I was cutting on my rock," he recalls, "nothing would come on my mind to worry me, and I didn't count no time. I could work a half a day and it wouldn't seem like no time at all. I got as much out of that as any man could get. That's the best life anybody ever lived and the best feeling anybody ever had—me cutting on that rock."

—T.P.

9. *Dream Stone: Dry Bones*, 1988

NOTES

1. Chester S. Davis, "A Tour of the Sauratowns," *Winston-Salem Journal*, March 27, 1955, p. C-1. The legend that extraterrestrial craft are drawn to the Sauratowns is more recent, heard by the author from dozens of longtime residents of the North Carolina Piedmont.

2. Ibid.

3. Ibid.

4. Unless otherwise indicated, quotations from the artist are excerpted from an informal interview conducted by the author at Raymond Coins's home on December 1, 1994. The author wishes to thank Mike Smith for participating in this interview and for his assistance in clarifying some of Coins's statements.

5. Quoted by Rosanne Howard, "A Happy Hobby: Retired Farmer Gets Bored and Starts Carving Things," *Winston-Salem Sentinel*, January 15, 1985, p. 17.

6. These sculptures are similar to two larger ones that Coins carved a few years earlier and that represent the mother and father of a family of life-size wood figures, including two children and a family dog. These two pieces are presently in the collection of Barri and Allen Huffman. The entire carved family is shown in a well-known photograph shot by Roger Manley in 1984, illustrated in Roger Manley, *Signs and Wonders: Outsider Art inside North Carolina* (Raleigh: North Carolina Museum of Art, 1989), p. 30.

7. Ibid., p. 77.

John William Dey

John William ("Uncle Jack") Dey was born November 11, 1912, in Hampton, Virginia. When he was eleven years old, his mother, Bettie Siegel Dey, separated from his father, John J. Dey. Afterward, his mother worked in a variety of jobs to support John William and his sister, Lyda. For many years, Dey had an evening paper route and also worked as a janitorial assistant to strengthen the family income. A poor student, he finally dropped out of high school at age eighteen. In 1932 he left Richmond with a friend and moved to Maine. Though he stayed there for only two years, working as a trapper and a lumberjack, his memories of the Maine woods profoundly influenced his art. He often painted snow scenes and woodland animals: moose, bear, rabbits, and birds.

Dey worked briefly for a construction company and traveled along the eastern shore before settling in Richmond, Virginia, in 1934. He worked as a barber for several years, met and married Margaret Pearl Cleveland, and in 1942 joined the Richmond police force. He and his wife had no children of their own, but Dey was affectionately called "Uncle Jack" by the neighborhood children because he was always available to repair their toys and bikes. At age forty-three, upon the advice of the police department physician,

Dr. Harold I. Nemuth, Dey retired from the force. He began to paint at this time, although his wife recalled that he had decorated household objects as early as 1935. By his own account, Dey found painting extremely absorbing. In a letter accompanying a group of paintings, he wrote, "I spent over three weeks on these works. . . . These days are not eight hour days but twelve, fourteen or eighteen."[1]

The surfaces of Dey's paintings glisten because he used Testor model airplane enamel over Masonite or other wooden supports. He sought out old frames in secondhand shops and, when satisfied, created compositions to fit his purchased frames. He used templates to trace his drawn images and was exacting in his execution, often going over his paintings with a magnifying glass to see if anything was wrong.

In *Charlie Chaplin Inspecting Country Real Estate*, c. 1974 (cat. no. 15), Dey combines familiar elements with surreal images. Memories of his life experiences, including his childhood in Virginia and time spent hunting and logging in Maine, are often intermixed and juxtaposed with references from popular culture or elsewhere. In this painting, comic actor Charlie Chaplin is incorporated into the rural landscape, becoming an important character in Dey's seriocomic narrative.

The snow-covered scene recalls Dey's winters in Maine and is the setting he used in many of his approximately six hundred fifty paintings, according to his estimate. Two similar examples include *Maple Sugar, Harlan County, Monterio, Virginia* and *Maple Syrup, Highland County, Monterey, VA*, both in private collections. *Maple Sugar Harlan County* and *Portrait of Miles Carpenter*, in the collection of Robert Bishop, also include a log cabin in the landscape very similar to the cabin in the Charlie Chaplin painting. A source for Dey's frequent incorporation of a cabin in his artwork was noted in an essay by R. Lewis Wright, Jeffrey T. Camp, and Chris Gregson. They pointed out that Dey had written on the back of one painting, "out of respect for the magnificent work of Russel Gillespie," a folk artist whom Dey knew and whose small sculptures of cabins were made of twigs and branches.[2]

Crows, another of Dey's trademarks, fill the blue, cloud-strewn sky. Crows, which some have observed convey a feeling of entrapment, do not in this painting seem at all menacing. Instead, they balance the dark animals scampering on the light ground and punctuate the light sky area.

In *Charlie Chaplin*, rabbits prance about, a deer stands alert, and four horses—two black, one gray, and one

15. *Charlie Chaplin Inspecting Country Real Estate,* c. 1974

golden—are depicted in profile. On another painting, Dey wrote of rabbits, "as a rule a pair will occupy an acre and a half of ground and have their tunnels and all dug out ready to jump out in case the coast is clear."[3] Apparently the coast is clear; the comical figure of Charlie Chaplin adds an unexpected, whimsical touch and his presence does not intrude in any way on the animals' freedom and behavior.

Dey died in Richmond, Virginia, on October 12, 1978. *Charlie Chaplin* strongly typifies his legacy, which reflects a blend-

ing of his life experiences seen through an original and imaginative lens.

—L.K.

NOTES

1. From letter dated 1974 in the Jeffrey and C. Jane Camp Papers, Archives of American Art, Smithsonian Institution; quoted in R. Lewis Wright, Jeffrey T. Camp, and Chris Gregson, "John William ('Uncle Jack') Dey," *The Clarion* (spring 1992): 36.

2. Wright et al., "John William ('Uncle Jack') Dey," p. 38.

3. Ibid.

Thornton Dial, Sr.

In a recent article, art critic Michael Kimmelman chided the curators of *The Black Male*, an exhibition at the Whitney Museum of Art, for neglecting to include Thornton Dial among the featured African American artists. Though his list included such other neglected notables as Jacob Lawrence, Faith Ringgold, and Benny Andrews, Dial was the only self-taught artist Kimmelman mentioned.[1] Despite the fact that he wasn't included in the Whitney show, Dial's career since his recognition by the art world in 1988 has developed meteorically. He has also won deserved acclaim from art critic Thomas McEvilley, African American literary leader Amiri Baraka, and museum directors Gerard C. Wertkin of the Museum of American Folk Art, Russell Bowman of the Milwaukee Art Museum, and Maxwell Anderson of the Michael C. Carlos Museum at Emory University.

Dial's most recent watercolor show, at New York's Ricco/Maresca Gallery, was nearly sold out the first day; Ricco/Maresca also sold nearly all the Dials exhibited in their booth at the 1995 Outsider Art Fair in New York. Lively interest in this gifted artist's oeuvre attests to his powerful talent and his tremendous ability to create works in many media, communicating his art through the lens of his personal experience and wider worldview. Dial challenges, surprises, teases, amuses, and pleases with his large and small sculptural assemblages, paintings, and works on paper. His artistic growth is dizzying and shows no sign of incipient weakness. He applies himself to his artwork as a thorough professional, working hours every day, experimenting, distilling ideas, and working them out in a wide variety of materials.

The artist is not unaccustomed to hard work. Born September 19, 1928, in Emelle, Alabama, a rural area near the Mississippi border, he had a difficult childhood. His mother was herself very young and he never knew his father. Dial left school after third grade and helped support the family by working as a farmhand. The Great Depression combined with social repression of blacks were enormous obstacles with which to deal. Dial's family life took a positive turn when he moved to Bessemer, Alabama, to live with his great-aunt Sarah Lockett, a loving person who also raised the father of another Bessemer artist, Ronald Lockett.

Like many self-taught artists, Dial has held a number of different jobs: carpenter, housepainter, cement mixer, ironworker, and businessman. From 1952 to 1980, he worked for the Pullman Standard Company, performing a variety of tasks. During layoffs, he worked for the Bessemer Water Works, repairing pipes

16. *Lady and Rooster*, 1991

17. *Lady Tiger Fish*, 1991

under the streets. Though these times were often very stressful, he is proud that he never applied for welfare. Fiercely conscious of his ability to work hard, he believed that he could always produce food on his land and keep his family fed and clothed. He believes strongly in the value of family ties and is proud of his close-knit family. He married his child-hood neighbor, Clara Mae Murrow, in 1951, and together they had three sons and two daughters.

The artist claims that he has always made things, though before 1987 he buried his artworks because he thought that one needed a license to create art.

His first pieces to be seen and appreci-ated were a cache of brightly painted and whimsically presented fishing lures. Many of the pieces in the Gitter-Yelen collection come from the early period of Dial's recent works. His work has always demonstrated the creativity of a thinking person. His interests focus on human relationships—man to man, man to woman, race to race, man to govern-ment—and personal interpretations of history. He uses whatever materials are at hand—often industrial items and sometimes as many as two hundred different materials, such as house paint, metal wire, sponge, recycled carpet,

plastic, and Bondo (auto body filler for textural buildup) in a single work.

In *Chair Man,* 1987 (cat. no. 20), one notes the powerful presentation of a seated, mustached, black man (possibly a self-portrait) emanating from a metal chair shape. (The chair form calls to mind a business created by Dial and members of his family—Dial Metal Pat-terns. This chair related to the business's chief line, Shade Tree Comfort, a collec-tion of lawn and patio furniture.) The large, fully conceived head and the large hands contrast with the suggested out-lines of the slender body, which closely follow the metal chair shape. The thick, dark, wavy hair; piercing yet friendly dark eyes; and black mustache suggest a self-portrait, an idea supported by the oversized, outstretched hands of one who is accustomed to manual labor. The hatted figure may refer to an old yet sig-nificant custom among African Ameri-cans: It was only after they achieved their freedom that they were permitted to wear hats, which were then worn with a certain consciousness of their po-litical significance. The splashes of paint in short, brisk strokes lend movement to an otherwise fixed pose. By selecting red, white, and blue as his major colors, the artist identifies the worker, once viewed as the foundation of a nation's indus-trial strength, with the United States of America. He thus associates himself with pride as an integral part of our country's power.

In *Street People,* 1987 (cat. no. 18), Dial again shows his awareness of and con-cern for the less fortunate. He represents the people he plans to help as a series of individual figures in small tin cans an-chored in concrete. The figures reflect a plan that Dial had conceived to help the unemployed and homeless in his com-munity while recycling waste and clean-ing up the environment. Dial's ambitious plan would provide jobs for the unem-ployed and homes for the homeless. He believed that discarded tin cans could serve as forms for cylindrical bricks. The cans would be filled with an inex-pensive concrete mixture, and then the

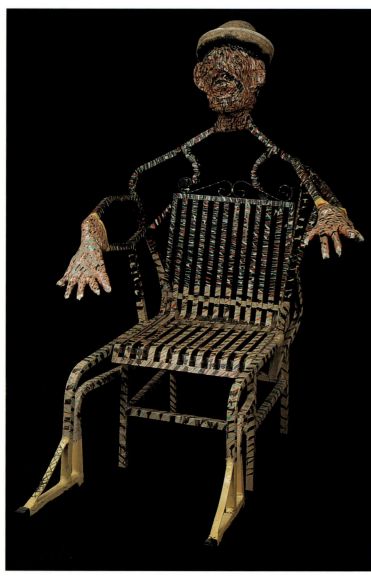

20. *Chair Man,* 1987

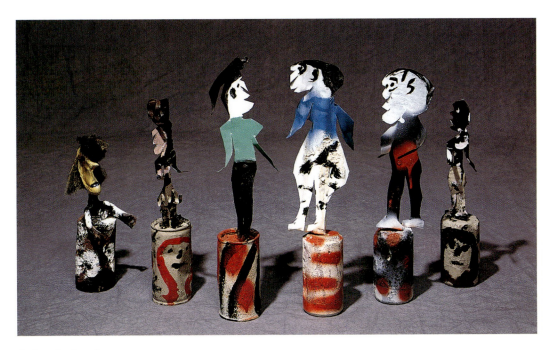

18. *Street People*, 1987

tin cans would be cut away, leaving the round brick. The bricks would become the main building material for new community projects. Dial believed that the government should offer the workers minimum wage and also offer free use of otherwise unused property for houses built with materials that would cost next to nothing. He also believed that the government should teach the homeless to build their own houses with the new brick materials. Dial's creative solutions to complex social problems demonstrate the workings of a mind both practical and ingenious.

In *Street People*, Dial illustrated this plan in a series of small examples. He cut out profiles of heads from tin can lids, mounted them on rods, and inserted the rods into wet concrete in tin cans. After cutting away the tin-can mold, he decoratively painted the gray concrete cylinders. The result is a parade of different personages not unlike Dial's neighbors, whom he believed could all be productively engaged for the community's benefit.

Demolition, 1987 (cat. no. 23), is an early assemblage consisting of both two- and three-dimensional components that

reiterate Dial's concerns about culture and the environment. His reverence for the land is implied in this sculpture and is also borne out in his personal life. Dial has maintained a vegetable and flower garden for many years, carefully tending it both for the food it yields and for its beauty. In this three-piece artwork, a bright yellow, three-dimensional steam shovel and two paintings of brick houses are the compositional elements. In one of the small paintings, the house is surrounded by trees and other vegetation, while in the other the house assumes more prominence in the composition and the vegetation has given way to only grass and two flanking trees. Dial seems to observe that, in the process of utilizing the land and building the suburbs, man removes the natural vegetation and replaces it with manicured lawns and an occasional tree for decoration. Dial stops there, but the subtle statement about man's encroachment on nature is abundantly clear. Man's intention appears to be to control his environment, "neatening it up" according to his standards. There is the sense that, in artificially redesigning his surroundings, man has gone farther than is necessary or desir-

able. In the present, man and nature seem to have a less than ideal partnership.

After the Atlanta Democratic Convention of 1988, when Michael Dukakis was nominated for president, Dial examined the event through his personal lens. In the multisectioned, two- and three-dimensional assemblage *Atlanta Convention*, 1988 (cat. no. 21), he chose to include a funky three-dimensional airplane bringing in the delegates, rows of people coming in cars, farmers arriving in trucks, and other people entering the city on their mules and horses. Although Dial and his family lived for many years in Pipe Shop, Alabama, a segregated, quiet suburb of Bessemer, the social needs of the urban masses are never far from his consciousness. He often reminds the viewer of the plight of many African Americans; here, for example, he includes the tenements where many of the poor live. His color choice of red, white, and blue is once again emblematic of his belief that it is a democratic country's responsibility to look after its citizens' needs. The assemblage conveys Dial's strong belief in the government's legislative power to effect change in a peaceful, law-abiding way.

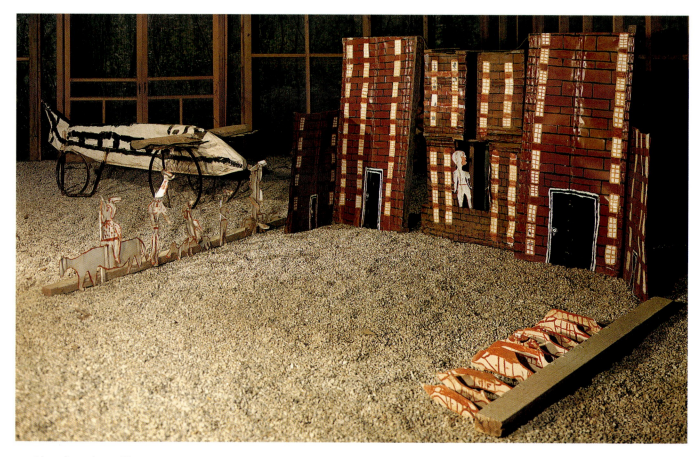

21. *Atlanta Convention*, 1988

Referring to *Keeping the Pigs from Rooting*, 1988 (cat. no. 19), Dial once shared a story with collector and patron Bill Arnett. Dial had invented a device to keep pigs from rooting for their food. Pigs are intelligent animals who have a tendency to stray, especially when they are seeking food. Dial's metal device, which looks like a two-pronged pitchfork, is placed over the pig's face, with the prongs upright and the bases of the prongs stapled to the pig's ears. As the pig bends over to root, the free-swinging gadget drops to the ground and the prongs hit the earth, preventing the pig's snout from touching the ground. The tool is intended to dissuade the pig from leaving home and to help it to remember the trough. Dial says that when a pig is unable to root, it returns dutifully to its home and its trough.

The story takes on other meanings as well when the viewer considers the woman in the foreground of the artwork. Dial often uses animals as metaphors for social conditions. The visual imagery may relate to women keeping their men under control and preventing them from straying. Dial's use of color seems to function as a symbology for control. The woman is white while the pig is black, perhaps suggesting that the white person has found yet another way to control the black person. Red and blue are the predominant colors, as if to say that this is simply the way things operate in the United States. Given Dial's other works on similar themes, either meaning—woman versus man, black versus white—may be applied.

Schoolteachers, 1988 (cat. no. 22), presents two women in one of their major roles: bearers of knowledge and power. The brown faces of the figures suggest that they are black. The two teachers appear in dresses buttoned to the neck, hinting at the women's propriety. Unlike the movie star, who fulfills a sexual role as the seductress, the teacher, who is often the head of a family, imparts wisdom. Perhaps the dollar sign over each woman's head reinforces the notion that knowledge is power and that power translates into the ability to earn money. Dial is not crass or materialistic, but he is a realist. He strongly believes in education as a strategy for elevating the black person economically and socially. Dial has painted this subject several times. Another example is included in the Gitter-Yelen collection, the surface augmented with industrial sealing compound, giving a greater dimension and sculptural quality to the painting.

Lady and Rooster, 1991 (cat. no. 16), is one of Dial's elegant works on paper, which are often executed in monochromatic shades of gray and black charcoal and graphite as well as in watercolor.

This example is in watercolor—various shades of yellow, red, and black. Women are important in Dial's imagery and in his philosophical scheme. As early as 1990, in his *Life Go On* series on paper, repeated but varied drawings of women with birds, nests, and eggs show the crucial role of women in life's cycles. As Paul Arnett notes, the subject was enlarged to encompass "aspects of the human life experience: mating rituals and sexual behavior, childbirth, the constant struggle for freedom, and death. Dial acknowledges the critical role of women, not only as producers and nurturers of life but also as instigators of social change."[2]

In *Lady and Rooster*, the woman's head is large and, although asymmetrically placed, is central to the composition. The figure is well balanced by the form of the enveloping rooster. Her blond hair, which almost seems to be an adornment, surrounds her head. Both the woman's head and the rooster's appear very close

to the picture plane, and the receding gray-black nonfigural background serves to emphasize the figures' forward thrust. Dial's animated line illustrates his energy and instincts for life renewal. The circular strokes of the rooster and the thicker, more compact, more chaotic, though quite contained dark background strokes contrast with the delicate pencil outline of the head of the blond, fair-skinned, slender young woman. But her delicately presented skin and hair tones are activated and energized by the wavy outline of her hair and the rounded red outline of her full, sensual lips. Contrasts of

color—pastel tones and deeper hues —differentiate solid areas, while short, dark strokes lend a feeling of motion to the narrative.

This watercolor concentrates on the rituals of mating and the relationship between men and women. The woman seems to be at the seat of power; however, the male, represented by the rooster, or cock, over her head, may signal that the woman's hold on power may be tenuous. Robert Farris Thompson, in his treatise on African cultural traditions, notes that in Yoruban life the bird frequently appears as the head of the staff, hinting at dominance and power.[3] In other Dial works, the woman is seen taming the tiger, which is often a symbol for man. Dial grew up surrounded by women, and he has a longstanding respect for them and their survival strategies. As Allison Weld has observed, "In most of Dial's pictures it is women who are in control and who are making things happen. The artist has come to revere them,

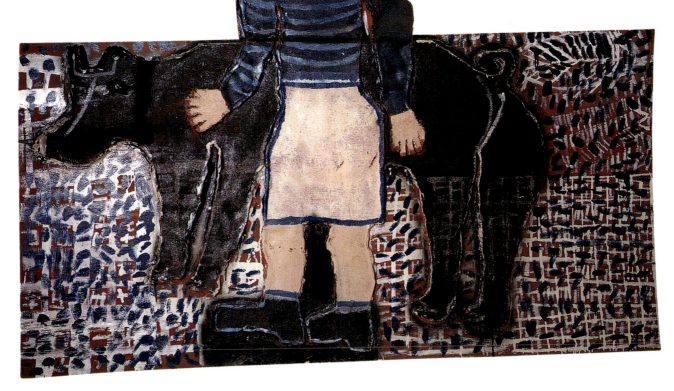

19. *Keeping the Pigs from Rooting*, 1988

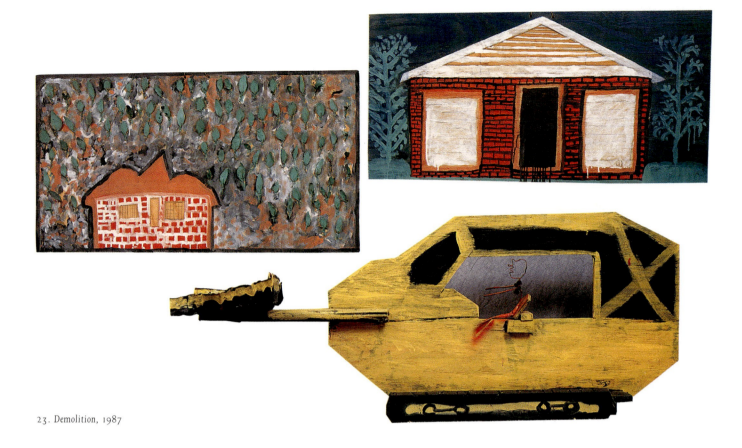

23. Demolition, 1987

exalting them as initiators of change in the world."[4]

The male-female relationship and its many nuances continue to interest Dial, and in *Lady Tiger Fish,* 1991 (cat. no. 17), the blue fish sets the theme in hinting that fishing for love sums up "the complex way 'life travels' from generation to generation."[5] A tiger, symbolizing the male, and an African American female are intertwined in an energetic circular motion implying mating. While Dial chooses dark red for the tiger and the woman, he cleverly intersperses bright yellow in between. Not only is yellow an excellent contrasting hue for highlighting the rounded red forms but it is also one of the colors of tigers' fur.

Dial artworks reviewed here are predominantly early works. In these pieces, one can trace the themes and issues that Dial continues to explore today: the relationships between man and woman, black and white, humanity and nature. One can also trace the reit-eration of imagery and materials. Both his paintings and his large sculptural assemblages, which are a unique contribution to folk art, can be appreciated as much for their political and social messages as for their artistic merit. — L.K.

NOTES

1. Michael Kimmelman, "Constructing Images of the Black Male," *New York Times,* November 11, 1994, p. C7.

2. Paul Arnett, in *Strategy of the World,* ed. Robert Bishop (New York: Southern Queens Park, 1990), p. 33.

3. Robert Farris Thompson, *Flash of the Spirit: African and Afro-American Art and Philosophy* (New York: Random House, 1983), p. 45.

4. Allison Weld, *Dream Singers, Story Tellers: An African-American Presence* (Fukui, Japan, and Trenton, N.J.: Yoshida Kinbundo Co., Fukui Fine Arts Museum, and New Jersey State Museum, 1992), p. 81.

5. Imamu Amiri Baraka [Le Roi Jones] and Thomas McEvilley, *Thornton Dial: Image of the Tiger* (New York: Harry N. Abrams, 1993), pp. 84, 95.

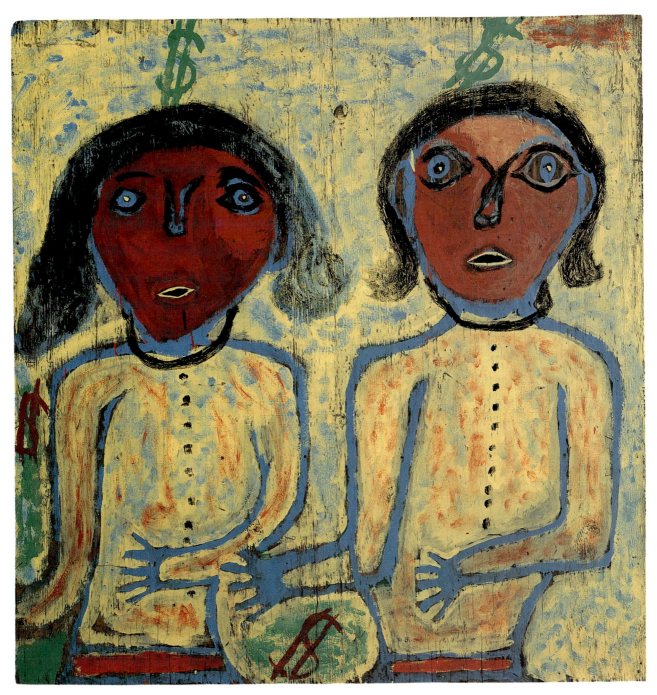

22. *Schoolteachers*, 1988

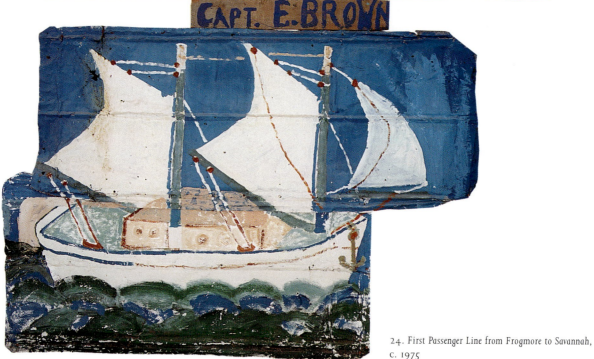

24. *First Passenger Line from Frogmore to Savannah,* c. 1975

Sam Doyle

The context for the development of Sam Doyle's career is as interesting as the artist and his art. The eighth of nine children born to Thomas Doyle, Sr., and Sue Ladsen Doyle of Saint Helena Island, South Carolina, Thomas Samuel Doyle was born in 1906 and grew up in an area steeped in African American history and culture. Doyle's youth was spent in relative isolation in the Wallace community of Saint Helena Island, which was then physically and culturally removed from the town of Beaufort on the mainland. In fact, a bridge connecting Beaufort and the island was not constructed until 1927. During the early decades of the twentieth century, Saint Helena was a unique, predominantly African American community composed largely of the descendants of former slaves who retained much of their African heritage as well as memories of the slave experience. Many slaves on Saint Helena Island were

held by absentee owners and were left relatively free to practice the cultural traditions of their homeland. Doyle vividly remembered the descendants of slaves who told him stories about plantation slaveholders, atrocities committed against slaves, and supernatural occurrences.

Many of the African American residents of Saint Helena Island are called Gullah. The name probably resulted from a mispronunciation of the African country Angola, from which thousands of slaves were brought to the coastal United States during the eighteenth and nineteenth centuries. The Gullahs of South Carolina speak in a clipped, melodic dialect (also called Gullah) that is not immediately comprehensible to outsiders and that still includes some West African words and phrases. Saint Helena Island is currently populated by whites and blacks; however, African Americans in

this small, remote area still cling tenaciously and proudly to both their African heritage and the local traditions that are an inextricable part of their lives.

The Wallace community was originally populated almost exclusively by freed slaves formerly owned by a plantation master named Wallace. Doyle attended nearby Penn School (a historical institution that was the first school established in the South for freed African Americans) through the ninth grade and then dropped out to work as a clerk in a neighborhood store. While Doyle was a student at Penn School, one of his teachers noticed his drawing ability and encouraged him to travel north with her sister to study art. He declined to leave his home on Saint Helena Island, and he remained in that vicinity throughout his life.

Doyle found employment in Beaufort, working as a porter from 1930 to

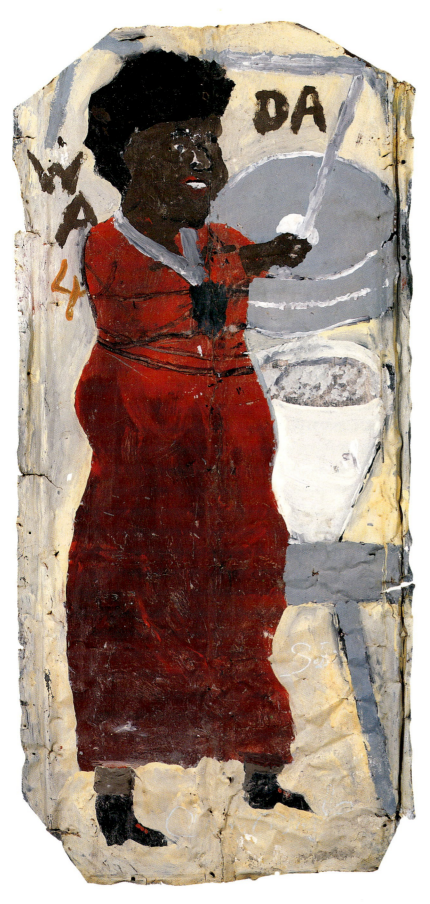

25. *WA DA*, c. 1975

1950 and as a laundry worker at the Marine base at Parris Island for sixteen years. He retired during the late 1960s. In 1932, Doyle married Maude Brown, and they became the parents of three children. Doyle's wife and children moved to New York, where the children attended college, but Sam decided to keep the home fires burning in the small house he had built in 1940 on Land's End Road on Saint Helena Island.

Following his retirement from the Parris Island laundry, Doyle worked as a part-time groundskeeper at the ruins of the Chapel of Ease. The chapel of Saint Helena Church had been built around 1740 and was made a separate church after the Revolutionary War. The structure was severely damaged by a forest fire in 1886, but it still stands today, albeit in a ruined state, and is maintained by the Beaufort County Historical Society. Doyle later depicted this roofless structure in several paintings on paper, incorporating crushed stones from the actual building.

Around 1968 Doyle resumed his childhood passion for drawing and painting. His paintings were executed in house paint on large wooden panels and cast-off pieces of roofing tin. The completed panels soon filled his yard, and the "outdoor museum" was born. Doyle was primarily a painter. He preferred to work on large sheets of roofing tin, but he also painted on paper, plywood, corrugated board, window shades, and any other materials at hand. Enamel paint was Doyle's medium of choice in powerful works that often included the titles painted into the backgrounds. Doyle did not make preliminary sketches but created his compositions during the painting process. He placed many of his paintings in his yard—some side by side, others overlapping, still others leaning against a makeshift fence. He propped some pieces against a small frame building that his wife had formerly operated as a café, and the remainder he simply displayed on the ground. The former café served as Doyle's studio during inclement weather. Usually, however, he preferred to paint outdoors.

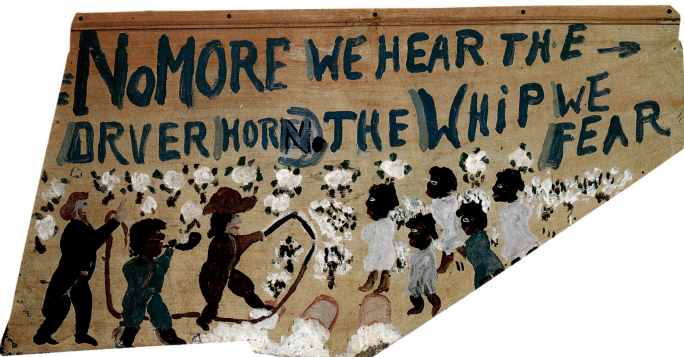

27. *No More We Fear*, c. 1982

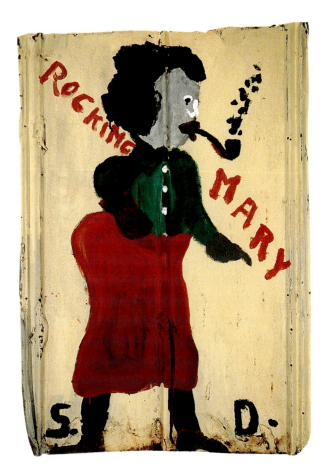

26. *Rocking Mary*, c. 1980

The sources for the subjects of Doyle's paintings were the people, scenes, and legends from the rich cultural heritage of Saint Helena Island as well as those of the outside world. One of Doyle's favorite subjects was Dr. Buzzard, or "Dr. Buz" (cat. no. 28), a voodoo doctor on the island who was once Saint Helena's wealthiest African American and who allegedly received his inspiration by listening through a conch shell. Doyle recalled that he visited Dr. Buz on numerous occasions and saw him listening through "that telephone." Other figures in Doyle's outdoor gallery were *We We*, the island's smallest woman; *Try Me* ("That's what she said, 'Try Me.'") (cat. no. 31); Lucinda Ladsen, Doyle's great-grandmother, who was the first African American midwife on Saint Helena Island (cat. no. 30); the first African American passenger ship (cat. no. 24); and the first African American bus driver, postman, policeman, and undertaker on the island.

Another group of Doyle's paintings have more risqué subjects: *Old Hag* (a woman riding a man's face while he sleeps); *Bull Dager* ("half stud, half slut"); *He-She* ("can go both ways"); and *Rocking Mary* (who wore high-heeled shoes and

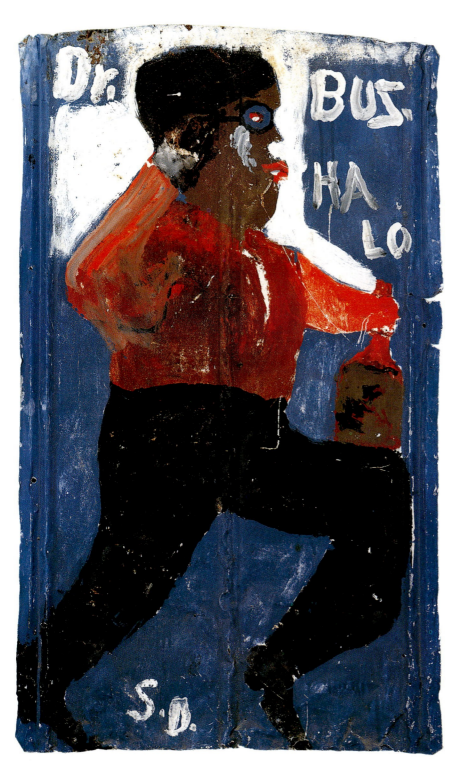

28. Dr. Buz, c. 1980

smoked a corncob pipe) (cat. no. 26). Doyle also clearly admired sports and entertainment personalities, and he depicted such luminaries as Joe Louis (cat. no. 29), O. J. Simpson, Jackie Robinson, Ray Charles, and Elvis Presley.

Although many of Doyle's paintings captured the comical characters on Saint Helena Island, it should be noted that Doyle was an intensely religious person who attended church regularly and served as the sexton of his church. Among the numerous paintings in his outdoor gallery were poignant representations of the Crucifixion of Christ, the Nativity, the Three Wise Men, and the Annunciation. Doyle's religious paintings occupied the space near the entrance to his home, a short distance and in a separate realm from the "worldly" subjects, and were displayed year-round.

Doyle also fashioned sculptures depicting serpents, reptiles, fowl, and other animals constructed from tree limbs and trunks, driftwood, and scrap lumber. His sculptures, usually painted black or dark brown, are very simple and often incorporate tar, feathers, and found materials. Doyle's dramatic sculptures were arranged strategically throughout his "museum" and also near the perimeter of his yard. Since, like many residents of Saint Helena Island, Doyle was highly superstitious, many of the sculptures were probably made to protect the artist, his museum, and his home from evil spirits.

Judging by his numerous portraits of African American heroes of local and national fame, one can see that Doyle was a man who possessed a deep sense of pride in his cultural heritage. His creativity made Doyle the bearer of a cultural code to which younger generations of Saint Helena Islanders had no other access. In fact, Doyle may be described as a visual "griot" (a West African oral historian who transcribed and preserved a rich tradition that ultimately had its roots in African soil).

For about fifteen years after his retirement, Doyle painted in relative obscurity, and his works were known only

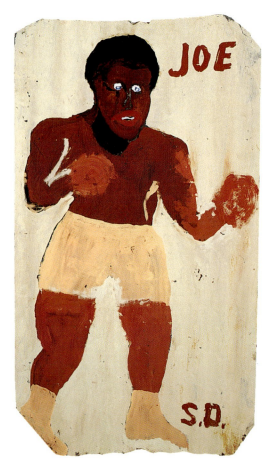

29. Joe Louis, c. 1980

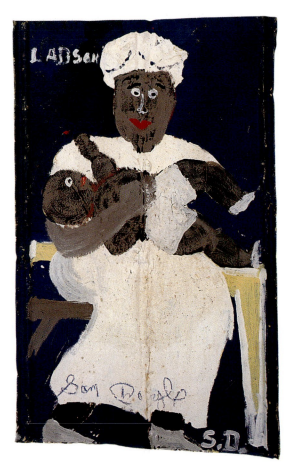

30. Nurse Midwife, c. 1980

to his neighbors and a few tourists who passed his outdoor museum and purchased a few pieces. In 1981, a curator from the Corcoran Gallery of Art in Washington, D.C., saw one of Doyle's paintings in a private collection in New York and decided to include some of his works along with those of nineteen other self-taught African American artists in the landmark exhibition *Black Folk Art in America, 1930–1980*, held at the Corcoran in January 1982. In December of the same year, Doyle had his first one-man show at the Gibbs Art Gallery in Charleston, South Carolina.

When Doyle went to Washington to participate in the opening activities for the Corcoran exhibition, it was the first time he had traveled outside his home state. He received a great deal of acclaim as a result of the Washington show, which toured throughout the United States for several years. When Doyle re-

turned to Saint Helena Island, he was a local celebrity, an "artist" who had dined with and been photographed with Nancy Reagan. Following the success of the Corcoran exhibition, Doyle painted feverishly, and some of his finest works were produced in the years between 1982 and his death in 1985, as visitors, collectors, artists, photographers, and curiosity seekers flocked to his museum in ever-increasing numbers. Fortunately, since Doyle never had a sponsor, a dealer, or a gallery representation, he benefited financially from the sale of his works, which he sold directly from his yard.

The art of Sam Doyle epitomizes that pure, bold, vibrant, emotive category called African American folk art. Born out of life's experiences and shaped by social, cultural, political, and religious values, it is a deeply personal, highly subjective, and occasionally humorous art. Unaffected by the formal elements

and principles of "fine" art, Doyle's simple yet powerful statements in his remarkable mixed-media works are pieces that many academically trained artists have attempted to emulate. Doyle's art is currently represented in some of the most prestigious museums and private collections in America. No other artist has captured the essence of life on the islands between Beaufort, South Carolina, and Savannah, Georgia, as effectively as he. Through his paintings one is introduced to a world where some of the longest-surviving African traditions in the United States still endure. It is heartwarming to note that the narrow road on which Doyle's house is located has been renamed Sam Doyle Road; plans are under way to preserve his home as a museum dedicated to the memory of Saint Helena Island's most famous resident, a true native son.

—R.P.

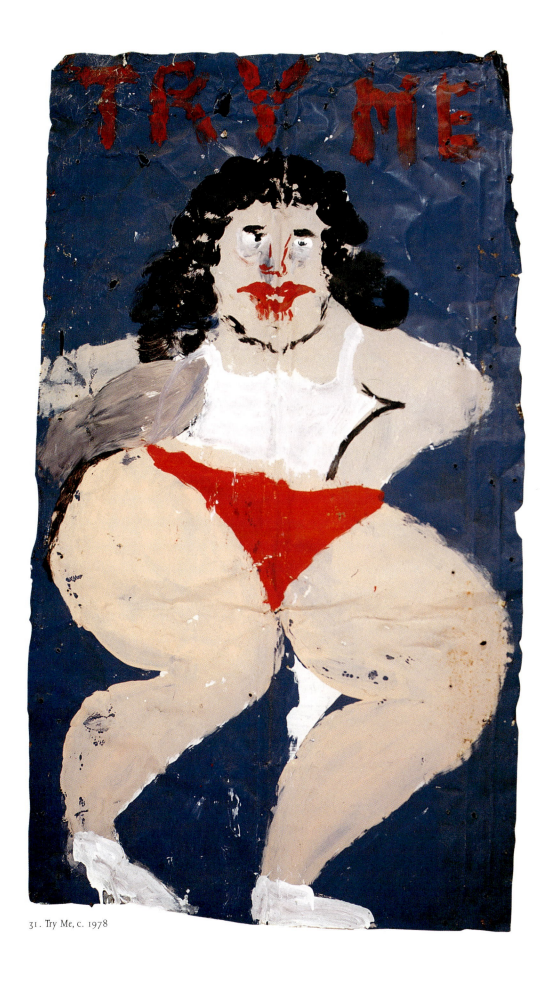

31. Try Me, c. 1978

William Edmondson

Many years ago, one of my colleagues, a native of Nashville, Tennessee, recalled a visit to the nearby home of sculptor William Edmondson. She described how, a moment after she announced her presence, the artist seemed to materialize at the dark, dusty screen door of his house. She remembered Edmondson as deep voiced and serious, a quiet, modest, dignified, and gentle man of profound religious convictions. That anecdote impressed me tremendously. It provided me with a special sense of Edmondson's work, and over the ensuing years it continues to serve as a bridge between the artist, his work, and myself.[1]

Edmondson is represented in the Gitter-Yelen collection by a marvelous figure of a female (cat. no. 32). The work is titled *Schoolteacher* in Edmund L. Fuller's *Visions in Stone: The Sculpture of William Edmondson*.[2] No doubt this identification is based in part upon the long garment and stern look of the figure, a stereotype of the old-fashioned schoolmarm, and in part by a book carried in each hand. Recently, another opinion on this carving suggests that it represents a nurse. The garment seems "right"; the books could be file folders or clipboards; and the peculiar mass of the hair, which appears to be pulled back and captured in a large kerchief or similar headdress, suggests a style traditionally worn by nurses in the early part of this century. This interpretation fits nicely when one recalls that Edmondson worked for nearly twenty-five years at the Women's Hospital in Nashville, where he would have routinely observed nurses on their daily rounds.[3]

Whichever, *Schoolteacher* or *Nurse*, (personally, I find the latter identification convincing), the sculpture shares features characteristic of a number of Edmondson's carvings of women. The full-bosomed figure wears a long, old-fashioned garment gathered at the waist by a strip of fabric tied at the back in a bow; the hem of the dress brushes the floor and flares outward at an exaggerated angle. Her outsized head, with its diminutive, delicately picked facial details; her straight-backed posture; and the stern, frontal set of her head all convey total concentration. This sculpture suggests someone of presence who, determinedly undertaking a mission, will not be distracted from its completion.

What I have just described is an inventory of impressions, an awareness of what Edmondson's *Nurse* actually is. Though in reality it is a small piece of carved stone, there is something else there that gives the object "life"—and this in spite of Edmondson's reductive style, which here consists of cutting out and retaining the silhouette of a figure, supplying it with details that identify it and animate it as well. This quality of animation derives from another curious feature of *Nurse*: In spite of its undeniable lithic identity, it seems poised to lift off the surface on which it necessarily rests. This liveliness derives from certain formal elements that create a gentle but insistent upward movement: specifically, the diagonal lines in the coiffure, the upward tilt of the head, and the garments, especially the back portion of the dress, which has a backward, diagonal thrust.

This sculpture doesn't seem to be "levitating"; rather, it appears to be buoyant, filled with and moving by virtue of its own life force, seemingly denying its actual physical weight. It really does become, however momentarily, a human figure in motion.

William Edmondson worked this miracle of transformation over and over again in his carvings. *Nurse* stands as one of his most masterful accomplishments.

—G.J.S.

NOTES

1. I am grateful to Betty Kortlander, of Athens, Ohio, who shared this anecdote with me.

2. Edmund L. Fuller, *Visions in Stone: The Sculpture of William Edmondson* (Pittsburgh: University of Pittsburgh Press, 1973), pl. 64.

3. I have discussed the identification and the dating of this sculpture with John Ollman of Janet Fleisher Gallery and with Dr. Benjamin Caldwell, trustee of the Tennessee Fine Arts Center at Cheekwood, Nashville. Dr. Caldwell, an art collector who has been researching William Edmondson's life and art, dates this sculpture to the early part of Edmondson's artistic career—that is, to the early 1930s. He believes that Edmondson, having just retired from a quarter century of work at a hospital, would have had the image of the nurses very clear in his mind (telephone conversation with the author, November 12, 1994). I am grateful to Ollman and Dr. Caldwell for their help.

32. Nurse, c. 1935

Howard Finster

By faith Noah, being warned of God of things not seen as yet, moved with fear, prepared an ark to the saving of his house.[1]

Emblazoned in milky white uppercase script across the top of one of his earliest paintings, *Noah Being Warned*, 1976 (cat. no. 34), this quotation from the New Testament book of Hebrews says a lot about Howard Finster and the extraordinary artistic achievement to which he has dedicated his life. Finster has often compared himself to the builder of the great ark that rode out the biblical flood, claiming he is a "second Noah" sent by God to warn and convert the misguided denizens of "Earth's planet." But instead of a huge boat designed for his family and lots of animals, Finster created a dazzling two-and-a-half-acre sculptural environment with freestanding artworks that now number in the tens of thousands.

Born in 1915 on a small farm in DeKalb County, Alabama, Finster quit school after the sixth grade and became a Baptist minister while still in his teens. For more than thirty years he preached at churches and tent revivals across the southern Appalachians, supplementing his meager country pastor's income with a variety of odd jobs ranging from taxidermy to bicycle repair. Settling in the northwest corner of Georgia, not far from his birthplace, he and his wife, Pauline, raised a son and four daughters while he tirelessly spread the Gospel and labored at his various trades. In spite of all the demands on his time, he managed to undertake a wide range of creative activities that eventually (and much to his surprise) made him one of the postmodern era's most widely known visual artists.

Finster was in his late forties when he began building what became known

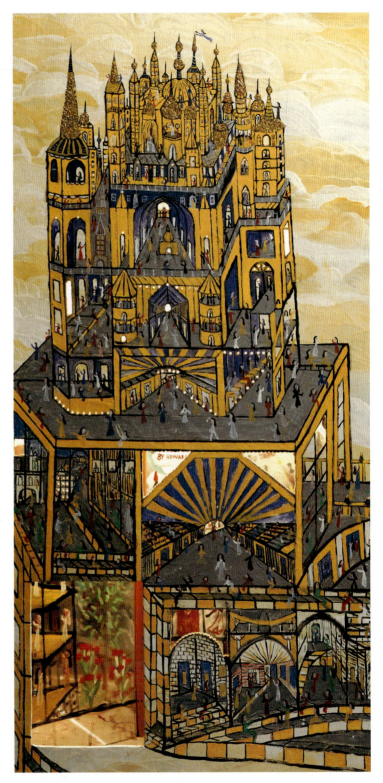

33. *Cathedral in Heaven*, 1979

34. *Noah Being Warned*, 1976

as his Paradise Garden. Covering much of the filled-in swamp behind the house where he lived for many years in Pennville, Georgia, this elaborate and fanciful labyrinth of encrusted cement monuments, found-object constructions, and exhibits dedicated to the "inventions of mankind" was what initially brought him to the attention of the world outside his little corner of the Georgia hills. Then in 1976—fifteen years after commencing work on the environment—he began painting, after receiving what he describes as a divine command to do so. At first he created his paintings solely to augment the myriad other objects in Paradise Garden, but popular demand quickly changed that.

Noah Being Warned is arguably the most historically significant work by Finster in the Gitter-Yelen collection because it was the first painting he sold. Its original owner was the artist Cynthia Carlson. Finster describes the transaction in amusing detail. Unable to remember Carlson's name, he recalls only that she was an art teacher from New York.

She wanted to buy one o' my paintings. It was a painting I done o' Noah's Ark that was hangin' up in the garden. . . . And I didn't understand. I told her, I says, "You can take a picture of it with your camera. . . . I'm not doin' paintings to sell. I'm doin' 'em to go in my garden." . . . And she just kep' after me about it, and I finally said, "Well, I guess I could draw another 'un." . . . She said, "I'll give twenty-five dollars for it." I says, "Well, okay, just go ahead. I'll do another 'un." . . . And then other people started comin' here wantin' my paintings, and it build up my morale to know that somebody wanted my art.[2]

Two decades later, this relatively simple early painting provides a convenient point of departure for considering Finster's astonishingly prolific and successful career. Those who know only his later paintings—with their signature visionary landscapes, gleaming ivory towers, smiley-faced clouds, and hovering angels and spacecraft—might not even recognize this as Finster's work. But this is how he painted twenty years ago, when he was just beginning to teach himself inventive techniques he has long since mastered.

Several visual clues in the Noah painting indicate that Finster intended to depict the early stages of the flood, after the waters had risen but before they had drowned the doomed citizens who had failed to heed Noah's warnings. More than one hundred of these hapless individuals can be seen in the roiling turquoise waters surrounding the ark. With their tiny arms raised above or in front of their heads, these anonymous, abbreviated figures are forerunners of the long-robed angels that appear in thousands of Finster's later paintings. But while the floodwaters are dotted with these unfortunate souls, neither people nor animals can be seen aboard the ark itself, which seems to have its hatches fully battened down as it floats securely at the painting's center, looking like a giant, wide-hulled rowboat on whose deck a huge barn has been raised. Finster's careful rendering of the vessel's planks and shingles as well as its sealed doorway hints at the fascination with architecture that emerges full-blown in the fantasy structures of his later paintings. With the exception of

these compacted intricacies, the Noah painting is much looser and sloppier than the work he was producing a year later, indicating that he hadn't yet acquired the tight control that eventually came to characterize his art or perhaps that he was more focused on the urgency of his message than on the technical and compositional particulars of the painting. After all, in his self-defined role as a modern-day Noah, his most important job is delivering what here is inscribed as the (literal) bottom line: "ONLY JESUS CAN SAVE IN THESE LAST DAYS."

The Noah painting is also an early signal of Finster's preoccupation with natural disasters: earthquakes, volcanoes, tornadoes, fiery meteors crashing to earth, and other such cataclysmic events. As a child he had witnessed the injuries and early deaths of several siblings as well as the burning of his family's home, so he hasn't been a stranger to disaster. Occurrences of this kind are reminders that we human beings are not in control of the world we inhabit, and this reality is one of the overarching themes of Finster's oeuvre.[3]

Another important early example of Finster's disaster fetish is *200-Foot Tidal Wave*, c. 1976 (cat. no. 39). Neither dated nor numbered, it exhibits the more labored and obsessively detailed style seen in many of his earliest paintings. Too, its frame is pieced together out of sixteen different dowel scraps with spiral or circular patterns incised in the woodworking shop where the artist had made ornamental cases for clocks in the days before he took up painting.[4] This is a rare feature; the only other example I've been able to locate frames a similarly dateless and numberless painting titled *The Dog Story of the Bible* (private collection), reasonably estimated by the collectors who bought it from Finster to have been created in 1976,[5] the artist's first year of painting. As for the marked stylistic differences between this work and the above-

36. *Concentration Camp (Gas Pit/Silent Death)*, 1990

discussed *Noah Being Warned*, they can almost certainly be attributed to a key distinction: Finster has pointed out that he made the Noah painting specifically for display in his Paradise Garden, whereas everything about *200-Foot Tidal Wave* tells us it was made after the landmark initial sale, at which point Finster began to create art for the new purpose of sending it out into the world, an effective means of spreading his spiritual and moralistic messages far beyond the boundaries of Paradise Garden and Chattooga County, Georgia. Like *Noah Being Warned*, the paintings Finster made for his garden are invariably unframed and were sometimes painted on scraps of tent canvas or on functional objects like the metal tabletop on which he painted *Roosevelt and Wilson*, c. 1977 (cat. no. 38), another early work. As exemplified by that work and the Noah's Ark narrative, these garden paintings are usually short on fussy details, as if they had been designed for viewing at a distance rather than at close range.

On the other hand, the minute scale and intricate detail of *200-Foot Tidal Wave* invite the closest kind of inspection. And the frame makes it even more evident that this work was meant to be hung in-

doors, preferably in the home or office of someone who would find inspiration in its exhortation to prayer and "OVER THE TOP FAITH" in the "POWER OF GOD." Besides its importance as one of the artist's first works made for sale, this painting shows him boldly experimenting with techniques that became increasingly important in his artistic development. For example, the bird's-eye perspective he uses here soon became a staple of the earthly and extraterrestrial landscapes that are arguably his best-known works—images such as *Talking Heads View the Whole World*, the 1985 painting that singer-songwriter David Byrne commissioned for the cover of his rock group's popular album, *Little Creatures*.[6] Finster's rationale for employing this spatial viewpoint isn't hard to figure out. Not only does it afford a practical means of presenting the kinds of expansive vistas he favors, but it is also a vantage point that is popularly associated with visionary phenomena of various kinds. So-called out-of-body experiences, for instance, are typically described from this perspective, which is also commonly associated with the omniscient Judeo-Christian deity and his angels, who look

37. *Wipe Rags (Captured Visions)*, 1989

down on the world from on high. And when Finster's deceased older sister, Abbie Rose, appeared before him on a stairway to heaven in the childhood vision that he claims foretold his career as a "man of visions," this would have been the angle at which she gazed down on her specially destined little brother.[7]

The setting for the calamitous scene thus viewed in *200-Foot Tidal Wave* is an unspecified location in California, famous for its deadly forest fires, earthquakes, and other natural disasters. Superimposed over a turbulent gray sky at the top of this narrow vertical composition, the title appears in cartoon letters of yellow outlined in black—the kind of decorative script that Finster used in a number of paintings before 1980, when he began routinely freehanding his texts in simple, unadorned black. Below the title and consuming most of the painting's upper background is the deadly blue tidal wave itself, carrying with it several tiny, capsized boats as it advances ominously toward the shore. The wave's frothy white crest carries a delicately scripted, misspelled announcement couched in the language of newspaper headlines: "TIDLE WAVE PROPHESIED." Filling the lower half of the painting is the area about to be walloped: an idyllic forested landscape whose detailed little houses, barns, churches, silos, and clock towers provide further evidence of the fascination with architecture noted earlier. Supported by a post near the left edge of this cozy rural townscape is what appears to be a massive billboard towering over even the tallest of these structures, and the yellow- and white-lettered text it bears is a particularly fine example of Finster's poetic skills (which, coincidentally, echo Herman Melville and T. S. Eliot, whose work the artist is unlikely ever to have read): "WHEN THIS WAVE / SWEEPS OVER THE WEST BEACH COVERING / THE CITY 50 FEET DEEP," it suggests, "PRAY YOUR GOD TO / RAISE YOUR

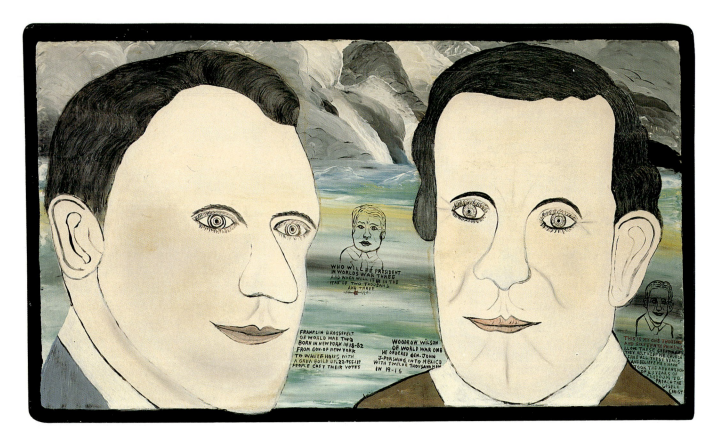

38. *Roosevelt and Wilson*, c. 1977

BOAT / BEHIND THE TIDE / TO ROCK AND
FLOAT." Then, it promises "OVER THE
DEAD AND / WASTED LAND / YOUR BOAT
WILL / DRIFT TO THE SOFTEST SAND,
A MAN."

As an alternative to this survival
strategy, Finster presents the painting's
central image: a schoolbus-yellow heli-
copter, labeled "LIFE SAVER" and "POWER
OF GOD," carrying nine passengers as it
hovers in the upper foreground above
the landscape and the advancing tidal
wave. Suspended on a cable from this
contemporary airborne emblem of spiri-
tual salvation is an oddly shaped red boat
labeled "OVER THE TOP FAITH," carrying
seven more passengers. These tiny fig-
ures, rendered in profile with hands
raised in prayer, are early versions of
those that appear in most of Finster's
landscapes and heavenscapes. It should
be noted that a simpler pencil sketch of
the helicopter, lifeboat, and tidal wave
appear on the painted panel's reverse side.

Probably drawn as a preparatory study, it
is accompanied by briefer variants on the
painted labels and texts. The helicopter is
simply labeled "CHRIST," and adjacent
lines read (in yet another creative spell-
ing of "tidal"), "200-FOOT TITLE WAVE /
ONE WAY OF EXCAPE / RAISE YOUR SHIP
SET IT OVER THE / TITLE WAVE."

The other early Finster painting in
this exhibition is *Roosevelt and Wilson*, cre-
ated on a metal tabletop sometime after
the artist began numbering his works.
Although he hadn't yet started including
the times and dates of each work's com-
pletion, as he would do not long after
painting this one, extrapolation from its
number ("THIS IS MY ONE THOUSAND /
AND SIXTEENTH PAINTING," highlighted
in red on the front of the painting) and
from data inscribed on hundreds of
other paintings indicates it dates from
sometime in 1977. Commemoration of
important historical figures has been a
concern of the artist from the time he

made his first painting—a small portrait
of George Washington that he sketched
in early 1976 from the image on a one-
dollar bill.[8] It is clear from the artist's
numerous portraits of U.S. presidents
that he views them as saintly figures who
represent not only the will of the citi-
zenry but also the will of God, and in
that sense they are similar to himself, are
fellow "men of vision." He hints at this
in the way he depicts the eyes of the two
presidents portrayed here: Their pupils
are surrounded by concentric circles
(and in Wilson's case an additional ring
of radiant lines) enclosed by the irises,
signaling a capacity to see a larger reality
than that perceived by ordinary mortals.

In addition to its commemorative
function, this painting also treats another
favorite Finster theme: war. Wilson and
Roosevelt are included in the same piece
because of their roles in presiding over
World Wars I and II, respectively, as the
accompanying text specifies. But as a self-

styled prophet with one eye always on the future horrors that await an increasingly sinful world, the artist is ultimately most interested in getting across the message contained in the text near the painting's center: "WHO WILL BE PRESIDENT / IN WORLDS WAR THREE / AND WHEN WILL IT BE[?]." Boldly venturing a precise answer to the second question, he suggests, "IN THE / YEAR OF TWO THOUSAND / AND THREE." And while he doesn't forecast who will be president, the small image of a third man's head just above this text bears an uncanny resemblance to his portraits of Jimmy Carter, Finster's fellow Georgian who occupied the White House when this painting was made.

The artist's interest in war-related history and his conviction that we are presently living in the "last days" foretold in the Bible are further manifested in a much smaller and more recent painting from the Gitter-Yelen collection, *Concentration Camp (Gas Pit/Silent Death)*, 1990 (cat. no. 36). Finster created the piece after learning that members of Kurt Gitter's family had died in Nazi concentration camps during World War II. In this grim scene—a rare Finster landscape, one devoid of the usual trees, hills, and happy-face clouds—he envisions such a facility, with dozens of tiny victims being forcibly led by gun-wielding soldiers to the infamous death chambers. These are more deftly stylized counterparts of the drowning figures in *Noah Being Warned*, and the artist here manages to squeeze more than eighty of them into a piece that measures only eight by ten inches. The central structure for which most of the victims are destined is tagged "GAS PIT / SILENT DEATH," while the painting's most horrifying vignette occurs in another building in the upper left, next to a sign labeling it a "FURNACE / ONLY TO / BURN / HUMAN." Its thumbnail-size arched doorway is open to reveal three white-robed figures

in Finster's trademark praying posture; they are surrounded by red flames that have evidently consumed many previous victims, to judge by the thick black plume emerging from the smokestack and serving as a backdrop for the words "HITLER'S HELL." Another passage narrates the horrible action: "BROUGHT IN ON BOX CARS. MARCHED TO GAS CHAMBERS ROB[B]ED. AND / KILLED. AND BURNED / FIFTEEN THOUSAND EACH / DAY." Apparently extrapolating from his vision of his own visit to the infernal realm, as recounted to me a decade ago, Finster laments, "SOMETHING THAT / DON'T EVEN HAPPEN / IN HELL WITH / SATEN HAPPENED HERE / ON EARTH / WITH US," and inquires rhetorically, "WHAT COULD / BE WORSER ON EARTH."[9] Echoing this unanswerable question against the cloudless blue sky across the top of the piece, "HOW WORSER CAN IT GET BEFORE / THE END OF EARTH.S. / TIME," the artist then delivers the inevitable evangelistic punch: "WE ARE IN THE / COUNTDOWN YOU / BETTER GET RIGHT WITH GOD TODAY." At the end of the silver-lettered inscription forming a frame around this historically based nightmare is the artist's helpful suggestion as to how Gitter might further publicize the awful reality of the Holocaust and simultaneously spread Finster's urgent call to spiritual conversion: "ENLARGE PAINTING. MAKE POSTERS."

On a much lighter note, both figuratively and literally, is an early three-dimensional work that ranks as the most unusual Finster piece in the Gitter-Yelen collection. Created in March 1979 and numbered "1000 AND 380," *Cathedral in Heaven*, 1979 (cat. no. 33), exemplifies in strikingly imaginative form the artist's fascination with architectural space. It can also be seen as a prototype for his mirror-lined "dimensional boxes" of the early 1980s, as well as his full-scale masterwork of vernacular architecture,

World's Folk Art Church, built largely during the early 1980s and still towering over the north edge of Paradise Garden. Surrounded by a Finster trademark frame ornately patterned with woodburning tools, the front layer of *Cathedral in Heaven* is a vertical, rectangular plywood panel that Finster has almost filled with the painted image of an impossibly complex, multitiered castle or "heavenly mansion," as he sometimes called the smaller but similarly configured buildings that appear in many of his otherworldly landscapes. At first count it appears to be eight stories tall, but several of these stories contain cutaway views of multilevel interiors and rooms within rooms, making it virtually impossible to determine how many floors this baroque architectural conundrum contains. In some ways it is reminiscent of M. C. Escher's architectural works. Capped with domes, spires, and turrets, the structure is painted in a combination of azure and bright yellow colors associated, respectively, with the heavenly realm and the gold that is said to line heaven's streets. Framed by this extravagant building's openings and perched on its balconies are more than two hundred of Finster's anonymous praying figures wearing robes of varied colors. The quarter-inch slab of plywood on which this fantastic architectural image is painted has been pierced with numerous small holes and cut away in several spots to reveal portions of the work's interior, a mirror-lined, three-sided plywood box that can be seen in its entirety by lifting the facade panel, conveniently hinged at the top. This inner compartment contains an example of Finster's characteristic heavenly landscape imagery, in this case painted directly on the mirrored surfaces (as in his "dimensional boxes" of a few years later). There are the usual ivory towers, praying robed figures, flying angels, radiant suns, and green trees and hills, but the cottony

39. *200-Foot Tidal Wave*, c. 1976

40. *Mailbox*, 1989

white clouds floating in the reflective sky lack the simplified faces with which Finster anthropomorphizes the clouds in most of his later landscapes. Difficult to see, since the front panel opens at its widest angle to little more than ninety degrees, is the painting on its reverse side, which features more stylized angels drifting amongst gray storm clouds that also lack faces. Among this work's other unusual qualities is the brevity of its text, which (aside from the artist's first name and the requisite numerical and chronological data) reads in full: "GODS GREAT DAY / THE END OF TIME BRINGS A NEW HEAVEN AND EARTH / HOMECOMING IN HEAVEN / HOMECOMING IN HEAVEN / JOIN US SOON." Here Finster shows us the bright side of the apocalypse; to highlight this idea he adds an appropriate finishing touch in the form of a light fixture whose bulb illuminates the piece from within.

In the ten-year period following his creation of *Cathedral in Heaven*, the artist saw remarkable changes in his life as he rose to international prominence and became one of this country's most original and colorful artists. Articles about him appeared in *Life, People,* and the *Wall Street Journal,* and he was on *The Tonight Show* with Johnny Carson. He appeared in a popular rock music video by R.E.M. and created album covers for that group as well as for Talking Heads. He received a five-thousand-dollar grant from the National Endowment for the Arts; two New York publishing houses issued books about him;[10] and his work was featured in group and solo exhibitions at the New Museum of Contemporary Art, the Museum of American Folk Art, the Corcoran Gallery of Art, the Venice Biennale's American Pavilion, and dozens of other prestigious art spaces. As a result of all this exposure and a growing popular interest in the field of self-taught, folk, or "outsider," art, demand for Finster's work increased dramatically, and he escalated his production accordingly. After completing an average of five to six hundred pieces a year during his first three years as a creator of freestanding artworks, he nearly doubled his annual output over the decade that followed, finishing and numbering eleven thousand works between the time of *Cathedral in Heaven* and *Mailbox,* 1989 (cat. no. 40), his painting of a standard-issue aluminum mailbox that is one of the later Finster pieces in the Gitter-Yelen collection.

Mailbox is one of many works the artist created by painting on ordinary objects such as old shoes and telephones.

It revisits a metaphor for spiritual communication that he had used several years earlier in *Heaven's Mailbox,* originally installed on a wooden post alongside an encrusted walkway near the center of Paradise Garden.[11] That first mailbox was painted with clouds and angels carrying pieces of mail, and it was emblazoned with such phrases as "MAILMAN FROM HEAVEN," "GET IN ON MESSAGES FROM HEAVEN," and "TELEGRAM—JESUS IS COMING BACK." But in *Mailbox* the artist employs a familiar yet differently handled motif: a tranquil heavenscape not unlike the one inside *Cathedral in Heaven.* Again there are towers, trees, radiant stars, soaring angels, and robed figures in prayer, but here these elements are more stylized and even formulaic. Finster nevertheless livened the motif with lots of bold color, which he has used more freely in his art since the mid-1980s, and in the lower sections of the heavenscape he has added amorphous forms with humanoid faces, figures that resemble earthbound versions of his anthropomorphized clouds and are labeled "RESTING SOULS." And while the Paradise Garden mailbox encourages the *receipt* of messages *from* heaven—presumably the divine commands and otherworldly visions Finster himself claims to receive from on high—this more recent mailbox urges the artist's audience to "SEND A LETTER / TO HEAVEN" (emphasis added).

Many veteran collectors and other longtime observers of Finster's art have bemoaned what they perceive as a marked decline in the quality of his work concurrent with his stepped-up production after the mid-1980s. While a comparison of the 1989 *Mailbox* or many other relatively late pieces with an early painting such as *200-Foot Tidal Wave* tends to support that view, it also oversimplifies Finster's artistic development. I've followed the artist's work for more than fifteen years, and I've observed that in any given year he produces some works that are fresh and inspired together with others that seem hastily made. Given this situation, it would be easy enough to produce isolated comparisons indicating

a substantial *improvement* in quality over the past ten years. For example, Finster has produced hundreds of paintings that are stronger and more compelling than the historically significant Noah's Ark image with which this discussion began. This fact is aptly illustrated by his most elaborate piece in the Gitter-Yelen collection—*George Washington in Another World*, 1987 (cat. no. 35)—a particularly striking painting.

However, any meaningful discussion of these issues ultimately leads to an acknowledgment of the vast difference between the art market's view of Finster's work and his own view. He has never made art to score aesthetic points with collectors, critics, or anyone else. On the contrary, he has always been very clear about his motivation for creating. He obviously enjoys doing it; but beyond that, it is simply a means of spreading the Gospel, saving souls, and converting the faithless—and also of bringing a little happiness into the lives of his fellow human beings. In addition to the thousands of major pieces he has created over the past twenty years, during every one of those years he also cranked out lesser works of the kind he calls "souvenir pieces"—mostly rehashes of images and themes he has treated countless times before. Populist that he is, he has always prided himself on offering "something for everybody": elaborate, labor-intensive paintings or sculptures for the high-rolling, big-city collectors as well as simple painted cutouts and other small items in the two-figure range for the young students and less affluent fans who regularly visit Paradise Garden.

At least partially in an effort to ensure a steady supply of work for the latter group of collectors, Finster originated his ongoing series of "wipe-rag art" pieces, such as the ones included here (cat. no. 37). Always looking to find new uses for all manner of cast-off materials, he began saving the old paint-smeared cloth scraps he had used to wipe his hands while working in his studio. Periodically he takes out a batch of these and goes to work transforming them into art, using felt-tip markers to convert their multiple smears and smudges into recognizable images, most often human and animal figures or faces. This practice of the late 1980s on harks back to the pivotal experience of twenty years before, when he claims he was divinely appointed to "paint sacred art" after he visualized a tiny human face in a paint smudge on his fingertip.[12] He finishes these wipe-rag pieces by filling open spaces with hand-lettered messages, most of which he has repeated innumerable times in previous works, such as "TAKE TIME TO BE HOLY," "GOD LOVES YOU," and "JESUS SAVES."

As his wipe-rag art indicates, Finster's work long ago developed such a life of its own that it has become one of its own main subjects. "MY RAG ART," he tells his audience here, "IS GOING OVER. SALES OF THESE RAGS SUPPORT PARODISE [*sic*] GARDEN CITY BLOCK." Like his hero who built the biblical ark, Finster ultimately had the last laugh on those neighbors who at first ridiculed his creative efforts on behalf of God and his fellow earthlings. He once told me, in an extension of that comparison,

> Like Noah, when he done all he could, and when he had his Ark built, he felt like he'd done his duty, and he just shut the door and floated off, and the rest o' the people was damned. Well, that's the way it is for me. I feel like I've 'bout got my duties done, and I feel like I've got enough art out there for the world to see how things really is. If they hadn't got the message now, it's their problem.[13]

If that sounds a bit hard-hearted coming from a man who has often proclaimed his love for everybody, keep in mind that it's an assertion Finster made about eight years ago, late one night when he was tired from painting all day. Since then he has created more than twenty thousand additional works of art, and as of this writing he is still at it, continuing to spread the Word far and wide. He hasn't shut the door and floated off yet. —T.P.

NOTES

1. Hebrews 11:7

2. Tom Patterson, ed., *Howard Finster, Stranger from Another World: Man of Visions Now on This Earth* (New York: Abbeville Press, 1989), pp. 125–26. Finster tells a slightly different version of this story in John F. Turner, *Howard Finster, Man of Visions: The Life and Work of a Self-Taught Artist* (New York: Alfred A. Knopf, 1989), p. 78.

3. See Patterson, ed., *Howard Finster, Stranger from Another World*, pp. 28, 30, 61–62, 65.

4. Ibid., pp. 102–4.

5. This painting is illustrated in Turner, *Howard Finster, Man of Visions*, p. 123.

6. This painting is illustrated in Patterson, ed., *Howard Finster, Stranger from Another World*, p. 188.

7. Ibid., pp. 32–33.

8. Ibid., pp. 123–24.

9. Finster's account of his visionary visit to hell is recounted in ibid., pp. 171–72.

10. See n. 2.

11. This piece is illustrated in Patterson, ed., *Howard Finster, Stranger from Another World*, pp. 87, 117.

12. Finster describes this experience in ibid., p. 123.

13. Ibid., p. 201.

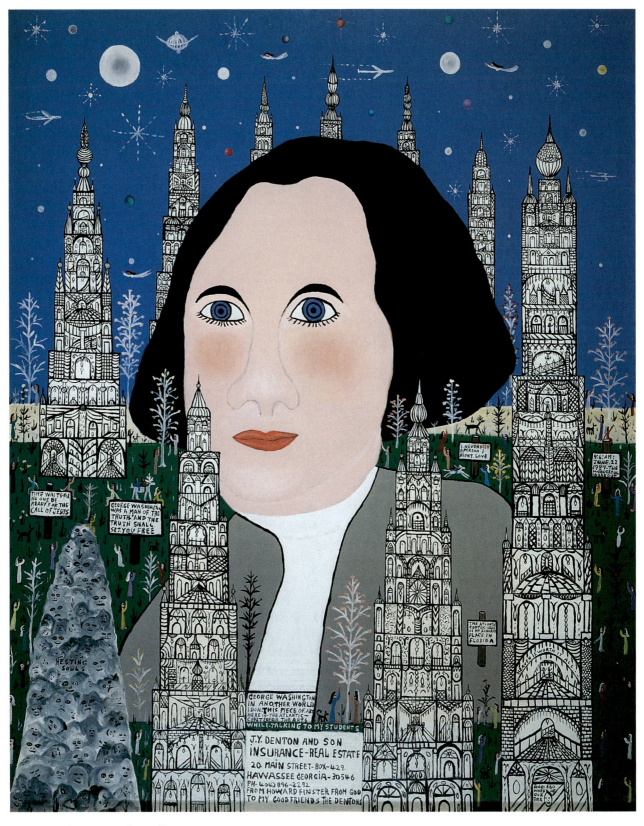

35. *George Washington in Another World*, 1987

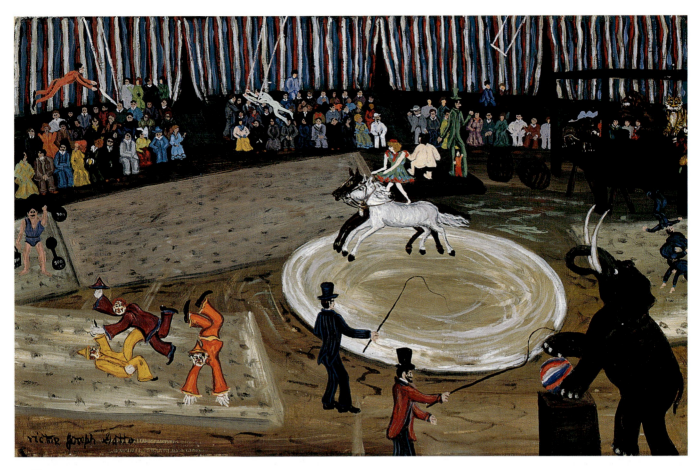

41. *Circus*, c. 1950

Victor Joseph Gatto

Born on July 23, 1893, in New York City, Victor Joseph ("Joe") Gatto created energetic paintings inspired by the world around him and his rich imagination. Although Gatto also did some pencil drawings and watercolors, the four examples presented here—*Circus*, c. 1950 (cat. no. 41), *Johnstown Flood*, 1955 (cat. no. 42), *Poppies*, c. 1950 (cat. no. 43), and *Jungle*, c. 1946 (cat. no. 44)—exemplify his strength in the medium of oil.

Gatto's painting seemed a positive outlet for his volatility and restlessness. Painting also provided a way for him to establish order and control in a life characterized by caprice. His hostile outbreaks and arrogance caused him many difficulties, including a dishonorable discharge from the navy and subsequent

criminal behavior for which he served time in prison. His quarrelsome nature and disdain for others cost him many friends. To Sidney Janis, the New York art dealer who wrote the seminal book on self-taught artists, *They Taught Themselves*, Gatto once bragged that he was great while the other artists Janis represented were "bums." Gatto may have paid for his brashness by receiving no more than cursory recognition in Janis's book.

However that may have been, Gatto later received recognition; his work has been exhibited at the Museum of American Folk Art, the Whitney Museum of American Art, and the Abby Aldrich Rockefeller Folk Art Center in Williamsburg, Virginia. While many found his manner off-putting, collectors Sterling

and Dorothy Strauser, of East Stroudsburg, Pennsylvania, remained loyal to Gatto, and they both collected and promoted his art to others.

Gatto worked as a plumber and a steamfitter and even had a stint as a professional boxer, but after serving time he mostly worked in temporary, menial jobs. When he was forty-eight years old, he attended a Greenwich Village outdoor art show. Upon learning that one could receive hundreds of dollars for a single artwork, he began to paint straightaway. He had always been excellent in drawing. According to one story, when he was growing up in a Catholic orphanage and school, he was complimented by Teddy Roosevelt, who visited the school and declared that Gatto was "the best drawer

in the school." After the turning point at Greenwich Village, painting became Gatto's passion. Although he spent considerable time on each painting, working for long, uninterrupted stretches, he created many hundreds of paintings by the time of his death in 1965.

Circus and Johnstown Flood are narrative works that seem strongly factual. Gatto loved circuses and had many opportunities to see them as he traveled from place to place. Circuses are marvelous places of refuge, escape, and fantasy. The circus Gatto pictures is possibly a local event of the sort once seen in so many towns across the United States. This is not Madison Square Garden and the Ringling Brothers Barnum and Bailey Circus. From an elevation, the artist illustrates several acts occurring simultaneously: the circus rings feature clowns, a strongman, and a trained elephant with a ball, while the spotlight focuses on a woman who courageously stands as she rides the horse bareback. The whitened ring surface frames her activity; the white horse with the darkened shadow echoes the graceful stride and adds dra-

matic essence to the busy narrative. The attentive crowd of viewers in the rear provides a horizontal band that compositionally layers the work and spatially deepens the picture plane. The tent curtain fills the background space. The use of red, white, and blue nostalgically recalls patriotic feelings, and the vertical banding breaks up the horizontality of the pictorial space.

The beauty of the organization of the compositional space is essential in Circus. Placing the highlighted rider asymmetrically to the right of center on the oval ring, Gatto avoids design monotony. He expands the central oval form by echoing it in the large oval of the outer form. The viewer's eye moves from the standing elephant in the right foreground, sweeps to the left while passing other circus performers along the way, and makes a gentle, arching curve to the right, observing the audience from left to right.

Johnstown Flood is inscribed August 1955, which may have been the date the artist painted the work, but the scene he painted was filled with details pointing

to the famous flood that took place in Johnstown, Pennsylvania, in 1936. Johnstown, an industrial city in southwestern Pennsylvania, was located in a river valley and was the scene of more than one disastrous flood. On May 31, 1889, a devastating flood killed more than two thousand people and caused $17 million in property damage. In the flood of March 17, 1936, eight people lost their lives, thousands were left homeless, and property damage was estimated in many millions of dollars. Gatto's presentation of the flood definitely places the narrative in the twentieth century. A truck and another vehicle, both red, are seen in the foreground. According to Larry Scheef, managing director of the American Trucking Historical Society, the red truck in Gatto's painting resembles the red trucks built by Ransom E. Olds, especially the heavy-duty 1927 model.

If the artist used a newspaper or other print source as a model, to date it has not been found. Research in the Johnstown Flood Museum has turned up many photographs of the flood, but none seems to be a visual source for

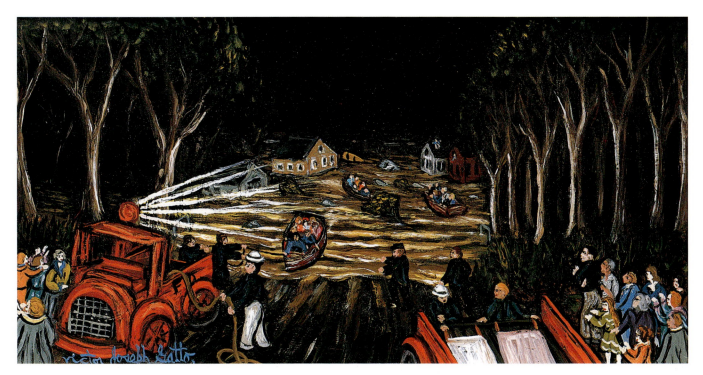

42. Johnstown Flood, 1955

Gatto's composition. This writer suggests that a written description such as the following probably served as inspiration for the painting:

> Darkness and water enveloped the stricken areas together. . . . The night was one of suffering and terror—both for those marooned in the flood and for relatives and friends on higher ground. . . . Throughout the afternoon and early evening of March 17 and again during the morning of March 18, trucks and boats were used wherever it was possible to remove those trapped by the flood to places of safety. Narrow escapes and acts of heroism and daring were common.[1]

Gatto's painting calls to mind the heroism of the residents in helping with the rescue operation. It is recalled in local history books that the town quickly rallied, as it had in 1889, to establish order, clear the mud and debris, and provide food and shelter for the homeless. Their courage was astonishing considering that the city, which in 1889 was a small community of twenty thousand, had grown considerably by 1936.

By cropping the foreground space, Gatto adds a journalistic touch to the drama, similar to his cropping of the space in the foreground of Circus. Also as in Circus, the artist uses highlighting and a sharp contrast of light and dark. The blackened sky of the disastrous night scene is in sharp focus, heightened by a strong, radiating beam of light from the red truck in the left foreground. The truck's headlights illuminate the flood and guide the viewer's attention to the central area, which is, as in Circus, a generally ovoid shape. Floating houses and debris appear amidst the horizontal waves of floodwater, and rescuers are rowing boatloads of people to safety. Clusters of onlookers in the right and left foreground cheer the rescuers on, as a few, probably survivors or perhaps relatives or friends of survivors, clap their hands in gratitude. Trees balance both sides of the central area, the light shining on them accenting their vertical trunks. The darkened sky in the upper middle ground completes the composition, which suggests a containment and control brought about by technology and cooperation among people.

These two equally compelling paintings—with their dark-and-light palettes, enveloping compositional forms, and high energy levels—successfully express an exceptionally intense mood, which is the hallmark of the artist's style.

Rather different in mood and technique is Poppies, a dazzling close-up of

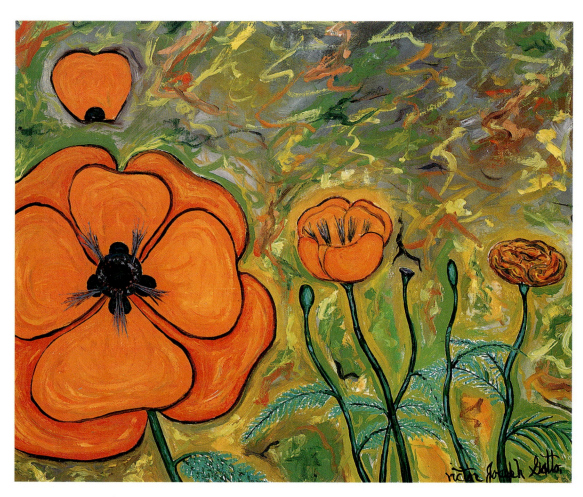

43. *Poppies*, c. 1950

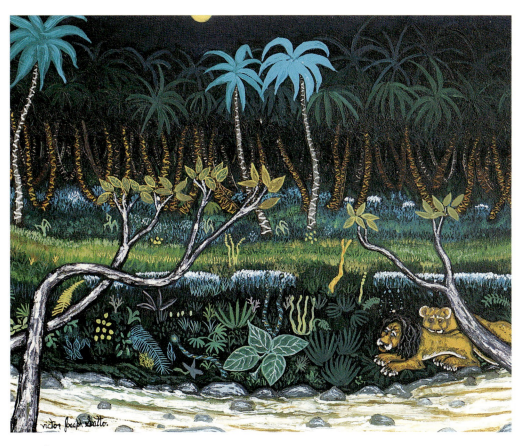

44. Jungle, c. 1946

what appears to be an Iceland poppy. Its green pinnate leaves, asymmetrically placed blossom, and echoing smaller flower burst on the canvas, emitting an intense brilliance from the bright orange petals and dark centers. The plants vibrate against a multicolored, striated, and glowing background. Gatto successfully infuses the composition with vigor by his bold use of color, unconventional compositional placement, and short, curving, painterly strokes in the background.

Another generally dark-hued painting is *Jungle*, an exotic night scene that appears as Gatto's idealized Peaceable Kingdom. Unlike the works of that nineteenth-century Pennsylvania artist, Edward Hicks, whose more than sixty Peaceable Kingdom paintings were inspired by the book of Isaiah, or the works of Horace Pippin, whose revised version of the subject was inspired by

Hicks but was rendered in an African American context, the subject matter of Gatto's painting was, on a conscious level, probably unrelated. Nonetheless, one cannot help but connect Gatto's *Jungle* to the works of these two artists. Instead of populating the canvas with many animals and including a child, as in the Isaiah verse, Gatto includes a pair of peaceful lions as his only figural subjects. Using dark greens, blues, and golds in contrast to lighter hues, he surrounds the lions with a body of moving water and a few exotic plants. A few twisting, branched trees occupy the foreground space, which is layered by a horizontal band of flowing water interspersed with rocks and another band of exotic foliage, with the animals off to one side. Additional bands of grass and three palm trees glow in the midground, followed by a darkened strip of palm trees horizontally stretching across the entire can-

vas and punctuated by a blackened sky in the distance.

For Gatto, *Jungle* seems to represent a serenity he longs to achieve, but there is an undercurrent and edginess in this strong work, notably in the moving water, the twisting tree trunks, and the artist's vigorous brushstrokes. Nonetheless Gatto has created an exotic, hypnotic fantasy painting that invites the viewer to share in life's wonders and mysteries.

—L.K.

NOTE

1. Raymond Cooper, "Report of the City Council of Johnstown, Pa. 1936," courtesy Johnstown Flood Museum, Johnstown, Pa.

Ralph Griffin

Burke County, Georgia, is one of those out-of-the-way corners of the rural South where time seems to have stood still. It's a place where the plantation system survived more or less intact for a century after the Civil War and where traces of that system still exist. Even today the county's economic and political life is dominated by a small number of white citizens who own large amounts of farmland. In the decades after World War II, when other small southern communities were busily recruiting new industries, these landowners discouraged such efforts in Burke County, since industrial development meant higher-paying jobs for the poor blacks who had traditionally worked the local plantations. The resulting shortage of nonfarming jobs, combined with the increased mechanization of agriculture since the 1950s, has made survival a challenging proposition for African Americans living in Burke County in the late twentieth century.[1]

As a black man born there in 1925, Ralph Griffin confronted these difficulties on a daily basis for most of his sixty-seven years. Griffin grew up near the small community of Girard, and like most African Americans of his and preceding generations in Burke County, he worked in the cotton fields. In the mid-1950s, when he was about thirty, he left, no doubt hoping to find more tolerable

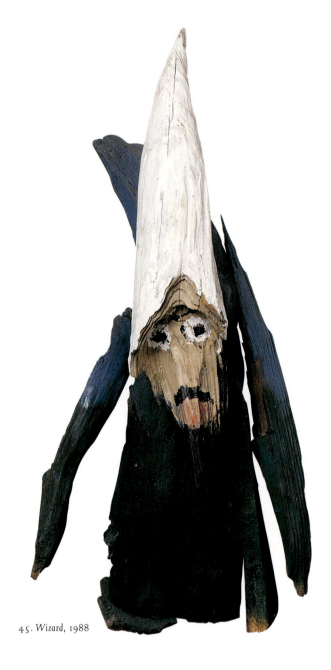

45. *Wizard*, 1988

and more profitable employment elsewhere. He spent the next ten years traveling and working at various jobs in other parts of the southeastern coastal plain before returning to Girard to settle down. From the late 1960s until his retirement in the late 1980s, he supported his wife and six children by working as a janitor at a bakery.[2]

It wasn't until the late 1970s, when he was over fifty and his children were grown, that Griffin found his true call-

ing. It all started with a piece of gnarled driftwood that he salvaged from Poplar Root Branch, a stream that ran through his property. Noticing that the fragment bore a striking resemblance to an anteater, he took some red, white, and black paint and used it to highlight the visual correspondence. He named the creation *Midnight* and set it out in his front yard for his neighbors to see. It caught the eye of a passing collector, who stopped and bought it.[3] The stream contained plenty

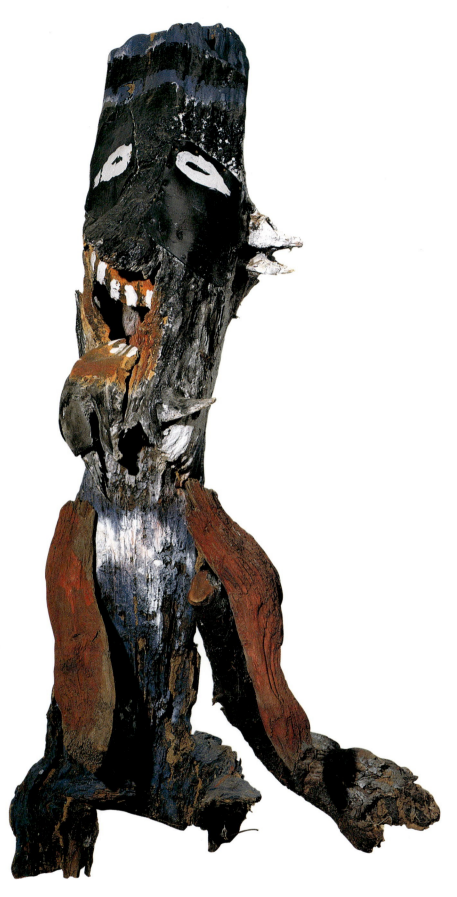

47. *Grimacing Figure*, c. 1988–89

of other twisted tree roots and branches reminiscent of animal and humanoid figures, so Griffin gathered a few more of these bits and pieces and set about making other sculptures, which he also installed in his yard. What began as a whim soon developed into an obsession, as Griffin kept adding to the collection of animated figures surrounding his small, one-story home. His yard quickly became a topic of local conversation, and his neighbors began referring to him as the "Root Man." Meanwhile, collectors continued to show up from time to time to buy his sculptures.

In an interview recorded ten years after he began his artistic activities, Griffin described how he worked, revealing something of the visionary basis for his sculptures:

> I go to the stream. I read the roots in the water, laying in clear water. There's a miracle in that water, running across them logs since the Flood of Noah. . . . This is the water from that time. And the logs look like Old Experience Ages.
>
> I take a root from the water and have a thought about it, what it looks like, then I paint it red, black, and white, to put a bit of vision on the root.[4]

In another account from the same period, Griffin elaborated:

> A lot of people ask me where I start when I make one of these. The first thing I do is get the eyes. When I get this eye I can make him come out of the root. I can bring a man out of it, then make heads on heads. It seems like a dream until I get it made. . . . I feel just like the astronauts exploring up there; I just want to see what I can find in these roots and things.[5]

What Griffin found in them was a kind of spiritual presence, and in locating, highlighting, and capturing it, he was following an ancient protective and divinatory tradition whose cultural origins lie in the Kongo region of western and central Africa. It is likely that Griffin's ancestors came from the Kongo, as did more than a third of the slaves brought to the southern United States after 1808. Despite prohibitions against African religious and social customs on

the plantations, the slave communities surreptitiously maintained their traditions and belief systems, many aspects of which continue to survive on this side of the Atlantic. Among them is the Kongolese belief in *bisimbi*, spirits of the dead, and in Funza, their supernatural custodian. These noncorporeal entities are associated with natural bodies of water and with unusually formed roots and branches, in which they are believed to incarnate themselves.[6]

Art historian Robert Farris Thompson has pointed out the parallel between Griffin's driftwood sculptures and the *bisimbi* spirits, while noting that the artist seemed unaware of Kongolese spiritual traditions. But Griffin's own comments suggest that he knew he was dealing with a form of spiritual entity when he created these pieces. For instance, when he said he "read[s] the roots in the water," he asserted his ability to recognize an encoded presence in them. Likewise, his claim that "there's a miracle in that water" suggests an attunement to a level of reality that is invisible to most of us. And his telling phrase "Old Experience

Ages" calls to mind ancestral spirits that have transcended death to remain active in the phenomenal world—or at least remain ready to resume activity when summoned by a capable agent in this world. That Griffin believed himself to be such an agent is implied in his explanation, "When I get his eye I can make him come out of the root." In other words, by giving sight to these previously hidden spirits, he was able to coax them forth into our realm. When one considers these comments, it isn't much of a stretch to describe Griffin as a kind of modern-day version of the Kongo *bangango simbi*, a ritual expert who honors and works with the *bisimbi* spirits.[7]

There are other striking correspondences between Griffin's art and the spiritual and iconographic traditions of sub-Saharan Africa. Thompson has noted that Griffin's favored color scheme of black, white, and red mirrors the sacred Kongo color triad.[8] And Griffin's habit of giving many of his figures two pairs of eyes recalls the concept of double sight—ordinary vision augmented with an ability to see on a spiritual level—

which is found in a number of sub-Saharan traditions.[9] Although in Africa traditional representations of nature spirits are stylized and symmetrical, verbal descriptions of these spirits closely coincide with Griffin's often grotesque figures.[10] The fact that he placed these sculptures in his yard may have been motivated partially by commercial concerns—a desire to advertise that they were for sale—but he may also have seen them as guardians of a sort, charms to protect his home, which would connect them with a widespread tradition of African and African American yard decoration.

Africanists and other scholarly types aren't the only ones who have recognized the spiritual component in Griffin's art. Griffin's black neighbors in Burke County also suspected that he had tapped into some visionary current with his art making; after witnessing the transformative power manifested in his root sculptures, they began to seek him out for spiritual consultation. A few years before his death, he told artist and curator Judith McWillie, "People still come over

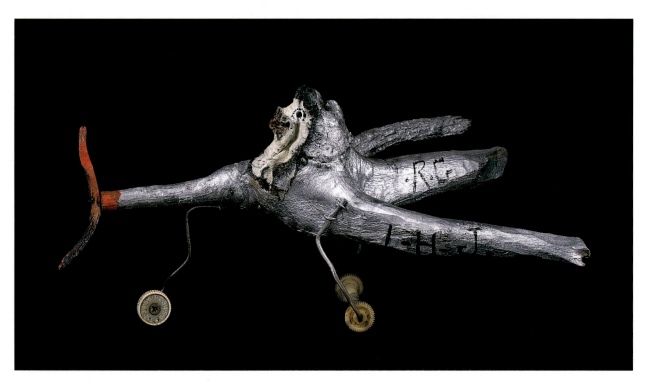

46. *Man in Airplane*, 1990

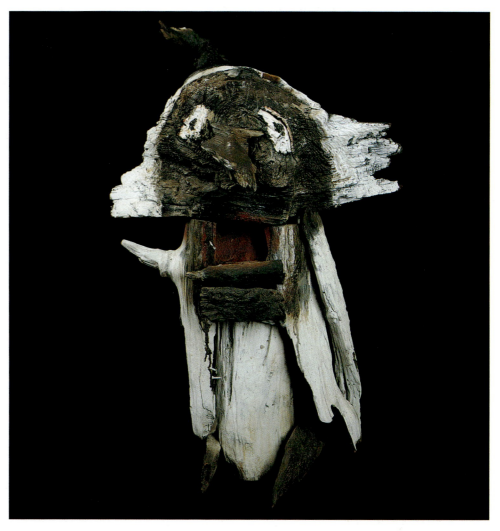

48. *Dwarf*, 1989

and ask me to help them with their dreams and all, but I don't go that far." While this caveat clearly meant that he refused to set himself up as some kind of self-advertising seer, he was quick to add, "I am one who is pretty wise about that kind of thing. I believe that the more I do this, I could maybe shake your hand and give you all the luck you want. I'm for real about that." And then he reiterated, "But I don't go that far."[11]

There are striking similarities between Griffin's work and that of several other self-taught artists, most notably Bessie Harvey. Harvey also worked primarily with gnarled and twisted wood fragments. Although hers weren't usually pulled from a stream, her approach, like Griffin's, involved highlighting the faces and figures she perceived in the natural shapes and patterns of the wood. This creative technique isn't limited to African American artists such as Griffin and Harvey; it is also practiced by artists such as Clyde Jones and Howard Finster. Finster refers to his "captured visions," which he creates by highlighting faces he visualizes in the roiling fields of intermingled color he obtains by mixing enamel and linseed oil on slabs of Masonite. So, while African traditions may well have had an indirect influence on Griffin's sculptures, they can also be seen as manifestations of a universal impulse toward zoomorphizing or anthropomorphizing what is amorphously organic. Whatever their cultural backgrounds, children seem instinctively adept at seeing faces and figural forms in clouds and other phenomena, but somewhere along the way to adulthood most of us lose this capacity, or at least lose interest in exercising it. Maybe this is one of the characteristics that set artists and seers apart from the rest of the adult population—their ability to maintain an aptitude for transformative vision.

No matter how one accounts for Griffin's motivations in making them, his sculptures have a strong, animated presence. They are haunting creations—sometimes amusing, often disturbing, but always compelling. One senses a mysterious life force in them, almost as if they were independent intelligences returning our gaze and even watching us when our eyes are averted. Consider, for

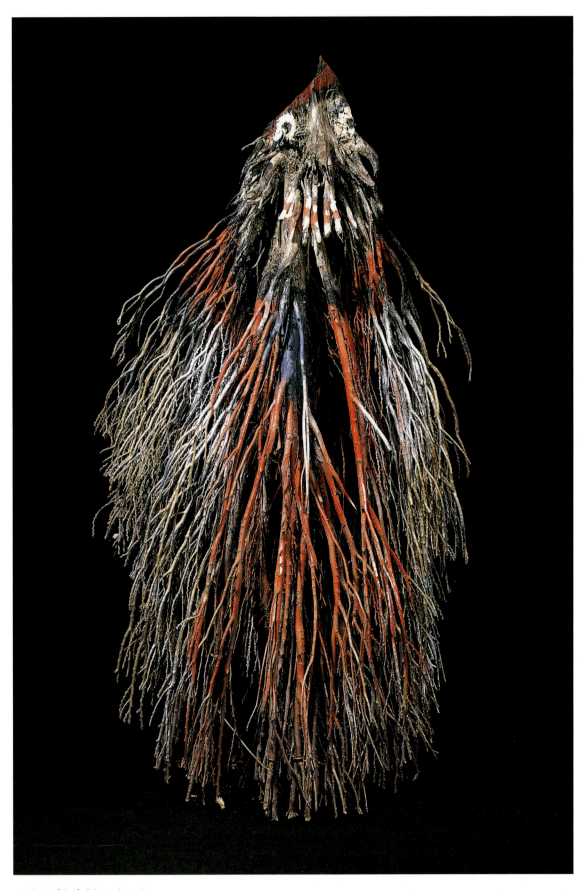

49. Inverted Bush (Monster), 1989

example, the work identified here as *Inverted Bush (Monster)*, 1989 (cat. no. 49). Griffin reversed the natural orientation of this chopped-off bush so that its dense network of tiny branches resembles the root system of an uprooted tree stump, but he added nothing more than a little paint to "get the eyes," as he would say. This is one of his many works with two sets of eyes, corresponding to the African double-sight paradigm mentioned above, and in this case they create two distinctly contrasting visages. One face appears to have long, red-and-white striped teeth that suggest the bloody fangs of some carnivorous monster (the better to repel evil influences), while the other is much more benign.

In addition to his works created from a single piece of wood, Griffin also made sculptures from multiple driftwood shards that he nailed together or otherwise connected, sometimes adding other found materials. A vivid example from this collection is the one labeled *Grimacing Figure*, c. 1988–89 (cat. no. 47). Several fragments of wood have been nailed around the dark hollow in the upper half of this tilting, columnar driftwood log to form a gaping, snaggle-toothed mouth. In an unusual use of cast-off, mass-produced material, the artist painted the figure's single pair of white eyes on two scraps of heavy-duty black plastic sheeting and nailed them a few inches above the prominent mouth. As altered by Griffin, this weatherbeaten hunk of wood takes on a formidable personality: He seems to be a strangely malformed forest gnome howling in pain or screaming a warning to anyone who would dare go where he has just been.

Less ominous is an unusually bright and lighthearted piece, here entitled *Man in Airplane*, 1990 (cat. no. 46). Although it doesn't evoke the restless spirits Griffin conjured elsewhere, this small sculpture is among his most striking. Like all of his other works, this was clearly inspired by the natural shape of the wood fragment

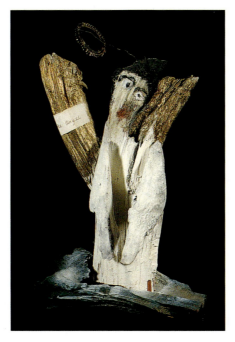

50. *Angel*, 1991

that is its main component. Even without his additions and alterations, this root or branch formation obviously resembles an airplane with a tapering fuselage and streamlined wings. Departing from his usual color scheme of red, white, black, and sometimes blue, Griffin painted the plane's body silver, a realistic color choice, and added a touch of bright orange at the nose, where he attached a twig propeller, also painted orange. He transformed the gnarled protrusion at the center of the plane's body into the head of a tiny pilot peering out from an open cockpit; his choice of red-and-black-accented beige is similarly uncharacteristic. Finally, he added a lower support frame consisting of aluminum wire connected to wheels improvised from a plastic spool and a plastic transistor radio dial. The dial serves as the front wheel and symbolically associates the entire vehicle with the radio waves that also traverse the air. Created toward the end of Griffin's life, this inventive variation on a standard folk-art toy makes one wonder what surprising developments we might have seen in this late-blooming artist's work had he lived beyond his sixties.

Ralph Griffin's art is a testament to the power of personal vision allied with a deeply felt sense of nature's spiritual aspect. Although hemmed in by a socio-economic system that seemed to ensure his perpetually marginal status, he nonetheless kept an ancient faith and followed his own mystical instincts. Channeling these strengths into creative activity, he was able to transcend his circumstances and communicate his vision far beyond the little world of Burke County, Georgia —a humbly executed but heroic act from which we continue to benefit. —T.P.

NOTES

1. Bill Cutler, "The Faces of Burke County," *Brown's Guide to Georgia* 6, no. 7 (November 1978): 18–34. This article provides a fascinating glimpse of the social realities of life in Burke County, Georgia, at about the time Ralph Griffin began creating his sculptures there.

2. The biographical material presented here is from the following exhibition catalogs: *Another Face of the Diamond: Pathways Through the Black Atlantic South* (New York: INTAR Latin American Gallery, 1988), pp. 47–48, 62–63; *Diving in the Spirit* (Winston-Salem: Wake Forest University, 1992), p. 30; *Even the Deep Things of God: A Quality of Mind in Afro-Atlantic Traditional Art* (Pittsburgh: Pittsburgh Center for the Arts, 1990), p. 11; and Alice Rae Yelen, *Passionate Visions of the American South: Self-Taught Artists from 1940 to the Present* (New Orleans: New Orleans Museum of Art, 1993), p. 310.

3. Robert Farris Thompson, "The Circle and the Branch: Renascent Kongo-American Art," in *Another Face of the Diamond*, p. 48.

4. Ibid., p. 63.

5. *Even the Deep Things of God*, p. 11.

6. Robert Farris Thompson, *Flash of the Spirit: African and Afro-American Art and Philosophy* (New York: Random House, 1983), pp. 107, 137.

7. Ibid., p. 107.

8. Thompson, "The Circle and the Branch," p. 47.

9. Grey Gundaker, "Double Sight," in *Even the Deep Things of God*, p. 8.

10. Martha G. Anderson and Christine Mullen Kreamer, *Wild Spirits/Strong Medicine: African Art and the Wilderness* (New York and Seattle: Center for African Art and University of Washington Press, 1989), p. 42.

11. *Even the Deep Things of God*, p. 11.

Joseph Charles Hardin

Joseph Charles Hardin began painting around 1975. Working primarily in oil, acrylic, and oil pastel, he created highly expressive paintings characterized by vibrant, dense colors and abstract, symbolic imagery. Hardin was isolated by a severe and debilitating disease that limited his world but not his vision. At age thirteen, he was diagnosed with rheumatoid arthritis, whose crippling effects he had been experiencing for several years. An excellent student with a bright, inquisitive mind, Hardin continued to attend school on crutches. As his disease progressed, he was confined to a wheelchair and was forced to abandon formal education when he was fourteen.

After the death of his parents, Hardin alternately lived with relatives, in nursing homes, and on his own in Birmingham, Alabama. It was during a period when he was living unassisted in an apartment on Birmingham's Southside (an area of the city that has a concentration of students and artists) that Hardin began to paint. "I started [painting] in the seventies," he once recalled. "I lived in a complex where all my neighbors were students. I had to do something because I was by myself all the time."[1]

Hardin said he began by copying comics in *Playboy* magazine on very thin sheets of paper. His family regarded his art primarily as therapy, but Hardin, encouraged by the response he received from his family and neighbors, began to paint and draw more.

Red Woman, 1988 (cat. no. 51), like many nude female figures Hardin drew, leaves little doubt that he was influenced by images published in "girlie" magazines such as *Playboy*. Hardin also talked about watching the young women who studied ballet at the University of Alabama at Birmingham. Their studio was near his apartment, and seeing the lithe and flexible bodies of the dancers passing by his window must have had an impact as well. Whatever their influences, Hardin's paintings seem to reflect his loneliness and repressed sexual desire. Isolated by a crippled body and with movement so restricted that he had to use a pickle fork to hold his cigarettes, he found a physical relationship impossible.

Hardin worked on relatively small pieces of paper that could easily fit on his lap when he was seated in his wheelchair. Instead of creating a sense of intimacy, Hardin created paintings that feel monumental despite their reduced size. His images fill the space, and he often outlined his shapes with black lines and filled them with bright colors, creating strong linear patterns.

While the female form is recognizable in many of Hardin's works, the form is abstracted, often distorted, or the perspective is ambiguous, giving rise to the oft-made comparisons of Hardin's paintings with African art and the Cubist work of Pablo Picasso. His palette of intense colors has been compared to the dense colorations of the Expressionists. Hardin's strong sense of design and color could have given his paintings a merely decorative quality, but the emotional content, the sense of his having something to say, give his works tremendous substance.

—G.A.T.

NOTE

1. Elaine Witt, "From Pain and Paint," *Birmingham Post-Herald*, May 19, 1989, Kudzu Magazine section, p. 6. The biographical information included here is drawn from the above article and from Kathy Kemp and Keith Boyer, *Revelations: Alabama's Visionary Folk Artists* (Birmingham: Crane Hill Publishers, 1994), pp. 118–25; and *Outsider Artists in Alabama* (Montgomery: Alabama State Council on the Arts, 1991), p. 26.

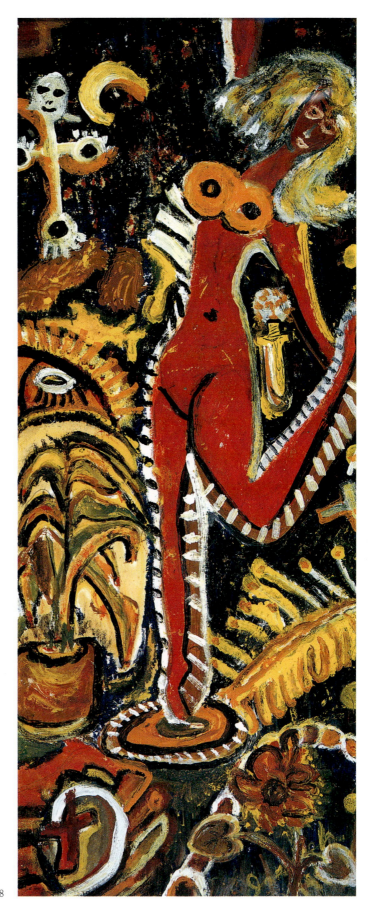

51. *Red Woman*, 1988

Bessie Harvey

Bessie Harvey was a uniquely gifted contemporary sculptor who arrived at her singular place in the art world through an unlikely route. A visionary in the most literal sense of the term, she was a seer, a prophet, a dreamer. She often spoke of the spirits she saw and the voices she heard, and she claimed they guided her in making her extraordinary figural sculptures and other works.

Born on October 11, 1929, in the small town of Dallas, Georgia, Harvey grew up in a large, poor family that suffered particular hardship after the death of her father when she was only four or five years old. She married her first husband when she was fifteen, but theirs was a troubled union, and she left him before she was twenty. She moved to Alcoa, Tennessee, where a cousin was then living, and supported herself from the late 1940s through the late 1970s in a variety of service and industrial jobs. By the time she was in her mid-thirties she had given birth to eleven children, and by the time she died on August 12, 1994, she had thirty grandchildren and several great-grandchildren.

With no formal art training and little schooling of any kind, Harvey didn't begin creating art until she was in her early forties. In later years she described her initial art-making activities as a form of spiritually driven therapy for the emotional turmoil she was experiencing during the late 1960s and early 1970s. Her adolescent sons had become involved in drug use and small-time thievery, and her concerns for their safety and well-being bred in her a deep sense of fear and anxiety. "I was afraid," she said, "but the Lord began to show me faces in the wall to soothe me, and I began to talk to the trees and to the grass. And I discovered they're alive, just like we are, and you can talk to them. . . . And the Lord showed me how to bring these faces out of these pieces of wood, so I could have somebody to talk to, so I wouldn't be afraid."[1]

Harvey worked with a wide range of materials, but she is known primarily for her "root sculptures," which were usually inspired by suggestions of figures and faces she perceived in the natural contours and cracks in roots and other gnarled wood fragments that are the main components of these works. When she began creating such pieces, some of her neighbors didn't know what to make of them, and they accused her of being a "voodoo person." Upset by these negative responses, she burned a number of her earliest works, but she soon created more. She received more favorable reactions a few years later, when she entered one of her sculptures in an employees' art exhibit at the hospital where she worked. One of the doctors introduced her creations to a few art dealers in New York, and thus began the process by which she became one of the world's most widely known self-taught artists.

Although examples of her work were shown in New York as early as 1983, Harvey's art began to gain widespread attention only after *Artforum* published an enthusiastic review of her solo exhibition at Cavin-Morris Gallery in early 1988.[2] Admirers quickly noted visual and conceptual similarities between her work and certain types of traditional African sculpture.[3] After hearing these comparisons, Harvey developed a keen interest in African art and ritual traditions, which she studied on her own and which influenced the content and titles of some of her later works. She also claimed that at one point during the 1980s, "God told me I was an African five hundred years ago and that's where I got these things from."

Her masks made from found objects —several examples of which are in the Gitter-Yelen collection (cat. nos. 52, 53, 54)—may have been inspired by illustrations of ceremonial masks she saw in books on African art, but they also recall those "faces in the wall" that had mysteriously comforted her in the troubled times that saw her emergence as an artist. Like the root sculptures she exhibited widely during her last years, these works reflect the material resourcefulness and visionary sensibility that are hallmarks of Bessie Harvey's work. —T.P.

NOTES

1. Quotations and other information contained in this essay are from an interview with the artist conducted by the author on August 31, 1993.

2. Carlo McCormick, "Bessie Harvey/Cavin-Morris," *Artforum* (January 1988), no pagination.

3. Many of these visual parallels also apply to the work of Ralph Griffin. See the author's discussion of Africanisms in Griffin's work, found in the essay on Griffin in this catalog.

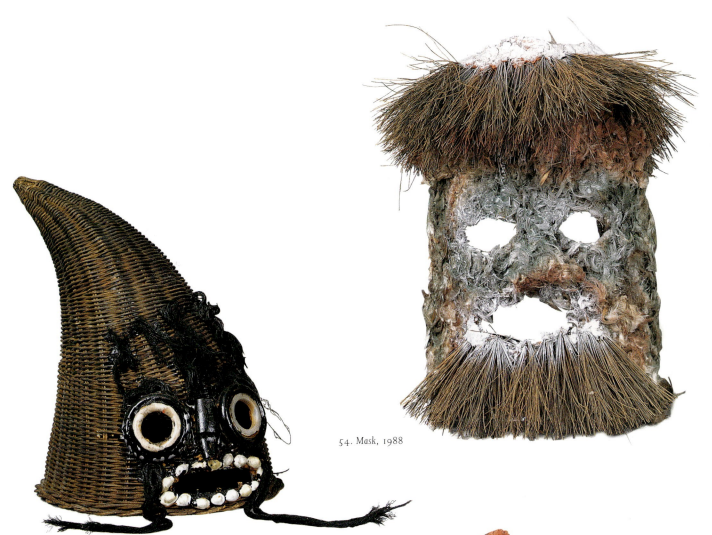

54. Mask, 1988

53. Mask, 1988

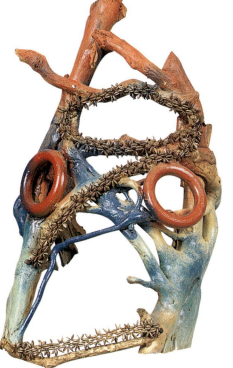

52. Mask, 1988

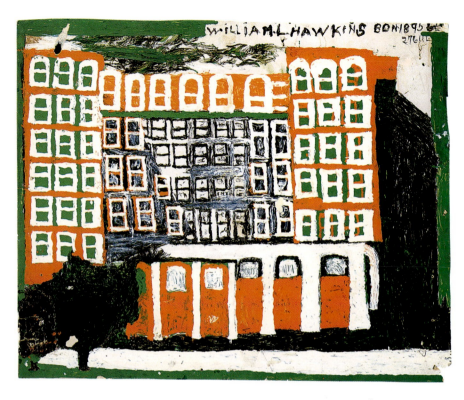

55. *Neil House No. 1, 1979*

William Lawrence Hawkins

Imagine yourself walking down a busy street in an ethnically mixed, working-class neighborhood in a large, mid-western American city. Coming toward you, in the distance, is a man. Short in stature but physically imposing, he is dressed flamboyantly. His trousers are woven in a bold, black-and-white houndstooth check. He wears a pink dress shirt with a cataract of ruffles spilling down its front, which is partially covered by a loosely flapping, black leather vest encrusted with gaudy buttons, medallions, and ribbons. Loops of beads and shells are strung around his neck and swing in response to his easy, loping gait. William Hawkins is coming your way. Instead of wearing the enormous, embroidered green sombrero that Hawkins reserved for special occasions, he has chosen this day to don a dark cloth cap covered with pins and coins that flash in the sunlight. As if this cos-

tume were not enough to make him stand out, he wears a pair of high-top work boots, which he has just painted with a brilliant orange-red gloss enamel. These steadily moving "points of flame" illuminate his every step, evoking the presence of a being not of this earth. That he is indeed "one of us," however, is confirmed by the friendly greetings of automobile drivers who pass him on the street, of women carrying bags of groceries and children coming home from school—all of whom know William Hawkins and greet him warmly, and sometimes stop to pass the time of day or to cadge money from him. He returns their greetings with a big, tooth-less smile, a shout of recognition, or a lift of the arm in salutation.

Hawkins died in 1990. When he was still alive, his round, wrinkled face and pale brown eyes shone with friendliness. He was a warm, affable man, intelligent

and possessed of vast life experience, which included military service in World War I and innumerable jobs thereafter. Conversing with him, one listened attentively to his interesting, vernacular, often highly seasoned but always cordial speech, delivered in the soft drawl typical of rural Kentucky, where he was born. Hawkins's hearing was astonishingly sharp, and his eyes, even up to his death in his ninety-fourth year, needed no corrective lenses. If one spent some time with him, it became evident that William Lawrence Hawkins was a "people person," that his memory was virtually photographic, and that his love of telling stories was truly extraordinary.[1]

In short, Hawkins was humane, intelligent, colorful, engaging, imposing, and accessible. These are all words that help to describe the man, but they are also keys to a fuller appreciation of his art.

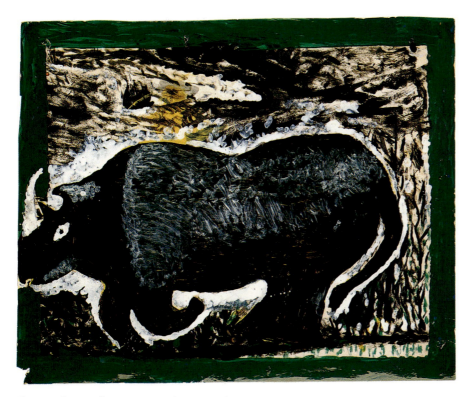

Rhinoceros (verso of cat. no. 55, Neil House No. 1), 1979

In the nine years following his introduction to the American art public in 1981, William Hawkins produced more than five hundred pictures that established him as one of the premier artists in the field of contemporary self-taught art. In a very brief time, Gitter and Yelen have assembled what is a remarkably comprehensive representation, both historically and with regard to subject matter, of William Hawkins's paintings. These paintings are excellent specimens for revealing a great deal about the artist's working methods—his artistic techniques and his materials—because the quality of this collection is so high. In fact, most of the paintings must be counted as masterpieces of Hawkins's work.

Aspects of these paintings help to explain them specifically and also to describe the artist's achievement generally. First, Hawkins, almost without ex-

ception, worked from commercially printed images clipped from magazines, newspapers, brochures, posters, and the like. He did not create his own compositions, nor was he a "memory painter." Second, Hawkins had a love of life and the gift of vividly recalling events, and without attempting to illustrate them (as a memory painter might), he monumentalized his experiences and thoughts by a kind of "pictorial association." Third, the artist was a consummate adapter and restless innovator—he delighted in coming up with new combinations of colors, surface effects, or mixed-media strategies. Furthermore, in his earliest works he used paints and supports that he found or retrieved from piles of trash. He believed in recycling long before it became fashionable, and he was frugal in his working methods. Thus it makes sense that, even after he began enjoying an income from his art, Hawkins never

quit his daily rounds of dumpsters and curbside discards, looking for interesting materials he could use in his artwork.

A number of these features are illustrated by two versions of one of Hawkins's favorite subjects—the historical Neil House hotel, which once graced downtown Columbus, Ohio. Both paintings are from 1979 and represent the first phase of his artistic development.[2] Each was painted on a sheet of thick paper that Hawkins scavenged from junk heaps. The original illustration on which Hawkins based these pictures has been lost, but it seems most likely that it was an ordinary black-and-white newspaper photograph of the hotel facade. This would not seem to be the kind of image that would fire the imagination of an artist, but Hawkins had lived for a long time in Columbus (from 1916 to his death in 1990) and had spent many of those years driving delivery trucks

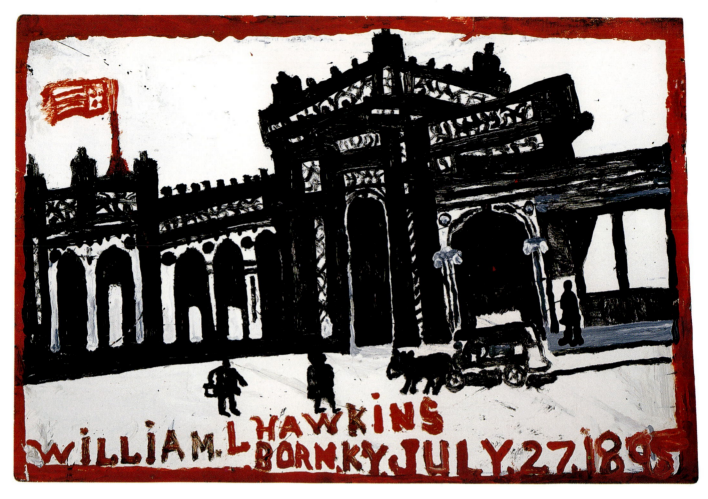

56. *Union Station*, 1982–83

around the city. To improve his expertise as a driver, he frequently took long walks through the city to learn its streets. He often delivered coal to Neil House and counted the custodian as one of his friends. It was natural that the impressive Neil House became an "old friend" as well, so that painting its portrait was Hawkins's way of conjuring up old and precious memories of times past.

Neil House No. 1 (cat. no. 55) and *Neil House No. 2* (also in the Gitter-Yelen collection but not included in this exhibition), both dated 1979, are typical of Hawkins's early paintings. Each was executed with a limited palette, most certainly dictated by whatever paints he happened to have on hand. Each picture is distinctive in the interpretation of such architectural details as the windows, no doubt reflecting Hawkins's often asserted

dictum that one should never repeat oneself, that people wanted variety, so every painting should "catch the eye." Throughout his career, Hawkins's palette and compositions were informed, not by any interest in documenting local color, but by his desire to astonish his audience with spectacular pictorial effects.

In both of these versions, Hawkins must have swung the facade of the Neil House parallel to the picture plane. It is unlikely that the original illustration was such a head-on shot, since in these paintings Hawkins included an abbreviated reference to the right flank of the building in "sharp perspective." In *Neil House No. 1* this fragment includes five rows of windows, while in *Neil House No. 2* it is a simple, solid black shape. Although comparison of the facades indicates that both paintings derived from the same

photograph, Hawkins has varied the renderings. One can almost sense the decision-making process as the artist worked out the vertical and horizontal details and structural arrangements for each picture.

The ease with which the attentive observer can trace much of Hawkins's artistic procedures is a feature of all his work. He was most comfortable developing architectural views that flattened space and expressed details in rhythmic patterns, as he did in *State Capitol*, 1982–88 (in the Gitter-Yelen collection but not included in this exhibition), and *Peco Food Bar No. 2*, 1985 (cat. no. 59). Certain other studies presented unique opportunities of expression, such as the remarkable, bold rendering entitled *San Francisco Golden Gate Bridge*, 1986 (cat. no. 62). This painting includes details

that provide an important insight into how Hawkins converted images to serve his intentions. Across the horizontal center of the composition, curving boldly from one side of the painting to the other and virtually cutting it in half, is a broad, black arc decorated with a series of white Xs; the crossings and arms of the latter are often given black dots.

A first reading of this part of *San Francisco Golden Gate Bridge* suggests that it represents a structural element of the bridge; the Xs would then be understood as diagonal braces riveted or bolted in

place. In fact, in the original illustration these Xs are phenomena created by photography; they are simply very slender rays of illumination from the bridge lights. Hawkins, who had worked for decades driving supply trucks to construction sites and was familiar with all stages of building, must have felt compelled to give the romantic photograph greater strength and a sense of the dramatic by adding something from his store of technical expertise. The result of this and other pictorial strategies in *San Francisco Golden Gate Bridge* is the conversion

of the ordinary into the extraordinary— something that Hawkins did throughout his artistic career.

Hawkins's painting *Union Station*, c. 1982–83 (cat. no. 56), is one of his interpretations of another downtown Columbus landmark, the large railroad terminal designed after a Roman building. In this painting, Hawkins was to some extent willing to stay with the two-point perspective of the original illustration. However, one senses that the artist was a bit uneasy with this academically "correct" arrangement: He has rendered

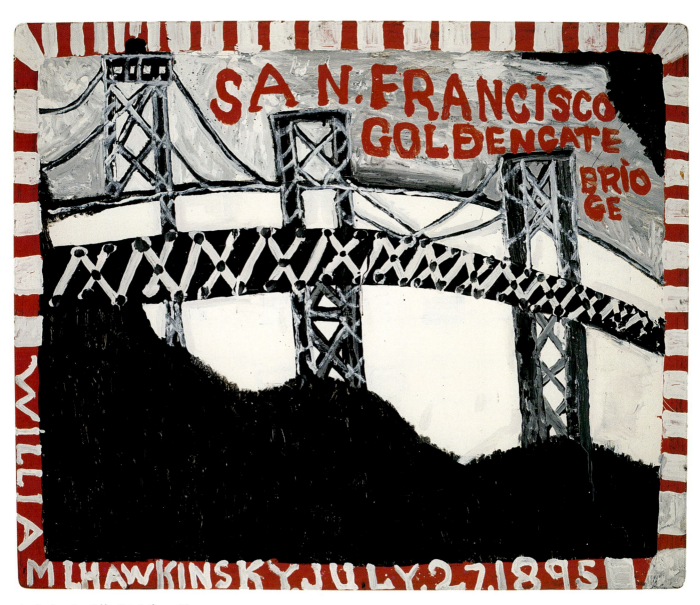

62. *San Francisco Golden Gate Bridge*, 1986

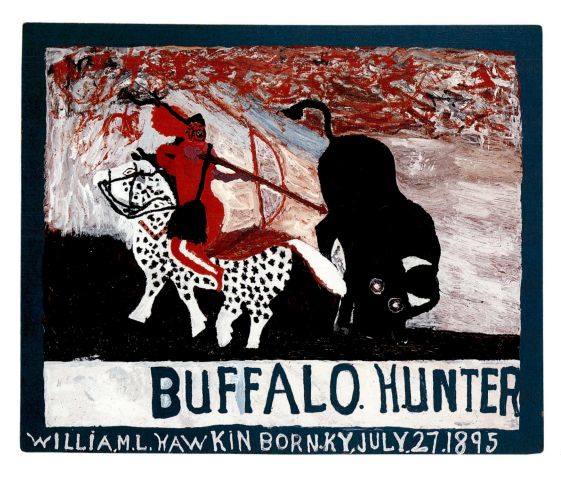

57. Buffalo Hunter No. 2, 1985

60. Alligator and Lovers No. 2, 1985

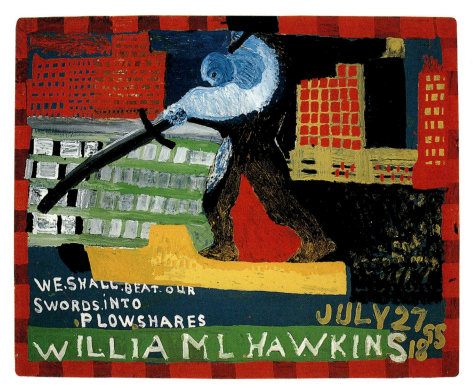

58. *Swords into Plowshares*, 1985

some sections of the structure more or less frontally, while he did not do so with others. Curiously, this "lack of resolution" imparts to the whole a highly satisfying energy that is a hallmark of Hawkins's most compelling pictures.

Hawkins's history paintings are typically derived from images illustrating events from the Wild West. Over a ten-year period he completed seven versions of his *Buffalo Hunter*, all of them based on an illustration of a mid-nineteenth-century painting by an anonymous artist.[3] *Buffalo Hunter No. 2*, 1985 (cat. no. 57), a striking composition in black, white, and red, features the artist's unique rendering of sky, scumbled in what I call his Jackson Pollock technique. The artist successfully conveyed the drama of the moment, but his depiction of the wide-eyed buffalo lends a note of humor to this composition.

Speaking of humor, there is something about Hawkins's painting *Puma Kitten*, c. 1985–86 (cat. no. 61), that borders on the outrageously amusing. The artist was delighted by a *Smithsonian* maga-

zine cover photograph,[4] probably taken at night, that captures this creature peering at the camera. The image is captioned, "Two-month-old puma kitten in Utah takes a curious look at its wild world," a brief story line that must have delighted the artist. Hawkins loved animals and believed that if man respected their nature and treated them accordingly, man and beast would exist in harmony. He gave many vivid accounts of his dealings with farm animals; his knowledge about feeding, milking, training, and slaughtering seemed encyclopedic. Many times he described how he observed and learned the habits of wild animals so he would be more successful in trapping them. Hawkins was fond of comparing himself with felines, which he admired for their intelligence, quickness, and independence. When he decided to paint *Puma Kitten*, he wanted to express the alertness and cunning of the creature. He enlarged the page-size image to a monumental scale, and by emphasizing its eyes and ears and by intensifying its coloration, he came up with a face

that is almost human, even clownlike; it really is difficult to be intimidated by this particular feline. To give the cat great presence, Hawkins built up the creature's face with a modeling paste that he devised by combining cornmeal and enamel paint. A dusting of glitter gives the work a sheen that is almost magical.

Hawkins also painted many representations of elephants, beasts whose size, power, and intelligence he admired. Gitter and Yelen's *Elephant*, c. 1988–89 (cat. no. 64), created toward the end of the artist's life, is a remarkable composition. Painted using only black and white with touches of red, the creature fills the picture plane almost to bursting; one imagines that nothing can quite contain this immense creature. An important detail is the chain wrapped around the animal's right rear ankle: Painted in fine black lines, it resembles a fragile necklace, hardly sufficient to restrain its wearer. The futility of such a restraint is evidenced as well by the animal's ears and trunk, raised in panic or fear— details that Hawkins painted to press aggressively outward against the borders of the painting, making it clear that in the next moment the elephant would likely break loose and cause trouble. Yet, as with Hawkins's rendering of *Puma Kitten*, his *Elephant* is presented as a comical figure: For all its impressive power, it can hardly fail to amuse. Once again, Hawkins shows that he is master of his craft. *Elephant*—roughly executed, its great quantities of enamels poured directly from the can onto the panel— makes a dramatic statement about process. Just how thick Hawkins could pile paint on his pictures is apparent if one gently presses the expanse of white paint of the elephant's body: A thick pocket of paint was formed that sealed a quantity of still-fluid pigment within. This spontaneous technique, along with a limited palette and bold, graphic image, suggests the art of the cave painter.

Hawkins expressed little interest in painting religious subjects, unless he believed that they would be remunerative.

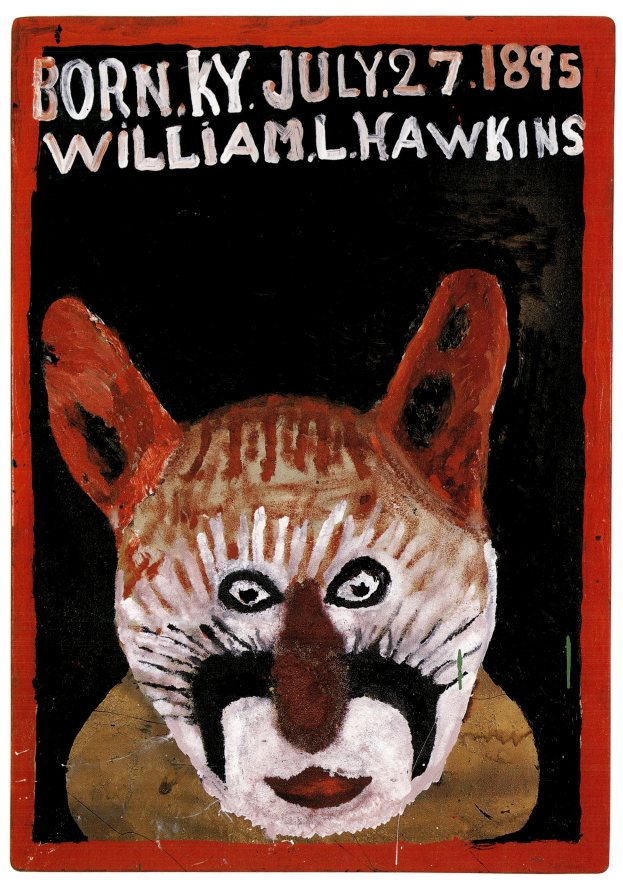

61. *Puma Kitten,* c. 1985–86

This was the case with Christ's Last Supper, for he completed at least nine versions of this subject. Hawkins had recovered from a dumpster a remarkable, framed pastiche based on the famous composition by Leonardo da Vinci, except that the modern illustrator converted the participants in the event to African Americans. *Last Supper No. 9*, 1987 (cat. no. 63), is a highly innovative collage of enamels, modeling paste, and other materials. Hawkins used miniature illustrations of real food, such as pizzas, to set the sacred supper table. Perhaps most striking is the representation of Christ; one has to ask if the artist was allowing his sense of humor free rein when he incorporated a photograph of Stevie Wonder into his depiction of this central figure.

Hawkins often departed from his usual themes—the Old West, urban settings, wild animals—when his imagination was caught by an unusual and dramatic illustration. *Alligator and Lovers No. 2*, 1985 (cat. no. 60), was taken from an article that discussed the kinds of artwork prepared for the so-called nickel weeklies, short adventure stories published around the turn of the century and printed on cheap paper. This painting illustrates a scene from a Frank Merriwell drama in which the hero saves a damsel in distress from the jaws of an alligator.[5] The boldness of the composition, with its two large areas of Jackson Pollock brushwork, is astonishing. How does he get away with such wonderful effects, time and time again?

From quite another source is the incandescent painting *Swords into Plowshares*, 1985 (cat. no. 58), which is based on a photograph of a statue of the same name, a gift from the Russian government, set up in the plaza of the United Nations complex in New York. Hawkins was struck more by the authoritative pose of the warrior-turned-peacemaker than by the political message being conveyed. (Hawkins was almost totally indifferent to politics and world events—he simply loved to take advantage of an illustration that fired his imagination and inspired him to "run away with it" in his own fashion.) The original illustration is an undistinguished photograph of no artistic merit whatever; the black-and-white halftone lacks any interesting patterns of light and shadow. In this instance, Hawkins could only have been inspired by the idea of the smith beating the sword into a plowshare; his imagination won out. Never much interested in pictorial problems such as the rendering of space, he created a composition of such flowing forms and unusual combinations of brilliant color that *Swords into Plowshares* appears to be as much an abstract painting as an illustration.

This note of artistic independence was characteristic of the man and the artist. Hawkins had an interesting relationship with "the world of art." From his earliest years he realized that, in order to get on in this world, one must always provide for oneself—there were no free rides, much less any easy paths to financial reward. For him the sale of paintings meant one thing above all else: cash in hand. He was uninterested in art history or theories about art. Although he lived within walking distance of a major museum of art, he expressed contempt for what one might see on exhibit there or elsewhere. He agreed to attend art gatherings only when he was to receive prize money or when the occasion enabled him to pay a courtesy to a fellow artist.

Hawkins regarded representational, academic painting as lacking in excitement and the feeling of "real experience." As for modern, nonrepresentational painting, his reactions were expressed in scatological terms; he saw no value in something that did not pulse with the beat of life as he himself lived it.

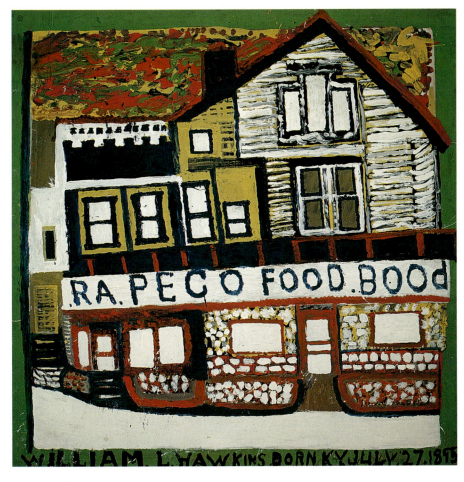

59. *Peco Food Bar No. 2*, 1985

He could not believe that a painting by Mondrian, for example, could be sold for hundreds of thousands of dollars, since for him such work lacked the resonance of human experience. He wanted his pictures to inspire wonder, his work to, as he once said, "amuse the people, show them something they'd never seen before," but also to make them want to buy it.

Hawkins could be very amusing when he spoke of the stupidity of "school-taught" artists who valued their works so highly that, rather than sell them for whatever could be gotten, they piled up numbers of finished pictures and waited for someone to give them the prices they had set. Hawkins, on the other hand, had the mentality of a true survivor.

Furthermore, Hawkins approached the act of painting without any hesitation and certainly without a trace of self-consciousness. Making pictures was for him as basic as breathing. Only a few other artists interested him; the history of art, not at all. He often spoke of the "competition out there" and loved to boast that he was "the greatest artist in the country," that he was "against those boys in New York," but this was his tongue-in-cheek way of promoting himself—the bravado that was expected in the streets. I never saw him with "artist's block." There was never a moment when he felt "out of ideas," "run dry," much less uncertain of his importance as an artist. All this was true, in spite of the very real physical peril he experienced toward the end of his life, when his afflu-ence began attracting hangers-on, some of whom would have thought little of using violence in order to exploit the artist.

In the final analysis, William Hawkins's accomplishments as a painter center on his unique gift for taking mundane, even pedestrian, images that were intended to be forgotten soon after their appearance and investing them with a transcendent vision based on direct experience and deep feeling. What is especially significant is that he evolved an easily recognizable artistic style—one can spot a Hawkins painting a mile away—yet he responded to printed images without ever locking into any single strategy of pictorial treatment. Thus each of his paintings is truly unique. It is as though every time William Hawkins began working on a picture, he was starting out for the first time. —G.J.S.

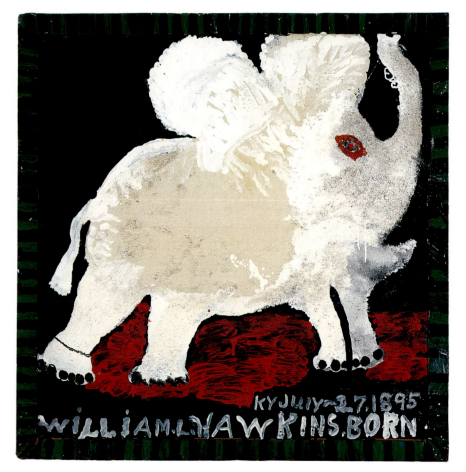

64. Elephant, c. 1988–89

NOTES

1. From 1988 until his death in 1990, I frequently visited with William Hawkins, recording his accounts of his life and documenting his art. In 1992 I completed a book-length study of Hawkins's background and artistic career. I have drawn upon my study for the information in this essay.

2. I have divided Hawkins's work into three chronological groups. In the earliest paintings he usually worked small, on very irregular supports such as plywood and paper, often using pencil and a limited palette of enamels. During the early 1980s, after his discovery by the mainstream art world, Hawkins's palette opened up enormously and the scale of his paintings increased, in some cases to monumental size. By 1986, the artist introduced mixed media into his pictures, using modeling paste, wood, metal, and other materials.

3. One of Hawkins's favorite sources of illustrations was *The Golden Book of America* (New York: Simon and Schuster, 1954). Hawkins's source for his many versions of *Buffalo Hunter* was a painting by an unknown artist, illustrated on p. 85 of *The Golden Book of America*.

4. *Smithsonian* (September 1985).

5. *Alligator and Lovers No. 2* is based on an illustration found in *The Golden Book of America*, p. 196.

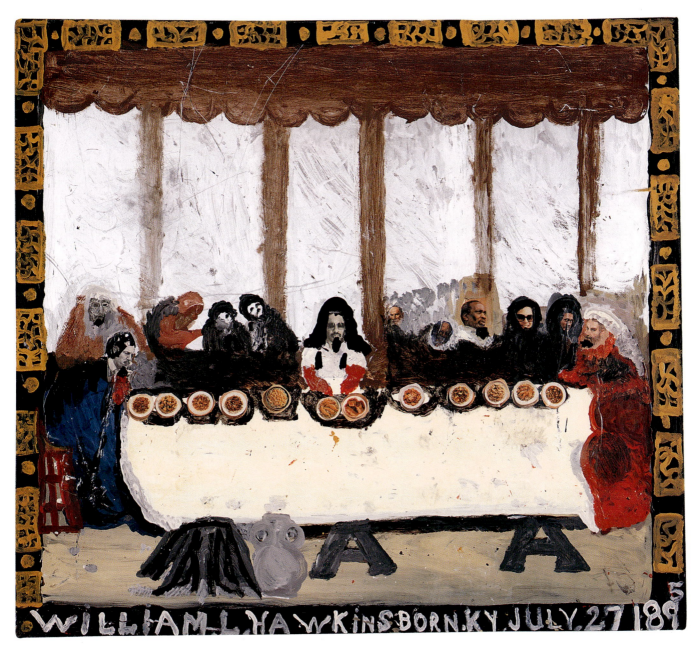

63. *Last Supper No. 9*, 1987

Clementine Hunter

Clementine Hunter's paintings and appliqué wall hangings reflect the rural plantation world she lived in and observed so closely for the 102 years of her life. Hunter was born in late 1886 or early 1887 at Hidden Hill Plantation on Cane River near Cloutierville, Louisiana. Her family left the isolated and difficult world of Hidden Hill and moved north, following job opportunities on other plantations along the Cane River.

The centerpiece of Cane River country was Melrose Plantation, acquired in 1898 by John and Carmelita ("Cammie") Henry. Miss Cammie, as she was known, took on the restoration of Melrose, its gardens, and its outbuildings with energy and determination. She had a vision of Melrose as a center for artists and writers. She wanted not only to establish a library at Melrose but also to revive local arts and crafts. Above all, "she wanted to restore the abiding sense of

place, sense of history that once belonged to the plantation."[1] In time, Melrose did become the cultural center she envisioned, hosting numerous painters, writers, and photographers.

Melrose became home to the Hunter family when Clementine was about fifteen years old, and there she began work as a field hand. Sometime in the 1920s Clementine was given new duties in the main house. Her creativity found expression through a variety of domestic tasks: She was known as an innovative and imaginative cook and an adept seamstress who made clothes and dolls for the children and pieced quilts of brilliant color and design.

An auspicious event for Clementine Hunter was the arrival of François Mignon, a writer who moved to Melrose in 1939 to work as the curator for the plantation library, collections, buildings, and grounds, a position he retained for

thirty-two years. Mignon was the first to recognize Hunter's talents as an artist, and he continued as her greatest mentor, admirer, and friend until his death in 1980.

Hunter's creativity was fostered by the artistic climate and circumstances offered by Melrose. In about 1940, taking advantage of some discarded paint, she created what is regarded as her first painting. She showed the work to Mignon, who was immediately struck by her ability. From that time forward she began to paint as much as time and materials would allow. She painted on anything she could find—cardboard, scraps of lumber, paper bags—her painting supply dependent on discards from Melrose's visiting artists. Mignon recognized her need for supplies: "She painted constantly," he wrote, "constantly. You couldn't stop her. It was terrible because at that time she didn't have any money."[2]

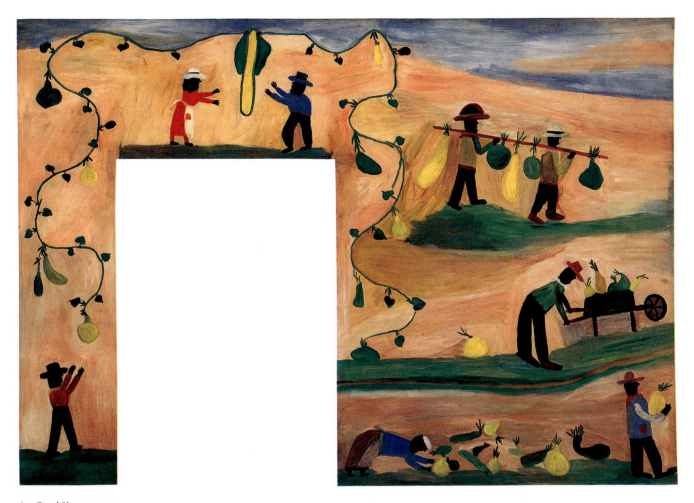

65. *Gourd Harvest, 1955*

This compulsion to paint is recorded by many of her friends. Mignon wrote of her long days working in the Big House, returning to her home with washing and ironing to be done that night, caring for her ill husband, Emanuel, and then beginning to paint, sometimes at midnight. Mignon recalled seeing Hunter up all night, sitting beside the dim glow of an oil lamp, caring for Emanuel, and painting. Collectors and friends Robert and Yvonne Ryan wrote: "Clementine relates how, once, in the wee hours of the night as she was painting, her husband called from bed to say, 'Woman, if you don't stop painting and get some sleep, you'll go crazy.' 'No,' she replied, 'If I don't get this painting out of my head I'll sure go crazy.'"[3]

James Pipes Register, an Oklahoma-based writer who, along with Mignon, provided the needed support for Hunter's artistic career, wrote: "Evidently the long hours of the workday instilled in Hunter little need for sleep or rest. 'I don't like to sleep much. . . . I sleep a few hours, then lie there thinking about pictures, so I get up and start painting pictures.'"[4]

Register sent small amounts of cash, boxes of paints, brushes, art paper, and other gifts to Hunter and her family. In 1945 he secured for her a grant from the Julius Rosenwald Foundation. Register and Mignon became the primary collectors and promoters of her work, securing exhibitions, reviews, sales, and national recognition.

Hunter painted the world around her, and home was the central place in her life; she rarely left her native Cane River. She painted landscapes, scenes of work and leisure, religious scenes and ceremonies, and a series of abstract paintings based on an exercise devised by James Register.

The large painting *Gourd Harvest, 1955* (cat. no. 65), illustrates Hunter's mastery as an oil colorist. The pinks of the background blend with the yellow and green, giving the effect of watercolor. In the early years, when painting supplies were especially scarce, Hunter would stretch her paint as far as possible by thinning it with turpentine. As a result, many of her oils have some of the transparent qualities associated with watercolor. Hunter's restrained use of bright blue, red, and yellow gives the scene sharpness and energy. The impact of the work is derived from the color and the overall pattern created by the stacked figures and the meandering vine that carries the eye through the composition.

66. *Quilt, Melrose Plantation, c. 1960*

A letter, written by Mignon and attached to the back of the panel, reads: "Cane River Gourd Harvest, painted by Clementine Hunter on October 23th [sic] and 25th, 1955. The figures are Cane River charters [sic] such as S[mith?] Peace and his wife over the door, reaching for the prize gourds, Willie Brown at the wheel barrow, etc. This panel and the accompanying one of gourd gathering are the personal property of François Mignon." The support used for *Gourd Harvest* is large and is an excellent example of Hunter's ability to take a discarded panel and compose a scene that fits it successfully. This panel was painted the same year Hunter painted a series of murals for the African House on the grounds of Melrose. The house dates to around 1800, when former slave Marie Thérèse Coincoin (b. 1746) owned the plantation; either she or one of her sons built the two-story structure with plantation-made brick and thick cypress beams. Massive eaves extend ten feet beyond the exterior walls, giving the structure its distinctive appearance. It is believed to have been designed after the West African huts known to Marie Thérèse. Along with Melrose and Yucca House, African House is often included in many of Hunter's paintings and appliqué quilts.

In the quilt, or appliqué wall hanging, Hunter made about 1960 (cat. no. 66), Melrose Plantation is placed in the center, African House at the top left. On the top right and bottom left is Yucca House, which may predate African House and may have been the first house on the plantation. A female plantation worker is depicted at the lower right.

This piece, like other appliqué examples by Hunter, is technically not a quilt, as it does not have a cloth backing or batting (filling). In this case the appliqué is stitched to a backing of brown wrapping paper (bearing the address "Clementine Hunter / General Delivery" and a sixty-cent stamp) and a bag that once contained "steel-cut poultry chops." Fabric is wrapped around cardboard to form the body of the female figure. A bit of cotton is tucked in the red scarf, and small embroidery stitches delineate the eye. Hunter did make pieced quilts that are backed, have batting, are quilted, and seem to have been made as bed quilts. It is not clear whether the appliqué works were intended for the bed or the wall.[5]

The artist did not sign her paintings in the early 1940s, although some were signed "Clemence," her given name (she later changed it to Clementine), by James Register between 1944 and 1947. By 1949 she was signing her initials herself. A decade later she reversed the signature to ƆH, stating that she did not want her work to be confused with other women of Melrose who had the same initials (Cammie Henry and her daughter-in-law, Celeste). In the mid-1970s the artist began moving the Ɔ into the H until it became superimposed completely.

Clementine Hunter's paintings and quilts are joyous and imaginative. While she painted what she knew, her work represents more than a desire to paint memories of Louisiana plantation life. She once said she didn't want to paint flowers she looked at because God made flowers grow in her own mind and she wanted to paint them, not the ones that merely grow in the ground. Her distinctive approach to perspective and her intuitive sense of color and design give her work freshness and energy. She was compelled to paint, to create, and this spirit is evident in the best of her work.

—G.A.T.

NOTES

1. James L. Wilson, *Clementine Hunter: American Folk Artist* (Gretna, La.: Pelican Publishing, 1988), p. 22.

2. Ibid., p. 2.

3. Robert Ryan and Yvonne Ryan, "Clementine Hunter," *Louisiana Life* (September/October 1981): 36.

4. Quoted in Wilson, *Clementine Hunter*, p. 29.

5. Eva Ungar Grudin, *Stitching Memories: African-American Story Quilts* (Williamstown, Mass.: Williams College of Art, 1989), p. 30: "Some who knew her say Clementine used these as bedspreads, though others contend that they are pictures in cloth and were intended as wall hangings."

Rev. John L. Hunter

Rev. John L. Hunter of Dallas, Texas, is a self-taught wood-carver and an ordained minister. At ninety years old, he is still working hard at both vocations.

Hunter was born in 1905. His father died when he was an infant, and he lived with his grandparents in Taylor, Texas, until he moved to Dallas with his mother in 1918. He attended a Catholic school there and later married; his wife, Ruby, was also from Taylor, Texas. He worked for fourteen years as a general assistant at the Cotton Exchange, a drugstore in downtown Dallas, before he received his calling from God.

Hunter decided to become a Baptist preacher in 1936. He attended Southern Baptist Training School in Austin and took a few extension courses from Bishop College in Dallas. Not long after finishing school, Hunter moved his family to Texarkana and then to Sherman, Texas, where he spent eight years as pastor of a church. In 1962 the Hunters returned to Dallas, and for more than thirty years, Rev. Hunter has served as senior pastor of the True Light Baptist Church on the city's south side.

Hunter doesn't recall being especially interested in art as a child, and he never received any formal art training, but he always had a knack for making utilitarian items like a television stand, a nightstand, and shelves for his home.

His art career began as a hobby in the late 1960s or early 1970s, when he began carving small figures to give to various members of his congregation. The church members liked his carvings so much that they encouraged him to make more.

Given that Hunter has been a minister for more than fifty years, it is surprising that most of his carvings are not religious images. Hunter carves animals, birds being confronted by lions or tigers, Santa Claus figures (often complete with small trees sprouting out of their sacks), fishermen with poles and dangling fish, Statue of Liberty figures, and humorous treatments of drunkards, some slouched against lampposts. Of the religious subjects he does treat, his favorites are Adam and Eve, the Crucifixion, David and Goliath, angels, and red figures burning in hell. Most of his sculptures are moderate in size—eight to twenty inches tall—but recently he has made many life-size carvings from felled trees.

Hunter prefers to use found wood of any variety, and he carefully selects pieces in which he can visualize an image that he wants to bring out. He uses simple tools: a saw, a knife, sometimes a drill. Often leaving a great deal of the wood intact, Hunter makes only the most necessary cuts in order to shape the image. Almost all of his sculptures are assembled rather than carved from just one piece of wood. He adds the arms, feet, or other appendages by nailing or gluing separate pieces of wood to the main structure. Hunter uses his own "secret sauce"—a mixture of glue and wood shavings—to affix the appendages to the body. Some extra details, such as women's skirts and hair, are often modeled with the same substance, allowed to harden, then painted along with the rest of the sculpture. Each carving of a man or woman is made from a Y-shaped piece of wood inverted to form the trunk and legs; he doesn't attempt to carve perfectly straight legs from the wood but leaves it as is, except for painting it. The crooked legs account for the whimsical, often animated appearance of his human figures.

Using mostly house paint and some enamel, Hunter paints his sculptures with bold, pure colors, never mixing or blending unusual shades. The eyes of his sculptures are often made from screws, and the hair is sometimes his own or Ruby's. Hunter is familiar with woodburning and uses this technique to create mouths, eyebrows, tigers' stripes, or lettering and to sign his initials or his name on the carvings. He does not use a standard woodburning tool, but instead uses ice picks heated in the flames of his kitchen's gas stove. Hunter prefers to work outside in his yard or in his studio, a small workshop attached to his garage. It usually takes him one or two days to complete a sculpture, and he often has several in progress at one time.

—D.G.R.

67. Standing Figure of Man, 1990

Clyde Jones

Clyde Jones's art is born of the industriousness and ingenuity that are essential skills for those who live close to the land. Raised on a small North Carolina farm, Jones has spent most of his life working outdoors. In 1956, while still in his late teens, he moved with his family to the small community of Bynum, North Carolina, where he and his father took jobs in a textile mill on the banks of the Haw River. The younger Jones soon realized that he didn't like spending his days inside a noisy factory, but financial necessity kept him at that job for six years. In the early 1960s he left the mill to take the first of several outdoor jobs. He was employed as a construction worker, a day laborer, and a logger, but an accident in 1979 brought a tree down on one of his legs, breaking it in several places and putting him out of commission for an extended time.

It was at this point that Jones began the activities that would eventually bring him to the attention of the art world. Unaccustomed to being idle, he started using the tools and materials of his various trades to create sculpture. His first inspiration was a tree stump whose shape reminded him of an animal. He highlighted this resemblance by carving up some smaller scraps of timber with his chainsaw and nailing them onto the stump to form legs. To keep himself busy,

68. *Two Guys on a Car*, 1988

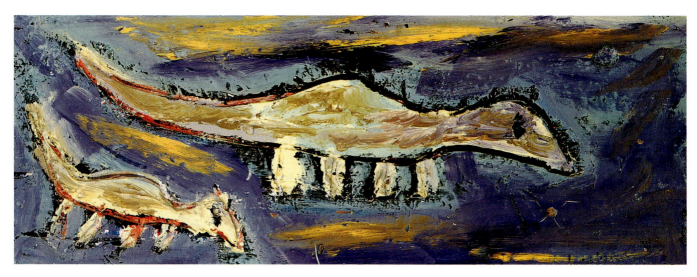

69. *Two Dinosaurs*, 1990

he scavenged a few more zoomorphically suggestive logs and stumps and made several more of these rough-hewn creatures, which he displayed in his yard. Both his parents were deceased by this time, and he was living alone in the mill house he had occupied since moving to Bynum, so there was no one to discourage him from cluttering up the place with his fanciful sculptures. By the time he regained full mobility, he had a number of these "critters," as he calls them, and they gave him the distinction of having the community's most unusually decorated yard. The neighbors began good-naturedly referring to his place as a zoo, and they tagged him with the moniker "Jungle Boy."

To further amuse himself and his local audience, Jones started embellishing his sculptures by painting them and attaching a variety of found objects to them. Old tennis balls and plastic flowers became bulging eyeballs; a rusty mattress

spring served as a coiled tail. He found similarly ingenious uses for wine-bottle corks, industrial thread spools, surplus plumbing fixtures, film canisters, bicycle reflectors, and other assorted items. In the early 1980s, word of his eccentric slapdash menagerie spread beyond Bynum, and the owners of a trendy restaurant in nearby Chapel Hill acquired several of his critters to display on the roof of their building. Examples of his work were included in art exhibitions in Winston-Salem and Raleigh, and these led to other showings of his sculptures in North Carolina and elsewhere. By the late 1980s Jones had expanded his repertoire to include painting. His work in this medium also focuses on animal imagery, invariably rendered in an expressionistic style on slabs of plywood or other wood-based boards. His painting of two small dinosaurs (cat. no. 69) is fairly typical of these works. In recent years Jones has also begun to sculpt

human figures, such as the two who share a compact convertible in *Two Guys on a Car*, 1988 (cat. no. 68).

Despite the attention his work has received during the past fifteen years, Jones rarely sells his sculptures or paintings, preferring to display them around his home or give them to children. His small yard in Bynum now contains hundreds of his pieces, which spill into his neighbors' yards and crowd the edge of his street. — T.P.

Shields Landon Jones

The cultural traditions of southern Appalachia are the main influences that inform the art of S. L. Jones, who has spent his entire life in the mountains of West Virginia. Born in 1901 in the community of Indian Mills, he and his twelve siblings grew up on a small rural farm that his parents worked for an absentee owner. His father also worked as a lumberjack and was skilled at making things with his hands, as most farming people had to be in the early years of this century.[1]

In addition to the other skills that he came by as a part of growing up where he did—skills such as hunting and trapping animals and foraging for ginseng and other wild herbs—Jones also learned to play old-time, mountain-style music on a fiddle that he acquired in trade for his shotgun. He threw himself wholeheartedly into fiddling, and he won first place in a competition before he was twelve years old. But as passionate as he was about it, music wasn't his only artistic interest. While still a child he taught himself to sculpt pieces of wood with his pocketknife, and he would often carve small bird and animal figures in his spare time.

Jones was interested enough in animals that he dreamed of becoming a veterinarian someday, but his family's lean economic circumstances discouraged him from pursuing a career that would require an expensive education. Instead, he left school after finishing the eighth grade and, while still in his teens, went to work on a construction crew with the Chesapeake and Ohio Railway Company, the beginning of his nearly fifty years with C&O. Early in his tenure with the company, in 1923, he married Hazel Boyer. They eventually had four children and lived together for more than forty-five years, until she passed away. By this time their children were grown and living elsewhere, and Jones had been re-tired for several years, so he suddenly found himself alone and unoccupied.

Jones, like many other self-taught artists, found that leaving a full-time job and experiencing long hours of unaccustomed solitude fueled his work as an artist. As a kind of self-prescribed therapy for his grief and loneliness, he turned to the creative activities that had given him such pleasure in his youth. He picked up his fiddle again and began entertaining himself with the old-time tunes he had learned so long ago. He also started carving wood again, but with far more time to devote to this old hobby, he began to refine his technique and create larger and more detailed pieces. Soon he was sculpting life-size human heads and fully articulated standing figures that were sometimes three or more feet tall. Although he originally made these humanoid sculptures as stand-ins for the real human company that he missed, he continued to create them after he remarried in 1972. During the 1970s he often displayed and sold his work at crafts fairs in his area and in the gift shop of a nearby state park, and this exposure eventually led serious collectors of folk and self-taught art to his door.

Three Musicians, c. 1975–78 (cat. no. 70), is one of Jones's most elaborate and ambitious pieces; it is of particular interest because it illustrates his other favorite artistic activity—playing string-band music. The features and postures of these musicians are typical of Jones's humanoid figures. Each one stands ramrod straight and has distinctive, sharply defined facial features. Dominating the trio, at more than three and a half feet tall, is the blue-suited banjo player, and in this connection it's worth noting that Jones's father played a banjo, which Jones remembers watching him make by hand sometime around 1907. The artist has said that his figural sculptures "aren't of anyone in particular," but it's still possible that he was thinking about his father, at least subconsciously, when he created the banjo "picker."[2] It's also worth pointing out that the smallest of the musicians is the one holding the fiddle—Jones's own instrument—as if the trio represents his father, himself, and a young guitar-picking friend playing music together during the old days.

Unfortunately, in recent years Jones has suffered health problems that have severely curtailed his wood-sculpting activities. As he nears the century mark in his long and productive life, he lacks the physical strength and control that enabled him to deftly handle and carve wood as he once did, but this hasn't meant the end of his artistic career. At this writing, late in the summer of 1995, he continues to produce small pencil drawings whose subjects are clearly related to those he once depicted so vividly in wood.

—T.P.

NOTES

1. Biographical information for this entry is drawn from Ramona Lampell, Millard Lampell, and David Larkin, *O, Appalachia: Artists of the Southern Mountains* (New York: Stewart, Tabori, and Chang, 1989), pp. 30–33; and Chuck Rosenak and Jan Rosenak, *Museum of American Folk Art Encyclopedia of Twentieth-Century American Folk Art and Artists* (New York: Abbeville Press, 1990), pp. 166–68.

2. Lampell, Lampell, and Larkin, *O, Appalachia*, p. 30; Rosenak and Rosenak, *Museum of American Folk Art Encyclopedia*, p. 167.

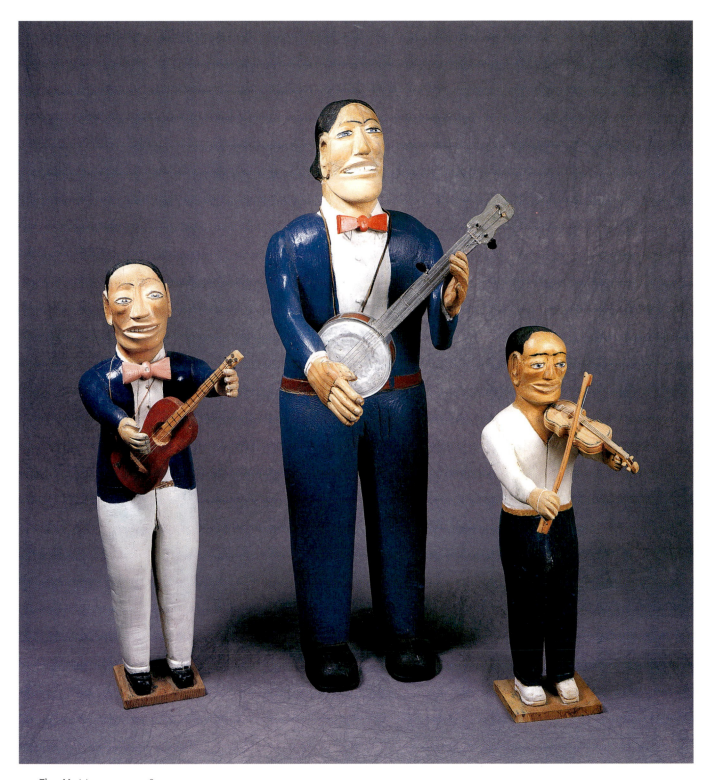

70. Three Musicians, c. 1975–78

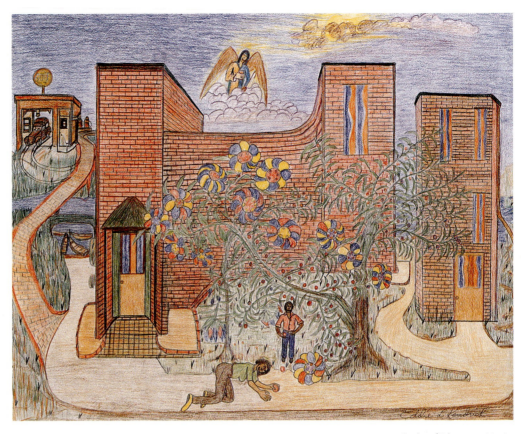

71. *Garden of Eden*, c. 1988–89

Eddie Kendrick

Eddie Kendrick's work appeared on the art scene only recently. Born in Arkansas in 1928, he was a deeply religious man who painted and drew numerous highly inventive, didactic visionary pictures.

Eddie Kendrick's *Garden of Eden*, c. 1988–89 (cat. no. 71), and *Ascension to Heaven*, c. 1991–92 (cat. no. 72), demonstrate a remarkable shift in the artist's style over a two- to three-year period. The earlier work, *Garden of Eden*, depicts an imaginative scene dominated by a large tree placed near the center of the composition's foreground. From its roots and trunk, firmly embedded in the earth, extend a complex of branches bearing green leaves; small, bright red fruits; and enormous, varicolored flowers. A man stands under the tree, looking down at a woman who is on her knees retrieving one of the fallen fruits. Both people are in modern, casual dress. Behind the two figures is a large, modern-looking build-

ing of unusual shape. To the right is a smaller building of more conventional form. In the upper left, a gas station is depicted; a road leads from it down to the roadways and paths that surround the two other structures. Two of the buildings are meticulously patterned to indicate that they are constructed of bricks. In the sky, hovering over the scene, is the figure of an angel.

Kendrick fashioned this curious, contemporary restatement of one of the great events of the Old Testament by using a pencil, a straightedge, and a compass to create a composition of geometric precision, which he then carefully colored in with crayon. The back of the paper is scored deeply, indicating that Kendrick applied great pressure to his pencil. There is no evidence of any corrections, erasures, or changes.

This seems to be the work of a person who knew precisely what he wanted

to achieve and had full control over his media to bring his idea to completion. The low-keyed color, never strident or out of control, gives to *Garden of Eden* a peaceful, confident aspect, suggesting that to Kendrick the world is in a state of balance, overseen by a benevolent spirit.

I view Kendrick's *Ascension to Heaven* as the work of a very different state of mind. The skyline of a city, drawn along the bottom of the picture, forms a base for an expanse of evening sky above. Dominating the sky and the center of the picture is an airplane that looks very much like a spacecraft. Its nose lifted toward the upper left, it is preparing to "ascend to heaven." In an interview, Kendrick remarked on this mode of celestial travel, observing that "Jesus is my airplane and he'll never let me fall. He'll pick me up in an airplane on Judgment Day."[1] The care and technical precision used to execute *Garden of Eden* have been replaced by

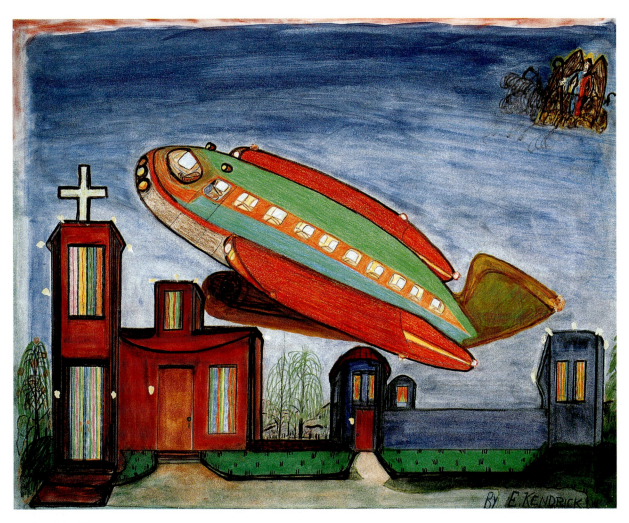

72. *Ascension to Heaven*, c. 1991–92

intense, glowing color that, with its contrasts of lighting, creates a baroque visual drama. Using a variety of media—ink, crayon, colored pencil, and watercolor —Kendrick worked swiftly, expressionistically, almost erratically, as though he feared that, if he hesitated, he would lose his inspiration. *Garden of Eden* seems firmly linked to the earth, to worldly existence. In *Ascension to Heaven* the perfunctory, almost begrudging, reference to material existence in the city skyline defers to the spectacular metaphor of transcendence

to the heavenly realm above. Once again an angel motif—a constant in Kendrick's pictures—oversees this event from the upper right corner.

Eddie Kendrick died in 1992, the year he completed *Ascension to Heaven*. With this painting Kendrick was clearly engaged in a mode of inspiration that was quite different from the tranquil, even meditative aura of *Garden of Eden*. One wonders what his inner eye was experiencing just then. —G.J.S.

NOTE

1. From Alice Rae Yelen, *Passionate Visions of the American South: Self-Taught Artists from 1940 to the Present* (New Orleans: New Orleans Museum of Art, 1993), p. 138. This quote was taken from an interview with Kendrick conducted by Kurt A. Gitter in November 1992, the month of the artist's death; see notes, p. 143, to the chapter "Religious and Visionary Imagery," by Alice Rae Yelen (pp. 135–44). The catalog includes a biographical entry on Eddie Kendrick on p. 316 and another, brief reference on p. 49. I have also consulted an article on Kendrick published in the *Arkansas Gazette*, March 13, 1977.

Charles Kinney

Charley Kinney was born on May 30, 1906, at his parents' home on Toller Branch (near Vanceburg) in northeast Kentucky. Sometime before 1912, his family relocated, about a tenth of a mile on up Toller Hollow, to the farm where he lived for the rest of his life. Life on the farm followed the ways of his ancestors who had migrated to Kentucky from Ireland during the nineteenth century.

Measured against the home comforts of the late twentieth century, this lifestyle seems hard, but in many respects it was a harmonious one: hard work that afforded a living based on respectful coexistence with the natural environment. Charley's early life was so thoroughly integrated into his being that it served as his reference point and provided the central source for his subject matter as an expressive artist later in life.

When Charley was a child, his father, Frank, taught him the essential skills of subsistence farming: how to grow fruit, vegetables, and corn, and how to raise cows, hogs, chickens, and ducks as well as tobacco as a cash crop. He also learned how to hunt the surrounding hills for wild game—deer, raccoon, squirrel, rabbit, grouse, pheasant, quail, and dove. He fished, trapped turtles, and gigged frogs. His younger brother, Noah, recalled that in their childhood, before the proliferation of the "fast-shooting rifle,"

wild fowl and game were abundant and easily snagged.[1] Life on the farm also taught Charley how to build fences, houses, and barns and to accomplish a host of other tasks that were useful in this isolated, self-sufficient way of life. His life was rooted in an oral tradition, in which time-tested methods were passed on from one generation to the next. There was human continuity in these skills, and Charley relied on them all his life, participating only minimally in the mainstream economy.

Charley Kinney was born with a birth defect, pectus excavatum, or an abnormally concave chest.[2] Today the defect would be surgically corrected in childhood,[3] but in 1906 no such remedy was available. Lacking normal upper-body strength, he adapted his stance to the task at hand. To lift a bale of hay, for example, he rested it on his thighs to help bear some of the weight. Whether or not his disability and the constant innovations it required helped to nurture his innate creativity, Charley's artistic bent showed itself early. When he was just a child, he demonstrated a creative energy that he exercised in a variety of ways until his death on April 7, 1991.

Despite his disability, Charley spent most of his life working on the family farm in partnership with his brother, Noah. Though they later acquired a trac-

tor, for many years they farmed with horses.[4] It was a life of hard work, dictated by the changing of the seasons and the rising and setting of the sun. Stewardship of the farm cultivated Charley's appreciation for the forces of nature. Largely free from the distractions of the world outside, he developed a level of knowledge and understanding which may now be impossible to accrue and which bred in him a reverence for nature, later a driving force in much of his art.

As was common at the time, Charley attended school for about three years and learned to read and write, but he was a reluctant student. When not roaming the hills playing hooky, he spent much of his school time drawing pictures. His teacher tried to discourage him, telling him that he wouldn't make any money because no one would be interested in his art. "She tried to stop me, but she couldn't. . . . [laugh] . . . I went ahead anyway. They didn't care whether you went to school or didn't go."[5]

As a young man, Charley left home to work as a farmhand some miles away. He received food, modest wages, and a place to stay, but after a short while he returned home and resumed the family farming routine. A resourceful man, he baked and sold pies and cut people's hair on the front porch of the family's log

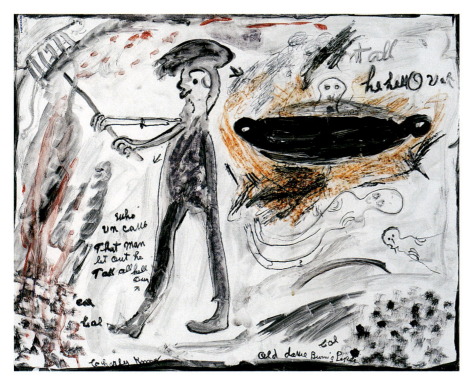

73. *Old Devil Burning People*, c. 1989–90

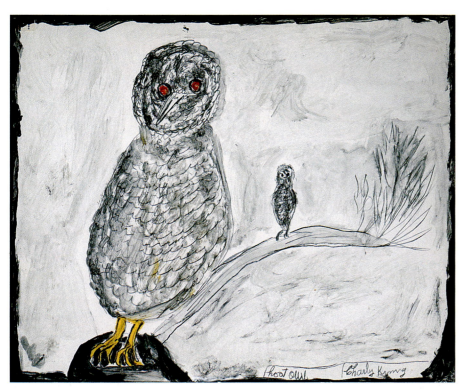

74. *Hoot Owl*, c. 1989–90

home. Hanging on a nail on the porch was a shock of hair from a horse's tail. To clean his barbering comb, he would run its teeth through the horsehair.[6]

Somehow (probably from a neighbor or family member), Charley learned to make functional split-oak baskets. This traditional craft was quite common at the time, but his baskets in particular were valued for their durability. Using the same materials and adapting his skill, he once honored a request and made the ultimate basket, a split-oak infant's playpen.[7]

Although one account suggests that he took up the fiddle in 1955,[8] Charley said that his father gave him a cigar-box fiddle when he was in his teens. His father promised that if Charley learned to play a tune, he would give him a real fiddle.[9] Charley quickly earned the fiddle and developed a passion for music. At that time, gatherings of neighbors and friends constituted the whole of rural social life, and it was in those settings that Charley learned music, which he played for the rest of his life. Most of his music consisted of local variations on melodies that had evolved out of grassroots music from the British Isles. But he learned to play with a bow style unique to the area of southwestern Lewis and eastern Fleming counties where he lived. The subtle, haunting tones achieved through certain wrist actions produced recognizably different interpretations of commonly known fiddle tunes.[10] Charley became locally renowned as a fiddle player, and he frequently played at local events and celebrations in Vanceburg, the Lewis County seat. He had frequent opportunities to make music with Noah, who played guitar, and musical gatherings at the Kinney homeplace became legend.

In the 1960s and 1970s Charley added a visual element to his musical performances. He constructed a series of small puppets, casually put together from a wide range of scrap materials—wood,

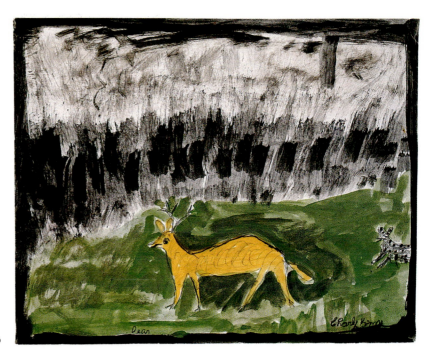

75. *Dear* [sic], c. 1989–90

cardboard, cloth, wire, corn silk, and so on. The puppets were articulated with movable knee, hip, and shoulder joints. Individually or in groups of two or three, these bizarre characters were suspended from wire coat hangers attached with bailing twine to a tobacco stick[11] that lay across the forked top of a portable post decorated with aluminum foil. More bailing twine ran downward from the other end of the tobacco stick to a foot pedal. With the puppet in place, Charley would work the pedal in time with the music as he played, making his "children" dance. The puppets launched into a wild frenzy of loosely swinging arms and legs, a spectacle that was outrageously funny and at the same time eerie, exuding a raw, untamed energy as the puppets' dance transformed familiar melodies into unfamiliar improvisations. The beat of the music loosely defined the movements of the puppets, whose wild gyrations were starkly at odds with the comforting symmetry of the tunes themselves.

After discovering the plasticity of creek-bank clay, Charley taught himself how to shape it, and he eventually made hundreds of small sculptures of animals

and human figures, which he sold to state park gift shops.[12] These pieces were not fired but were hardened in his woodstove and finished with paint. He also sculpted larger clay pieces, including Abe Lincoln, George Washington, and Moses with the Ten Commandments. While his brother, Noah, first made drawings and then switched to making wood sculptures after he retired from farming around 1970, Kinney's art evolved in the opposite direction, from three-dimensional to two-dimensional. He said that after years of shaping souvenir-sized clay pieces, working in two dimensions was "as easy as falling off a log. You could just sit down there in the dark and paint."[13]

It is unclear precisely when Charley began to paint. Following his death, the Kentucky Folk Art Center acquired two paintings that were back-to-back in a simple, two-sided frame. On each of these the artist had written in pencil, "draw 1934." When they were removed from the frame, one turned out to have been painted on the back of a piece of wallpaper. The second painting, of a lion, a creature he had never seen except in photographs, was on cardboard. As the

painting was removed, it was revealed that the cardboard was actually the backing for a point-of-sale Coca-Cola poster with a 1956 copyright.[14]

Storytelling—the oral tradition in its purest form—had become a part of Charley's identity as he grew up learning the tales of his family and region. An accomplished storyteller in his own right, he was inspired not only to reinterpret ever so slightly with each telling but to recreate his own experiences through the medium of the story. Many of his stories dealt with subjects unfamiliar to most of us. In the lingo of the 1990s, we would say Kinney lived "on the edge." His respect for the forces of nature led to a faith that easily accommodated a parallel acceptance of the *supernatural.* His world was inhabited by numerous spirits, some of which we would call poltergeists. A "knockin' spirit" inhabited a house where he once stayed. In the middle of the night the ghost banged loudly, repeatedly, on the wall, creating fear and trepidation in his heart. Houses and even some outdoor locations could be haunted, governed by vengeful "haints" who terrorized children and adults alike; they were real, live

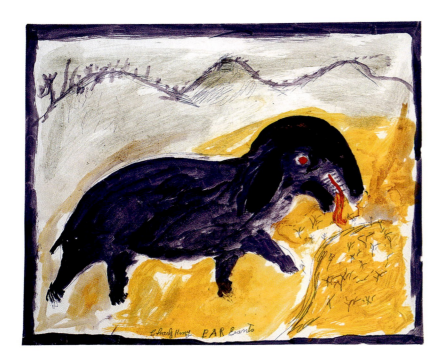

76. *BAREants*, c. 1989–90

bogeymen to be feared, respected, and avoided. In calling these entities "supernatural," we may draw an imaginary line between normal and abnormal, between experiences that can be rationalized and those that cannot be explained except by faith, but Charley Kinney knew no such distinction, living instead in a unified world in which experience dovetailed with beliefs that were unshakable.

In any case, beginning in the late 1970s, Kinney painted almost constantly, right up to his death. Many subjects were repeated over and over, his images evolving much as an old story, interpreted anew, raises new possibilities from old ideas. Revisiting the concerns and truths of a lifetime, he created paintings that threw new light on past experiences. His paintings from the late 1970s through the early 1990s were almost exclusively narrative works depicting a wide variety of subjects.

It is perhaps not surprising, given Charley's proven manual dexterity, that his style was fluid and expressionistic. The human figure was gestural and stylized, most often outlined in pencil. Human personality was at best secondary to the situation, issue, or idea being

portrayed. In works such as *Charly Kinny in Wilde Wilinis*, c. 1989–90 (cat. no. 78), he treated his own figure the same way he treated generic males in all of his paintings.

Along the way, he painted a number of subjects from the world of his youth: farming scenes, animals, moonshine stills, and peddlers. These works affirmed his identity as a citizen from a different time, the keeper of a sacred and disappearing body of knowledge.

Not surprisingly, he portrayed animals with far greater detail than found in his human figures. A life spent in the wild had made him familiar with the unique nature and personality of animal and bird species. In *Hoot Owl*, c. 1989–90 (cat. no. 74), for example, he powerfully conveys the bird's essence. The painting is almost entirely in monochrome paint and pencil, but the bird's legs are bright yellow, there is a random yellow brushstroke on the body, and the bird in the foreground has piercing red eyes.

Dear [sic], c. 1989–90 (cat. no. 75), is a seemingly peaceful depiction of a yellow deer standing in a lush green meadow next to a woods. A spotted dog, rendered in pencil and much less obtru-

sive, is running from the right toward the deer in the center of the painting. Is the dog frolicking, is it part of a pastoral scene, or is it a predator positioning itself for the kill? Charley's preoccupation with nature was summed up succinctly in a 1990 video interview: "I believe that animals has got as much sense as some humans, not all humans but some humans. . . . I believe they have, boys, it's give to 'em, . . . because they learned me things that humans couldn't learn me."[15]

Tornado, c. 1989–90 (cat. no. 77), depicts the violent potential of nature. At ground level, all detail is lost in a black swirl, which then rises in a funnel cloud that has thrust a house, a truck, a man, and a bicycle upward into the air. Charley must have experienced the fear-inspiring power of a twister during his lifetime. The sudden and uncontrollable force of a tornado is further underscored by his inclusion of a still-smoking chimney atop the airborne house.

Because Charley did not separate the natural and the supernatural, it was logical for him to portray in supernatural terms the moral consequences of a life spent in evil. In *Old Devil Burning People*, c. 1989–90 (cat. no. 73), we see one of

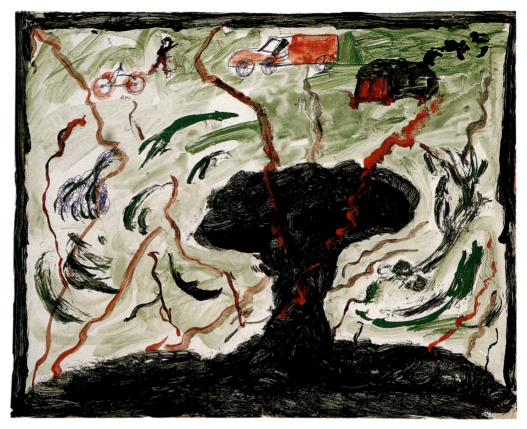

77. *Tornado*, c. 1989–90

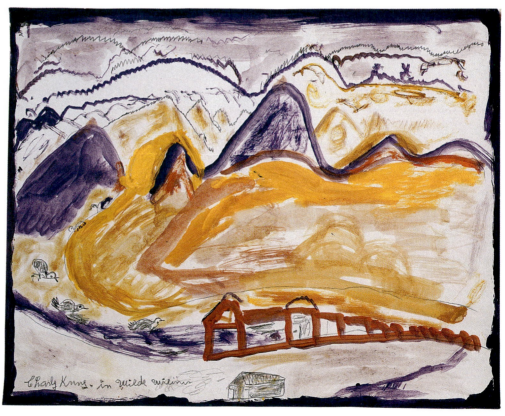

78. *Charly Kinny in Wilde Wilinis*, c. 1989–90

his favorite subjects. He fervently believed that the devil took on human form and appeared as a man.[16] In this version, the devil stands feeding the bodies of sinners into the fire at the left. Around him whirl ghosts and apparitions, and at the bottom right rests a pile of coal. We would call this a religious painting, because we equate matters of the soul with formalized religion, but Charley's faith, richly colored by his Primitive Baptist upbringing, was absolute; it was an idiosyncratic yet dynamic mix of biblical tales, local lore, and personal experience.

Despite his brief schooling, Charley was literate enough to write inscriptions on his paintings, further enhancing their storylike quality. His spelling was mostly phonetic ("col" for coal, "wilinis" for wilderness), and a familiarity with his regional dialect helps a great deal in interpreting his writing. *BAREants*, c. 1989–90 (cat. no. 76), a "bar" (bear) eating ants in the artist's lexicon, is a good representation of his awe before nature. Reflecting something he had once seen, it portrays the irony of a creature so large feasting on foodstuffs so small.[17]

His earlier paintings were executed in a variety of paints, whatever was handy at the time. His later works, however, were largely painted in tempera and were often "framed" with bold strokes of black stove polish. His use of tempera and of standard (22 by 28 inches) poster board began sometime after 1978, when he was introduced to an art dealer who subsequently supplied him with materials and purchased much of his work. Though his paintings appeared in urban, commercial galleries sporting significant prices as early as 1986, it is unlikely that the artist ever received more than one hundred dollars for any of his works, and he parted with most of them for less than half that amount. There is no doubt that he was a victim of ethical abuse, a perennial issue that plagues folk art and dilutes the fortunes of folk artists. Unaware of or uninterested in the complex workings of the marketplace, Charley Kinney sold his paintings to anyone who came along who was outwardly respectful.

He painted in his small two-room home, a sparsely furnished logging shack erected on the family farm during the 1920s. He often worked on the floor, squatting on his hands and knees. Many times, when the paintings were completed, he would carry them over a flimsy, swinging footbridge to the tobacco barn, where he hung them with a hammered nail in each corner. The barn served as a temporary gallery in which a painting seldom hung for more than a day or two before it was purchased and carried away.

The large number of people who met or were acquainted with Charley Kinney would remember him distinctly for his widely differing vocations: fiddler, magician, puppeteer, barber, baker, basket maker, sculptor, painter, and storyteller. Those who spent any time with him, and who could see beyond their media-fed preconceptions about Appalachian poverty, were richer for their experience of a man whose happiness depended very little on material wealth, and who was at one with himself and his environment.[18]

Toward the end of his life, Charley's output became prolific. Though he generally used less paint, his style became even more fluid as he worked more quickly and finished more paintings. Perhaps he understood that his time was running out. A consummate communicator, he appears to have been racing to tell his own story as many times as possible, through his paintings. The six paintings included in this exhibition are testimony to an artist who found his voice and was hell-bent on singing as loudly as he could before the final curtain fell.

—T.A.S.

NOTES

1. Interview with Noah Kinney, April 1989, conducted by the author.

2. Author's conversation with Charley Kinney, September 1978.

3. Interviews with Dr. Danny Burns, University of Arizona School of Medicine, and Dr. Shelley Bennett, Cave Run Clinic, Morehead, Kentucky, May 1995, conducted by the author.

4. Author's conversation with Hazel Kinney, Noah Kinney's widow, May 1995.

5. "Local Voices," a video interview of Charley Kinney conducted by the author, at Morehead State University, April 1990.

6. Interview with Charley Kinney, February 1988, conducted by the author.

7. Ibid.

8. Ellsworth Taylor, *Folk Art of Kentucky* (Lexington: University of Kentucky Fine Arts Gallery, 1975), no pagination.

9. Interview with Charley Kinney, February 1988.

10. Author's conversation with John Simon, Portsmouth, Ohio, after Charley Kinney's funeral, April 10, 1991.

11. A hand-split stick with pointed ends on which mature tobacco plants are skewered. The stick is set horizontally between two rails in a barn, where the hanging plants cure.

12. "Local Voices."

13. Ibid.

14. One can only speculate as to whether the artist's date, 1934, was an inadvertent error or a conscious ruse.

15. "Local Voices."

16. James Smith Pierce, *God, Man, and the Devil: Religion in Recent Kentucky Folk Art*, exhibition catalog (Lexington: Folk Art Society of Kentucky, 1984), no pagination.

17. Paintings of hawks catching rattlesnakes and of a colony of worms interlocked in a line and resembling a snake provide additional examples of this fascination.

18. In an interview with Charley Kinney, February 1988, the artist recalled having been cautioned by the game warden one particularly harsh winter for putting out food for the squirrels. He dared the game warden to arrest him, adding that his brother, Noah, would feed them until he got out of jail.

Joe Louis Light

Joe Louis Light, born in 1934 in Dryersbury, Tennessee, now lives in Memphis. One of Joe Light's paintings, which I call, simply, *Inscription*, 1992 (cat. no. 81), is a long, narrow, horizontal surface coated with black enamel and lettered in bright yellow with the following message:

> If you think that it takes a lot of money to enjoy life in this world, you are wrong. But what it does take is good common sense. The environment in which a child lives is the teacher of that child whether it's right or wrong. But if that child has good common sense when they are grown they will do a research on their pass [sic] teaching to correct possible mistakes. So that they can live a normal life. 8/23/92 Joe Light.

Although he scatters upper- and lower-case letters throughout, the style of his lettering is casual, and his grammar and spelling are sometimes problematic, this painted panel—with its simple, bold, and direct statement—is a brief but candid expression of Joe Light's personal philosophy and a summary of his artistic style and technique.

Any number of self-taught artists have used the written word as a vehicle for conveying deeply felt messages. Some, like Sister Gertrude Morgan, are what might be called "miniaturists"; their work is small in scale, and the texts that dominate or accompany their pro-

ductions have the intimacy of personal correspondence. Others, such as Jesse Howard, a painter of remarkable signs, require a more aggressive, sometimes physically larger format. Joe Light's painted signs bear some kinship with those by Howard. Both artists fashion statements that seem like advertising campaigns; both prefer using the surfaces of found materials. There are significant differences, however. While it varies from work to work, Howard's script is consistent in its meticulously ruled, carefully shaped, cleanly fashioned lettering. One can feel the degree of intense concentration Howard brought to his work, letter by letter, line by line, in a time-consuming, painstaking process. It is as though he believed that the precision and clarity of the words themselves would convey the seriousness and authenticity of his message. I suspect that Howard achieved great satisfaction from the simple act of preparing, then painting, a sign, aside from his obvious wish to share his ideas with the world outside. In comparison, the primary impulse behind Joe Light's signs seems to be to get the message out as quickly as possible and not to be overly concerned with refinement. It is as though Light feels deeply the pressure of a society out of control and, indeed, going to hell. Alarmed, the artist urgently needs to get

something out there that might arrest this pernicious process.

This is not to say that Light's calligraphic panel is without its own kind of aesthetic appeal. Far from it. Within the apparently untutored style of his lettering is a consistency that has nothing to do with the uniform rendering of letters and the production of grammatical sentences. In Light's case, visual appeal emanates from inconsistencies that represent the directness and urgency of his thoughts in a way that more precise rendering might have inhibited. The apparently casual, even indifferent selection of colors accelerates the sense of movement in Light's messages. His preference for color rather than the black and white most frequently seen in Jesse Howard's work is another feature that separates the work of these artists. Even Light's spacing between the words of *Inscription* forms a visual rhythm and counterpoint not unlike the pauses in music.

While *Inscription* clearly possesses aesthetic merits, its didactic purpose was surely the artist's primary intention. Joe Light's place as an ethical teacher or moralist has been examined often. Biographies of the artist have emphasized his humble origins, his early employment as a farm laborer, the aimlessness of his early life. He served briefly in the mili-

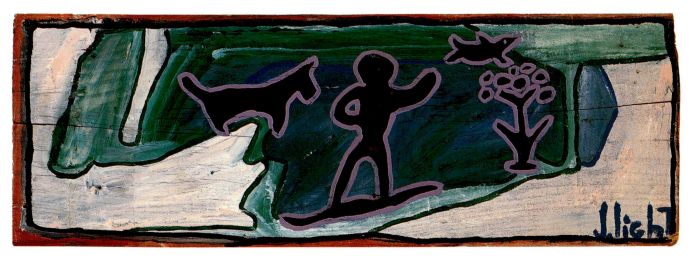

79. *Freeman*, 1989

tary, and afterward his shady activities landed him in prison from 1954 to 1955 and from 1960 to 1968. During the latter incarceration, Light underwent a spiritual transformation. He became a self-styled convert to Judaism, embracing the teachings of the Old Testament and taking upon himself the role of a social commentator.[1]

If Light's endeavors had focused exclusively on his signboards, it is likely that essays on them would emphasize content—the issues that were most pertinent to the artist, the drift of his personal philosophy, and his modes of expression. However, there are other sides to Joe Light's artistic production, as his paintings on panel richly illustrate. Colorful, bold, expressionistic, compositionally reductive, with forms outlined dramatically in black (a virtual trademark of the artist), they represent additional aspects of the very complex art of Joe Louis Light.

All of these qualities distinguish *Flower Diptych*, 1989 (cat. no. 80), *Freeman*, 1989 (cat. no. 79), *Earth and Sky*, 1991 (cat. no. 83), and *Rocks and Water*, 1991 (cat. no. 82). Some similarities can be traced among all of these paintings. Light favors enamels on panel, each one at least twice

as wide as it is high. Compositions are spare; color is bright; the outlined images have a bold, graphic simplicity. Brushwork is swift and "wandering," as though the artist were allowing some instinct to find its way through him to the final forms.

Although Light chooses a broad range of subjects for his paintings,[2] Gitter and Yelen have collected mostly floral pictures. *Flower Diptych* is one of the most interesting. Each panel, bordered in bright red, displays a tall, dark green plant set against a plain white background and anchored in a patch of grass represented by bold, saw-toothed blades painted the same color. The paint is applied in flat areas; there are no cast shadows. At the top of one plant is a blossom consisting of a red, circular center from which radiate nine triangular, bright yellow petals. As it rises, the stem of the flower curves sinuously. Two small, simply shaped leaves grow on either side of the stem, not far from the base. Just above them, branching off the main stem on different levels, are two smaller stems, one on the left side, the other on the right. They terminate in blossoms that are smaller versions of the one on top, and their color scheme is reversed:

They have yellow centers with red petals. All these shapes are edged with narrow black lines. The second panel of *Flower Diptych* depicts another floral motif. Using the same dark green, Light represented the stem as a sturdy, straight, vertical form thrusting boldly upward. Two pairs of large, thick leaves extend from the stem. Its flower is quite large, almost touching the left edge of the picture. Light shaped the flower's center as a horizontal oval and painted it red, like its partner. From it extend six semicircular, yellow petals, so rounded that they seem full, almost to bursting. Again, all these forms are outlined in black.

The iconography of *Flower Diptych* seems clear enough. However acceptable this interpretation may seem in today's political climate, Light has, instinctively or deliberately, reaffirmed a symbolism so old that it can be traced back to the dimmest beginnings of art. One flower, with the curved stem and the two blossoms, represents the female, motherhood, and thus productivity; the other flower stands for the male. A further identification for the "male" portion of *Flower Diptych* can be suggested: the artist himself. It is significant that Joe Light is a tall, imposing, robust man.[3]

81. Inscription, 1992

How important the flower motif is to Light is indicated not only by the number of times he has painted it but, in one case at least, by the scale he has chosen to represent it. *Flower Mural* (in the Gitter-Yelen collection but not included in this exhibition), measures forty-eight by ninety-six inches. Emerging from an enormous bed of green grass and leaves, a huge blossom, with a red center and blue and white petals shaped like those of irises, rises from a thick, trunklike stem and presses upward until it touches the top of the painting. Behind the bed of grass and the flower, Light has brushed in what appears to be a turbulent sky in bright blues and incandescent reds. This need not be seen as merely an amateurish convention for providing a setting for the main subject; the painting is too big, too boldly conceived and executed, for this canopy to represent anything other than Nature's vast and irrepressible potential. Light's frequent use of natural, growing forms speaks of an individual who, after leading a less than spiritually rewarding life, has found an alternative, one full of promise. Through both *Flower Diptych* and *Rocks and Water*, Light confirms artistically the value, and indeed the necessity, of the positive reaffirmation of concepts that have always spoken for the most fundamental needs and desires of humankind.

Light's *Freeman* is a curious painting (the title comes from the word painted on the back of the panel). *Freeman* depicts what I believe is a highly imaginative setting of water and shoreline painted in whites, pinks, and greens laid down with Light's typically quick, spontaneous brushwork and outlined in thin, black lines. A human figure, which I take to be a male, dominates the center of the painting. He seems to be standing on a slender base of some kind. To his upper left, as though perched above him on a low cliff, is a dog; to the right is a very large flower and, just above it, a small creature in the shape of a seal that seems to be swimming out of a body of water. These four shapes are painted black silhouettes outlined in a bright purple.

Before I knew about the inscription, I imagined that this painting whimsically depicted a surfboarder (the base that I have identified resembles a surfboard) accompanied by his pet dog; they are trying out the waves in some exotic locale graced with a curious plant and inhabited by an aquatic creature. The male figure bends one of his arms so that the hand rests on the hip, suggesting ease and control, while the other arm is extended, either in a greeting (to his dog?) or in a balancing gesture. Once the inscription was brought to my attention, however, I naturally began

speculating that Light, who has been described as an artist "who makes political art,"[4] is in fact making a statement that concerns freedom from some form of personal or political bondage. Since the artist is African American, it makes sense to ask the obvious: Is the use of the black silhouettes intended to indicate ethnicity? This works for the human and possibly for the "seal," is moot for the dog, and doesn't make much sense for the plant. I favor a more ecumenical explanation. If this were indeed intended as a political statement, Light opened it up to include all people; thus, black is a nonidentifier.

Earth and Sky and *Rocks and Water*, both painted in 1991, are for me very special paintings. First, they are typical of a number of paintings in which the artist has reduced the composition to the most meager number of elements. Second, they are similar in that each is a horizontal composition divided into two virtually equal horizontal parts. And third, they are both puzzling as to their meaning. *Earth and Sky* and *Rocks and Water* challenged me in ways that I had not encountered when developing my remarks on other artists in this collection or, indeed, on Light's other paintings. The problem was, with two such simple paintings, how much could one say about them? Why were they so compel-

NEY TO ENJOy liFE iN This WoRld, you
d COMMON SENSE, ThE ENViRONMENT iN
hER iT's RighT oR WRoNG, BuT iF ThAT child hAS
hEy will do A RESEARCh oN ThEiR PASS TEAChiNG
MAi liFE, 8-23-92 JoE lighT

ling to the collectors who acquired them and to the curator as well—in spite of there being so little apparently available for comment?

There is something to be said for the cliché "less is more." Often, in the absence of rhetoric, we are encouraged to listen more attentively to a more modest selection of words and to open ourselves up to nuance. Light's painting *Earth and Sky* consists of hardly more than three pictorial elements. The picture is divided almost equally into two triangular parts by a sinuous, black line that extends toward the lower left and the upper right corners but does not connect corner with corner. Rather, at its left terminus, the line runs to the left edge of the panel just above the lower corner. At its right terminus, the line runs to the right edge of the painting, just below the upper right corner. Were it not for the fact that the line in its entirety is curvilinear and irregular, a kind of "asymetrical mirror image" would have been created. Since the upper triangle is a bright blue color scumbled with passages of warm red, and the lower triangle is a warm yellow also inflected with red, a kind of eidetic image results, and we have a rudimentary representation of a landscape. The black line, the third pictorial element, dramatizes what is understood as the horizon—in nature not a line at all but a

perception that constantly changes as our position as spectator changes. Light has seized on a pictorial strategy that seems straightforward and logical enough but upon closer scrutiny proves to be illusory, albeit familiar, and pictorially active, rather than passive. Seen on a wall, *Earth and Sky* generates an uncanny power—decorative in one sense but evocative in others.

A similar analysis can be suggested for *Rocks and Water*. Here, however, instead of a balanced splitting of the picture plane into two comparable triangles, the picture is divided into two similar horizontal areas. In *Earth and Sky* the bright blue of the upper register signifies the sky; in *Rocks and Water* the blue represents an aqueous world, while a mix of browns and reds below represents the riverbed, and again a curving black line accentuates the meeting of the two areas. *Rocks and Water* has a fourth pictorial element: the white object moving through the center of the area of water. When I first looked at this painting, I interpreted it as a landscape, with either a bird or an aircraft flying across the sky. Given the painting's title, however, the white object must be considered a fish or some other water creature. I think *Mountains and Sky* would work just as well as its given title, and I feel the ambiguities that I have suggested should be allowed to stand.

There are advantages to permitting this liberty of interpretation. Aircraft are, after all, technology's imitation of the natural creature; thus, with the title *Mountains and Sky*, the biological world and the world of human invention momentarily fuse into a greater metaphor, a symbol of freedom. This is a concept that is most certainly understood and appreciated by the artist. As with Light's *Earth and Sky*, when *Rocks and Water* is seen in isolation, its graphic power and symbolism become almost physical experiences. Light accomplishes this feat of visual legerdemain in the most reductive and ingenious manner imaginable, turning up the heat of the experience just that much more.

Both *Earth and Sky* and *Rocks and Water* —with their severely reductive compositions and their black, calligraphic lines— recall some of the marvelous ink paintings by the Qing dynasty (1644–1911) painter Zhu Da (1624–1705). In many of his most impressive works, Zhu Da created worlds of natural forms even as he eliminated all but a few key forms in perfect relationship to each other—a method of composing that suggests the next logical step would be to eliminate phenomenal references altogether. A rock form, for example, may be placed in one area of the picture, along with a modest evocation of a fish in another. By means

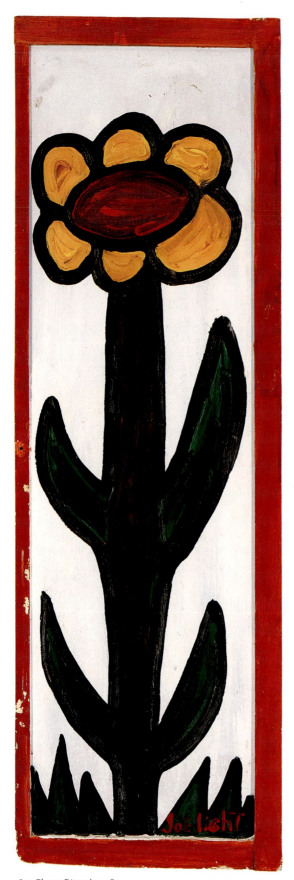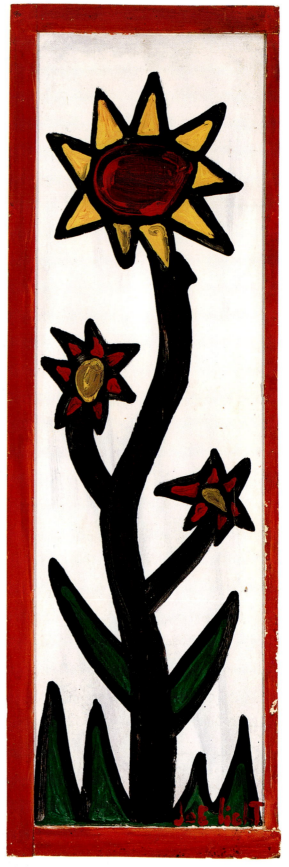

80. *Flower Diptych*, 1989

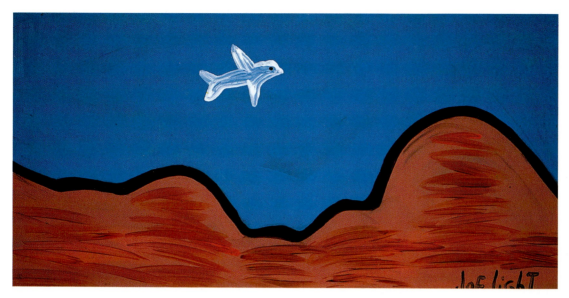

82. *Rocks and Water, 1991*

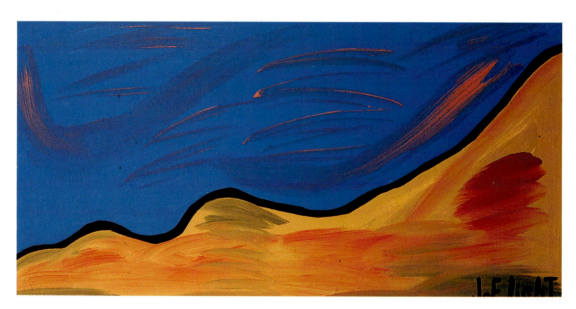

83. *Earth and Sky, 1991*

of only these two elements, in a perfect formal and symbolic relationship, a rich natural setting is evoked in the viewer's mind. Using other pictorial strategies, Light has accomplished something similar in *Earth and Sky* and *Rocks and Water*.

It is characteristic of Joe Light's art that by enlarging—that is, monumentalizing—the scale of his subjects, or by a reductive process of pictorial intensification, he encourages the reconsideration of the commonplace, transforming it into what might be called a "revelation of the familiar."
— G.J.S.

NOTES

1. I have relied on three sources for the details of Joe Louis Light's life: Judith McWillie's entry on Light in *Another Face of the Diamond: Pathways through the Black Atlantic South* (New York: INTAR Latin American Gallery, 1989); Alice Rae Yelen, *Passionate Visions of the American South: Self-Taught Artists from 1940 to the Present* (New Orleans: New Orleans Museum of Art, 1993), p. 318; and Chuck Rosenak and Jan Rosenak, *Museum of American Folk Art Encyclopedia of Twentieth-Century American Folk Art and Artists* (New York: Abbeville Press, 1990), pp. 190–91.

2. Fax sent to me by Alice Yelen, dated February 4, 1993. Edited, Yelen's paragraph says, "Light considers a variety of subjects, basically of two types. First there are idealized, abstracted landscapes, then there are symbols of the artist: hobo, hunter holding up a slain rabbit, male head with a bird projecting from the top, and various animals."

3. Kurt Gitter, who has met Joe Light, described him to me as "about six feet five in height and weighing about two hundred and forty pounds" (various personal discussions between the author and Kurt Gitter and a telephone conversation on January 22, 1995).

4. Rosenak and Rosenak, *Museum of American Folk Art Encyclopedia*, p. 190.

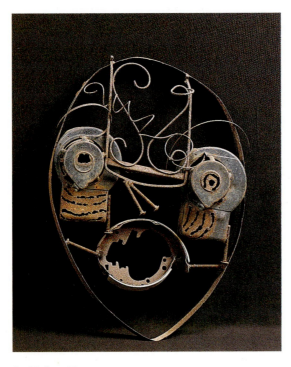

85. *Mask, 1988*

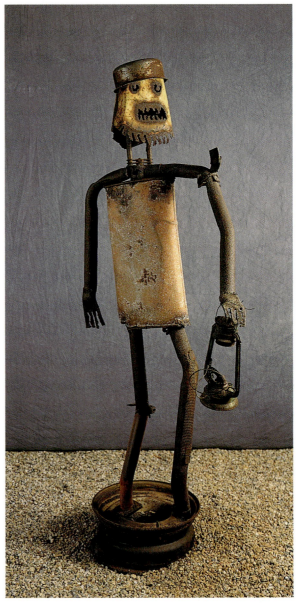

91. *Man with Lantern*, c. 1987–88

Charlie Lucas

A visit to Charlie Lucas's house and studio is a lesson in slowing down, in listening and looking. His property spans two sides of the road running through the rural community of Pink Lily, north of Montgomery, Alabama. Lucas created with his own hands almost everything on the property. He salvaged and reassembled packing crates and a discarded garage door into an attractive and functional residence for his family. Across the street, he transformed a large field into a combined vegetable and sculpture garden, with corn, peanuts, and squash creating new affinities with Lucas's metal figures. His studio, a long and irregularly shaped building, stretches along the north side of the property and will eventually, says Lucas, become an enormous dinosaur which will enfold the entire garden. The site is populated by a host of creations: a large airplane by the corn, a giant mask suspended from the pines,

Two Sisters Waiting for the Mail at the driveway entrance, as well as birds, fish, dinosaurs, and other creatures assembled and welded from found metal objects and given life by the creative genius of Charlie Lucas.

When Lucas began making art, he says, he wanted to recycle himself. Using metal banding, scrap metal, car bumpers, and other cast-off materials,

he constructs sculptures and paintings that spring from personal examination yet speak to universal concerns. When Lucas suffered a disabling injury in 1984 and was unable to work, he asked God to give him a talent that no one else had. He had been tinkering and making objects, or toys, as he calls them, since he was a child. But it was not until 1985 that Lucas focused his talent and energy on

the creation of the large-scale sculptures that fill both sides of the road by his house.

The nature of his materials is especially important to Lucas. He works with metal, assembling discarded objects and using his welding torch and other tools when necessary to detail a face or figure. But the wheels, gears, tillers, and metal bands aren't merely parts for the whole or means to the end. They are a part of Lucas's life, inseparable from his experience. A jack-of-all-trades whose father was an auto mechanic, Lucas has always lived in a world where taking machines apart and putting them back together was as natural as planting a garden. By fitting together machine parts and other at-hand materials, Lucas creates complex metal assemblages that are re-creations of his daily life. In his art, self and object are seamlessly one.

Lucas is also inspired by his family, and his desire to pay homage to them is an ever-present theme in his work. Even as a child, Lucas recognized and appreciated the skills and creativity of his family. His father was, as mentioned, an auto mechanic, his mother and grandmother were prolific quilters, his grandfather was a gunsmith and basket maker, and his great-grandfather was a blacksmith. As children, Lucas and his brothers and sisters spent a lot of time with their great-grandfather, watching him work. Lucas was especially struck by the transformation of iron; seeing it change under the skilled hands of his great-grandfather filled him with wonder. "That guy was just magic to me," he recalls. "I learned how to put the rhythm in a piece from him. He didn't just rush to do it because it needed to be done at that moment. He was a true artist."[1]

Lucas senses the possibilities in the most mundane of objects. *Camels*, 1988 (cat. no. 87), is made of railroad spikes and gears welded together. The camels are animated and possess rhythm and movement. They seem to strut, as if on parade, heralding their individuality by a turn of the foot or a cock of the head. Indeed, their presence is so strong that

a viewer sees only the camels, not the metal spikes. In discussing these figures, Lucas says, "My daddy smoked Camel cigarettes and one day he dropped the package out in the yard. I picked it up and said, . . . 'I am going to show you that I can recycle that,' and I made the camel from it."[2]

In the case of the camel, Lucas recycled, not the literal package, but rather the idea of the camel and what had been discarded. Typically, however, Lucas does use what he finds or what is brought to him for his sculptures. He never forces a sculpture or hurries it to completion; instead, he tinkers with many pieces for extended periods of time: "There are several pieces that I just didn't go out in the scrap yard and get. It took several months and years to get the pieces. People don't quite understand that part of it. I leave something alone until it is the right time and come back and do it because the piece introduces itself to me." In describing this method of working, Lucas says, "They [the sculptures] tell me what needs to be done. It's like talking to a friend, the conversation makes them a better friend."

Lucas views most of the sculptures he makes as friends, as objects with whom he can maintain a dialogue and who can teach him lessons about life. In discussing *Mr. Charlie*, 1992 (cat. no. 84), Lucas says,

> He was like an old guy who went around smoking cigars and talking junk to people, but he had that ability to be in the background and be kind of quiet in a way, and I could see that. . . . When Dr. Gitter seen it he liked it and saw the royalness of it. . . . Mr. Charlie was a guy to me that anytime I needed some strength, I could go to him and draw from him; it is not a self-portrait, but just a good, great friend. . . . I can tell you a long history about this one little piece and that it was introduced to me many, many years ago. . . . I waited until it was the right time to digest this piece. My brother-in-law gave me this part here that is off a little ole tiller [pointing to the head of Mr. Charlie]. He said, "You might can do something with this." I said, "Oh yes, this is like working with

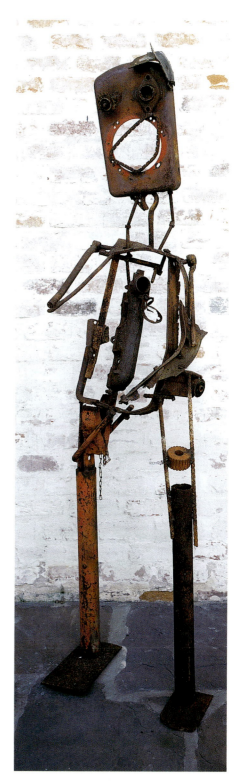

84. *Mr. Charlie*, 1992

Mr. Charlie." . . . The head was the first piece that started it and it went to growing from that. I then went out to the junk yard and was working on this car engine and this is where the manifold come from. . . . I knew that was the one that could go into the sculpture.

This quote helps to illustrate Lucas's approach to material and subject. Nothing is rushed. He uses the time involved in making each piece to come to a fuller understanding of himself and of the lesson that particular piece is teaching. Charlie Lucas's sculpture has a strong narrative quality, and he listens, learns, and tries to pass the lessons on. Standing on his property, one feels the tranquility he has created and the wisdom he is trying to share through his sculpture and his garden. Both take time, patience, and a special insight. Lucas is eager for people to understand and appreciate the gifts of the earth as well as the gifts of their lives and the talents God gave them. Using his life as an example, he says,

> God has used them [problems in his life and career] to test me to see if my faith was in the right place, . . . to see if I'm gonna be so hung up on material things that I can't really give the gift from my heart. . . . If [only] man wouldn't look at the richness of the money side of it, and would look at how much can I do for others through my richness. That was my goal. As long as I can [make art] and plant my food and show kids the truth of what I'm about, I'm living fine with this.

Lucas's work is deeply spiritual, and he also comments on many social issues, but he is mostly concerned with family, social unity, and the worth of each individual. He has tremendous respect for the elderly in his community; mentioning two neighbors specifically, he says he cannot even begin to communicate all

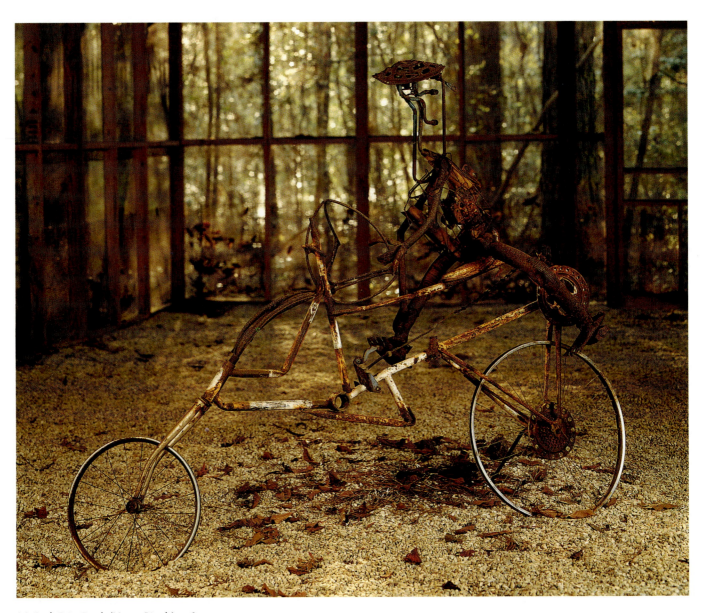

86. *Don't Drive Drunk (Man on Bicycle)*, 1987

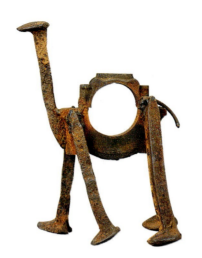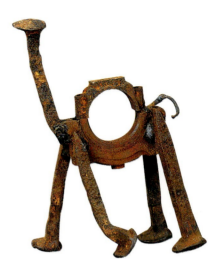

87. *Camels*, 1988

he has learned from them. His children don't want to take the time to listen, but he is saving up this knowledge for them: "We shouldn't can the old people up like a can of peaches. We need to go visit them because we can still *benefit* from them."[3]

Dinosaurs figure in a number of Lucas's sculptures and paintings. He says the dinosaur is one of his favorite animals; he appreciates the curve and shape of its body and sees it as a gentle creature. He has made large figures over ten feet tall, woven from scrap-metal banding, as well as smaller figures like *Dinosaur,* c. 1987–88 (cat. no. 88), made of wire. Working with wire is like sketching or doodling, and the wire figures often portray his sense of whimsy and humor. Lucas says, "Sometimes when I am doing a sculpture, especially a wire sculpture, I don't really even look at it when I am making it. I be doing something else inside myself and I basically just let it be like playing a guitar in a way. It gives me that extra spare time I be wanting."

It also offers an excellent vehicle for involving children and giving them the opportunity to participate in his sculpture making. The dinosaur in the Gitter-Yelen collection has telephone wire in various colors wrapped around sections of the standing figure. Lucas says, "The color of the dinosaur is from classes I've

been in where the kids put the color in. That kind of gives me that play time between my work time and it gives that kid that play time in the piece."

Charlie Lucas's sculpture has a lyrical and poetic quality. Under his hands, the rigidity of the metal becomes fluid. Augmenting this fluidity of line, he intuitively balances the negative space in his work. In *Mask,* 1988 (cat. no. 85), he successfully melds found objects (the cover of a lawn mower, screws, wire) into an expression that mesmerizes the viewer with the strength of its gaze.

Man with Lantern, c. 1987–88 (cat. no. 91), depicts a construction worker who had fallen down many times. Says Lucas, "That top piece [referring to a piece of metal protruding from the sculpture's left shoulder] was like a Band Aid. . . . He has really struggled with his life. That made him like a guide that has always shined a bright light in my life, even with the bruises and the bumps on him." As in *Mask,* the face carries a powerful expression. The mouth, chin, and fingers have all been snipped in a similar fashion, creating a rhythm that effectively guides the eye over the entire piece. Lucas's unintentional reference, via the lantern, to Diogenes is nevertheless appropriate, a symbol for the truthfulness and integrity Lucas follows in his life. In *Don't Drive Drunk (Man on Bicycle),*

1987 (cat. no. 86), Lucas uses the figure on the bicycle, "not to jump on the drunk driver," but to make him aware: "It is like the little kid's feet are putting the brakes on it [the driver's actions]."

Lucas's paintings carry similar messages of social commentary and compassion for mankind. His paintings are generally on plywood with house paint in a variety of bright colors: "When I mix my colors for my paint I want them to be just from scratch. . . . I basically want all of my paint to be direct on the board; I don't even make it up in a small container. To me it is a playtime. You are free enough to swim into the colors and you are not worried about what you look like when you come out of it."

Crossing the Line, 1988 (cat. no. 89), is a painting on a long board. The paint is thickly applied to the uneven board, creating a densely textured surface. This surface, along with the images of disembodied faces and abstracted forms, creates a turbulent yet ambiguous composition. In discussing this work, Lucas points to the double line between the man and woman, near the center of the painting:

> When you get back off into my paintings, it is like crossing the line. It is like when romance come about. You tell a girl, you come over here and be introduced into my part of life and then I

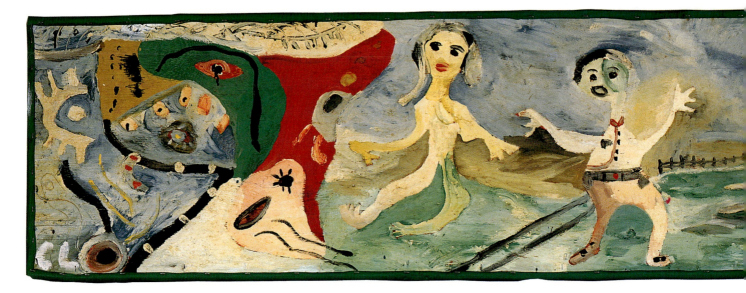

89. Crossing the Line, 1988

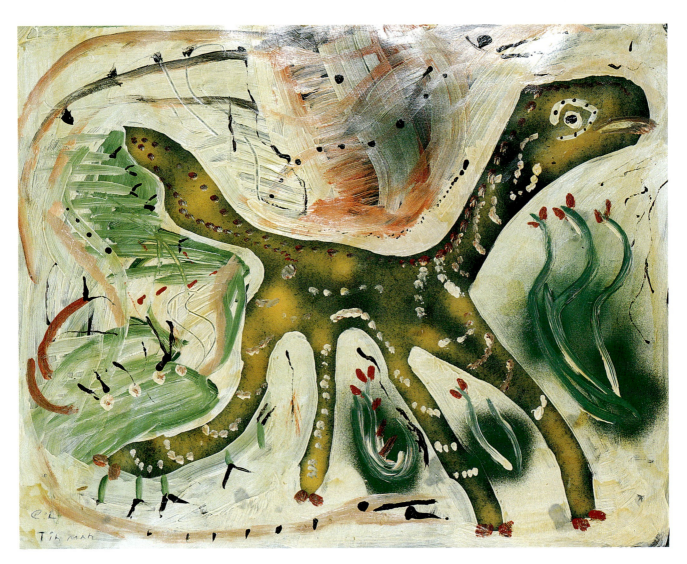

90. Dinosaur, 1990

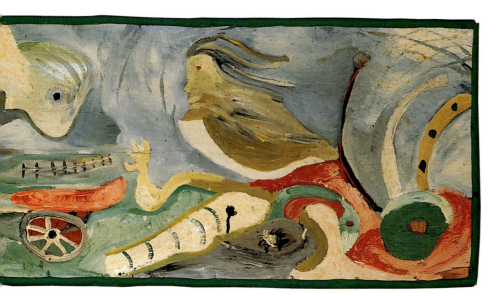

want to share that life with you. But sometimes the man has to go over into the woman's life, too, and he has to cross the line. That is why there are two lines in the painting.

Many of his sculptures and paintings address relationships between men and women generally or between him and his wife, Annie, specifically. Issues such as love, honor, and communication (or lack of it) are addressed both directly and subtly. In *Crossing the Line*, a long road stretches behind the figures and symbolizes the road traveled together in their marriage.

Lucas says he wants his work "to be free inside of itself. I want it to have laughter, and I want the characters to be really tuned into speaking to people." In selecting and using materials that have been discarded by others, Lucas gives them new meaning and life. The cast-off materials are symbolic of Lucas's attitude toward people: Individuals can find—or regain—dignity and a sense of purpose for their lives, even when they feel like cast-off trash themselves. Lucas's objects are his means of self-discovery and a powerful method of communication. They speak to each individual's potential, symbolized in the discarded, inanimate objects.

—G.A.T.

NOTES

1. Pamela Whyte, "The Tin Man Has a Heart," *Alabama 55*, no. 6 (November/December 1991): 32.

2. Unless otherwise noted, quotations are from taped interviews with the artist conducted by the author in November 1990 and July 1994.

3. Whyte, "The Tin Man Has a Heart," p. 32.

88. *Dinosaur,* c. 1987–88

Justin McCarthy

Justin McCarthy was born in Weatherly, Pennsylvania, on May 13, 1892, to a well-to-do family. His father was the manager of a local newspaper, the *Hazelton Sentinel*, and was also involved in politics and the financial world. A family tragedy occurred in 1907 when Justin's younger brother, John L., died of pneumonia. Grief-stricken, the McCarthys moved to Europe for a while, spending time in both London and Paris. They returned to Pennsylvania, and in 1908 another tragedy befell them: Justin's father died under dubious circumstances.

Financial reversals left Justin and his mother, Floretta Musselman McCarthy, in a precarious situation. They had almost no money, though they still owned the family property and house, which local residents referred to as "the mansion." Mrs. McCarthy went back to teaching on Staten Island, in New York, living during the school year at her sister's house. Justin was accepted at the University of Pennsylvania Law School and managed to pass the first-year examinations, but he failed his second-year tests. He studied for a while to retake them but eventually abandoned law school altogether.

Around 1914 he suffered a nervous breakdown, and his mother sent him to a private institution to recover. They were unable to sustain the expense, however, and in 1915 Justin was admitted to Rittersville State Hospital for the Insane, where he remained until 1920.

While hospitalized, McCarthy began to draw, often signing his works with names like Prince Dashing or Gaston Deauville. He returned to Weatherly, moved into the family house, and continued to draw and paint. He also began to grow and sell vegetables, earning a modest living. Generally very shy, he peddled his produce to the local community from the backs of various old cars he owned at different times. After his mother's death in 1940, he stayed at the decaying mansion and worked at a series of menial jobs to support himself.

McCarthy also attempted to sell some of his paintings at neighborhood fairs. In 1960, he was discovered at an outdoor art show in Stroudsburg by Dorothy Strauser, wife of artist and collector Sterling Strauser. From 1960 until his death in 1977, the Strausers collected and promoted his work; they also befriended him and looked after his needs.

The Strausers' belief in McCarthy's extraordinary gifts eventually helped the artist gain recognition. His work was included in a traveling exhibition, *Seventeen Naive Painters* (1965–67), sponsored by the Museum of Modern Art, New York, and also in another exhibition, *Contemporary Folk Art* (1970), at the Museum of American Folk Art, New York.

The Philadelphia Academy of the Fine Arts, under the directorship of Thomas N. Armstrong III, gave McCarthy a solo exhibition in 1972.

McCarthy's work covered a wide variety of subjects, from glamorous women and Hollywood stars to sporting events, political figures, historical and biblical events, still lifes, landscapes, and animals. He also painted or drew cartoonlike pieces that were arranged in what appeared to be series, though the sequential logic was not always clear. The artist's choice of media was equally broad: pencil, pen, chalk, crayon, watercolors, and oil paints, which he claims he began using during the four years he worked for the Bethlehem Steel Company. In the 1970s, he worked with acrylic paints as well.

The artist's style varied from very detailed line drawings demonstrating

92. *Christ Entering Jerusalem*, c. 1960s

uncanny draftsmanship to broad, painterly abstractions. He often used non-naturalistic color and shape to achieve heightened emotional intensity and movement. In his final years his brushwork became looser, his forms exaggerated. Vigorous line and color are hallmarks of many of his artworks.

Sterling Strauser once said that McCarthy was a "naive expressionist." People often found it difficult to believe that "he was a self-taught naive, because . . . some of his things look like Emil Nolde, some look like Milton Avery—

people that he was not aware of at all. They look like Ernst Kirchner. Some of his watercolors look like Demuth. This is all purely accidental." Strauser added, "He said he was painting for the ages. He didn't know that his work was quirky. He thought he was painting straight."[1]

Though ethnicity and religion were not his only sources of creative energy, his treatment of religious subjects seems to have been particularly inspired. In the 1960s, according to McCarthy scholar N. F. Karlins, the artist painted several works based on religious themes, in-

cluding Christ entering Jerusalem, the Last Supper, and Noah's ark. Although McCarthy frequently drew from popular sources, the prototypes for these works remain unknown.

Christ Entering Jerusalem, c. 1960s (cat. no. 92), demonstrates McCarthy's ability to take a dramatic narrative and infuse it with vigor. The biblical passage upon which this work is based begins with Jesus' appearance at the Mount of Olives, where he instructed his disciples to bring him an unbridled colt. It continues: "And when he was come nigh, even now at the descent of the Mount of Olives, the whole multitude of the disciples began to rejoice and praise God with a loud voice for all the mighty works that they had seen" (Luke 19:37). The rejoicing of the multitude is energetically conveyed, as many of Jesus' followers are depicted with outstretched, welcoming arms. McCarthy also masses the figures, intensifying the drama of the worshipers crowding around Jesus, who is placed in the central foreground, riding a colt. The dark, painterly background thrusts the pale-robed foreground figures into high relief. Among the crowd is a figure in a rich purple robe that lends variety to the assembly of light-colored robes and compositionally integrates the lighter and darker elements of the whole. The figures are representational yet painted in an expressionistic manner, with their clothing and facial details only broadly suggested.

Noah's Ark, c. 1966 (cat. no. 99), probably painted during the same period, also demonstrates McCarthy's dramatic ability—this time not by massing elements in the drama but by using a brilliant background color against a huge ark visible in shadow in the central ground. The broad brushstrokes and the background's orange and gold take on a fiery glow. More concerned in this work with the general emotional atmosphere, McCarthy does not detail the multitudes of animals entering the ark. Instead, he shows only a pair of giraffes entering the ark from the side as another pair of animals enter from the front.

93. *Two Women in the Snow*, c. 1920

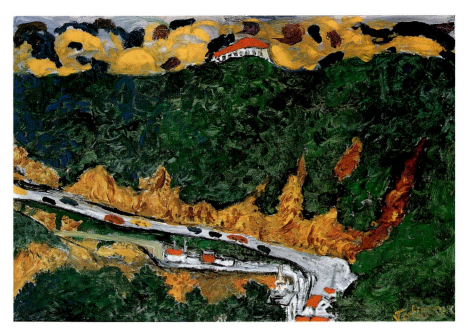

97. *Jim Thorpe Highway*, c. 1962

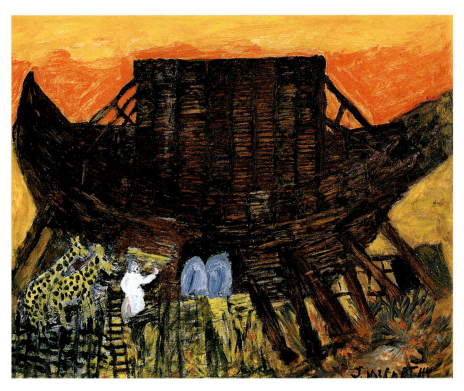

99. *Noah's Ark*, c. 1966

Popular culture was a major influence on McCarthy. He drew inspiration from the "funny papers" and, according to McCarthy scholar Nancy Thoman, used comic strips in two ways. Sometimes the drawings, sketched quickly, seemed to suggest a thematic narrative. But just as frequently, McCarthy used the cartoon format, arranged in compositional tiers, to present faces, busts, and full-figured characters.[2] In *Cartoon Series*, c. 1930s (cat. no. 94), faces with exaggerated noses, mouths, and chins are highlighted by shaded, inked outlines. Interspersed among the heads (which also depict varying expressions, from grimaces to worried glances to broad grins) are what appear to be more personal references: a self-portrait (bottom tier, third from left) and a train (second tier), a possible reference to McCarthy's good friend Jack Savitsky, who often drew and painted trains. Another face on the bottom left resembles Jiggs, a former mason and millionaire in the popular syndicated cartoon *Bringing Up Father*. McCarthy's cartoon drawings also refer more generally to other cartoon characters of the twenties and thirties—Jitney Jessie, Purple Pennyless Peer, Gasoline Alley, Moon Mullins, the Gumps, and the Katzenjammer Kids.

Justin McCarthy also loved to paint vegetables and fruit. In an early work in watercolor, *Cherries*, 1920 (cat. no. 95), the main subject is identified by text reference and by six bright-toned red and numerous yellow examples, all spread on the surface with no overlapping of fruit or leaves so that each is seen in its entirety. Such stylistic devices also characterize McCarthy's still lifes in later years.

McCarthy's favorite subjects, though, were women. According to Ute Stebich, curator of his solo exhibition at the Allentown Art Museum in 1985 and author of the exhibition catalog, McCarthy was "too shy for courtship in real life; women were admired, adored, caressed, flirted and fought with through his art."[3] Sometime during 1920, while he was institu-

tionalized, McCarthy created *Two Women in the Snow*, c. 1920 (cat. no. 93), and signed it with the pseudonym Prince Dashing. The composition depicts two pretty young women in woolen caps, mufflers, and belted tunic sweaters, modeling their chic outfits to attract the viewer's attention. The watercolor, created with a secure hand, belies the problems that McCarthy must have experienced during his breakdown and recuperation. Indeed, his art may have been part of his healing process. A burst of artistic expression following an accident or a traumatic experience is illustrated in the lives of other self-taught artists, such as Jack Savitsky, Mose Tolliver, and Martin Ramirez.

Even after his release from the hospital, the world of fashion, models, celebrities and the glamour they evoked continued to be appealing subjects for McCarthy. *Fashion*, 1967 (cat. no. 98), set against a backdrop of what appears to be a bridge in Paris, epitomizes the look of high fashion. While the images seem to come directly from *Vogue* magazine (all the stylistic elements were current in 1967), the exact source, if there is one, has not yet been identified. As in the earlier watercolor, *Two Women in the Snow*, the models are prominently presented in the foreground, each one conveying a particular "look." Three models appear to be wearing high, close-fitting black boots and black hats. The hats vary from a wide-brimmed homburg to modified opera and English riding hats. The middle model's hat sits above a red, snugly wrapped head scarf. The model on the left wears a long-sleeved, A-line mini-dress that is softly tied at the waist. The central figure wears a white tattersall pantsuit or split skirt topped by a thigh-length coat. The model on the right, in her elegant black turtleneck and mini-length sheath dress, is reminiscent of Audrey Hepburn; Hubert Givenchy, who designed many of the actress's outfits, had designed a similar black sheath dress during this period. McCarthy may have been inspired by several of Hepburn's

94. *Cartoon Series*, c. 1930s

95. *Cherries*, 1920

roles, including her part in *Funny Face* (1957), in which fashion and grace were important elements. McCarthy's brushstrokes are vigorous, his style painterly. Details are pared down to essential elements and are delineated expressionistically so as not to compete with the broader outlines or lessen the dramatic impact of the main subjects. Thus the street lamps and bridge in the background are subdued, grayed, and tonally softer than the main subjects. Paler yet are the whitish pavement and the sky. The entire painting is perfectly balanced and tonally orchestrated.

McCarthy painted views of Mauch Chunk, also known as Jim Thorpe (cat. no. 97), several times. Located in the foothills of the Poconos, this town of approximately five thousand people is near Flagstaff Mountain Park, which offers a splendid view of the town and the adjacent valley from an observation deck. The town is approximately sixteen miles from Weatherly, and it made a perfect setting for McCarthy's landscape interests. With oil on Masonite, McCarthy painted the scene from above, freely interpreting perspective to include Highways 209 and 903 along with some of the town buildings. The Gitter-Yelen landscape is typical of McCarthy's plein air paintings, as are several views of the Delaware Water Gap and renditions of the Lehigh division of the Bethlehem Steel Company. Multiple perspectives seen simultaneously; broad abstraction of the land, sky, vegetation; and winding roadways rendered with intense color and vigorous brushstrokes are stylistic hallmarks.

McCarthy loved nature and created hundreds of drawings and paintings of animals, flowers, and insects. *Lion and Cub,* c. 1962 (cat. no. 96), conveys the sympathy that McCarthy felt for the king of beasts by emphasizing one of the gentler aspects of the lion—the artist depicts the animal nurturing what may be one of its cubs. Though it is placed in the foreground, the reclining cub is only hinted at: McCarthy wants the lion to be his singular focus. The kindly animal seems to have a smiling expression articulated in dark outline features, lending definition to a whitish face and body capped by a full, softened, reddish mane. The yellow-green foreground and bluish-green background add a verdant context to this serene study.

During his forty-year career as an artist, McCarthy continued to explore new media and techniques. His paintings are in many major collections, and his reputation continues to grow. His transformative artworks exemplify an independent spirit and identify one of the twentieth century's major artistic voices.

—L.K.

NOTES

1. Telephone interview with Sterling Strauser, conducted by Linda Hartigan, August 10, 1989.

2. Nancy Green Karlins Thoman, "Justin McCarthy: The Making of a Twentieth-Century Self-Taught Painter," Ph.D. diss., New York University, 1986, p. 79.

3. Ute Stebich, *Justin McCarthy,* exhibition catalog (Allentown, Penn.: Allentown Art Museum, 1985), p. 7.

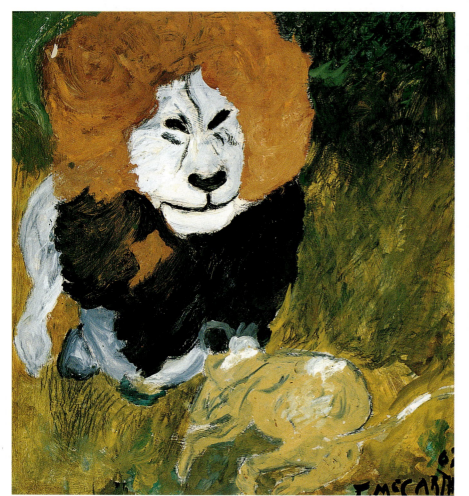

96. *Lion and Cub,* c. 1962

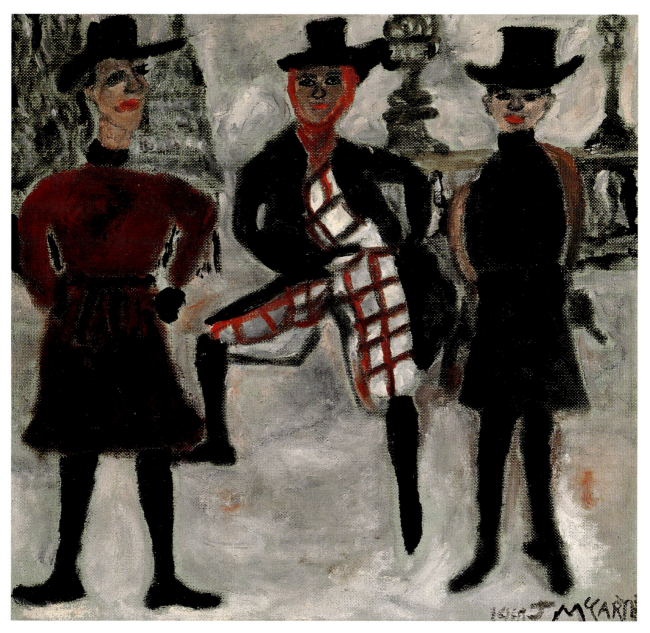

98. Fashion, 1967

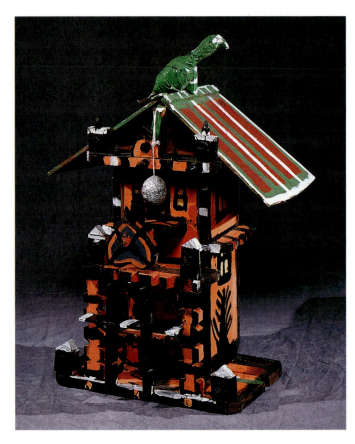

100. *Birdhouse* (orange, black, green), c. 1988–89

Willie Massey

Born in rural Brown, Kentucky, around 1908 to a family of sharecroppers, Willie Massey never traveled more than a few miles from his birthplace. He attended elementary and high school in Warren County, Kentucky, married early, and for more than seventy years worked on a farm owned by the Bohannon family.

In 1955, following the death of his wife, Massey began to create art, and when rheumatism forced him to retire from farming, he devoted himself full-time to his artistic career. Massey's works may be grouped into three categories: birdhouses (for which he is best known), miniature furniture, and paintings.

Perhaps the most interesting and the most complex are the polychromatic, multilevel birdhouses that he built from pieces of scrap wood. These structures were decorated with contrasting colors of enamel paint, inverted wooden hearts, buttons, balls of aluminum foil, and birds

modeled from foil (cat. nos. 100, 101). The birdhouses range from seventeen to thirty-six inches tall, are usually multi-level "condos," and display birds perched on the roofs and terraces. Most of them include small balls formed of crumpled aluminum foil. While the purpose of these balls is not known, they appear in both stationary and suspended positions on both the outside and inside of the houses, and they probably represent suet. Massey used a variety of wooden cast-offs in the construction of his bird-houses; his favorites were orange crates.

The birds that perch on Massey's condos are unique. Fashioned entirely of aluminum foil, they are sculpted without wings and therefore are incapable of departing from the symbolic domiciles of which they are an integral part. The concept invites speculation about a pos-sible analogy between the land-bound feathered creatures and the artist's own

nonmigratory lifestyle. (As a gesture of gratitude for Massey's many decades of sharecropping on their farm, the Bohan-non family deeded to Massey the small house in which he had lived for most of his life.) In fact, the rootedness of the artist and the absence of modeled wings on the birds are probably not symboli-cally related. It is more likely that Massey experienced difficulty in fashioning birds with attached wings of aluminum foil, and he therefore painted wings on the birds' bodies instead. This theory is sup-ported by the fact that all of the birds in Massey's paintings are depicted with wings.

Massey's miniature furniture is another aspect of his woodworking abil-ity. Employing pieces of scrap wood like those he used to build birdhouses, Massey created a number of small pieces of furniture, including side chairs, arm-chairs, rockers, tables, and benches. It

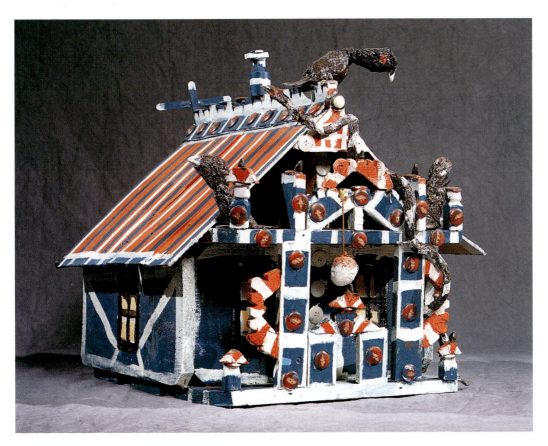

101. *Birdhouse* (red, white, blue), c. 1988–89

is not clear whether Massey made these small-scale pieces as independent artifacts or as models for full-size examples that he hoped to create. (In any case his advanced age and physical limitations would have made it difficult, if not impossible, for him to build standard-sized furniture.) Too large for dollhouse furniture and too small for displaying dolls, these little works must be classified as simply wooden constructions.

Most are armchairs with broad seats, wide armrests, and slat backs. Finished examples are painted in bright enamel colors and do not conform to any period or style of furniture other than those of Massey's own creation. A typical example is a rocker painted bright orange and accented with green (cat. no. 104). The chair has broad armrests; a wide, splayed seat; a crested apron; and a slat back flanked by curious, unevenly splayed spindles with knoblike terminals.

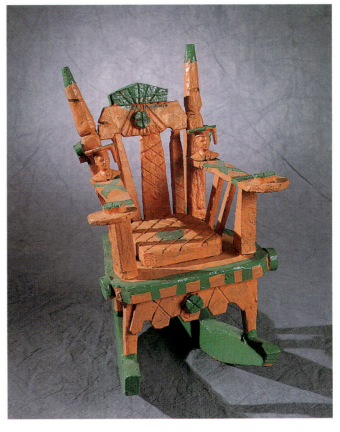

104. *Rocking Chair* (orange, green), 1989

Another unusual aspect is the "upholstered" cushion that is a part of the chair's design. In addition to decorating his furniture designs with bright colors, Massey was fond of incising lines and gridlike patterns on the wooden surfaces.

Massey's paintings provide an opportunity to assess his two-dimensional art, which in style contrasts sharply with his wooden constructions. The works are generally small and are painted in acrylics on board and stretched canvas. Massey's paintings depict only one or two objects; his subjects include birds, serpents, alligators, tigers, eagles, and other animals. Some of his paintings are embellished with buttons and pieces of aluminum foil.

Massey's method of painting was simple. Subjects were either outlined or silhouetted against a bright, solid background. He generally placed his single figures to the left in the paintings, and he usually balanced them on the right with a bare-branched tree that grows directly from the ground or is located on a steep hill. Figures appear in some of the paintings, as in the example with an alligator pursuing a delightful black-and-white striped serpent (cat. no. 102). (It is interesting to note that the motif of an alligator or crocodile chasing a serpent appears frequently in African American folk art and in West African wood carvings.) Celestial symbols, including stars, full moons, and crescent moons, function as upper-register spatial devices that reinforce the groundlines. Massey used colors that were simple, bold, and often unmixed. He was obviously fond of birds, and they figure prominently in his two-dimensional designs. The feathered creatures are depicted both as land-bound and with their wings spread in flight. In many instances, Massey outlined his figures with black or white paint to accentuate their appearance against the solid backgrounds. The sometimes awkward naïveté seen in his birdhouses and miniature furniture is replaced in his paintings by a graceful lyricism. His use of curved lines, formal balance, playful depictions, and interesting color combinations reveals his considerable talent.

All of Massey's paintings are self-framed by one of three methods. One group of paintings on wooden boards was framed with strips from wooden orange crates and scrap pieces of wood. The strips were painted with bold, geometric stripes and other patterns, and many of the upper transverse members display crests similar to those on his miniature chairs. A second technique included painting a solid border on the perimeter and sides of a stretched canvas. The third and most innovative method involved painting the design on the reverse side of a stretched canvas and decorating the stretcher as a frame. Not only was this a clever substitute for a frame, but it also produced the effect of a scene enclosed within a shallow, diorama-like space.

Since most of his works are birdhouses and miniature furniture, Willie Massey may be best described as a mixed-media constructivist. Massey clearly enjoyed building things, and he perhaps would have preferred a career as a carpenter rather than a tenant farmer. Symbolism played an important role in his productions: His birdhouses were not designed to be inhabited, his sculptured foil birds possessed no "real" wings, and his delightful pieces of furniture were not functional. Unfortunately, the symbolism of his designs may never be fully understood. His productive career ended in 1990, when he died as a result of burns suffered in a fire at his home. —R.P.

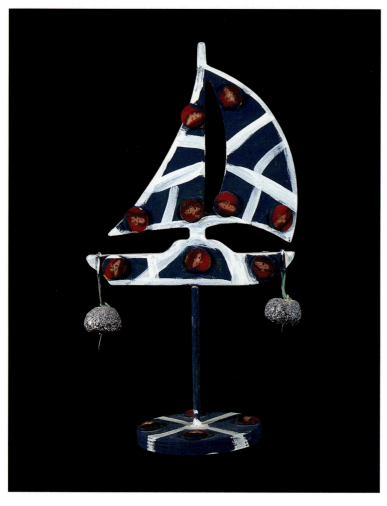

103. *Sailboat*, c. 1988–89

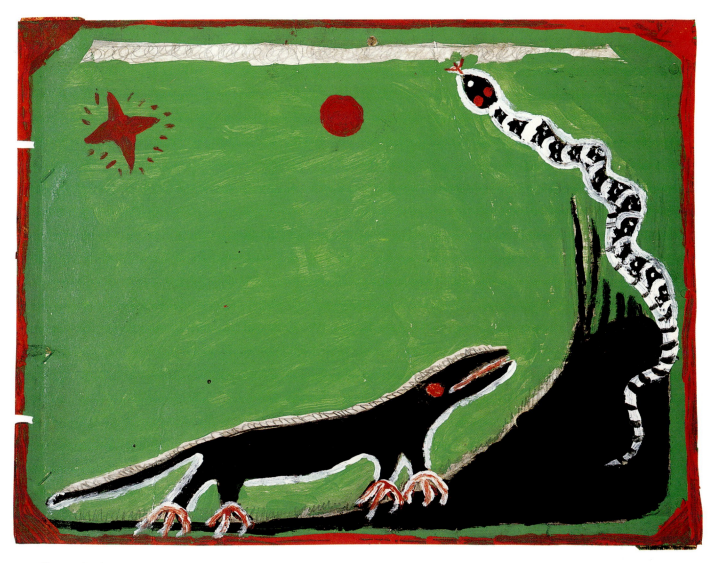

102. *Alligator and Snake*, 1989

Reginald Mitchell

Hundreds of artists try to capture the flamboyant spirit and architectural diversity of New Orleans. Reggie Mitchell, a young man who has been drawing since he was about fifteen years old, paints vibrant and expressive images of New Orleans's landmarks and street life which, while recognizable, often display a distorted treatment of perspective and scale. This skewed perspective, however, instead of detracting from the compositions, gives them a rhythm and energy evocative of the city's character. Art historian Regenia Perry, in writing about Mitchell, attributes this distortion to the fact that Mitchell is dyslexic. "Figures sometimes loom larger than houses, street scenes are depicted from aerial views, porches and balconies curve and bend so low that they touch the ground."[1]

Mitchell's dyslexia and the misunderstanding of his special needs and special gifts exacerbated a difficult childhood already made harsh by poverty. Born to a fifteen-year-old mother in New Orleans's Calliope Housing Project, Mitchell, because of his learning disability, was scorned by some family members and teachers, who thought him unable to learn, or "slow." As a consequence he dropped out of school in the fourth grade. In addition, Mitchell sometimes stutters and walks with an uneven gait, causing those who are unaware of his physical and mental handicaps to assume he is drunk or on drugs.

Besides the ridicule that surrounded much of his growing up, he was plagued by an environment of violence. Perry states that his childhood memories are "filled with ducking bullets and witnessing murders and other violence in his housing project, as well as having it directed toward him." Mitchell's drawing began as a way to escape from this environment. Although those who saw his work initially were not supportive and derided his efforts to make art, Mitchell continued to draw and found in this pursuit a means of coping with his violent and lonely world.

Mitchell began drawing still lifes in pencil on paper. According to Perry he is "a superb draughtsman with his own unusual sense of line and perspective. . . . Reggie's drawings are pages completely filled with sensitive renderings of the minutiae of everyday life—furniture, cereal boxes, electric fans, umbrellas, table lamps, roach spray." He began by drawing the simple yet numerous and varied objects that are directly observable in his world.

About 1989 or 1990, Mitchell began coloring his drawings and later painted them in acrylics. He paints on a variety of surfaces including poster board, cardboard, paper, canvas, and found objects,

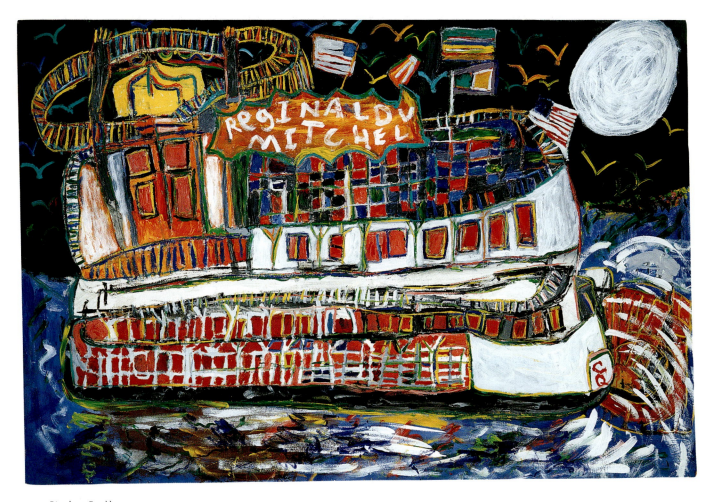

105. *Riverboat Gambler*, 1993

including lampshades and tabletops. Mitchell begins his paintings by making preliminary pencil sketches on his ground and then applying layers of acrylic colors in a thick impasto. His use of color is very sophisticated, and he creates complex arrangements of pattern with intense color. As he has continued to develop, he has also increased the scale of his paintings. Early works are small, approximately twelve by sixteen inches, whereas his recent paintings are twice to three times as large. This size increase is attributable to a greater confidence in his ability as well as a greater range of subject matter. Mitchell has moved from small still lifes to large scenes of New Orleans's homes, buildings, and street life; portraits of friends; and steamboats and floating casinos on the Mississippi River, such as his *Riverboat Gambler*, 1993 (cat. no. 105). *Riverboat Gambler*, like all of his work, is characterized by vibrant and energetic handling of color and distinctive perspective and spatial relationships. —G.A.T.

NOTE

1. All of the information regarding Reginald Mitchell has been provided by Barristers Gallery, New Orleans, and Regenia A. Perry, "The Kaleidoscopic World of Reginald Mitchell," *News Bulletin for New Orleans Leisure Club and Folk Art Collectors Guild* (New Orleans, 1992), no pagination.

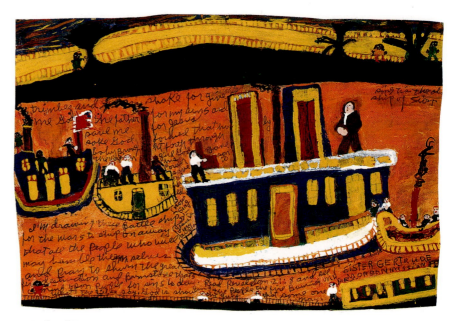

106. Ship of Zion, c. 1970–75

Sister Gertrude Morgan

When Gertrude Morgan was a child growing up in Lafayette, Alabama, where she was born in 1900, she frequently amused herself by using twigs to draw pictures in the sand in her family's yard. One day she drew a train with a waving female passenger, and her mother predicted that she would travel. Indeed, Morgan moved from Lafayette to Columbus, Georgia, during her early adulthood and in 1939 arrived in New Orleans, where she remained until her death. The reason for Morgan's relocation to New Orleans is not clear. She apparently had been married in Columbus, but she had separated from her husband, who did not accompany her to New Orleans, and she had no children.

Shortly after arriving in New Orleans, Morgan became affiliated with a group of street missionaries who specialized in praising God through music and dancing. During the early 1940s, Morgan adopted the title "Sister," and she and other missionaries of her "Holy and Sanctified" denomination wore black robes while preaching and conducting meetings. In 1959 Morgan had a vision that revealed she was the chosen bride of God. After that time, she wore only white apparel to symbolize her marriage.

Morgan and two other street missionaries, Mother Margaret Parker and Sister Cora Williams, operated a chapel, a shelter for runaways, and a childcare center in the Gentilly section of New Orleans for twelve years before their building was destroyed by Hurricane Betsy in 1965. Morgan had begun painting around 1956, but after the hurricane she pursued her art with much greater intensity. She also went to live with Mother Parker in her small house in Arabi, a community in New Orleans's lower ninth ward. After Mother Parker died, her heirs decided to sell the house where she and Morgan had lived, and it appeared that Morgan would be homeless. A French Quarter art gallery dealer who was familiar with Morgan's paintings and her plight purchased the tiny home and permitted Morgan to live there in exchange for paintings. Shortly afterward, Morgan transformed the small house into the Everlasting Gospel Mission, and she painted the interior and its furnishings white. The little mission house became the center of Morgan's universe, a sanctuary from which she rarely ventured other than to appear annually at the New Orleans Jazz and Heritage Festival. Her dealer constructed a small, white portable tabernacle in which she sat at the festivals, singing and chanting in her rich gravelly voice, using a megaphone of her own construction and selling her paintings for small sums compared to current prices.

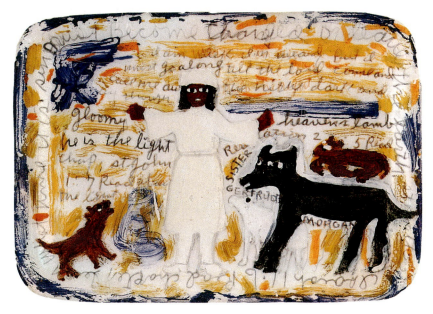

107. *God the Light of the City (Sister Gertrude with Black Dog)*, c. 1970–75

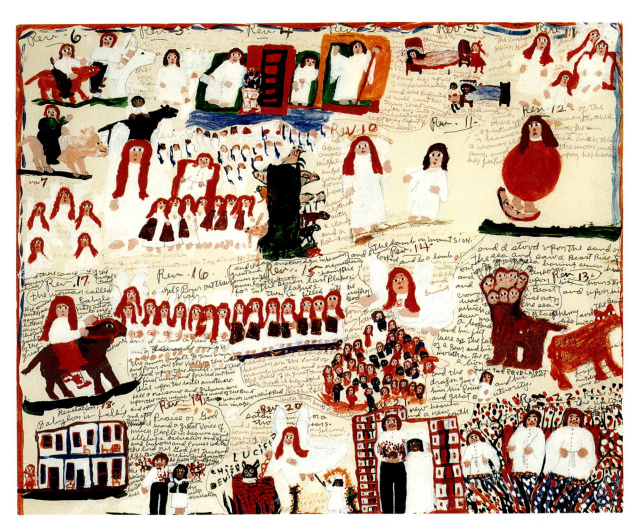

108. *John the Revelator (Revelations)*, c. 1970–75

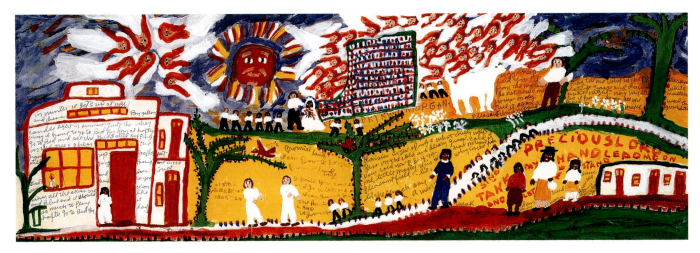

109. *Precious Lord*, c. 1970–75

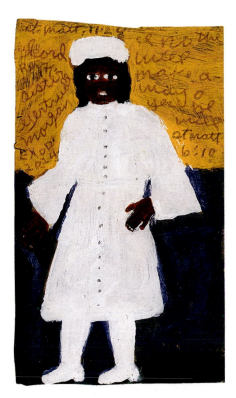

110. *Self-Portrait*, c. 1970–75

It is important to remember that Gertrude Morgan did not consider her paintings art but vehicles for teaching the word of God. When the "spirit" moved her, Morgan painted on any available material: cardboard, window shades, Styrofoam trays, plastic utensils, jelly glasses, wooden blocks, lampshades, picture frames, black-and-white photographs, her guitar case, fire screens, album covers, pillowcases, and the back of the "For Sale" sign that once stood in her front yard. Morgan created her designs with acrylics, watercolors, and wax crayons, outlining facial features and details with a ballpoint pen. She frequently wrote messages or quoted scriptural passages in her pieces, and her script forms an integral and vital part of the total designs. She usually signed but rarely dated her paintings.

Most of Morgan's paintings are religious in theme, often literal interpretations of biblical passages. She also painted a large number of self-portraits, depicting herself before and after her mystical marriage and clad in black or white, accordingly. Two self-portraits of the artist as the bride of God dressed in white are included in this exhibition (cat. nos. 107, 110). In some of her self-portraits, Morgan wears the black robe that predated her mystical marriage, and one unusual example depicts Morgan wearing white and seated on a sofa between Jesus and God.

A few of Morgan's paintings are autobiographical. A delightful example, entitled *Jesus Is My Airplane*, c. 1970–75 (cat. no. 113), shows Morgan and her heavenly bridegroom in an airplane flying among the heavenly host. The biracial couple tells the people that God said, "Wake Up, Look Up, Set Up, and Make Up Before It Is Too Late."

Morgan also painted a series of large, friezelike, narrative compositions that she called "charters." She illustrated them with pictorial representations from the Bible, some from the book of Revelation (cat. no. 108). Calligraphic verses link the flat, brightly colored scenes, creating an overall effect of compositional unity. After 1970, Morgan appears to have been preoccupied with representations from the book of Revelation that deal with the Second Coming of Christ. A number of paintings from this period depict the New Jerusalem described in Revelation 21:2: "And I, John, saw the holy city, New Jerusalem, coming down from God out of heaven, prepared as a bride adorned for her husband." A splendid example of this theme, and one of only two large versions completed by Morgan, is included in this exhibition (cat. no. 111). One of Morgan's finest paintings, it depicts the New Jerusalem as a multilevel structure. The cross-section view reveals empty chambers, Christ preparing for his marriage to Morgan, and the wedding cere-

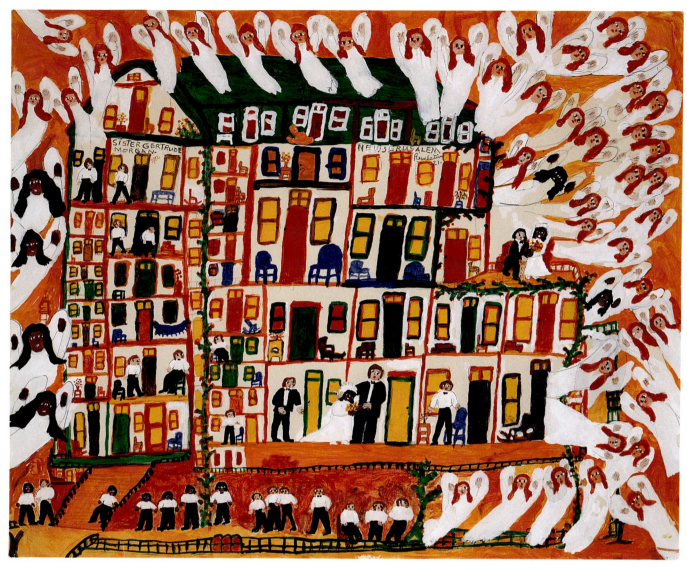

111. *New Jerusalem*, 1972

mony. Children from all nations and a great heavenly host are in attendance.

Morgan also made hand-constructed, handpainted cardboard fans to give to friends and to pass out during the prayer sessions in her missions (cat. no. 112). She embellished some of them with original poems, such as the following:

> Jesus is my airplane
> He holds the world in his hand
> Lord Jesus is my airplane
> Guide me through the land.

Morgan was a gifted poet, and some of her poems were set to music. She played the piano, the tambourine, and the guitar, and in 1971 the British-owned label, True Believer, recorded in her prayer room an album of her original song prayers, *Let's Make a Record*. She provided her own accompaniment, using a tambourine to complement her rich alto voice. The only financial remuneration that Morgan received from the recording was a box of thirty-five albums, and since she did not own a record player, it is unlikely that she ever heard the album.

The paintings by Gertrude Morgan in this exhibition belong to her middle period, around 1970–75, when her finest and most vibrant works were produced. The Gitter-Yelen collection includes many of her largest designs, including *Precious Lord*, c. 1970–75 (cat. no. 109); *Christ before the Multitudes, Christ at the Door, and the Raising of Lazarus*, c. 1970–75 (cat. no. 114); and *Dwelling Place* (a variation on the New Jerusalem theme). All of these paintings are proleptic (combining two or more scenes in the same composition) and narrative. The painting in which Morgan depicts Christ three times is especially masterful (cat. no. 114); here Christ is seen preaching to the multitudes, knocking on a door, and raising Lazarus from the dead. Morgan's storytelling abilities are considerable; her colors are bright and vibrant; and the numerous figures

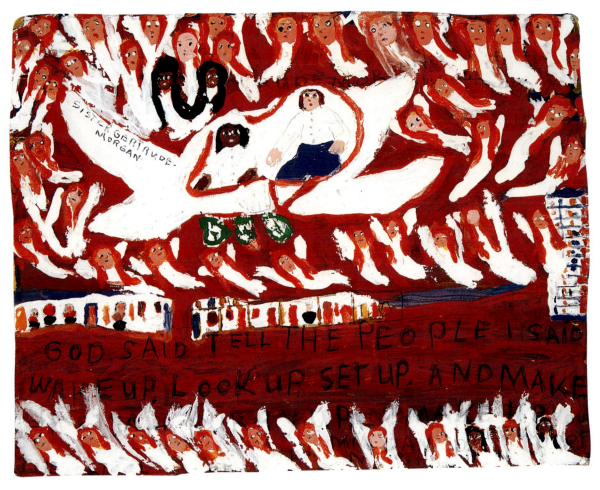

113. *Jesus Is My Airplane*, c. 1970–75

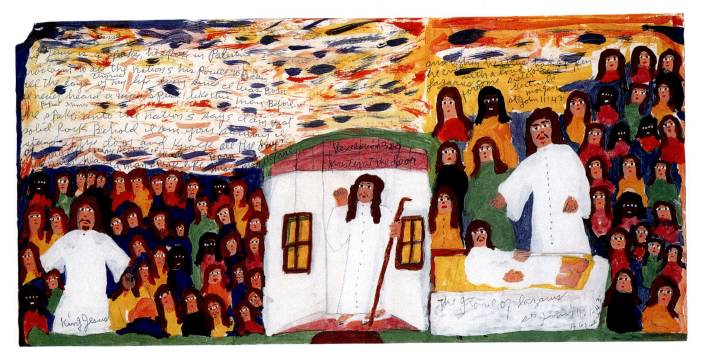

114. *Christ before the Multitudes, Christ at the Door, and the Raising of Lazarus*, c. 1970–75

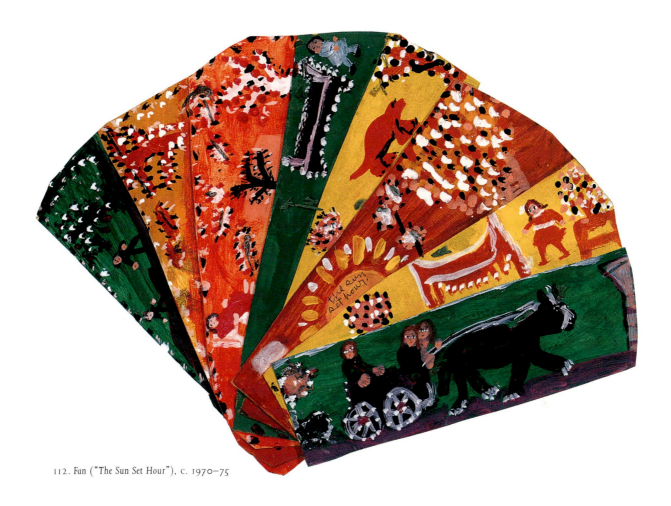

112. Fan ("The Sun Set Hour"), c. 1970–75

in the paintings always seem carefully ordered.

Morgan's earliest paintings were small, and she rendered them on paper and cardboard, using watercolors that she purchased from local variety stores. After she was discovered as an artist, her dealer furnished her with professional acrylic paints, but she preferred selecting her own painting surfaces. The late paintings were completed between 1976 and 1978, and they are very different in style and execution. After 1975 Morgan declared that Christ directed her to stop painting and to devote herself full-time to preaching his word. Her paintings thereafter are small, contain figures that are not clearly defined, and display confetti-like backgrounds. Her declared directive from Christ may account for the sudden drop in production, but there is no known explanation for the decline in the quality of Morgan's paintings after

1975. It seems that, as the popularity of her paintings increased, her interest in producing them decreased.

Although Morgan's artistic output was prodigious, the largest body of her work consists of letters, poems, and biblical writings. Gertrude Morgan was a fervently religious person, and her contact with the world outside her mission was minimal. A visit to her prayer room in the Everlasting Gospel Mission was a unique experience. One was ushered into the all-white room, seated in a white chair, provided with one of Morgan's handmade fans, and required to participate in the prayer session, which always included singing. During her last years, Morgan lived in absolute poverty. Since she did not pay rent at the mission, she accepted little money for her paintings. The mission was sparsely furnished, and she had no refrigerator. She rarely left the mission, some days declaring

that Christ did not want her to venture even into her yard. In the last two years of her life, Morgan produced no paintings and lived on small public assistance checks.

It was very difficult to converse with Morgan about her paintings because she was busy talking about the Lord. "I am a missionary of Christ before I am an artist," she stated. "Give all the fame to some other artist. I work for the Lord." Contrary to her self-assessment, Gertrude Morgan was an artist in the true sense of the term. Her seriousness of purpose, vivid imagination, gift of color, and intense religious belief resulted in a body of creative interpretations of the Bible that are among the most admired in the field of American folk art.

During the summer of 1980, Gertrude Morgan passed away in her sleep at the Everlasting Gospel Mission, leaving no known survivors. —R.P.

Mark Anthony Mulligan

"Mirth. It spills out . . . and colors everything he touches."[1] "Conveys his joyous love."[2] "Full of color and busy with life."[3] So have various authors described Mark Anthony Mulligan's art. As any examination of Mulligan's paintings will show, these are not the effusions of critics eager to celebrate yet one more talent among the self-taught artists who have flooded the contemporary art scene. Quite the opposite: They are fair descriptions of the work and, from all available reports, of the man himself.

Mulligan was born in 1962, so he is a relative youngster among contemporary artists. Thus it is not surprising that the world reflected in his paintings has the color, energy, layered imagery, and shameless hype of the television age or, perhaps more precisely, mirrors what I call the "MTV mentality."

Mulligan's *Is This Paradise?* 1993 (cat. no. 115), is a large acrylic painting on panel. Painted in bright colors and crowded with a restless sprawl of words and images inspired by the urban setting of his native Louisville, Kentucky, it is a virtual assault on one's visual sensibilities. Mulligan considers himself a "sign painter." On the one hand, he delights in quoting actual signs—"Exxon," "Winn Dixie," "Mobil," "Kmart"—that blink and shimmer with the energy and insolence of raucous neon. But Mulligan

also creates his own slogans, which at first glance seem as authentic as the others but prove to be mischievous parodies. Once aware of this game, the viewer is drawn into a more careful examination to discover how far this young artist can push his sense of the absurd. "Low Seat Pic-Pac Super Market"—I *assume* that there is no such place in Louisville! And "Garlic Fresh Bread Company"? Look for yourself. Be aware, however, that Mulligan is not setting out to indict our strident, intrusive consumer society. He loves it, celebrates it, and thinks it is great fun.

In *Is This Paradise?* Mulligan makes no effort to conceal the speed with which his gestural, high-energy technique enables him to complete a picture. Throughout, the brushwork is feverish, slanting and curving with the natural movement of the arm and hand. In this painting there are only a few places where the eye can "take a breather" before being jerked away and hurtled somewhere else. Along the bottom right edge of the painting, an inscription documents the fact that it took the artist just over three hours to paint this panel.

When I look at Mark Anthony Mulligan's paintings and think about how they might be described in terms of twentieth-century art history, the best summation seems to be an analogy: *Is This Paradise?* is something that might have resulted if Stuart Davis and Willem de Kooning had gotten together in one or the other's studio late one night and "jammed" for a few hours. —G.J.S.

NOTES

1. Dick Kaukas, "Mark Anthony Mulligan's Work Expresses This Young Artist's Joy for Life," *Louisville Courier-Journal*, August 8, 1991, pp. D1, D6.

2. News release, the Swanson Cralle Gallery, Louisville, Ky., undated (but after 1993).

3. Richard L. Westrup, "Mark Anthony Mulligan," *Folk Art Finder* 13, no. 4 (October/December 1993): 12–13.

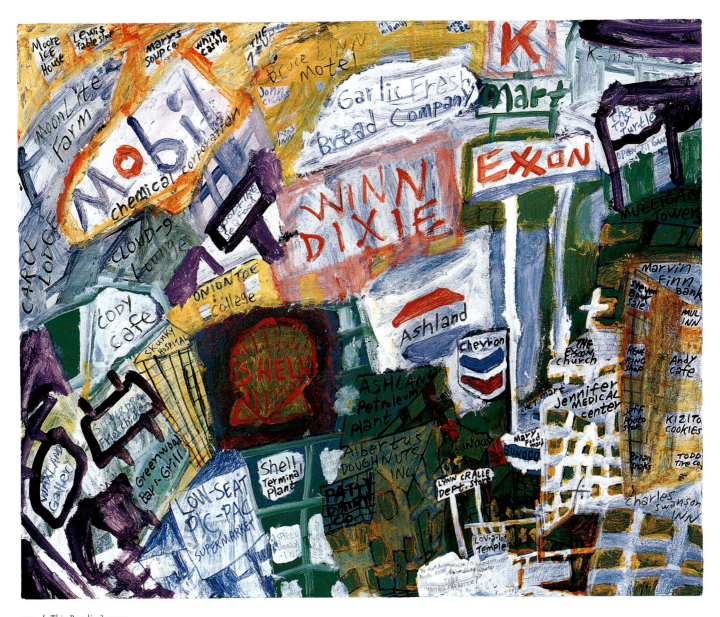

115. *Is This Paradise?* 1993

Edward Mumma

It is more than a little ironic that Eddie Mumma's career as a self-taught artist began with a formal art lesson. It was 1969, and he was sixty-one years old, a retired farmer and antiques dealer living in Florida and recovering from cataract surgery, when his daughter persuaded him to sign up for an art course. But he attended only the first class, refusing to return for subsequent sessions because the instructor criticized his work as "sloppy." This rebuff may have soured him on formal art studies, but something about that one experience in an art class apparently stimulated in him a sudden desire to make art. Soon afterward he began painting on his own, and this activity quickly turned into an obsession. He devoted the last seventeen years of his life to this pastime, despite the fact that he received little encouragement or financial reward for it. His work remained unknown to the public until after his death in 1986.[1]

Born in 1908 in the small town of West Milton, Ohio, Mumma was of Pennsylvania Dutch ancestry. Little is known of his early life except that he dropped out of school after the eighth grade and spent part of his youth or early adulthood as a hobo, traveling around the country in railroad boxcars and picking up odd jobs when he could find them—a lifestyle that wasn't un-common in this country during the 1920s and 1930s. He ended this period of relatively aimless travel by 1936 or 1937, when he got married and settled into the life of a farmer.[2] In 1941 he bought a small farm near Springfield, Ohio, where he and his wife lived for many years. Mumma grew and sold vegetables, and later he began a sideline business as an antiques and junk dealer. He and his wife had one child, a daughter, who is shown with them in the 1940s studio portrait of the family that seems to be the only known photograph of the artist.[3]

Mumma's wife died in the 1960s, and he reportedly stopped working and began drinking heavily in the wake of his loss. Then, in 1966, he moved to Gainesville, Florida, where his daughter was living. He sold the farm in Ohio and used the income from the sale to buy two small houses in Gainesville—one to live in and the other to rent out. He spent his last twenty years in Gainesville, and although this was an artistically fruitful period for him, it was also a period of declining health and physical suffering. In addition to cataracts and a drinking problem, Mumma had diabetes, and complications stemming from this disease eventually necessitated the amputation of both legs—the left one in 1970 and the right fourteen years later. Still, he managed to produce approximately one thousand paintings between 1969 and 1986, and when he died most of these were still in his house, where they covered every wall.

Mumma (or "Mr. Eddy," as he liked to call himself) occasionally painted landscapes and animal images, and he even attempted his own renditions of famous paintings by Leonardo da Vinci and Vincent van Gogh.[4] But the vast majority of his paintings are variations on a single image—a loosely abstracted human face and upper torso with hands held at chest level—rendered in acrylic on Masonite, wood, or canvas, and exemplified here by *Untitled*, c. 1970–80 (cat. no. 116). He varied the color combinations with each painting, but consistent throughout the series are his loose, bold brushstrokes and this recurring image, which vaguely recalls masklike faces in the art of pre-Columbian Mexico and other non-Western cultures. It has been suggested that this image might be a self-portrait; if so, it appears to represent Mumma as he ardently pleads for understanding or attempts to explain something. With its wide eyes and open mouth, this face is hardly expressionless, as some scholars have described it. And, simple as his imagery is, Mumma's handling of paint is quite sophisticated and somewhat reminiscent of techniques

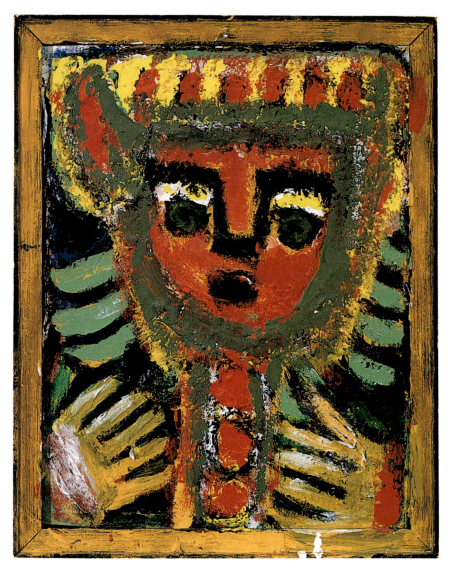

116. Untitled, c. 1970–80

used by certain modernist painters, including Georges Rouault and several of the Abstract Expressionists. Among other defining characteristics of Mumma's work are his frequent use of both sides of a painting surface and his preference for slapdash frames that he made from scrap wood and other materials.

During Mumma's lifetime the audience for his work consisted solely of those who visited his house, including a few college and university art teachers and students who also lived in Gainesville. Members of his family reportedly weren't interested in his paintings, and had it not been for the fortuitous intervention of a collector who happened to witness the family gathering for Mumma's funeral, his work might have been lost to posterity. The collector immediately negotiated to buy the bulk of the artist's remaining paintings, which have since found their way into several major exhibitions and books about self-taught artists.

—T.P.

NOTES

1. Biographical information for this entry is drawn from the following sources: Chuck Rosenak and Jan Rosenak, *Museum of American Folk Art Encyclopedia of Twentieth-Century American Folk Art and Artists* (New York: Abbeville Press, 1990), pp. 221–22; Frank Maresca and Roger Ricco with Lyle Rexer, *American Self-Taught: Paintings and Drawings by Outsider Artists* (New York: Alfred A. Knopf, 1993), p. 159; Alice Rae Yelen, *Passionate Visions of the American South: Self-Taught Artists from 1940 to the Present* (New Orleans: New Orleans Museum of Art, 1993), p. 321.

2. The Rosenaks cited 1936 as the year of Mumma's marriage, but Maresca et al. say he was married in 1937.

3. This photograph is reproduced in Claudia Sabin, *The Passionate Eye: Florida Self-Taught Art* (Orlando: Orlando Public Art Advisory Board, Orlando City Hall/ Terrace Gallery, 1994), no pagination. A detail from this same photograph, showing only the artist, appears in Yelen, *Passionate Visions of the American South*, p. 321.

4. According to Maresca et al., Mumma painted his own versions of the Mona Lisa and a van Gogh self-portrait in which van Gogh's ear is missing.

John B. Murry

The artistic productions of J. B. Murry are among the most nonrepresentational in contemporary American folk art. Few facts are available about the artist's early life. He was born in Glascock County, Georgia, in 1908 and remained in that area throughout his life. He was apparently unschooled, was married early to Cleo Kitchens, fathered eleven children, and worked as a sharecropper and farm laborer until a dislocated hip forced his retirement during the late 1970s.

Shortly afterward, Murry had a religious experience or vision that changed his life. He began communicating through an undecipherable "spirit script" of numerous serpentine and tadpolelike characters that later formed the designs of his well-known paintings and drawings.

Murry's earliest expressions in spirit script were apparently executed on scrap paper and cash-register tape, and his development as an artist was quite accidental. Unlike many self-taught artists, Murry neither considered himself an artist nor his writings works of art. He believed that the designs were communications from God and that while he was drawing, God guided his pen automatically across the paper. It is uncertain as to when Murry's writing passed into the realm of folk art. Following his discovery, he was provided with large sheets of colored paper, pens, colored pencils, and acrylic paint, and his career as a folk artist began.

The small frame house in which Murry lived alone in rural Georgia was in a remote location, and the artist's home never became a mecca for collectors and visitors, as is the case with many folk artists. His physical appearance was strikingly attractive: He was tall and slender, and his ebony-complexioned face with finely chiseled features was framed by closely cropped, stark-white

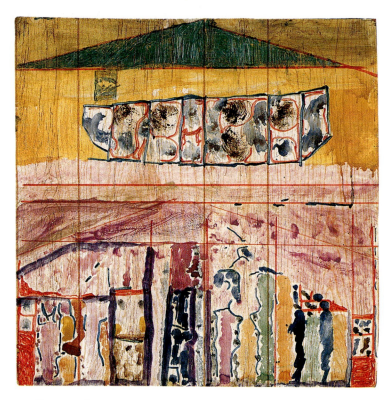

117. House, c. 1980

hair. He was shy and did not talk much about his art. In fact, Murry appeared to be most comfortable in the presence of visitors when he was "reading" his script through a glass or bottle of water and speaking in tongues (a ritual not unlike a West African divination process). By the time Murry's works became known to the general public, his artistic activities were largely regulated by several patrons who furnished his materials and discouraged him from selling his art or even receiving visitors in his home. In effect, Murry became a private art factory, producing large numbers of drawings and paintings that were regularly picked up by his patrons and exchanged for fresh art supplies. It is not known how Murry was financially compensated for his art.

Although many folk artists are deeply religious and several have written in undecipherable script (including James Hampton, creator of *The Throne of the Third Heaven of the Nation's Millennium General Assembly*, in the collection of the National Museum of American Art, Washington, D.C.),

Murry is believed to be the only known American folk artist who read his script while viewing it through a container of water. Murry's divining process was as interesting as his art and was in fact an integral part of it. When one witnessed the artist-diviner decoding his script through water obtained from a well in his yard, a transformation occurred: The introverted Murry became an intense, voluble person, speaking rapidly in unknown tongues while moving the jar of water back and forth across the surfaces of his colored drawings or lengths of cash-register tape. One immediately sensed that this was not hype or a publicity stunt, but the deeply emotional experience of a man who probably did not fully understand the implications himself. The spirit world of J. B. Murry appears to have been similar to centuries-old West African practices. Murry may not have been the only member of his family who practiced divining; he may have inherited the talent from a parent or grandparent. Diviners in West Africa still rely heavily on the use of water during

118. *Gray, White, Black, and Blue and Script Abstraction,* c. 1987–88

the divination process to depict the future, to heal, and to dispatch good or evil spirits. If Murry had been born in a West African society, he probably would have been a village diviner. Since he could not have been familiar with any aspects of West African culture firsthand, Murry's divination technique is yet another inexplicable "Africanism" that has survived in the African American culture of the Deep South.

Even setting aside the spiritual and mystical qualities of Murry's drawings and paintings, one must classify him as one of the most talented creators in contemporary folk art. He worked primarily on paper, using pen, colored pencils, felt-tip markers, and acrylic paint. His spirit calligraphy is arranged in horizontal or vertical registers that are frequently compartmentalized or confined within boxlike spaces. Murry's drawings and paintings are entirely different from the standard folk art repertory. There is little or no representational imagery. There are no animals, birds, or serpents; no references to religious, political, or patriotic themes; no reflections of the artist's personal experiences. And there is nothing to suggest that the artist was mentally unbalanced. First and foremost, Murry was a superb colorist whose adept combinations of subdued tonalities rival those of some of the most talented of academically trained artists. His skill in combining his original calligraphy with nonrepresentational areas of color reveals the innate abilities of an unusually talented designer. Murry's divining technique, spirit script, and inborn artistic impulses coalesced in a remarkable body of works, many of which bear an uncanny stylistic resemblance to Oriental screen painting and works by abstract expressionists of the New York School of the 1950s.

It is difficult to categorize stages or periods in Murry's artistic career. He apparently began writing in spirit script shortly after retiring in the late 1970s. Most of his works were completed during the last ten years of his life (he died in 1988), and his production is un-

120. *Pink and Yellow*, c. 1987–88

usually even. His early designs consist entirely of spirit script, and the middle and late works frequently depict a combination of the calligraphy with free-form areas of colors (sometimes outlined with black felt-tip marker) against a solid background.

Murry's works were included in several exhibitions during his lifetime, and he made at least one trip to Atlanta to view his art on display. To date, the most important exhibition to include Murry's works was the 1989 *Biennial Exhibition of Contemporary American Painting*, organized by the Corcoran Gallery of Art in Washington, D.C., one year after Murry's death. In fact, one of his paintings was selected to be the cover illustration for the invitation to the opening reception (cat. no. 122).

A painting entitled *House*, c. 1980 (cat. no. 117), which was also included

in the Corcoran show, is noteworthy for several reasons. It is one of the few works that the artist painted on a wooden panel and one of only several that contain semirepresentational imagery. The thinly painted panel is visually divided into two horizontal registers. A green, pyramidal, rooflike form floats mysteriously above a rectangular area filled with free-form patches of color. The lower register contains vertical areas of color with a few subtle renderings of what may be human forms. This painting probably belongs to Murry's early period, as do many designs that consist entirely of spirit script, sometimes in a calendar-like format (cat. no. 121).

The most typical works are those that combine calligraphy with free sections of color in vertical or horizontal registers (cat. no. 118; and cat. no. 119,

121. *Red and Black Script Abstraction*, c. 1987–88

122. *Untitled*, c. 1987–88

not illus.). The spirit script usually appears near the center of the designs, bordered by broad areas of circular, serpentine, and tadpolelike color segments. The energetic nonrepresentational areas that border Murry's calligraphy or, in some of his works, appear independently are themselves points of interest. Initially they appear to have been applied randomly. Closer observation reveals that some of the color areas are monochromatic and painted directly on the background of the colored paper, while other areas consist of mixed colors applied in overlapping layers on the paper's surface, resulting in constantly changing definitions of foreground, middle ground, and background.

Yet another category consists of paintings that are basically essays in color, with little or no spirit script (cat.

nos. 120, 122). These paintings represent Murry at the height of his artistic powers, and they are sensitive and lyrical in their subtle gradation of tonal values. Murry taught himself the age-old technique of allowing the watercolors to intermingle freely, creating blurred outlines. Some areas are defined by black, curvilinear outlines, while others are bordered only by neighboring colors or a minimalist application of spirit script. Murry's combination of simple color areas and calligraphy suggests a stylistic kinship with both Japanese painting and American abstract expressionism, neither of which could have directly influenced the Georgia artist.

J. B. Murry had an extraordinary ability to combine innumerable color areas and calligraphy in the same composition, to compartmentalize each

group in its own space, and to create a dynamic interplay of dark and light, large and small, and related and nonrelated forms. As is the case with the works of Thornton Dial, the talented, self-taught African American artist from Alabama, it is difficult to categorize many of Murry's works as folk art. The productions of both Murry and Dial may be compared favorably with some of the finest art currently being produced by academically trained professionals. Ultimately, the most appropriate classification for Murry is simply American artist par excellence. —R.P.

Morris Ben Newman

In writings about artists, it is a commonplace to draw congruencies between the details of the artists' lives and the style and iconography of their work. In Morris Ben Newman's case, the Edenic vision suggested by his painting *Landscape with New Flowers*, c. 1977–79 (cat. no. 123), resists yielding much of anything about the artist, one of the most remarkable, eccentric, visionary figures to have appeared on the contemporary art scene in many years.

Although living and painting in Cleveland, Ohio, in the 1970s, when his work was first noticed, Newman asserted that he was from another planet and, through 33,906 reincarnations of one hundred years each, was manifested on earth as a black Ethiopian Jew descended from King Solomon and the queen of Sheba. Clues to other of Newman's claims—that, for example, he was trained as a medical doctor, that he had studied and gained recognition as an artist in Europe, that as a priest-sorcerer he had conducted a school of voodoo in Haiti, that he had mastered astral travel, that he had learned "all the languages and the dialects of the world"—are hidden in the artist's eerie, evocative renderings of a world much like our own but somehow different, exotic.

For a number of reasons, *Landscape with New Flowers* could be called "classic"

Newman. The artist worked in house paint, temperas, and artist's oils on any support he had on hand, from traditional artist's canvas to bedsheets stretched on old frames, or from window screens to pieces of paper mounted on discarded cabinet doors with knobs and handles still attached. Here he chose to use a large, fabric window shade. The bottom edge is still intact, including a wooden strip faced with a row of decorative fringe that originally served to reinforce the fabric as the shade was raised and lowered. A process of "transformation" from a commonplace, somewhat precious article of interior decoration to a transcendent icon is obvious.

On this unlikely support, Newman painted a remarkable landscape that includes what he called a "new-flowers" motif: a cluster—sometimes a row—of brightly colored blossoms with green stems and leaves. "New flowers" is the translation of Addis Ababa, the capital of Ethiopia, the country Newman claimed as his birthplace. The new-flowers motif is a recurrent theme in Newman's paintings, which I take to signify not only the artist's professed place of origin but, more broadly, the principle of fruition and rebirth.

Vegetation cannot exist, of course, without water. Therefore, in his *Landscape with New Flowers*, Newman placed his

flowers among lakes and ponds of shimmering, pale blue water. Stretching away into the distance is a convincingly rendered representation of hills, suggesting cultivated fields and orchards—most certainly Newman's vision of Ethiopia. What is curious and significant about Newman's style is that he worked quickly and surely—there are rarely any "false starts" or overpainting in Newman's work. It is as though he were borne by an inspiration that, were it not recorded quickly and without too much deliberation, would not survive in the painting. While much of the composition of *Landscape with New Flowers* appears to conform to conventions adopted by many amateur artists, Newman makes clear how transcendent is the new-flowers motif: Bright spots of yellow and red, these plants are enormous in scale against the tree motifs around them. Furthermore, Newman's restrained palette—he favored quiet greens, grays, white, and black—creates a neutral backdrop against which the brilliant blossoms glow. Morris Newman does not paint "pretty" pictures. In all of his works, there is something dark, brooding, and ominous. Subtly but with great power, in *Landscape with New Flowers* Newman reveals something of his visionary world.[1]

— G.J.S.

NOTE

1. Very little has been written about Morris Ben Newman, who has only recently gained recognition on the contemporary art scene. For my information I am indebted to two of his acquaintances: Lee Garrett and Judith Bommer, who befriended Newman a few years before he died and who made the first efforts to promote the artist's work.

Other references to Newman's work are found in Gary J. Schwindler, *1 + 3 from Ohio* (Athens, Ohio: privately published, 1986); and *Contemporary American Folk, Naive, and Outsider Art: Into the Mainstream?* (Oxford, Ohio: Miami University Art Museum, 1990).

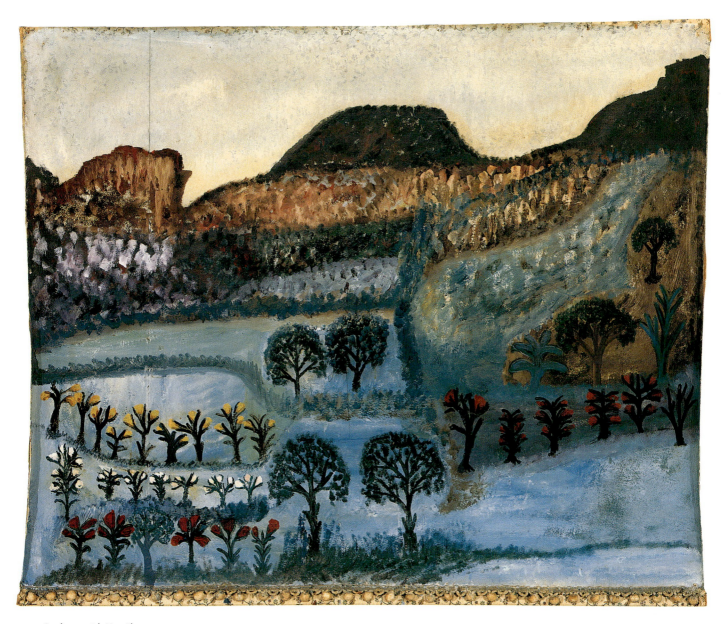

123. *Landscape with New Flowers*, c. 1977–79

Elijah Pierce

To those familiar with American art of this century, Elijah Pierce hardly requires an introduction. His humble birth in Mississippi, his emigration north, where he eventually settled in Columbus, Ohio, ran a barber shop, and served as an itinerant preacher, and then his rise to international renown as a wood-carver have been recounted many times in numerous exhibition catalogs and articles.

In a less public sphere, this man's quiet, courtly presence, his deep religious faith, and his profound sense of humanity endeared him to his community and to countless other people from every walk of life. Indeed, those who met the man, however briefly, consider the event a memorable life experience. Pierce's polychromed wood carvings include an enormous range of subjects from the secular to the religious, although it is clear that the latter were the most important to him. When he was in his thirties, he began this kind of work innocently enough, by carving a gift for his wife. Finding in wood carving an effective medium for the spreading of the Gospel, Pierce continued this work until his death.

When I began studying the wood carving (cat. no. 124) that appears in this exhibition, it was labeled "Head of Christ." In what appears to be a natural setting, it depicts Christ from the chest up. This is a powerful rendering of the great religious figure. His black hair, eyebrows, and beard contrast dramatically with his light brown skin—no doubt the artist intended to portray Christ as an African American. The large eyes, their whites set off by the dark centers, are lifted upward, as though he is seeking some connection with the heavenly realm. Christ's costume is simple. It consists of a brilliant white garment overlaid with crossing sashes or scarves, one a deep blue (perhaps suggesting

purple, the color of royalty), the other gray. His status as a sacred figure is indicated by a band curving around the top and left side of the head and painted to represent a halo. Beneath Christ is a wide, horizontal section embellished with distinctly carved rocks and flowers. Surrounding Christ's head and filling the top portion of the composition is a mass of leaves. Painted green, they are carefully arranged in rows, and their stems seem to converge toward Christ's head. Across the top of the panel is a patch of sky.

As I took more careful note of all these details, it became clear to me that Pierce intended to depict Christ at a stage of his Resurrection. His body is inclined slightly to the right, which I interpret as a gesture of upward movement. With his eyes cast upward, the Savior is emerging from the bed of rocks—surely a reference to the tomb. Of the four flowers, two seem to be red roses (the color referring to Christ's blood, the flower symbolic of martyrdom and of Mary), the other two red and pink carnations (possibly representing pure love). Together, these flourishing plants signify the indestructibility of nature or life everlasting: Christ has confounded death and is passing beyond the condition of mortality. The manner in which the leaves surrounding him have been shaped and placed to extend the radiant halo and the patch of sky above him suggests to me that heaven and nature are "welcoming" him—that is, drawing him forth, reborn. Considering these details, this work should be retitled *The Resurrection of Christ*.

Dated 1965, *The Resurrection of Christ* represents a phase of Pierce's artistic career when, at age seventy-three, he had evolved beyond his more polished, classical work of the 1940s and 1950s. In this particular piece, because its subject was so fundamentally important to Pierce's spiritual being, the artist was visited

with an enthusiasm and a surge of technical control so marked that the results are transcendent. Elijah Pierce's *Resurrection of Christ* is a masterwork of the artist's later period.[1]

—G.J.S.

NOTE

1. The literature on Elijah Pierce is considerable. The most recent, authoritative publication of which I am aware is *Elijah Pierce, Woodcarver,* the exhibition catalog produced to mark the Pierce retrospective held in 1992 at the Columbus Museum of Art, Ohio.

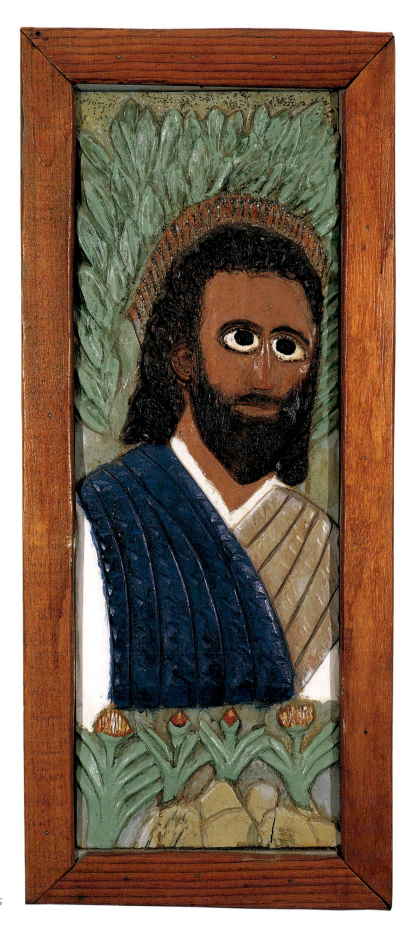

124. *The Resurrection of Christ*, 1965

Lamont Alfred Pry

Lamont Alfred ("Old Ironsides") Pry is one of the lively Pennsylvania artists whose work was first promoted by painter and folk art collector Sterling Strauser and his wife, artist Dorothy Strauser. In 1974, Peter Pfeiffer, the custodian for the Carbon County Home for the Aged, where Pry was a patient, called Sterling Strauser and asked him to evaluate some paintings hanging in the home's boiler room. The administration of the home had ordered them burned as part of a project to raze the building. The paintings turned out to be by Pry; the Strausers believed him to be a very good painter and thus acquired several of his works. Through the years, Sterling Strauser helped Pry by buying his artworks, bringing him supplies, and assisting him in entering several county fairs, among them the Lehighton County Fair, where he was awarded ribbons for excellence.

Pry was born in Mauch Chunk (now Jim Thorpe), Pennsylvania, on February 12, 1921. His father worked in the anthracite mines in the area. Pry had only nine years of schooling. In 1941, he enlisted in the U.S. Army Air Corps. He was severely injured when the B-25 he was in crashed on a routine reconnaissance mission, but he recovered. It is thought that he was nicknamed "Old Ironsides" at the hospital where he was sent to recuperate.

He returned to Mauch Chunk in 1943 to assist his ailing mother, working first in the civil service and then at a hospital in Gettysburg. He married and divorced his first wife, Virginia Logan, in the early 1940s and married for the second time in 1947. Following the death of his second wife, Myrtle Binder, in 1952, he suffered a heart attack. By 1968, his health had deteriorated, and he was no longer able to take care of himself. He entered the Carbon County Home. It was there that he began to paint on cardboard with house paint, enamel, metallic radiator paint, and poster paint. Following the razing of the home in 1974, Pry was transferred to the Weatherwood Home for the Aged in Weatherly, Pennsylvania. He remained in this newly constructed facility until his death in 1987.

Pry's painting *Ringling Brothers Barnum and Bailey Circus*, c. 1970–75 (cat. no. 125), which is made of poster paint on corrugated cardboard, is a vigorous work focusing on one of Pry's main interests. The circus was in his blood, so to speak. His father had regaled him with stories of his own youthful adventures with the Sells and Downs-Floto circuses. In his late teens, Lamont left home to see for himself what circus life was like, and he worked as a clown in such events as the Fireman's Carnival. However, as he said, he never made it to the big top. Yet he continued to be attracted to the circus, and it was the central subject of most of his 150 paintings. Other favored subjects include vintage airplanes, flowers, birds, farm scenes, cowboys, and Indians.

The large *Ringling Brothers Barnum and Bailey Circus*, a segmented composition that is among Pry's liveliest and most successful works, was kept for many years in the Strausers's personal collection as a "keeper." It combines many of the facets of the circus's main events and introduces another favorite subject of Pry's—Susy, a real or imagined heroine or possible love interest, identified in some of her appearances in Pry's paintings as Mrs. Susy Pry. The prototype for this ideal woman may have been imagined or may have been Susan Maury, a nurse at the Annie M. Warner Hospital in Gettysburg, where Pry was employed.

Here, Susy is featured in many of the simultaneous vignettes within the segmented composition: upside down in the zebra act, as the human stick, as the world-champion tightrope walker, as the world's greatest human cannonball, and as the world's greatest saw-me-in-half girl. These and other side events surround the central three-ring circus.

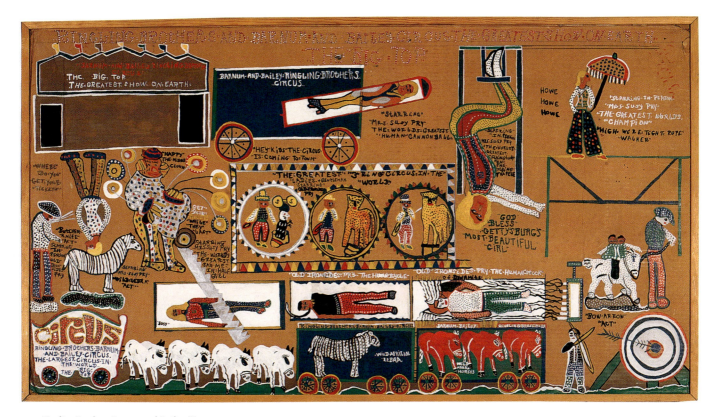

125. *Ringling Brothers Barnum and Bailey Circus*, c. 1970–75

Interest may be aroused by the ring on the left, in which a tamer is shown with a clownlike character balancing on his head weights that read "S." Is this an inside joke regarding Pry's friend Sterling Strauser or does it stand for Susy herself? The action-packed narrative has additional goings-on: a bow-and-arrow act, an oversized clown called Happy, a midget clown, and, finally, a display of animals in circus wagons along the bottom.

The viewer's attention moves from scene to scene, back and forth and around again, taking in this activity-packed spectacle, which, like the real circus, consists of a series of simultaneous events. Rectangles and circular patterns keep the eye moving, as do the bright, unmixed reds, yellows, blues, greens, and whites against the plain beige cardboard background. Perspective is generally flattened, with cross-section views providing unhampered access to the action. Simultaneous per-spective is also applied to show figures on the ground as well as upright. Proportion is imaginatively handled, with figures sized according to their compositional importance. The text accompanying the visual imagery serves sometimes to identify the performers, sometimes to convey the artist's thoughts.

Pry was an imaginative artist who had the good fortune to become part of the Strauser circle, which also included such notable self-taught artists as Justin McCarthy, Jack Savitsky, Victor Joseph Gatto, and Charlie Dieter. His early paintings are generally considered to be his best. These highly energetic, brightly colored paintings are included in a number of private collections and have been exhibited at the Abby Aldrich Rockefeller Folk Art Center, among other places.

—L.K.

Nellie Mae Rowe

"My work's guesswork," Nellie Mae Rowe told me in 1981. "I never had a chance to learn about it. I just guess at my work."[1] This was her way of saying she had never received any formal art instruction and was guided entirely by her imagination and intuition. "Most of the things that I draw, I don't know what they are by name," she explained to another interviewer. "People say, 'Nellie, what is that?' I say 'I don't know, it is what it is. That is all I know.' . . . I see what I draw in my mind late at night and I don't care how crazy it is, I'll probably draw it."[2]

Born Nellie Mae Williams on July 4, 1900, Rowe began drawing and making rag dolls as a child growing up with nine siblings on a small farm in Fayette County, Georgia. Her father, a former slave, was a basket maker and a blacksmith. Her mother, born the year the Civil War ended slavery in this country,

was a quilt maker and herbalist who sang hymns and played an old-fashioned pump organ. Like all creative children, Rowe considered her drawing and doll making a form of play, and in her case she used these activities as an escape from the drudgery of farm work, which she disliked. For most of her adult life she worked as a domestic in Vinings, Georgia, the small community north of Atlanta where she and her second husband, Henry Rowe, moved soon after their marriage in the 1930s. Together they built the three-room, wood-frame house where she continued to live after his death in 1948. She never remarried, but she did resume the drawing and doll-making pastimes she had enjoyed so much during her childhood, and she also began to decorate her house and yard with found objects. These activities rejuvenated her, in a sense, enabling her to cope with her husband's death while

experiencing again the freedom she had known as a child immersed in her own imaginary world. As she told me in 1981, "I had played as a child in a playhouse, and after my husband passed, I said, 'I'm gonna make me another playhouse.'"[3]

For thirty years Rowe lived a quiet, solitary life in her "playhouse," festooning its walls, windows, and grounds with children's toys, religious memorabilia, Christmas ornaments, costume jewelry, plastic fruit, artificial flowers, and other ordinary objects as well as hundreds of her drawings and other artworks. Ignorant passersby occasionally vandalized her property, and she was approached more than once by others who assumed she was a fortune-teller or "hoodooer."[4] But it wasn't until the late 1970s that her work came to be known in the art world, thanks largely to pioneer art dealer Judith Alexander. As a result of her fortuitous meeting with Alexander, Rowe spent

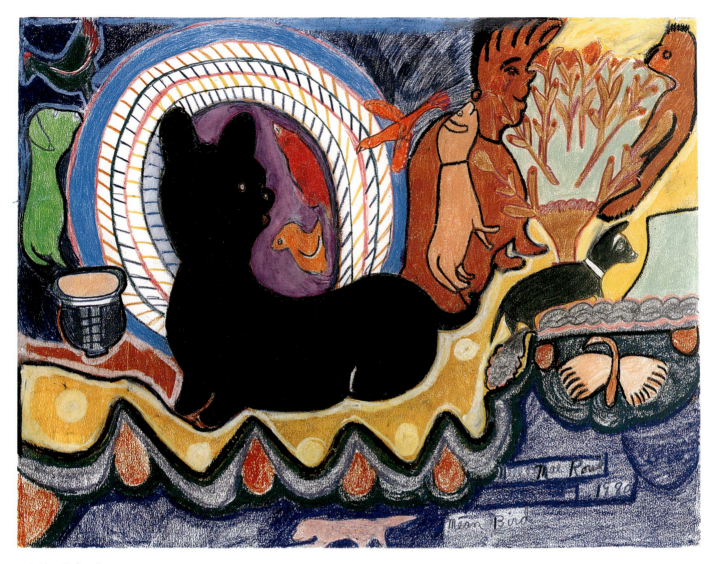

126. *Mean Bird*, 1980

the last five or six years of her life as a celebrated artist, creating pieces not only to ornament her own small domain but also for enthusiasts of folk and "outsider" art.

Although she continued to make dolls and also made collages, chewing-gum sculptures, and assemblage works, Rowe is best known for such lively, colorful drawings as *Mean Bird*, 1980 (cat. no. 126). With its array of imaginative bird and animal forms, a prominent tree of life, and a small self-portrait integrated into a composition that also features rhythmical geometric-abstract designs, this drawing is fairly typical of the work she produced during her twilight years.

Among its other striking qualities, it indicates an unconscious affinity with traditional art forms of which she had little if any direct knowledge—Haitian folk paintings, various kinds of African art, and even the mythological, boldly colored imagery of Mexico's Huichol Indians. Despite the battle with cancer that shadowed her last years, Rowe remained artistically active until her death on October 18, 1982. —T.P.

NOTES

1. Tom Patterson, "A Strange and Beautiful World," *Brown's Guide to Georgia* 9, no. 12 (December 1981): 52–53.

2. Judith Alexander, *Nellie Mae Rowe: Visionary Artist* (Atlanta: Judith Alexander, 1983), p. 11.

3. Patterson, "Strange and Beautiful World," p. 52.

4. Alexander, *Nellie Mae Rowe*, p. 9; Roy Blount, Jr., "Five Who Make America Great," *Parade*, July 4, 1982, p. 6.

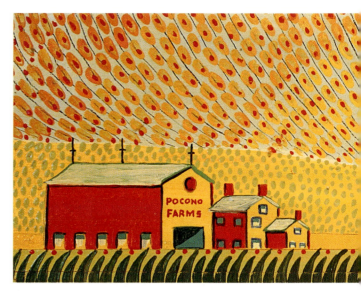

127. *Pocono Farms, 1962*

John Savitsky

An important figure in artist and collector Sterling Strauser's inner circle of artist-friends (which also included Justin McCarthy, Victor Joseph Gatto, "Old Ironsides" Pry, and Charlie Dieter), Jack Savitsky benefited from Strauser's patronage and encouragement. Strauser thought of Savitsky as an authentic folk painter. He saw him as distinct from naive and primitive artists (both categories Strauser applied to other contemporary self-taught creators) and perceived that Savitsky worked within a tradition similar to that of Yugoslavian, Russian, and Czechoslovakian folk artists in that he used the "same treatment of line and the same repetition."[1] He also noted a "tendency to become decorative rather than profound." While there is much merit in Strauser's statements, Savitsky's paintings call for closer scrutiny. With an economy of line and a narrow range of pure, unmixed colors, Savitsky was able to create sensitive renderings free of all superfluities. In these seemingly simple artworks, he successfully abstracted the essentials and documented an age that has passed.

Savitsky was born in January 1910 to a coal mining family in Silver Creek (now New Philadelphia), Pennsylvania. His father came from Linos, Russia, a small farming village; his mother was from Warsaw, Poland. After completing six years of schooling by age twelve, he obtained a full-time job underground as a slate picker at the Kaska Colliery, near Pottsville, Pennsylvania. When he married in 1932, he worked in the coal mines ten hours a day for $5.45 a day. In the early 1940s he worked as a contract miner and was paid for the number of coal-laden cars that he and his crew brought from the mine. He worked at the no. 9 colliery in Coaldale until 1959, when the mine closed. He also worked with Reading Coal and Haddock mining companies. The work was taxing, dirty, precarious, and repetitive, but steady employment made it possible for Savitsky to purchase a red brick house at 303 East Abbot Street in Lansford, where he and his wife, Mae Spack, lived and raised their son, Jack, Jr.

Unfortunately, Savitsky's years in the mines seriously impaired his health. He contracted black lung disease and experienced chronic pain from a mining accident that broke his back. He also suffered from emphysema, diabetes, and a diseased prostate. Savitsky did not return to work after the mine closed in 1959. Instead, on the advice of his son, he returned to painting as a hobby.

Savitsky had a longstanding interest in art. His mother, Anna, had encouraged this interest before he was ten: She gave him crayons, then watercolors, and finally a small set of oil paints. Savitsky once recalled these early experiences:

> I'd be walking the street and I'd find a piece of paper. I'd draw a cat or a dog on it with a pencil. In school, when I went to school, they gave me a little slate, chalk, and a little bottle of water and a rag to wash it off. Instead of doing ABCs I was doing cats and dogs. . . . At home my mother gave me a wooden trunk that came from Poland. . . . Everytime I'd make a drawing I'd put it in this box. I had it up in the attic for years and it was pretty near full with all kinds of drawings, pen and ink and all.

His father called his artwork "monkey business" and discarded the trunk and its contents without Savitsky's knowledge.

During the 1920s, Savitsky had earned some money painting signs and murals in bars in Silver Creek and Pottsville. According to his recollection, some paintings were as large as ten feet high and twenty-five feet wide. He painted on many different surfaces, including wallpaper and mirrors. He also did some paintings on velvet. After 1959 he painted mostly landscapes and sold some work at local outdoor art shows

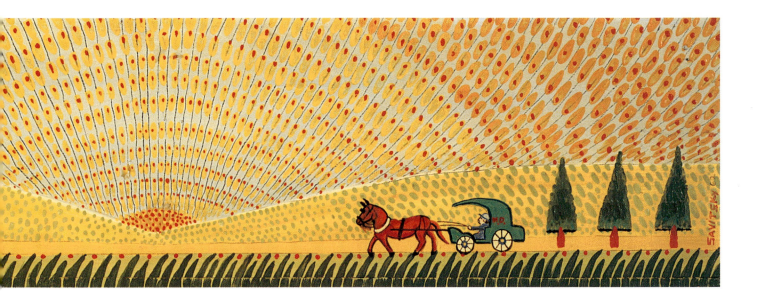

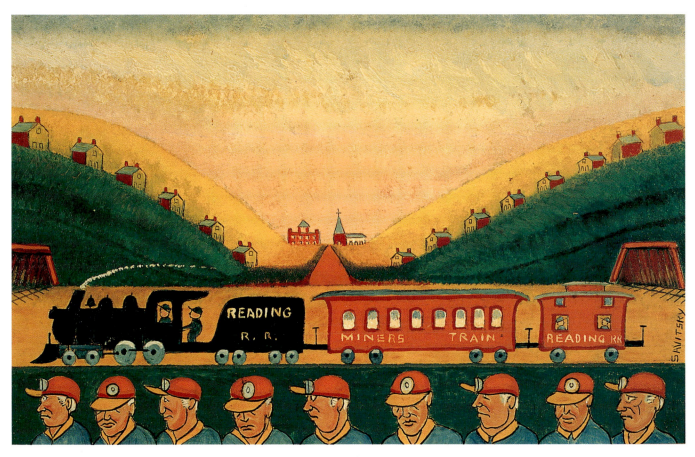

129. Miners' Train, c. 1975

and flea markets. His artwork received wider attention after he met Sterling Strauser and his wife, Dorothy, who lived in nearby East Stroudsburg. Jack, Jr., had earlier met Strauser at an art show at the Monroe County Security Bank and Trust in Stroudsburg. Strauser, who nurtured many self-taught artists, was little impressed by Savitsky's paintings on velvet, but he recognized Savitsky's talent in other media. He also encouraged Savitsky to forgo landscapes and instead paint trains and the world that he knew as a coal miner. Thereafter, subject matter closely related to his experience became Savitsky's trademark.

Savitsky worked in many media: pen and ink, charcoal, colored pencils, pastels, crayons, watercolors, and oils on a variety of surfaces, including paper, cardboard, Masonite, wood, and canvas. He painted the coal trains, the mine shafts, the miners breaking coal, the rows of small houses in which the miners lived, and the miners themselves, sometimes adding their wives, children, and pets. The subjects are enlivened by their placement in the surrounding land-scape. Savitsky was also inspired by religion, and he painted numerous biblical subjects, favoring the Peaceable Kingdom, Adam and Eve, Noah's Ark, and the Last Supper.

Savitsky did not sign his earliest works. When he did begin to sign them, he frequently used only his last name. Strauser recounted that when Savitsky was hospitalized the first time in 1973, he made a vow that if he survived, he would sign his works with a signature followed by three dots signifying the trinity. Many of Savitsky's later works bear this combination.

In *Landscape of Town*, c. 1961 (cat. no. 130), Savitsky demonstrates his good draftsmanship and unique vocabulary of form in the use of bright color, partial black outlining, flattened perspective, decorative placement of elements, and formal abstraction within a representational framework. The red flowers in the foreground and the strong, elongated blades of grass and large shade tree in the midground contrast with the clustered town with its stately church steeple. The artist also includes a not-too-distant view of the factory where the townsfolk work and the mountains beyond, and an atmosphere of stability and order pervades. The deeply textured sky, its striations similar to the treatment of the foreground grass, adds an intensity and mystery to what on the surface appears bucolic.

Pocono Farms, 1962 (cat. no. 127), exemplifies Savitsky's mastery of linear balance and the ability to create a highly decorative surface. Based once again on a flat compositional style, the setting is dramatically staged, with all elements close to the picture plane. Heightening the effect is the selection of a panel that is much wider than it is high (measuring 8¾ by 37½ inches) with sufficient space to highlight five areas. The linear, grassy, flowered foreground is set almost as a chorus line. Just beyond, but also in the foreground, are a few farm buildings on the left balanced by trees and a horse and buggy on the right. A sunlit midground and an energy-packed, radiating partial sun (probably rising), with its glowing rays acting as an umbrella over all, bring brilliant light to the elongated

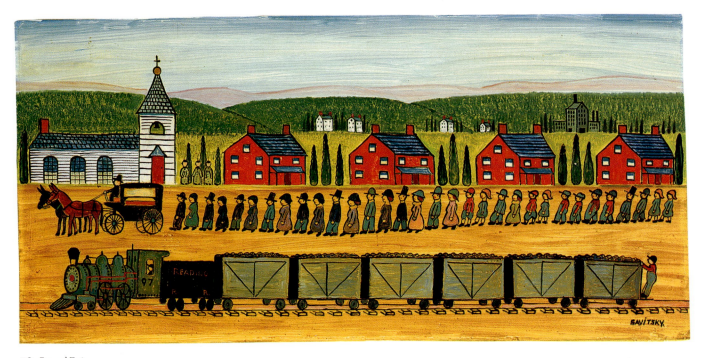

128. *Funeral Train*, c. 1975

surface. The structured, contained patterning of the vibrant sky is punctuated by red dots, which are echoed in softer green tones in the midground yellow field.

In *Reading Railroad*, 1964 (cat. no. 133), which is based on Savitsky's memories of his workaday world, his linear compositional technique is at once apparent. Like members of a chorus, miners stand in the foreground, taking the place of *Pocono Farms*'s blades of grass and flowers. Nine portraits of miners are presented in various positions, adding human interest to the composition. All wear identical caps and light blue shirts with yellow neckerchiefs, as if to suggest the conformity of their lives. The steam-driven locomotive and three cars occupy the midground, highlighted against a yellow field. Taking up half the picture surface, the background and sky are punctuated by train trestles on the far right and left, and green hills cascading toward a road that leads to the ever-present church in the center. The hills are topped in a decorative pattern by what appear to be identical houses. As in *Pocono Farms*, the light, unembellished sky area illuminates the scene. The slightly deeper blue sky at the upper border subtly echoes both the lineup of miners at the lower border and the horizontal pattern of the train while also balancing the entire composition.

In *Funeral Train*, c. 1975 (cat. no. 128), Savitsky combines his subjects—train, people, town—with the landscape. Although size, placement, and color would seem to favor the foreground train or the midground houses as the dominant elements, these never overshadow the tasteful handling of the narrative: the procession of thirty-two townsfolk solemnly following the horse-drawn hearse. What is conveyed is a quiet sense of community in this mining town, where people understand their lives and what is expected of them. This unifying order and balance reveal nothing about the deceased; one is aware only of the women and men, some identified as miners, who attend in a respectful response to

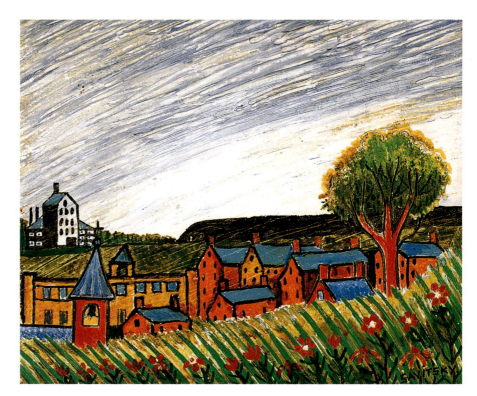

130. *Landscape of Town*, c. 1961

a death. Savitsky clearly delineates the white church just to the rear of the hearse, emphasizing its importance to community life and especially to matters of life and death.

Religion and patriotism have informed American folk art for centuries, and this thread is apparent in Savitsky's bicentennial commemorative painting *God Bless America* (cat. no. 131), possibly painted in 1976. On the back of this oil painting on Masonite, Savitsky wrote in black marker: "Title: God Bless America By Coal Miner Jack Savitsky Lansford PA 18232. Jack Savitsky worked in and around the coal mines for 35 years / Never took a [sic] art lesson He paints in oil charcoal pencil, watercolar [sic] crayon ink." Unlike nineteenth-century folk painters who left their works unsigned (possibly because they were painting for their own communities and, in some cases, because they considered themselves artisans, not trained portrait painters), Savitsky frequently made a point of signing his work and

adding his address. His patrons, most of whom were from outside his community, appreciated his signed works, and Savitsky was aware that mainstream artists typically signed their works to authenticate them. Savitsky was eager to identify himself as an artist, perhaps partially to gratify his ego but also to advertise himself, as a matter of good business strategy.

In *God Bless America*, the praying figures in the foreground may represent the artist and his wife. Seeking continued protection for life and community, metaphorically identified as an unbroken row of identical houses, the praying figures are enveloped in the background by a large red, white, and blue flag with a single star. Savitsky's solemn prayer, simple and unencumbered in format, reveals his faith in an inextricable unity and his reverence for God and country. Decorative dotting on the clothing of the male and female figures and linear bands in the foreground vary the otherwise solid areas of color.

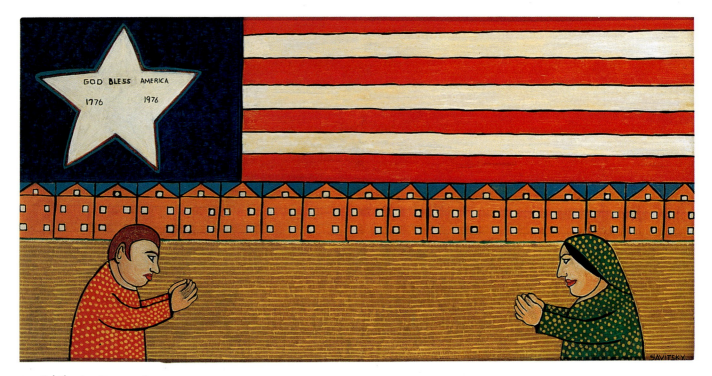

131. *God Bless America*, c. 1976

Adam and Eve, c. 1975 (cat. no. 132), contains all the elements of the Old Testament story. In this painting, the naked protagonists are shown fleeing the garden after their expulsion. The garden seems to be not an exotic place at all but rather a bucolic Pennsylvania landscape. The elements of the story do not intermingle in the landscape. Perhaps for emphasis, each has its own formal space in the composition. The apple tree—its bright red apple marred by a single bite—along with the triumphant green snake and the merest suggestion of the powerful Almighty, cryptically revealed as a lightning bolt, all contribute to the viewer's understanding. For anyone familiar with the Old Testament narrative, the painting is decorative and pleasing to the eye. Savitsky introduces the effect of a dramatic, billowy curtain within the broad area of sky to make the didactic content more forceful and at the same time to make the picture more aesthetically pleasing.

Breaker Boys Picking Slate 1925, 1964 (cat. no. 134), a drawing in pencil, reveals Savitsky's enormous drafting and drawing skills and is also an accurate, intimate picture of work inside the breakers, the buildings where coal is processed and sent from the mines to the railroads. One focal point of work inside the complex is the area where the breaker boys separate pieces of coal from slag, slate, rock, and other detritus. In an enormous, high-ceilinged room, ten figures and a supervisor attentive to their routine are shown seated in profile in a two-dimensional plane. The supervisor, who sits on an elevated stool, holds a long rod, as if ready to beat an unruly breaker boy or to prod loose a piece of coal stuck in one of the descending chutes. The round pails with dome covers, one for each worker, represent the lunch pails often filled with hot soup and frequently kept for generations as family mementos. While the artist presents the figures flatly, there is some shading in the slate containers and columns. Savitsky follows some of the rules of perspective in the ceiling boards and small shadows near each worker's pail. A sign identifying the setting in the upper center wall reads, "Silver Creek Breaker"; in the lower left bottom, Savitsky printed the title, "Breaker Boys Picking Slate 1925."

By 1925, the era of the breaker boys was already on the decline, and after the Great Depression and the disaster of 1959, when digging too deeply under the Susquehanna River caused the flooding of several mine shafts in Wilkes-Barre and Scranton, the reign of "king coal" came to an end and other sources of power gained ascendancy. But in his painting, Savitsky details one aspect of its production. As coal was moved through long chutes to railroad cars or delivery trucks, it went through a series of refinements. First, rock or slate was separated from oversized pieces. This job was relegated to young boys between the ages of eight and twelve and to men too weak to work in the underground or in strip mines. (The working conditions of breaker boys prior to a 1902 strike were appalling. They improved only slightly after the strike, when the work day was reduced to nine hours and better ventilation and light were provided.) Following the sorting, the coal went through

a series of washes and strainers, depending in the early years on gravity and later on conveyor belts, to the final loading onto railroad cars or "gondolas" at the bottom of the breaker. The slag, or refuse, was discarded in various dumping grounds, thereby damaging the natural environment.

Reading Railroad, also executed in 1964, though larger in subject, can be seen as a companion drawing to *Breaker Boys* in its attention to the Schuylkill coal region. Just as the Van Bergen overmantel (New York State Historical Association) details life in eighteenth-century upper class New York, or *Old Plantation* (Abby Aldrich Rockefeller Folk Art Center) captures African American life in the eighteenth-

century South, the Savitsky drawings are important for their documentary value, for they tell the story of coal production in central Pennsylvania from the late nineteenth century through the first half of the twentieth century.

In *Reading Railroad*, for example, Savitsky records many significant details, such as the railroad cars; the industry-driven architecture for producing coal and housing the workers, supervisors, and owners; the surrounding landscape; the steam shovel; the mule-driven wagon; the chatting neighbors; and the pair of gleaners in the left foreground. All are intrinsic and accurate to the place and period. Consider, moreover, the two central elements in the drawing: the

light-colored breaker buildings and the Reading Railroad locomotive and cars in the foreground. The breaker buildings are clustered together; coal is crushed, cleaned, and separated in the main structure. The building complex also encompasses machine shops, storage areas, a powerhouse, and prominent smokestacks. The breaker is only part of the operation of the colliery, which also includes the underground mine shafts and haulageways. The picture that Savitsky presents to the viewer is idealized by the choice of pastel tones and quiet, orderly lines. In reality, the upper area of the breaker building, where the coal was first dumped to be crushed between spiked rollers, vibrated steadily

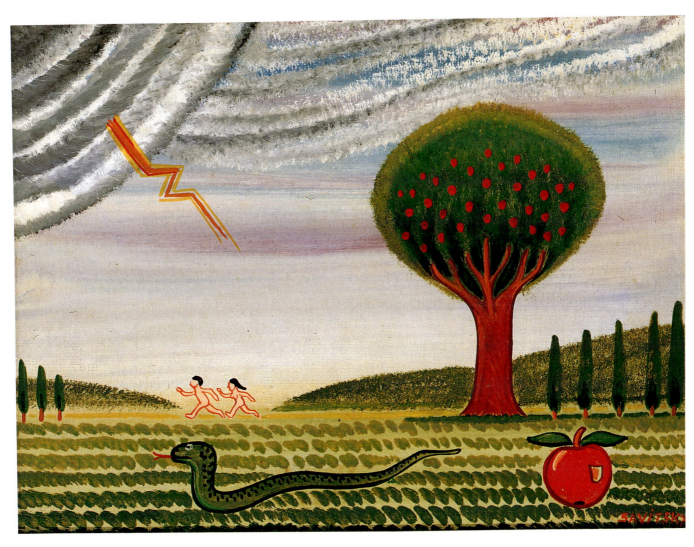

132. *Adam and Eve*, c. 1975

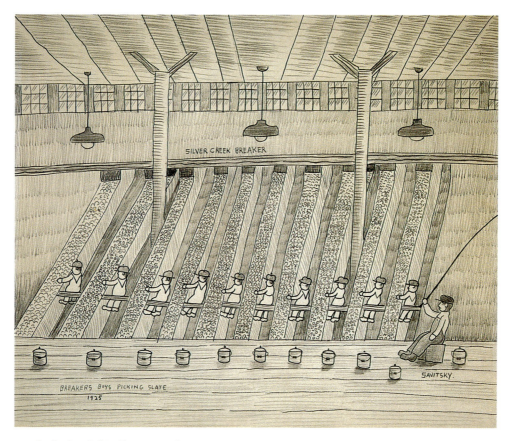

134. *Breaker Boys Picking Slate 1925*, 1964

from the thunderous dumping of coal and the crushing machines. The artist avoids any visual reference to the thunderous noise of coal processing, which included shrill whistles announcing weather reports to the workers. There is also no hint of the dirt associated with the operation.

The other central element in the drawing is the Reading Railroad locomotive. As the advantages of rail transportation were recognized, anthracite was shipped to market on one of nine railroad lines serving the area. The leading railroad in 1930 was owned by the Reading Company, which eventually took control of the local coal company. Thus Savitsky's centrally positioned train has many meanings, both symbolic and practical. The Reading railway stood for power and leadership, but practically speaking, it was also important in hauling coal from the mines to the breakers and from the breakers to the nation. An

early painting of a single train in the Gitter-Yelen collection shows the locomotive in silhouette moving across the horizon against a creamy pink sky, which underscores the train's significance in the lives of the community. In this work, the train takes on spiritual meaning.

The mine patch pictured in the right foreground of *Reading Railroad* suggests the small mining communities associated with the anthracite collieries. Many of the houses were hastily constructed and built in long rows. Neighbors chatting add a light touch to the scene, as does the mule-driven cart filled with coal, which probably served local needs. The gleaners were also a common sight: People often picked coal from the gigantic waste banks in preparation for winter. A detail easily overlooked but immensely important is the steam shovel, with its unsightly piles of waste, in the background. Savitsky indicates that a strip or open-pit mining operation is

in progress, which further attempts to "harvest" the coal still in demand as an energy source.

Savitsky died December 4, 1991, in Lansdale, Pennsylvania. In his art he recorded a part of American social history that affected the lives of so many who were the backbone of the American working class. Savitsky's artworks call to mind John Kane, the twentieth-century Pennsylvania artist, and his paean to the American working man. Savitsky, like Kane, created art made all the more authentic by his own experience as the often unheralded working man who performed the backbreaking chores that helped the country become a strong industrial force. —L.K.

NOTE

1. Quotations are from a telephone interview with Sterling Strauser conducted by Lynda Hartigan, August 10, 1989.

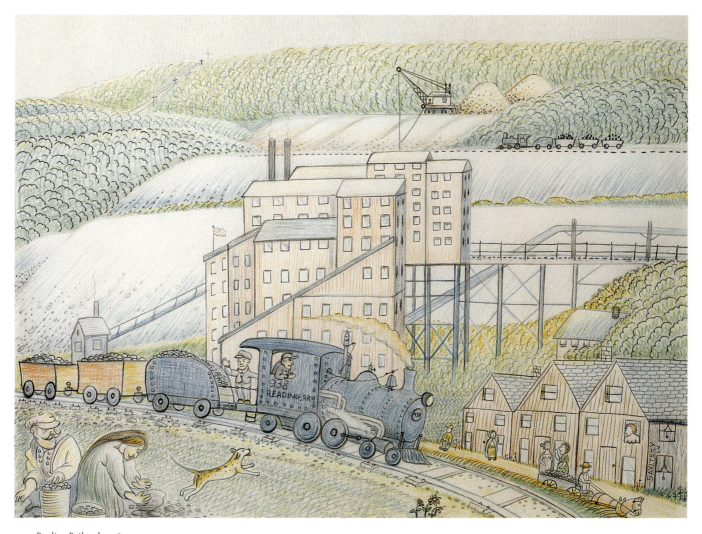

133. *Reading Railroad*, 1964

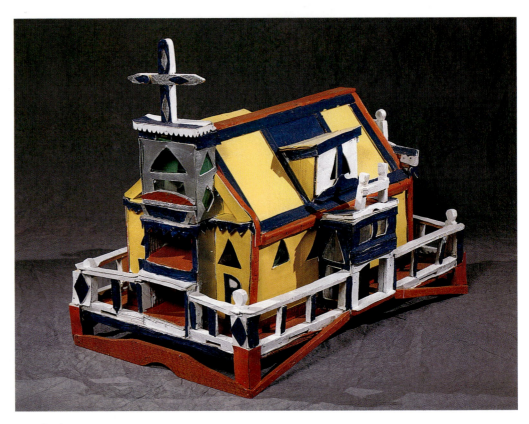

137. *Church, 1991*

James P. Scott

James ("J. P.") Scott of Lafitte, Louisiana, is not a visionary artist, and he does not incorporate religious or narrative imagery into his work. He simply builds model boats. But his boats are not artless, generic vessels; on the contrary, they are sophisticated works of art that are closely tied to Scott's life on the bayou.

Scott has always lived in or near fishing communities. Though not a fisherman himself, he has worked in a number of jobs in the fishing industry and knows the region well. In Lafitte, he is deeply influenced by the variety of fishing boats that line the bayou and can be seen from his house. Scott quickly points out that a shrimping trawler looks different from a pogy boat, which looks different from an oyster boat, and so on.[1] His model boats are usually four to five feet in length, painted in multiple colors, and detailed with a vast array of found objects. Using crude materials, Scott manages to create fairly accurate replicas of vessels he has known his entire life.

Born in Orina, Louisiana, in 1922, Scott is the son of a fisherman. He attended Orina Church School until the sixth grade, when he dropped out to get a job.[2] Following his father's example, Scott went to work on a number of boats out of Empire, Louisiana, another fishing community. He recalls:

> One of my jobs was toting salt on pogy boats. Fifteen sack o' salt on each side the deck for the nets, for salting the nets down. . . . But a trawler, you see, a trawler uses tar on the net to dirty it up. I've worked on all kinds of boats, 'cept oyster boats. 'Cause on oyster boats, you got to go 'round the clock. They fish at night. . . . I only made about three or four trips. That was in '44. I didn't work on 'em too long. That's all rough gang there, they gamble all night. I never did gamble.[3]

As a young man Scott also unloaded trucks at the port of New Orleans and later worked at various construction jobs in the city. He married Evelina Jackson in 1946, and they had three daughters and one son. The marriage broke up in 1962 when Scott inherited a house in Lafitte and Evelina refused to move from New Orleans.[4]

After moving to Lafitte, Scott did a little work on commercial fishing boats, hunted muskrats, and performed odd jobs. From 1975 to 1984, he worked at Lafitte Canning Company as a maintenance man and a machine operator. In his spare time Scott began building model boats. While working on the bayou, he salvaged cypress logs, scrap tin, and scrap paint, thus acquiring the materials that sparked his interest in boat building.[5] What began as a hobby ultimately became an artistic outlet to which he is passionately devoted.

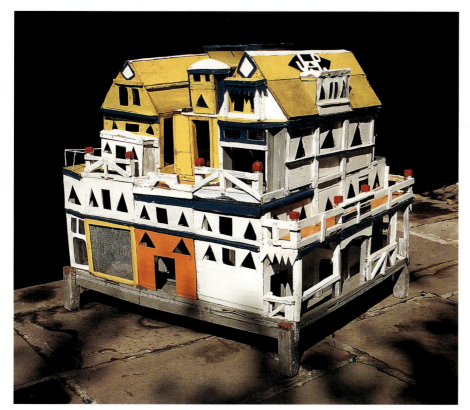

135. *Houseboat, 1987*

Today, even though people offer him construction materials, Scott prefers to obtain his own from garbage dumps or along the bayou, where fishermen toss unwanted scraps of net and where pieces of driftwood are his for the taking. Scott admits that even as a child he liked scrounging the dumps, finding things that people had thrown away. He enjoys finding the materials as much as making the boats, and he says, "People try to give me stuff to build with, but they can't do that, 'cause I gotta do it myself."[6] With an artistic eye, Scott carefully seeks out quality pieces of wood, selecting only those that will look good and hold up during the building process. His passion for perfection and attention to detail are apparent when one watches him work or listens as he discusses his art: "Everything has to match on both sides," he says. "I have to use the same type of wood for the trim all the way around. If it breaks on me, or if I run out, I'll have to take it all off and find enough of another piece of wood."[7]

Scott uses ordinary hand tools such as saws, metal cutters, hammers, nails, and pliers. He prefers to work without any previously drawn plans: "I just go on side the bayou and I look at 'em, come back here, sit down and think about 'em, and get to it. I just sketch out the shape of the tin and cut it out. Then I nail it onto the frame of the hull and plank it up."[8] Reflecting even the smallest characteristics of the original, each of Scott's model boats is extremely intricate. Their appearance goes beyond that of surface detail in that most of the parts are movable and serve the same functions as their counterparts on an actual boat. The hatches open up to reveal the holds where the fish would be kept, and the smaller doors to the captain's cabin and the crew's quarters open and close. Net

boats ride properly on deck; the rigs and nets can fall into place as they would when used in fishing, or they can be secured upright as they would be when idle. Complete with a spy's mast, rope ladders, and, of course, an anchor, every boat is true to form but original in the choice of materials and methods of construction.

Working outside in his yard as often as weather permits, Scott begins with a skeleton frame made of wood and secures sheets of tin to form the hull. Using wood partitions, he segments the interior of the hull into storage, ice, and fish-holding compartments. He then creates the surface of the deck out of wood, cutting hatches to match up with the various compartments below. He usually glues found pieces of linoleum to the surface of the deck, also using it to trim the windows.

Next, the complicated captain's cabin is built separately from the rest of the boat but made to fit snugly on deck when put in place. Scott may also build crew's quarters, or he may place tin cans on the prow of the deck to represent fuel tanks. Each boat is meticulously trimmed with strips of molding or garden hose that run lengthwise along the hull, defining the streamlined construction and creating an authentic nautical appearance. In addition, the decks are often trimmed with intricate railings. The accuracy of the complex structures is evidence of the many years that Scott has spent observing and admiring every nuance of their bayou prototypes.

Scott then paints each boat with pure, vivid colors—blue, white, red, or orange. Since he uses leftover house paint, he is sometimes limited by what he has on hand, so at times he will use other colors. However, he insists that red and white must be used on certain parts of a ship if it is to be an accurate replica. As he explains, colors are important directional devices for boats passing each other in the channels: "If a boat is coming in, then the red is going to keep

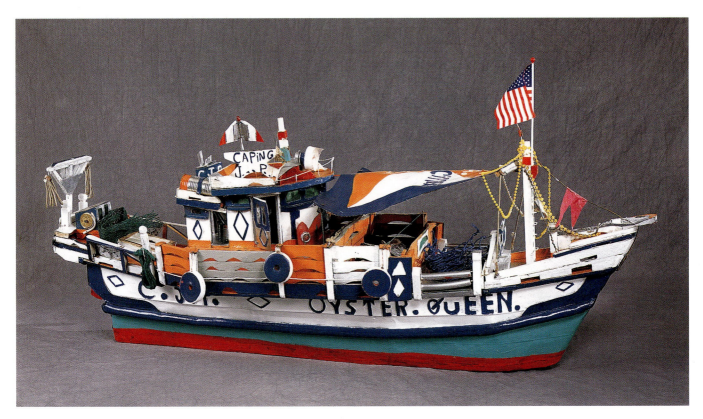

138. *Oyster Queen*, 1988

you this way—that's the deep water. When you're going out then the white is going to keep you on the other side. The boats coming in have to take the deep water, the channel side. All boats have red lights on one side and white on the other."[9]

Using letters he cuts out of wood, Scott "signs" each boat with either his initials or his full name. These raised letters are painted and attached to the side of the hull or the captain's cabin. Scott often names his boats after family members, friends, or port towns; he sometimes gives his boats more unusual names, such as *Scott Family Reunion*, which commemorate a special event.

After constructing and painting each boat, Scott begins to attach numerous found objects: Mardi Gras beads, seashells, plastic objects, small trinkets, flags. This stage can take weeks or even longer, until Scott believes that he has accumulated enough decorations. He says: "I dress 'em up good, but I don't sell anything I'm not done with. I set the ones I want to sell on that table out there. But if I start thinking about money and what I'm going to get for it, then I can't work. When they are finished the way I want, then I decide."[10]

Scott is uncompromisingly stern in his refusal to allow people to rush him, especially during the finishing stages. He embellishes the boats with as much care as he puts into the building and painting processes. It takes him at least a month to build a boat; often it takes longer. Once a boat is finished, Scott will set it outside on a specially decorated stand to "weather" and also to receive his careful evaluation. If he decides that it passes inspection and he is ready to let it go, he will finally sell it. However, he has been known to scrap a nearly completed but unsatisfactory boat and salvage pieces for reuse in building another one. For this reason, Scott does not consider himself an artist:

> I don't think myself an artist 'cuz if I build something and take it back down, and I know when I'm gonna get to it

again, you see. Now an artist, he go on with something right all the way. He don't be breaking up nothing or going back over it. Whatever he do, you see, he see he can get it right, whatever it is. It's what he do. . . . I'm just a plain li'l builder. A li'l cheatin' builder, you see. Now another thing to do. An artist, he don't have to fool with his cracks or nothing, you see. He make sure it sealed. Everything you see against the wood, it be sealed. Just like it come from the factory. That's an artist.[11]

Before collectors discovered Scott's work, he was well known by the residents of Lafitte for his roadside armada. As he finished each boat, he put it outside in his yard, and in time he had an entire fleet to enjoy. These days, however, with all the attention his work has received, Scott rarely has more than one or two on display at any given time, and he is inclined to keep them as long as he can. "If the price is right" and he is ready to part with a finished boat, he will sell it to the first lucky person who happens to visit and inquire.[12]

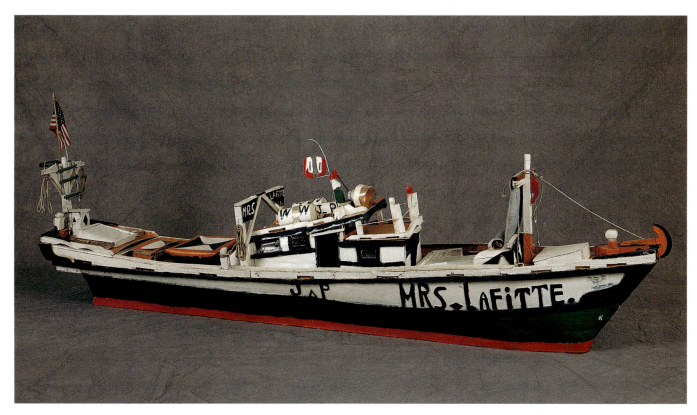

136. Mrs. Lafitte, 1986

Scott lives in a small house that sits hard by the main highway in Lafitte and is usually surrounded by standing water. His home is cluttered with simple furniture, Christian images (crosses, rosaries, and devotional prayer cards), and building materials (tools, paint, and cut-out pictures of boats). He has occasionally built replicas of churches, planes, and houses in the fishermen's quarter, but it is obvious that his artistic self-fulfillment comes from building his boats. He recognizes that he has a God-given talent, and he is proud of his creations. Each one represents a compelling personal accomplishment and an unflagging inspiration. The fact that he will not sell anything until he is completely satisfied with the final product is a testimony to his commitment to his art.

Although Scott's work appears similar to traditional forms of folk art and craftsmanship, it is fundamentally different. Unconcerned with communal traditions, he is untrained and idiosyncratic in his choice of materials. Even though there is no "narrative" quality to his work, it has become for him a significant outlet of personal expression. For Scott, the process of creating boats is more rewarding than the end result. He is willing to devote considerable time and effort to each step, thinks nothing of breaking down an inferior example and starting over, and is motivated not by monetary reward but by something more intangible, more personal—all signs of the committed artist at work.

—D.G.R.

NOTES

1. J. P. Scott, from the author's interview with the artist, tape recording, Lafitte, La., March 11, 1992. A pogy boat is approximately 180 feet long and is used to net pogy fish, which are small fish commonly used for fertilizer. The boat drags a net with the help of a smaller boat that gathers the fish together. Shrimp boats are generally smaller and use tow nets that are held out over opposite sides with booms.

2. Chuck Rosenak and Jan Rosenak, Museum of American Folk Art Encyclopedia of Twentieth-Century American Folk Art and Artists (New York: Abbeville Press, 1990), p. 275.

3. Scott, from interview by author.

4. Scott and his wife never officially divorced, and he occasionally visits his children in New Orleans (Rosenak and Rosenak, Museum of American Folk Art Encyclopedia, p. 275).

5. Ibid., p. 276.

6. Scott, from interview by author.

7. Ibid.

8. Ibid.

9. Ibid.

10. Ibid.

11. J. P. Scott, interview by Dr. Warren Lowe, in It'll Come True: Eleven Artists First and Last (Shreveport, La.: Mid-South Press, 1992), p. 67.

12. Scott, from interview by author.

Jon Serl

A great artist is identified with his subject; it is his subject. . . . It fuses and blends with his personality. . . . He stands in place and it finds him.

—John Burroughs[1]

In a dusty desert town set at the edge of a phantom lake, Jon Serl created his rugged Eden. He turned a modest borrowed house into a rambling compound of improvised dwellings surrounded by a jungle canopy of fruit trees; wandering birds; tame, sociable chickens; and a steady stream of admiring pilgrims attracted by the paintings of this odd, gentle, determined man. Entering his domain on the corner of Scrivener Street in Lake Elsinore, California, one began to understand what true personal independence costs and what it offers. Serl had a curious gift for intimacy. Gently, seductively, he laid out his unique vision of life, making each visitor feel like his new best friend and confidante. (Some also sensed that the next person to arrive would be drawn into a similar conversation and implied relationship.) Serl inspired enormous affection but firmly drew a line at any kind of exclusivity or constancy. There may be a standard, clinical psychological profile for such a person, but it couldn't possibly contain his electricity and magic.

Jon Serl was born in Olean, New York, perhaps in the year 1894 or a few years after that.[2] He came from humble origins and led an unstructured childhood, sometimes in school, often not. To make sense of the world he relied upon his remarkable gifts of observation. He studied the habits of birds and animals, learned the names of plants and trees, and made astute, humorous comparisons between their behavior and that of his human family. Most colorful and influential were his sisters, who became dance hall performers, drifters, and vagabonds,

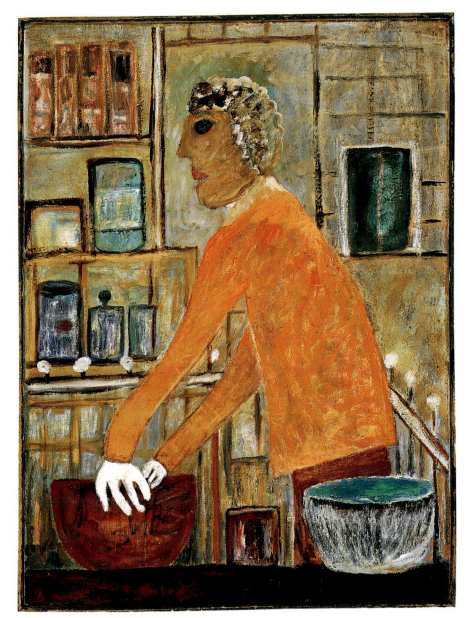

139. *Blind Chemist,* 1977

taking their skinny brother with them as far as the mining camps in Colorado. As a child, Jon was often dressed as a female member of the troupe; his blond, curly hair and lithe body made him perfect for the part of an angel who flew up to heaven on a guy wire. As he matured, he performed as a dancer and singer, and spent other periods as a cook in hotels and mining camps.

Serl had no taste for war and avoided service in both world wars by fleeing twice to Canada, where he worked as a

fire watcher, manual laborer, cook, and woodsman. Living under the name Jerry Palmer, he changed some of the official aspects of his identity: his name, his birthdate, his occupation. As the writer he initially aspired to be and the painter he eventually became, Serl devoted his attention to his observations of life and the American landscape, which he traveled through so freely and knew so well. Capable of hard physical labor, mountain climbing, hiking, farming, dancing, and pleasure taking, he saw the vast majority

of his fellow citizens as soft, unimaginative souls buying into prefabricated slots in an empty panorama of soothing sameness.

Jon Serl migrated to California in the 1920s and headed to Hollywood to search for a role suiting a lanky, charismatic young man with a beautiful face and voice. He took bit parts in films—walk-ons and voice-over assignments for silent-film stars who couldn't handle the transition to talkies. They called him "Slats" and drew him into a circle of actors, critics, and producers, including Hedda Hopper and Howard Hughes. Serl's voice was indeed one of his special charms. He had lovely diction and a musical lilt, an old-fashioned grace hinting at a literary education and propriety he admired and imitated through his speech. Having grown up among actors, dissemblers, and creators of fantasy, Serl began to create an artistic personality out of his irregular background, his genuine intellectual gifts, and his flair for the vivid and dramatic.

Serl's artistic adventure began in British Columbia during the months after World War II ended. He created a few small, tentative paintings on scavenged materials: a window shade, a scrap of board, a used canvas. He painted a handsome young boy who had recently drowned but who was still radiantly alive in Serl's memory portrait. Less successful were a few domestic interiors and hazy landscapes. Serl was then and would remain a consummate chronicler of human tragedy and human folly. His was a world illuminated by emotion, and his expressionist art became the vehicle he used to record his observations of his fellow human beings.

Drifting back toward California after the war, he spent time in Texas harvesting crops, traveling, taking odd jobs, and occasionally painting. All the while his indignation grew as he witnessed the social and economic transformations of postwar American life. Small towns gave way to suburban tracts, and self-reliance became increasingly compromised by the streamlined distribution of goods. Serl was dismayed and unnerved at the structured lives of his fellow citizens because he saw them as dependent upon employment by large firms, factories, and government. While others celebrated material prosperity, Serl continued to live on the margin and to keep on the move.

Serl spent the 1950s in the seaside town of Laguna Beach, where he worked as a gardener and handyman. His growing devotion to painting seemed unremarkable in a town lauded in California history as an artist's colony with spectacular ocean views and a preference for impressionist styles. Now in middle age, Serl might have passed for a Sunday painter, but his work had an odd passion and an expressionist edge seldom seen among the other artists at Laguna Beach.

In the early 1960s he moved into the historical barrio adjacent to the mission San Juan Capistrano. Taking up residence in the landmark Del Rios Adobe, Serl slipped into the Mexican culture of the village and took on the garb of a monk. It was perhaps his most memorable self-created role. There he found his antidote to American middle-class sameness, and his taste for a vivid, earthy, extravagantly loving, yet often violent way of life was satisfied. He created a lush garden and populated it with chickens and dogs. He kept his door open to his many neighbors, especially welcoming old drifters like himself and the young rebels of the 1960s whom he fed, housed, and encouraged in their challenges to establishment values. Within the walls of the Del Rios Adobe, Serl created an unconventional salon which drew some of his old Hollywood contacts back into his life. Hedda Hopper, now Hollywood's most influential gossip columnist, was a favorite friend and frequent visitor. Women of the barrio even taught Serl how to cook traditional Mexican recipes, which added to the attractions of his table and home.

His paintings grew more ambitious, wild, and erotic as he struggled to come to terms with his bisexuality. Serl married three times. His first marriage, in his early youth, was annulled for lack

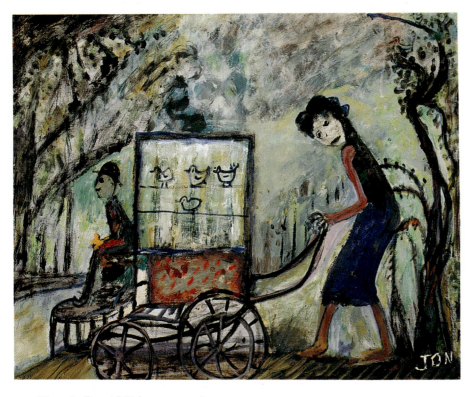

140. *Woman Strolling with Birdcage*, c. 1975–80

of consummation. Twice again he fell in love with women, but his passion for them was strictly intellectual and spiritual, and both marriages drifted into unfulfilled companionship and ended sadly, wistfully. Serl had a great capacity for genuine affection, but his terror in the face of any demands for exclusivity or continuity was apparent to even casual friends. Many of his paintings at midlife demonstrate the tenderness of which he was capable and the underlying fear that drove him into solitude again and again.

It was fortunate for Serl that in his art he was able to make a productive life out of this passion and solitude. He often described himself as a dreamer, by which he meant he possessed a special state of freedom rather than a state of rest. Living in the barrio helped him to understand and discover the dreamer in himself. "It is of the dreamer we write—and his life we offer as a panacea for jaded nerves. Sleep or partial sleep must have greater qualities than most gringos know. The Mexicans' theory was right. Life can be simple—and simplicity seldom needs a doctor's advice because simplicity is a doctor."[3]

As he recalled, at the Del Rios Adobe he painted in a furious whirlwind of activity, working night and day until he dropped from exhaustion. His capacity to render the physical world grew as he taught himself from craftsmen's manuals and intense observation and practice. Without knowing the term for it, Serl became a powerful expressionist, bending and inventing forms so that they might embody the creatures, events, and experiences he saw and felt so intensely. His own physical agility and beauty made him aware of the language of the body, especially as it is expressed in dance.

> To me, there is only one kind of movement in anything. It is a dance. A carpenter, a fellow driving a team of horses, everything is a dance. It's all flowing, everything is flowing, your speech, the way you walk. Things flow in space, don't they?
>
> You never walk, you dance. You don't run, you dance. How are you going to

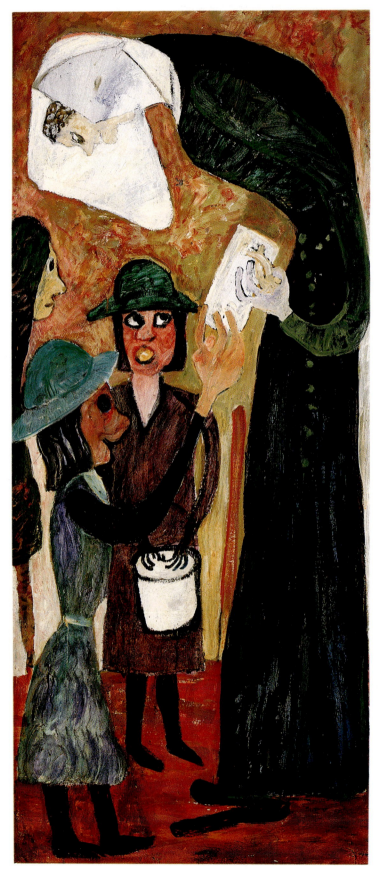

141. Nuns, 1980

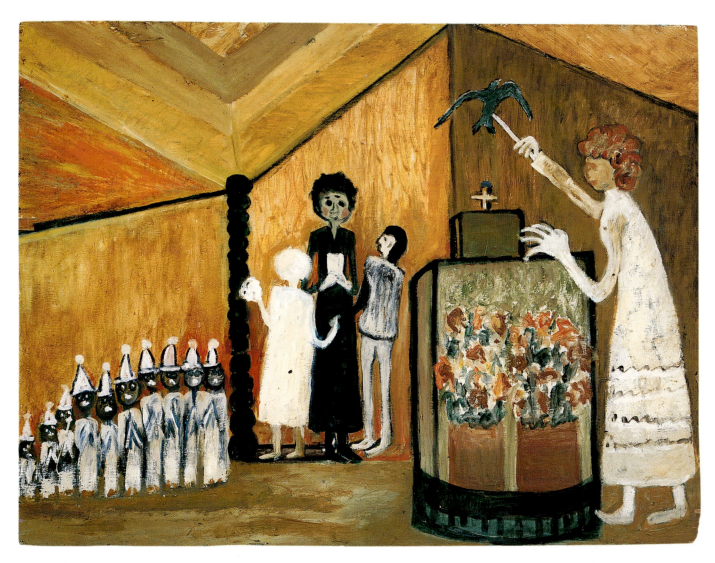

142. *Church Scene*, c. 1970

tell movement except to make it move? Everything is moving all the time, just look out the window. A squirrel running up a tree, a snake moving in the branches going after a bird. It's a matter of breath, it's a matter of living. Total.

One of the hallmarks of Serl's style as a painter is his creation of lean, elongated figures whose slender, impossibly limber bodies allow them to reach and dance in space. They have a calligraphic grace identified with Serl as an artist and as a living personality. Serl's painting of an athlete (cat. no. 145) vividly translates the artist's joy in the physical elasticity of his body into a striking visual icon. He confessed:

I had a dancing studio once and danced all by myself sometimes three or four hours a day. It must have looked pretty silly to see this tall, skinny man dance around as though he were Pavlova. I was in tune with something, I don't know. But it kept the body totally in tune and my reflexes would take me into the nothing, the dream, the escape.

Serl's gentleness and love of living creatures are evident in his painting of a young woman pushing a stroller through a park (cat. no. 140). Her pram is filled with birds perched in a traveling aviary. It is an odd, but charming fantasy speaking of man's stewardship of nature. Two different titles appear on the reverse of

the painting: *Woman Strolling with Birdcage* and *Moving from Brushfire*. Serl delighted in renaming his extant works and often gave them new, more dramatic, identities. Everything about this painting favors the first title and interpretation. Serl sometimes regretted having too freely revealed the sweeter side of his nature. He may have invented and added the second title at a subsequent moment while in one of his well-known, diabolically playful, moods.

Curious but memorable is the *Blind Chemist*, 1977 (cat. no. 139), which portrays a pharmacist briskly compounding his prescriptions in a large bowl. He does so cheerfully, although we notice

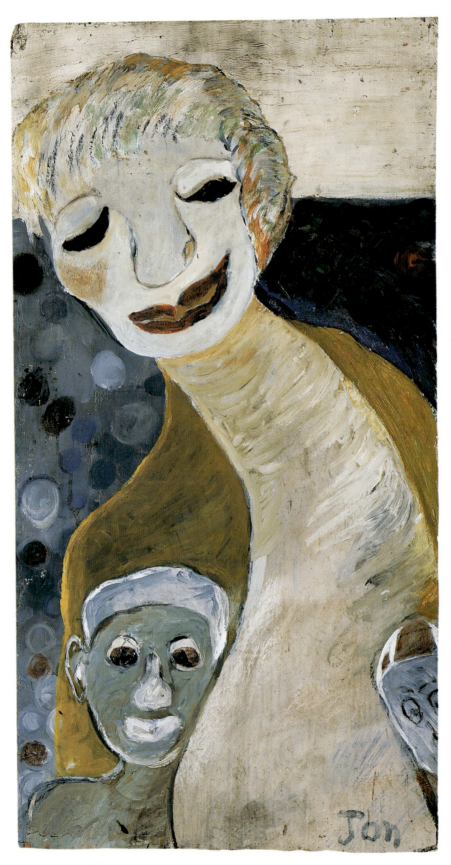

143. *Mother and Child*, c. 1975

his opaque eyes and wonder about the efficacy of his labors. Is he operating by inner sight, or is Serl lodging a protest of complaint? This painting is typical of his penchant for role-playing, his habit of recasting the familiar into the unorthodox.

Serl's interest in things spiritual was genuine, although he had a humorist's contempt for religious doctrine. Perhaps this had to do with his anger at hierarchy and authoritarianism. Serl's sense of rage and mischief was aroused by any and all authoritarian situations. *Church Scene*, c. 1970 (cat. no. 142), is a typically se-ductive image that seems to depict a church meeting conducted by women for children. Serl employs hieratic scale, making the head preacher tall and im-portant but her assistants smaller and less significant. Most tellingly, he has created a row of black children in de-scending scale. They wear white robes and sing in chorus. Even as they cooper-ate and participate, these children are put into a compromising situation. Serl's analyses of authoritarian situations gen-erally portray the average person as gull-ible and well-meaning, and therefore easy prey for those who would impose false structures upon the lives of others.

In *Nuns*, 1980 (cat. no. 141), a tall nun in a traditional habit bends forward to receive an envelope from a much smaller parishioner, while another woman gazes skyward and holds an offering pail. Serl often includes a skep-tical witness to register his own view of the scene. To the left is an old woman in black; perhaps she is another nun, per-haps not. She stares at the collection of offerings with dark, mute disapproval. In Serl's cosmology, spiritual values and experiences had nothing to do with money. He endeavored to stay free of its influence in his thinking, his activi-ties, and his destiny. In large measure he succeeded.

Serl maintained an unsteady truce with the various women in his life. Many were drawn to him and would clean his house, cook him food, and even look after his menagerie of Chihuahuas. Serl

was quick to admit that, in his opinion, a woman operated under considerable burdens and handicaps imposed by nature. How wonderful it was to be born a man! However, he acknowledged in his art the very real power of women. In *Mother and Child*, c. 1975 (cat. no. 143), we see the haunting yet also cheerful images of a mother and her son rendered in shades of pale gray and ocher. She looms large, envelops the boy, seems to shape and condition the space of the painting. In another, even more curious painting, titled *Prodigals Return*, c. 1975–80 (cat. no. 144), two enormous women, one possibly pregnant, stand at opposite sides of a little girl who is crowned by a dancing figurine. Again, the women provide form and context for a child who appears beatified by their enthusiasm and attention, but one senses the underlying dangers. The influence of the women appears well-intentioned and benign, but it exerts a pernicious level of control over the actions of the young and also of the men. In Serl's universe, women and personal freedom are at odds. He records and celebrates women's good works while registering his fear and loathing of their mothering instincts.

In the early 1970s Serl moved to a borrowed house on Scrivener Street in the desert town of Lake Elsinore. A young friend had just inherited it and offered Serl a life tenancy, little suspecting that Serl would transform the place into an eccentric paradise and live there until he died quietly in his sleep in the back bedroom early in July 1993. Elements of the Del Rios Adobe lifestyle came along: the chickens, the rooms full of paintings, the ample kitchen with something always cooking on the stove, the garden which served as a pantry and as a refuge. Here the enterprise of painting was paramount. Serl knew these would be his last years, and he figured that a man in his mid-seventies had best get on with his life's work. During the hot summers, he often painted in the cool of the night and slept during the day.

Then it happened. Serl's art was discovered by a group of collectors and

other experts who knew how to place his work in context and who recognized him as one of America's most important self-taught painters.

Although he preferred to live alone, Serl was a sociable person who enjoyed having people in his home for brief, intense visits. He welcomed guests from all over the country—indeed, all over the world. He appeared twice on Johnny Carson's show, and his old show-business instincts came to the fore as he quipped with Johnny and got himself invited back. More than just cleverness, Serl's

sincerity was truly captivating as he described his love of people who, like himself, worked with their hands.

On several visits, Dr. Kurt Gitter had long conversations with Serl regarding his art, his health, his views on how American life had changed during his lifetime. Serl often telephoned Gitter when some physical problem presented itself or just to hear a reassuring voice. To some of his friends, Serl was a compelling person who lived a simple, healthful, spartan life. Many were drawn to him without having any interest in his

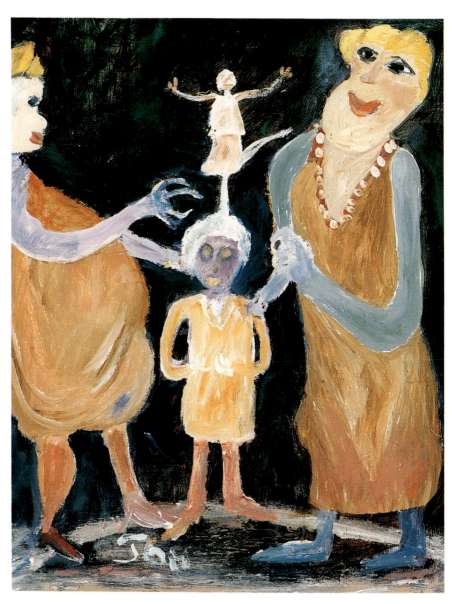

144. *Prodigals Return*, c. 1975–80

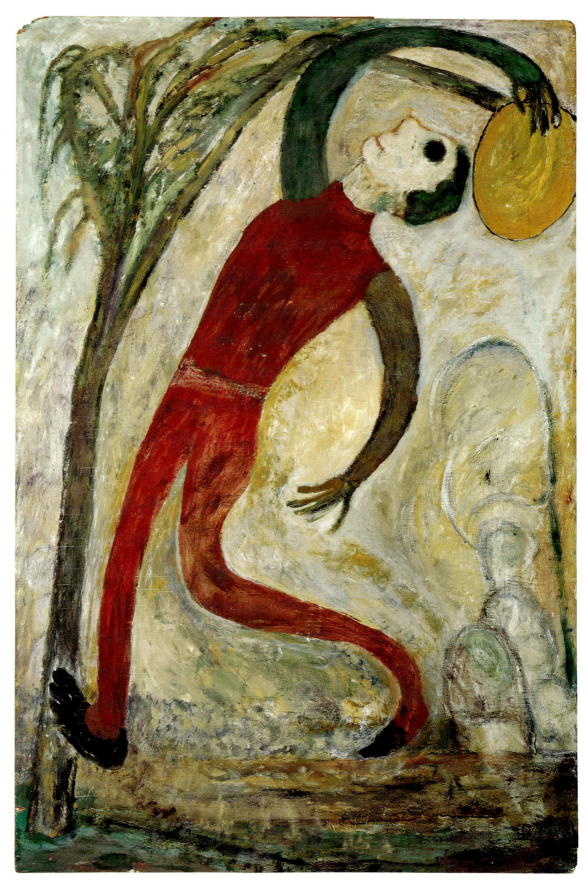

145. *Athlete*, 1988

art or his growing fame. His curious home environment was a laboratory of alternative living where people learned a variety of things while enjoying the company of this remarkable man. Serl occasionally availed himself of modern conveniences: a black-and-white television, a telephone, and a beloved old Volkswagen beetle that worked intermittently. He was no puritan, nor was he a hermit or ascetic.

During the winter months he painted in a room with a fireplace. Not wishing to stop in the middle of a painting session, he brought in the trunk of a tall tree and just shoved it foot by foot into the fireplace as it burned. Christmas decorations hung in his house all year long. He wrote the phone numbers of friends on walls or on the backs of paintings. When he didn't want visitors or decided to sleep for long hours, he posted on the front door a sign that said he was "praying."

Year by year the paintings accumulated, and he eventually began to have exhibitions. The first one was in 1971 at an art center in San Pedro, California. A museum show in 1982 was followed by numerous survey exhibitions and one-person exhibitions in various galleries and museums. Serl was reluctant to sell his paintings: "Why would anyone ask me to sell my children?" As time went by and he learned how the process of artistic validation worked, he reluctantly parted with paintings so that they could travel out into the world and find permanent homes. He changed neither his address nor his unique style of life, and he bore his growing notoriety with a wry sense of humor.

The body of his work is a testament to his understanding of American life in the postwar era and his frank disclosure of what has been lost in the midst of material progress. Even with its humor and fantasy, there is a poignancy about the art of Jon Serl. He always seemed to be in the position of that little boy from Olean, New York, who was cast adrift from home and family. Self-reliant, fearful, yet courageous, he watched the activities of others for signs of their true intentions, yet regarded his fellow man with humor and compassion. Serl always seemed to be the outsider looking in—the traditional role, of course, of the artist, of one who stands aside and observes, often with passion but always with an unusual vantage point affording greater objectivity.

Of what import, finally, are the paintings of Jon Serl? They are a vivid record of an unencumbered spirit from another epoch in American life. They tell us of people who are vigorous, free-spirited, filled with the basic joy of being alive, and unafraid of expressing themselves openly. They speak of a country where people invented their identities and activities daily, and they argue against measuring human life in economic terms. They urge us to dance, to love, to taste, and to touch. They present bizarre situations as if they were ordinary and turn everyday events into occasions for celebration. They are conscious artistic statements because their creator knew he was not merely recording something but inventing it.

When Jon Serl left this life well into his ninth decade, he did so as one who found his vocation late but in time to fulfill it splendidly. His achievement from 1947 to 1993 has yet to be fully explored, but it is a consistent whole with a powerful point of view, the work of a highly intelligent, uniquely persuasive personality. Serl was a vigorous and independent person who taught not by words but by example. "I had to do something about this world. *Look at* it. So I paint. Painting is life."

—S.C.L.

NOTES

1. Clara Barrus, ed., *The Heart of Burrough's Journals* (Boston and New York: Houghton, 1928), p. 175.

2. Biographical information is derived from papers and journals the artist made available during his lifetime.

3. All quotations are from taped interviews with the artist conducted by the author between 1981 and 1988.

Herbert Singleton

Perhaps no other wood-carver currently working in the United States is producing works that are as autobiographical and as illustrative of the corrosive character of urban African American ghetto life as those of Herbert Singleton. The rough environment into which he was born in New Orleans in 1945 still forms the context of his work. The oldest of the eight children of Herbert, Sr., and Elizabeth Singleton, Herbert, Jr., recalls that when he was around ten years old, his father, who worked for the New Orleans utilities department, left home one day to purchase a pack of cigarettes and never returned. His mother later found employment in a hospital. Singleton dropped out of school after the seventh grade and spent most of his time hanging out in the streets of New Orleans. He associated with gangs, pimps, and prostitutes and experimented with illegal drugs, eventually spending some thirteen years incarcerated in the Angola State Prison in Louisiana for various narcotic-related offenses. Two bullet holes in his left side are additional testimony to the violence of Singleton's past. He is currently divorced and the father of five children.

Singleton's encounters with law enforcement officials have been frequent and traumatic. In 1980 one of his sisters and two of his male friends were shot to

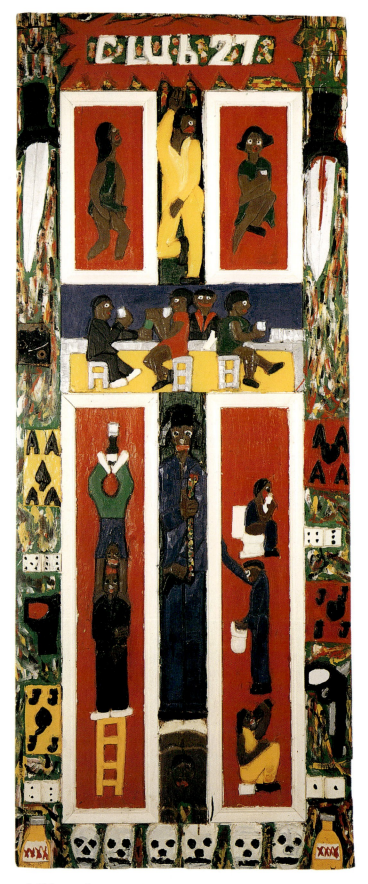

146. *Club 27*, 1989

death in an early morning raid by three white police officers who were searching for suspects in the murder of another white police officer. The raid occurred in New Orleans's predominantly African American community of Algiers, where Singleton still resides. During the aftermath of the raid, Singleton and several other residents were taken to police headquarters, where they were allegedly beaten and tortured in attempts to obtain confessions. Singleton recalls that he and the other suspects were detained for over twelve hours and that a plastic bag was placed over his head in an attempt to suffocate him. The Algiers incident was believed to have been racially motivated, and it enraged many people in the New Orleans African American community. While none of the white police officers were charged with any crime, the city of New Orleans eventually awarded sizeable monetary settlements to Singleton and several of the other victims and their survivors. Singleton has depicted this harrowing incident in one of his carvings, in which he is seen strapped to a chair with a white plastic bag over his head. In view of Singleton's background, the numerous scenes of violence and police brutality depicted in his carvings are not surprising.

Like those of his elders among the early twentieth-century school of

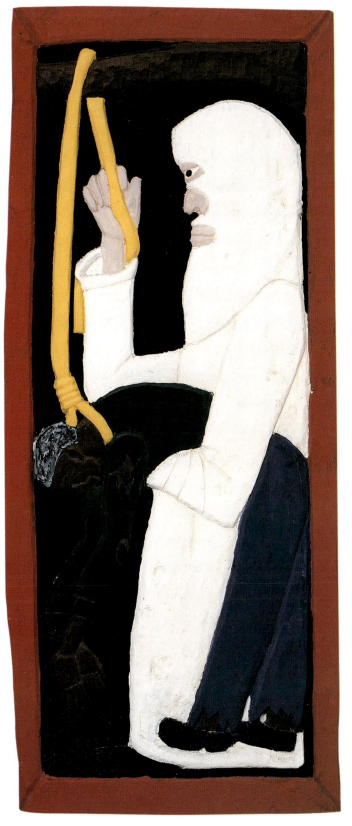

147. *KKK—The Lynch*, 1990

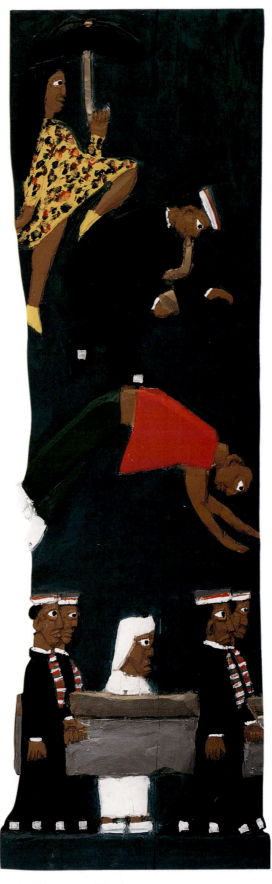

150. *Second Line—Funeral March*, 1994

African American wood-carvers, Singleton's artistic impulses were evident during his boyhood. As a young child, he frequently walked along the banks of the Mississippi River and amused himself by fashioning snakes from the muddy clay. "I would reach in and pull out a snake, just like that. I'd let it dry in the sun, but it would fall apart."[1] Unhappy with the impermanence of his clay figures, Singleton decided to work in wood and initially picked up pieces of driftwood from the river when it was low.

Around 1975 Singleton began carving walking sticks from ax and pick handles. His clients were buggy drivers in the French Quarter, pimps, and drug dealers with whom he hoped to exchange his works for heroin and cocaine. Singleton's walking sticks and staffs were also used in voodoo ceremonies and Mardi Gras parades. The staffs were eagerly sought after by the street people who were Singleton's associates. He recalls a well-known pimp called Big Hat Willie who never went nightclubbing without one of Singleton's sticks in his fist. Singleton abruptly discontinued his trademark walking sticks after a buggy driver in Jackson Square killed a robber by splitting his head open with one of them. Following that incident, Singleton's walking sticks were dubbed "killer sticks," and he received so many requests for them from persons with less than honorable intentions that he vowed never to carve them again. The killer stick by Singleton in this collection (cat. no. 149) was carved in 1990 from a pick handle and represents a hermaphroditic figure, with the female half painted brown and the male half painted black. The double figure shares common facial features and forms the upper register of the stick, whose tapered end is painted in bright yellow, green, and red enamel paints. The eerie facial expression of the bisexual figure can be seen in a number of other carvings by Singleton.

Three-dimensional sculptures and relief panels comprise another category of Singleton's work. These are carved from logs, tree trunks and stumps, dis-

148. *Schoolroom*, 1990

carded doors, pieces of driftwood that he finds on the levees of the Mississippi River, and panels from old wardrobes and other pieces of cast-off furniture. The fact that all of Singleton's sculptures are carved from pieces of found wood—he never purchases precut panels—contributes to the powerful, emotive quality of his work. Singleton paints virtually all of his sculptures in bright colors, as do the majority of his peers and predecessors.

Subject matter among Singleton's carvings may be grouped into three categories: religious scenes, scenes from contemporary African American street life, and social and political themes of national and international scope. The relief panels by Singleton in this exhibition belong to the street-life category, which Singleton apparently best enjoys depicting. Given the frequently violent incidents of his unfortunate past, it is not surprising that the majority of Singleton's sculptures recall his own experiences. Death, police brutality and harassment, lynchings, tavern brawls, dishonest card players, prostitutes and pimps, and scenes of prison life abound. Singleton's raw and emotive depictions of various aspects of the drug subculture are not always comfortable to view; they are unusually graphic since they were carved by a person who has experienced many of these activities firsthand.

In 1989 Singleton decided to carve relief designs on the surfaces of discarded paneled wooden doors. The door in this exhibition, titled *Club 27*, 1989 (cat. no. 146), was the first in a series that presently includes some fifteen standard-size doors and three 9½-by-4-foot portal-size doors. *Club 27* is a seminal piece among Singleton's works and a model for a number of his other doors and carved panels. Although Club 27 was a nightclub located in Singleton's neighborhood, the events that occurred within its walls are similar to those in almost any nightclub in an African American ghetto. The door's perimeter depicts the club's marquee, two enormous knives dripping with blood, several pistols, dice and playing cards, and skulls carved in relief. In the center of the upper register is a large figure of a male wearing yellow and posed in a ballerina position. This male "raspberry" is flanked by two female "strawberries" (subculture terminology for young males and females who sell their bodies for money to purchase illegal drugs). The next register reveals seated patrons drinking at a bar and cavorting under the vigilant gaze of the bartender.

Big Hat Willie, the infamous pimp (who was apparently admired by Singleton), is the subject of the entire central raised panel in the lower section of the door. Big Hat is seen with his trademark chapeau, a dark blue suit, and one of Singleton's killer sticks. His face bears an uncanny resemblance to the skulls in the carved frieze below, and he stands on the back of a kneeling woman, an allusion to the source of his income and the servitude of the women who work for him. In the recessed panels to the left and right of Big Hat are patrons who are depicted clowning, performing headstands, shooting heroin while seated on a toilet, urinating, and drinking wine. *Club 27* represents the true grit of African American ghetto nightlife, and its narrative panels tell a story that extends far beyond the perimeters of the artist's own environment to include the universally negative aspects of street life. *Club 27* is one of Singleton's finest works, and it was also a brilliant forecast for a subsequent series of carved doors modeled upon it.

Two other autobiographical panels are *Schoolroom*, 1990 (cat. no. 148), and *Marcello-Joe U Grocery*, 1991 (cat. no. 151). The classroom panel was inspired by the artist's early childhood, when his clowning activities frequently earned him the title of class dunce. Because of his inability to pay attention to his teachers and his lack of interest in schoolwork, he dropped out of school at age twelve. *Marcello-Joe U Grocery* depicts the interior of a neighborhood grocery store where Singleton was once employed, and its characters and activities are daytime versions of the incidents seen in *Club 27*.

An interesting panel that is symbolically autobiographical depicts a lynch-

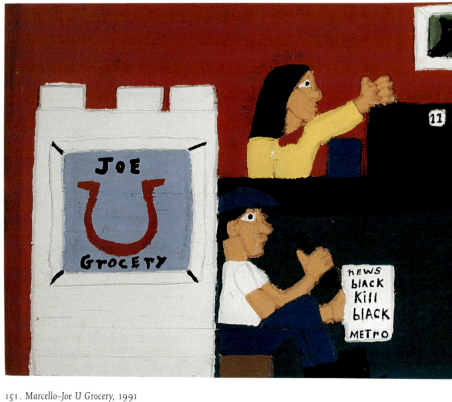

151. *Marcello-Joe U Grocery*, 1991

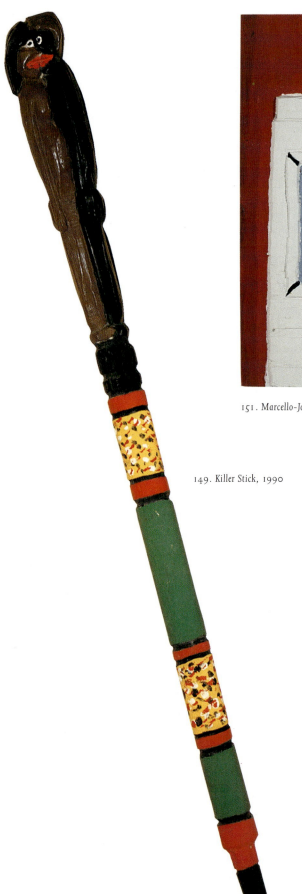

149. *Killer Stick*, 1990

ing by the Ku Klux Klan (cat. no. 147). A large figure of a white man wearing the white robe and hood of the KKK is holding the body of a handcuffed black man with a noose around his neck. The Klansman is preparing to lynch the black man, who hangs limply, helplessly, as if he were resigned to his fate. This scene does not merely represent a typical KKK lynching from a previous era in the South but is instead an artistic metaphor for the plight of the black artist and all other African American males who feel socially, economically, and politically oppressed by white American society. Given Singleton's frequent run-ins with law enforcement officials and his dislike and distrust of white police officers, it is not surprising that the black victim is a self-portrait of the artist.

Jazz funerals and "second-line" dancing are as much a part of African American life in New Orleans as Mardi Gras and red beans and rice. Male and female second-line dancers are renowned for their elaborate dance routines at

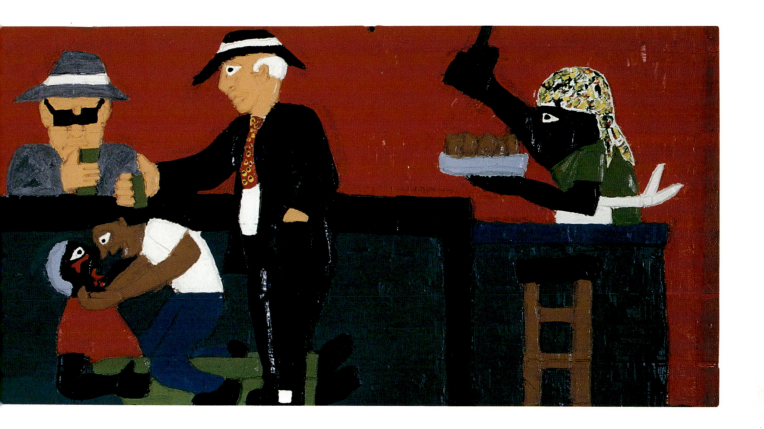

parades and funeral processions. Following the funeral ceremony and prior to the interment, the spirit of the deceased is symbolically "cut loose" in a special ceremony. After that point the mood of the mourners changes from solemn to celebratory, and musicians and second-line dancers, many of whom carry elaborately decorated parasols, accompany the casket to its final resting place. Singleton has attended scores of jazz funerals in New Orleans and has carved a number of panels depicting them. An example in this exhibition (cat. no. 150) was completed in 1994 and is a vertical arrangement of a second-line funeral march. The lower register shows a solemn procession, including the bereaved widow and a casket borne by pallbearers. The majority of the panel, however, displays the saxophone-playing musician and the acrobatic male and female dancers who are arranged in vertical perspective against the panel's dark blue background. The prominence of the dancing and music-making figures symbolizes the

festive atmosphere of jazz funerals. Singleton's compositional and emotional separation of the two groups in this composition is skillfully achieved. Panels of this category, as well as those that depict various Mardi Gras activities, provide a more lighthearted dimension to Singleton's work, which is most often characterized by violent and provocative themes.

Singleton is a prolific artist and estimates that he has carved more than two hundred works. Most of his sculptures are relief panels, but he has also carved a number of three-dimensional pieces. Some of his freestanding sculptures are large, standing seven feet high, and his largest doors are nine feet tall. He does not make preliminary drawings, preferring to sketch his designs directly on the wood. He carves primarily with a hammer and chisel and also pocket knives, and he generally does not incorporate negative areas in his panels. There are numerous inexplicable stylistic analogies between Singleton's sculptures and

those by wood-carvers of the Yoruba tribe in southwestern Nigeria, West Africa, with which Singleton is not familiar.

Due to their large scale, boldness, and frequently uncomfortable subject matter, Singleton's sculptures have not been as widely collected and have not received as much exposure as those of some of his peers. However, his most recent works, especially the powerful carved doors, have garnered widespread public acclaim. And that is as it should be, for Herbert Singleton is one of the most gifted and innovative self-taught wood-carvers currently working in the United States. —R.P.

NOTE

1. Singleton, in interview conducted by the author.

Isaac Smith

Dallas wood-carver Isaac Smith, the third of eleven children, was born in 1944 in Winnsboro, Louisiana. His father was a farmer and a nightclub owner in this small town near Monroe. Smith doesn't remember having any artistic leanings as a youth, but one incident left a profound impression on him: He remembers watching a man carve a broomstick into a chain of unbroken links. After seeing how it was done, he knew that he could do it, too, and he carved a few links just to prove that he could.

This initial exposure to wood carving sparked his interest, but it would be many years before Smith took it seriously. He dropped out of school in his early teens and went to work for a pipeline company in Mississippi. When he was seventeen years old, he moved to Dallas in search of a job and a better lifestyle. He worked for an airplane manufacturer in Dallas for more than ten years, but the physical strain and impending layoffs forced him to leave his position in 1975. It was then that he took up carving full-time.

He taught himself how to draw and experimented with painting, but he found that he much preferred carving. He took great care in studying different types of woods and learning all that he could. His first wood-carving attempt, a totem pole, was unsuccessful, but his second one, a monkey, was outstanding, and he has been carving a variety of animals ever since. As a youth he had spent a great deal of time fishing and exploring the woods in Louisiana, so he was familiar with many types of animals, and carving their likenesses came naturally. When an old woman saw his first monkey, she said, "You don't know what you got." When he sold the monkey a short time later, he realized he could make a living from his newfound passion.

Some of Smith's favorite images are tigers, bears, wildcats, bulldogs, salamanders, raccoons, birds, fish, alligators, and bears, such as *Polar Bear*, 1994 (cat. no. 152). The animals range from seven inches to seven feet, and many are close to life-size. Smith uses whatever wood he can find—oak, cypress, maple, elm, or hackberry. Once he finds suitable logs and branches, he cures the wood by soaking it in gasoline and then sealing it in a closed tank for several days.

When Smith begins working on a piece, he roughs out the shape with a chain saw, then further defines the image with hatchets or chisels of various sizes. Sometimes he'll use a knife for finer details, but usually all that is required is a rough file followed by a smooth file or sandpaper. To add legs, feet, ears, horns, or other features, Smith uses a concoction of wood shavings and glue to secure and model the joints. He also uses this modeling material to form smaller images like the salamanders. Some animals have sharp toenails and teeth made from splinters of wood. After carving and assembling the animals, Smith paints them with acrylics, striving for a realistic imitation of nature. The entire process usually takes two or three days, depending on the size of the sculpture. He typically works on more than one carving at a time; however, though he might make several of the same kind concurrently, no two are alike.

The backyard of Smith's small home accommodates a studio, a bird hatchery, and a vegetable garden. With a keen appreciation of nature and farm life, Smith grows greens, okra, tomatoes, and beans, and he raises chickens, pheasants, and roosters. His large studio area—covered with a patio-like roof, bounded by the fenced-in yard, but otherwise open to the elements—is often filled with scurrying chicks and adult fowl. Covering the ground are piles of wood of all shapes and sizes, waiting to be brought to life by Smith's creative hand.

Smith regularly refers to videotapes of wildlife to make sure that his sculptures are anatomically correct and, more importantly, to see what the colors should be. It is very important to Smith to get the colors right, and for that reason he doesn't like to rely on the photographs in encyclopedias. He believes that he has a God-given talent and a special calling to make these sculptures, and he says the videos allow him a firsthand look, "second only to God Almighty." —D.G.R.

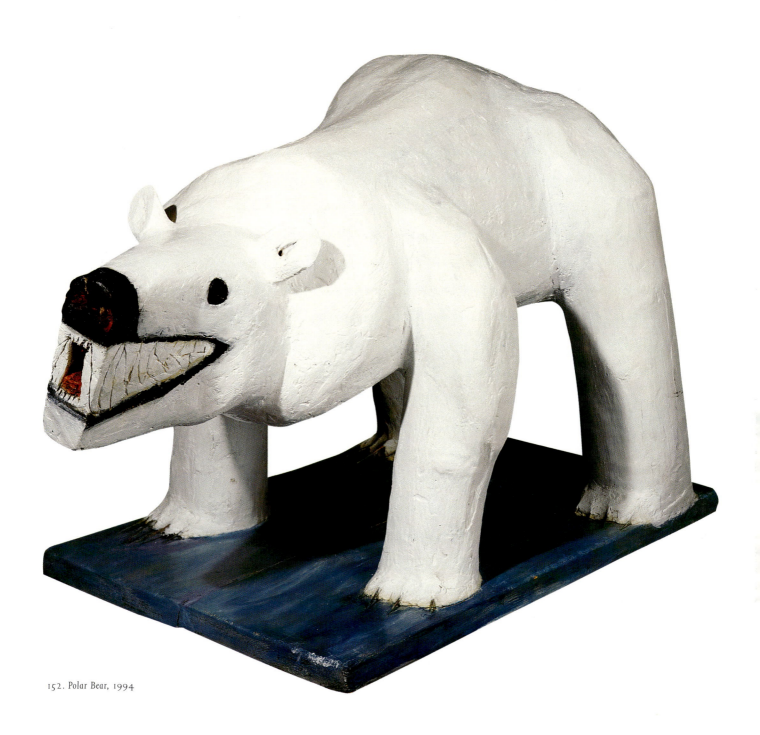

152. *Polar Bear*, 1994

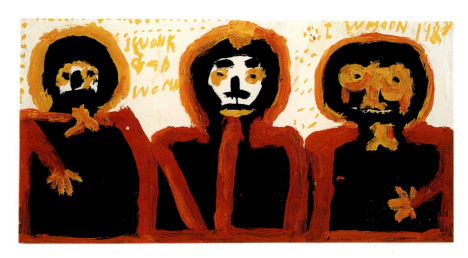

153. *Three Faces, 1988*

Mary Tillman Smith

Born Mary Tillman in 1904 in Brookhaven, Mississippi, Smith spent her entire life in central Mississippi, where she worked as a sharecropper, housekeeper, babysitter, and cook. Twice widowed and the mother of one son, Smith lived alone for over twenty-five years in a tiny, white frame house on the outskirts of Hazelhurst (near Jackson), having moved there during the late 1960s.

Around 1980 Smith began decorating the fence surrounding the yard of her home with painted tin panels shaped with an ax. The subjects of her pictures were portraits of herself and friends, animals, human figures, seasonal greetings, and biblical statements, such as "I believe in the Lord, the Lord was with me," "I thank the Lord all the way," and "Everybody for the Lord." Smith executed her paintings with bold enamel colors, usually employing only one or two hues

in combination with black and white in each panel.

Smith's yard environment soon attracted the attention of visitors and art enthusiasts. Her early paintings were very large, were usually of humans, were painted on corrugated roofing tin, and were predominantly vertical. Some of the human figures were over seven feet tall, with arms and legs cut from separate pieces of tin and attached to the bodies. Smith received newspaper and magazine publicity shortly after she created her unusual yard art, which accounts for the early public interest in her work. Her large yard originally contained scores of figures that were purchased for modest sums by enterprising collectors. Following their sale, Smith would attempt to replace the figures, but her poor health and frail physical condition prevented her from duplicating many of the largest

pieces. She discovered that she could make smaller paintings with far less effort and that buyers would continue to arrive.

Until a few years ago, Smith maintained an enormous menagerie of dogs and cats who were her constant companions in the small shed that functioned as her studio. Smith's canines appear frequently in her paintings and are depicted with her characteristic bold, broad brushstrokes and pure, primary colors. An unusual aspect of Smith's art is that, while many of her paintings bear biblical phrases and references, she rarely depicted a religious subject per se.

Following Smith's discovery and emerging reputation as a folk artist, her style changed somewhat and her repertoire of subjects increased greatly. She used smaller panels and began painting on plywood, cardboard, and paper in

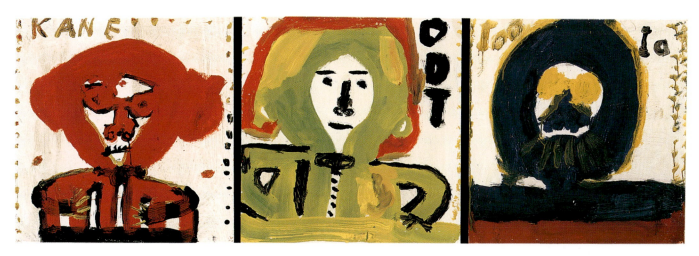

154. *Faces with Calligraphy*, c. 1980–85

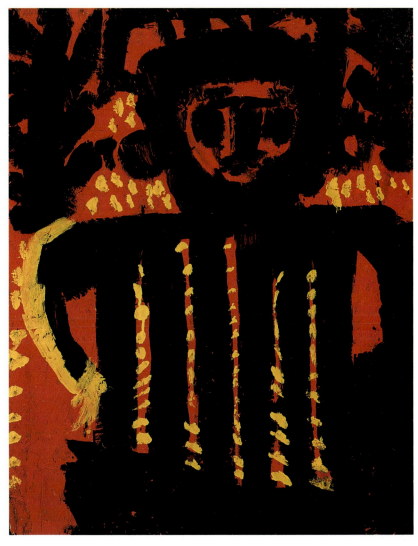

155. *Single Black Figure on Red with Yellow*, c. 1985

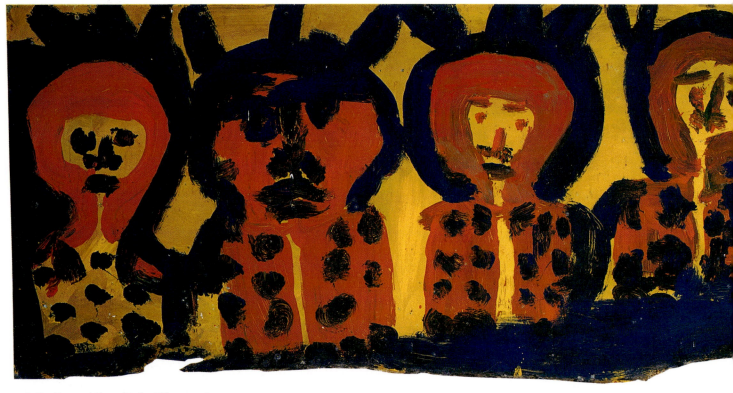

156. *Five Figures of Blue and Red on Yellow*, c. 1985

addition to her preferred ground of roofing tin. There are some stylistic characteristics of Smith's work, however, that remained constant. Her simple figures have enormous heads, abbreviated features, and small, rudimentary limbs; most of the facial expressions are benign. Bold lettering appears on most of her paintings, in addition to stripes and confetti-like dots of color. The extent of Smith's formal schooling is not known; however, judging from the frequently misspelled words in her works, her education was minimal. The fact that Smith limited her palette to one or two colors contributes to the success of her paintings. Smith's method of painting was very simple: She applied a solid background color to roofing tin, plywood, paper, or other material, and then she built the design up in several layers, with the background color providing the flesh tones and serving as a spatial device. Although Smith's paintings initially appear to be overly simplified and haphazardly executed, they are actually

the result of superimposed layers of paint that create the effect of shallow space.

Smith was a tiny, delicate woman who spoke in a shrill voice and seemed physically incapable of having produced and installed the five- to seven-foot figures that once decorated her yard. At the height of her early period (around 1984), Smith's yard became a gigantic outdoor museum and one of the most extraordinary folk art environments in America. Smith used corrugated roofing tin to fashion most of the large figures that populated her yard. Following her discovery as an artist, Smith began painting large, single figures on board and tin, including heads, busts, and full-length views (cat. nos. 155, 157). Some of the figures are portraits of her and her dogs, and they usually display titles or a simple message. She also painted hundreds of small panels depicting a single large head or bust, as in the series *Faces with Calligraphy*, c. 1980–85 (cat. no. 154).

As the demand for Smith's paintings increased, so did her productivity.

She began depicting groups of figures in single and double registers (cat. no. 156), with characteristic large heads, rudimentary limbs, simple features, and bold background lettering. Few of Smith's middle and late works rival the early pieces that she installed along the fence surrounding her home. The figures with jointed arms and legs resembled gigantic marionettes standing motionless against the Mississippi terrain. Probably as a result of requests from her customers, Smith attempted to replicate those pieces by cutting out arms or limbs, paper-doll fashion, from the same piece of tin on which the figures are painted (cat. no. 157). The effect is interesting, but the works are not nearly as dramatic as those produced earlier.

The almost universal appeal of Smith's paintings lies in their utter simplicity, vigorous execution, and raw emotive force. Her art contains no complex iconographic themes. It is not exclusively religious or autobiographical. It is, however, playful, schematic, and

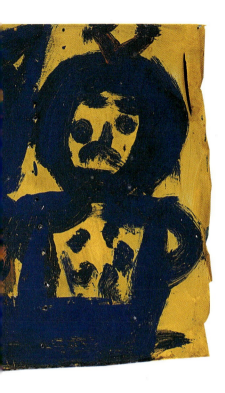

conceived with an unusual sincerity and freshness of vision. Smith's art may be placed within the category of Art Brut, and it bears some resemblance to the art of Jean Dubuffet and Georges Roualt.

During the past several years, interest in Smith's art has intensified greatly in art circles, and in 1995 her work was included in the Biennial Exhibition at the Whitney Museum of American Art in New York. A prolific artist, her late works nevertheless do not possess the power of the early pieces, about which she stated, "I did them to pretty the place and please the Lord."

Toward the end of her life, due to her advanced age and rapidly deteriorating health, Smith stopped painting. She died in August 1995. Her paintings are now housed in noted public and private collections, bearing vivid testimony to the skills of a creative and energetic folk artist in her prime. —R.P.

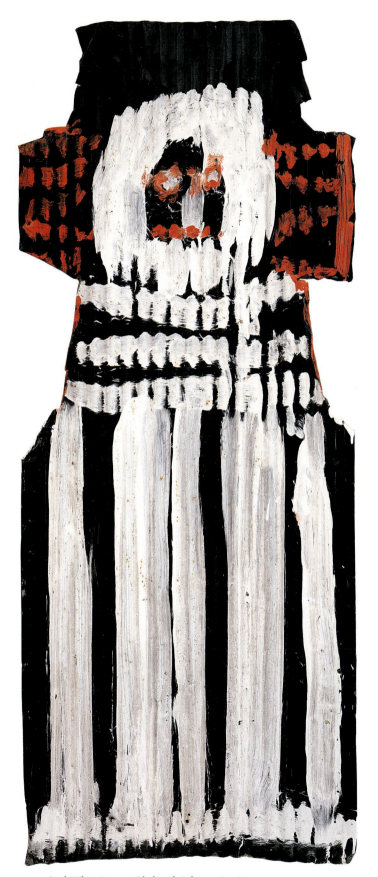

157. *Single White Figure on Black with Red*, c. 1980–85

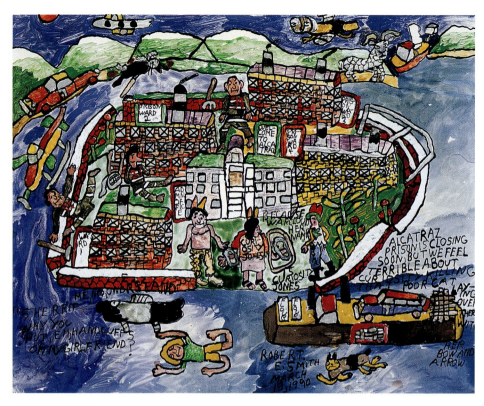

158. *Alcatraz Island*, 1990

Robert E. Smith

During one of my visits to New Orleans to work on their collection, Kurt Gitter and Alice Yelen handed me a small bundle of letters they had received from Robert E. Smith. Written on scraps of paper that were folded indifferently and thrust into odd-sized envelopes for mailing, they dealt mainly with matters of business between the artist and his patrons. However, Smith's rambling, ungrammatical, hastily written scrawl also described his concern about his apparently precarious health and mental state, his shaky financial situation, and above all his constantly reiterated hopes that his worth as an artist and as a human being would be recognized.

Born in St. Louis, Missouri, in 1927, Smith's uneasy relationship with the world and his preoccupation with achieving some form of personal triumph are understandable in the light of his biography, which chronicles an uprooted life

punctuated by unsteady mental health, a series of poor starts, outright failures, and other humiliating episodes.[1] Paradoxically, Robert E. Smith's art appears to betray little of the artist's dark life.

This exhibition includes two works by Smith. *Alcatraz Island*, 1990 (cat. no. 158) is exemplary of his pictures. Using acrylic, oil, pen, and marker on paper, the artist fashioned his response to a 1969 event in which a group of Native Americans occupied Alcatraz Island. Smith depicts the island from an aerial perspective. Watercraft, swimmers, a causeway crowded with automobiles suggest that everyday life goes on around the scene of feverish activities, as authorities, one of their helicopters hovering above, struggle with Native Americans demanding that a study center for their people be established on Alcatraz Island, a state park and tourist site since the closing of the federal prison there in 1963.

Perceiving himself an underdog, Smith found this subject a natural. He was able to identify with a people who exist as exploited and disparaged outsiders. However, Smith isn't without a sense of humor. Throughout *Alcatraz Island* he has written bits of commentary, such as the sign that says, ironically, "Welcome to Alcatraz." Another parodies white versions of Indian English: "Me no understand, Sheriff, why you put 'um handcuffs on my girl friend?" No matter how dramatic the subject, Smith's pictures are invariably rendered with a sunny, colorful palette, quickly drawn details, and energetic, vibrant compositions that sprawl all over the surface.

New Orleans Table, c. 1988–89 (cat. no. 159), is an unusual, original vehicle for Smith's artistic endeavors. Working with a craftsperson, Smith had made small tables—their three elements slotted so that they can be easily assembled or dis-

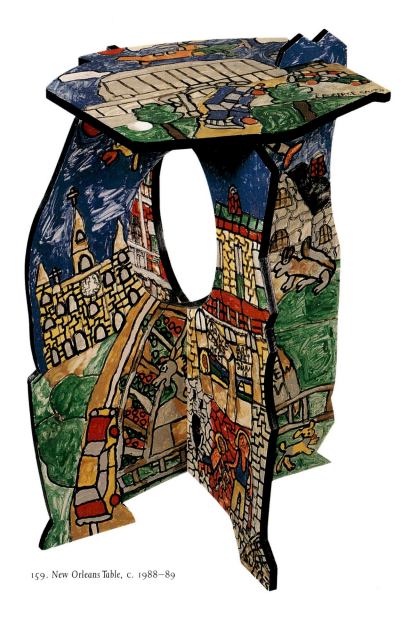

159. *New Orleans Table*, c. 1988–89

assembled. He then decorated the tables in his inimitable pictorial style. Sprawling and freely composed, *New Orleans Table* inventories many of the city's attractions: the French Quarter, the Superdome, a famous hotel, the riverfront where the New Orleans Barge Line tugboat and the sternwheeler *Natchez* ply the water. There is also a sunbather enjoying the clement weather of the city (it did occur to me that this figure could represent a comatose junkie—is Smith "keeping the record straight"?). One important section, which appears to be located in the French Quarter, shows a sidewalk artist with his easel and canvas. Nearby is another street person, perhaps selling art supplies. Are these people surrogates for Smith himself?

Altogether, there is a strong sense of engaging optimism in Smith's work —he does not use his art to express his despair. In fact, it seems that Smith, by recognizing his own plight as one aspect of more widespread social ills and by engaging them in his art, seeks to mitigate them—with determination, but with warmth as well. —G.J.S.

NOTE

1. See the entry on Robert E. Smith in Chuck Rosenak and Jan Rosenak, *Museum of American Folk Art Encyclopedia of Twentieth-Century American Folk Art and Artists* (New York: Abbeville Press, 1990), pp. 285–86.

Quinlan J. Stephenson

Quinlan J. Stephenson's Earth Museum is a one-room log, stone, and stucco cabin that sits alongside a two-lane blacktop road outside the small community of Garysburg, North Carolina. Despite its modest size, it is easily the most unusual building in Northampton County. When he built it in the 1940s it was an unobtrusively rustic addition to the local landscape, but he later distinguished it from the common rural architecture of eastern North Carolina by encrusting its walls with the thousands of natural and manufactured objects he had collected all his life. The interior and exterior surfaces of this solid little structure are an almost uninterrupted mosaic of bones, arrowheads, deer antlers, fossils, geodes, seashells, cypress knees, old bottles, Civil War relics, and other items. The building is further ornamented with hundreds of leaf and fern-frond imprints, several large cement discs incised with informational texts, and a number of fanciful sculpted animals.

Also known as the Occoneechee Trapper's Lodge, the Earth Museum occupies the front yard of Stephenson's home and sits across the highway from the house where he was born more than seventy-five years ago. Even today this part of the state's northeastern coastal plain is largely given over to vast stretches of forest and river swamp. As a boy growing up there in the 1920s and 1930s, Stephenson spent much of his time exploring the densely wooded areas, gathering artifacts and specimens that much later wound up among those embedded in the walls of his unique lodge. Early on he learned to track and trap the raccoons, beavers, and other wild mammals that inhabited the forests and fields near his home, and the income he earned from selling their furs helped his family through the lean years of the Great Depression. These activities engendered in him the respect for and extensive knowledge of nature that later informed his art. While learning about the region's wild plants and animals, he also studied the fossils and Indian artifacts he found, researching them to learn more about the area's past, which also later emerged as a favorite artistic theme.[1]

In 1936, when he was sixteen years old, Stephenson expanded his horizons by joining the Civilian Conservation Corps, the federal agency established three years earlier under Franklin D. Roosevelt's New Deal to provide young, unemployed men with public construction jobs. He was assigned to a unit in the redwood forests of northern California, where he spent a year building trails, planting trees, and fighting forest fires. Soon after his return to North Carolina, he found another outdoor job operating a dragline for a construction firm. Although he married and settled down in the house where he and his wife still live, he spent much of his spare time, as he had since childhood, roaming the woods and tracking wild animals or unearthing fossils and relics of the area's former inhabitants.

It wasn't until he retired in the late 1970s that Stephenson began using the thousands of items he had amassed over fifty years to decorate the one-room lodge in his front yard. Soon after he completed this transformation, the Earth Museum was spotted by Robert Lynch, a pioneering art collector (now deceased) from neighboring Halifax County.[2] Lynch suggested that Stephenson adapt the techniques he used for ornamenting his museum to creating assemblage plaques and freestanding sculptures, and he became the first of many to collect the works Stephenson began making in response to that suggestion.

Stephenson apparently views his compact art environment as a combination educational facility and tourist attraction. Accordingly, his plaques and sculptures are reminiscent of informational displays and old-fashioned handcrafted souvenirs. He has long been fascinated with prehistoric life forms, and many of his more recent sculptures are fanciful miniature dinosaurs that

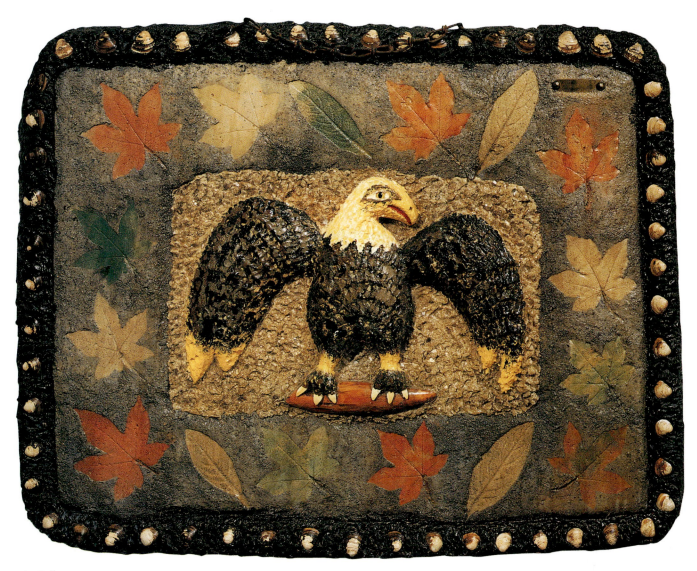

160. *Eagle*, 1992

reflect the influence of Hollywood special-effects artists. The ultimate function of the Earth Museum and Stephenson's many works is simply to celebrate the wonders of nature. He has spent the better part of a century immersing himself in what's left of the great American wilderness, turning up all manner of remarkable little treasures in the process. His distinctive art was born out of his desire to share all this with his neighbors and with passing strangers who stop to investigate his amazing roadside attraction. —T.P.

NOTES

1. All biographical information comes from the author's interview with the artist on August 13, 1993.

2. Robert Lynch died in 1989, while still a young man. His important collection—including early works by Q. J. Stephenson—is now housed at North Carolina Wesleyan College, Rocky Mount, North Carolina.

David Strickland

David Strickland, a self-taught artist from Red Oak, Texas, has found a creative way to recycle old farm equipment and scrap metal. He constructs magnificent large-scale sculptures using objects as small as a wrench and as large as a diesel gas tank.

Strickland was born in Dallas, Texas, in 1955. His parents separated when he was fairly young, and afterward he and his only sister lived with his father, a postal employee who worked long hours. For the most part, Strickland and his sister were raised by their grandparents.

During the school year his grandmother spent a great deal of time with them in Dallas, and in the summer they lived on their grandparents' farm in Clifton, Texas. Memories of these summers left such an impression on Strickland that, after graduating from Carter High School in Dallas, he moved to Clifton and went to work for the local telephone company.

In 1975 Strickland was convicted of driving while intoxicated and was required to take a state-sponsored trade course as a reform measure. He moved

back to Dallas and completed a welding course. To this day, he maintains that he wishes he had taken the heating and air-conditioning class instead. While taking the course, he met a man who had made small sculptures out of metal. This was Strickland's first exposure to metal art, but at that time he didn't pursue the interest.

After Strickland finished trade school, he went to work. In 1979 he married; his wife, Nancy, is a native of Red Oak, Texas, which is a few miles

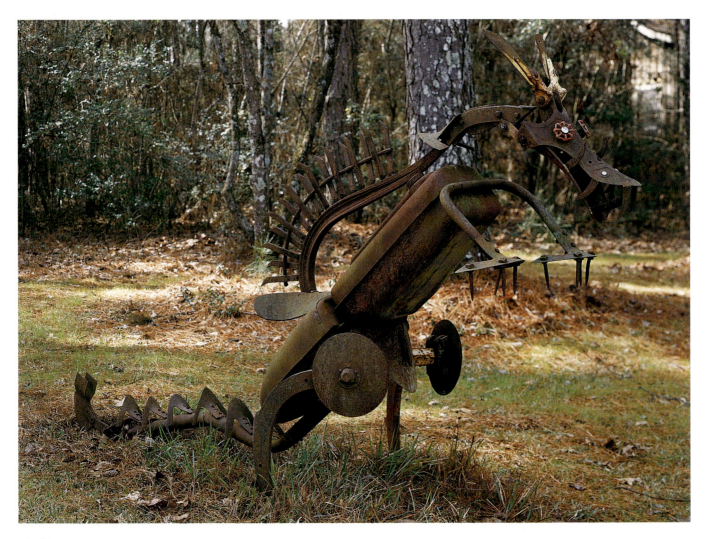

162. *Dinosaur*, 1991

south of Dallas. The couple settled in Red Oak, where Nancy was living and working for the Veterans Administration (as she still does). Strickland held various carpentry and remodeling jobs, and in 1982 he went to work at the VA as a general laborer. In 1988 he was laid off, so he brushed off his welding skills and went to work for the Glen Rose Nuclear Power Plant; the job lasted about a year. Tired of working odd jobs, he spent the next six months completing an addition to his home.

To supplement the family's income, Strickland often repaired farm equipment and sold scrap metal; then, in 1990, he noticed that some of the machinery parts lying around his yard resembled the features of a bird. He saw pieces that looked like beaks, wings, and legs, and he put them together. Soon he had fashioned from heavy equipment a bird that stood more than three feet high. Strickland enjoyed this creation and found himself looking at machinery parts in a whole new light. That year he made about seven sculptures, one of which he gave to the owner of a nearby junkyard. This sculpture, with a chest made from a radiator, stood at the front of the junkyard, facing Interstate 35. Local collectors noticed Strickland's work and encouraged him to make more. Soon regional collectors and gallery owners were knocking on his door, wanting to purchase the creations he had begun simply as a hobby.

Strickland acquires his materials by salvaging discarded parts whenever he sees them and by purchasing broken-down farm equipment from private sources or public auctions. Whatever he can't use he sells for scrap metal. Innumerable pieces of metal and machinery parts of all shapes and sizes crowd his spacious backyard: There are cogged wheels, blades, plows, chains, lawn mowers, radiators, milk cans, tractor seats, shovel heads, hubcaps, metal reflectors, barrels, axles, tractor grilles, and hundreds of other objects. Strickland admits he enjoys scavenging for sculptural materials, especially among the many farms in his rural community.

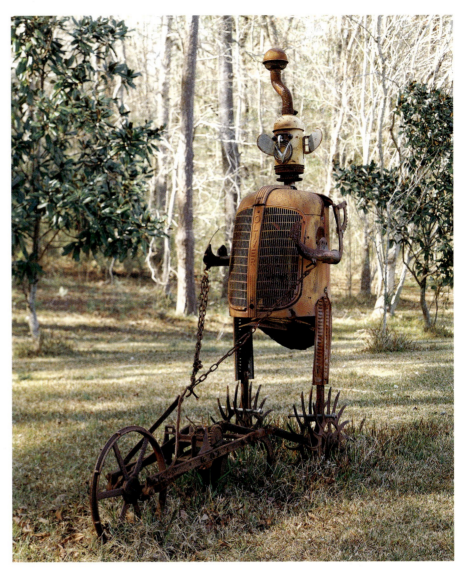

161. *Mr. Oliver*, 1991

He rarely has to venture outside county lines to locate objects he can use. If he buys a piece of old farm equipment, he can usually recoup the cost with profits from just one sculpture. He says that he can find good tin and other useful pieces of metal in junk piles or ditches where people throw discards. Rather than search for specific objects, Strickland looks for shapes that appeal to him or fill a specific need for one of his constructions. He acknowledges he doesn't always know the names of the machinery parts: "There's a lot of parts that I don't know what they are, [and] I never tried to find out, really. When I first started, I didn't know the name of any-

thing, because really I never did any farming or plowing."[1]

Driftwood is another material that Strickland uses frequently. Some of his sculptures have wooden arms or legs; some stand on logs. He never attempts to carve these pieces of driftwood into specific shapes; instead, he uses them just as they are. He's therefore quite selective about the wood he salvages from nearby Lake Whitney. When asked why he prefers driftwood, he says simply, "I like the way it looks."

The process of building the sculptures varies, and different types of materials call for different methods of assemblage. Sometimes Strickland begins with

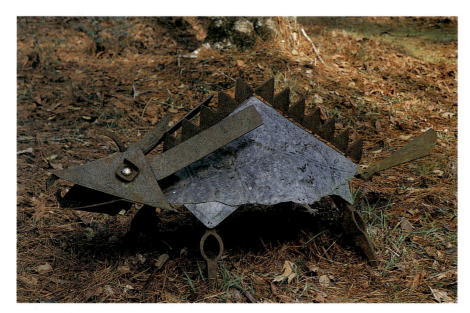

165. *Giant Horned Toad, 1992*

too hot and will burn a hole through it. For sculptures that incorporate driftwood, the limbs must be sturdy and the metal securely attached to the wood.

Each of Strickland's creations is unique, primarily because his materials are one of a kind. In subject matter his sculptures range from imaginative likenesses of living animals and people to dinosaurs and whimsical creatures. Although Strickland has made many small pieces fashioned from a variety of types and sizes of metal—such as *Red Snapper*, 1994 (cat. no. 163)—he particularly loves to make large-scale pieces. He even bought a winch and mounted it on the bed of his truck to make moving the large sculptures and salvaging large pieces of farm equipment easier.

The enormous *Dinosaur*, 1991 (cat. no. 162), has a gas tank for a torso; a soil aerator and a tilling device attached to it form a curved, spiny backbone and tail. It stands on its rear legs and leans forward menacingly, with spiked claws and sharp metal teeth. So it won't pitch forward, the majority of the weight is in the hips, back legs, and tail. *Mr. Oliver*, 1991 (cat. no. 161), is a massive, humanistic figure that appears to be driving a plow. Its head is made from an air filter of some type, its torso from a front tractor grille bearing the word "Oliver" in

a mental image of the finished work, so he will look for the appropriate parts and work from there. Sometimes he doesn't have a plan but "sees" something in a piece of metal or a machinery part that sparks an idea. As he works, he finds the parts that will structure the design and flesh out the form. In this way his sculptures evolve throughout the creative process.

Since most of Strickland's work is large—three to seven feet in height—and extremely heavy, structural integrity is crucial. If a sculpture is top-heavy,

then he must either figure out a way to stabilize it or, failing that, redesign it. If there is too much weight or stress on a joint, he reinforces it with extra bolts or adds a supportive element. Although he prefers the look of rusty metal, he admits that it is harder to weld such pieces together, and it is more brittle than metal that is not rusted. He screws or bolts pieces together as often as possible to ensure stability and in many cases to make parts movable. If Strickland wants to use tin, he nails or bolts it to the structure because the welding torch is

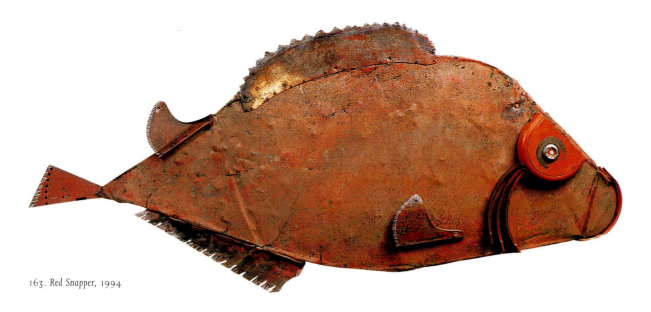

163. *Red Snapper, 1994*

raised letters. The feet are circular soil aerators, and the front wheel is a single-row planter device. This sculpture was top-heavy, but Strickland solved the problem by attaching chains from the arms of the figure to the front wheel to keep it from falling backward. One of Strickland's favorite sculptures is *Giant Horned Toad*, 1992 (cat. no. 165), made from dimpled barn tin, with sickle blades running the length of its back. Horned toads are native to North Texas, and he has made a variety of them along with the well-known Texas "mascot," the armadillo. In addition to these decorative sculptures, Strickland has made a few functional barbecue grills that are works of art in themselves: One is fashioned out of an old mailbox, and another is surmounted with a dragon whose nostrils emit smoke.

These are just a few of the ingenious creations that Strickland crafts from an odd assortment of spare parts. With dedication and single-mindedness, he finishes everything he starts. He never works on more than one sculpture at a time, and he sometimes reassembles one several times until it looks right. The smaller sculptures take him about a day to complete, the larger ones about a week.

Unlike many self-taught artists, Strickland is not consumed by his art. He works steadily and quickly when he is making a sculpture, but the time between projects can vary from several days to several months. He is most productive when the weather is favorable; summer's heat or winter's cold often sends him in search of some type of temporary employment. He frequently works on what are called "shut-downs": When a company closes or goes out of business, a crew is called in to clean up the facility, and Strickland does the repair welding. These and other temporary jobs last a few days or several weeks, just long enough for Strickland to make some extra money before he grows bored. He prefers short-term, intense work, and

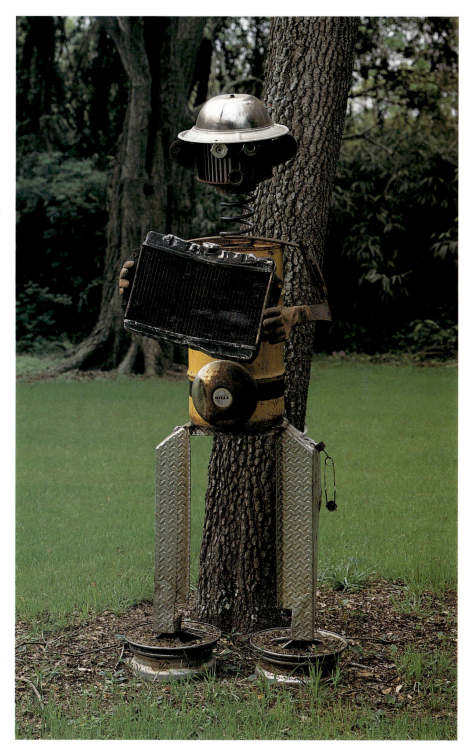

164. *Radiator Man*, c. 1993–94

this appears to hold true with his artwork as well. In his leisure time, Strickland enjoys raising goats and pheasants, and spending time with his two children, Myra and Brian. —D.G.R.

NOTE

1. All quotations are from interviews with the artist conducted by the author in July and December 1994.

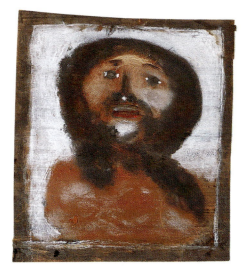

172. *Portrait of Elbert, 1988*

Jimmy Lee Sudduth

A native of Fayette County, Alabama, where he was born in 1910, Jimmy Lee Sudduth has been making art most of his life. His first memory of painting is of wandering in the woods at the age of three and making marks on trees. His interest continued as he grew older, though he had a great deal to learn: "As I growed up I'd think of these things and then I'd go back and draw me a painting. I was eight year old then. I saw me a painting and I could not draw but one end of it. I didn't know anything about coming back out here and drawing this, didn't know nothing about how to get back here,"[1] he once said, motioning to the side of a house he had just depicted and referring to its perspective.

The most unusual aspect of Sudduth's work is the material he uses. He paints with various muds and clays found near his home or gathered on special trips. Knowing where to find black, red, white, and yellow clays, he mixes them with sugar, which acts as a binder, and then lets them dry on the boards used for canvas.

Sudduth's discovery that mud could be used as paint came about by accident: "Someone was lickin' syrup and dropped some into the mud. I took it and put it on the side of an old rotten tree. The tree was real slick, and I said, 'Now I'm

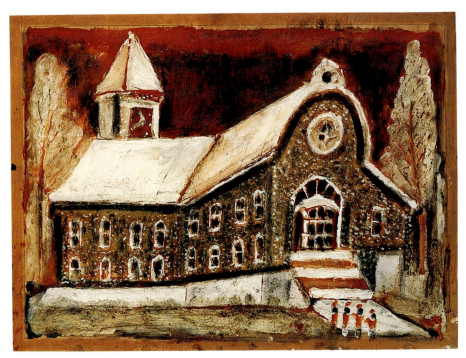

167. *Church, 1976*

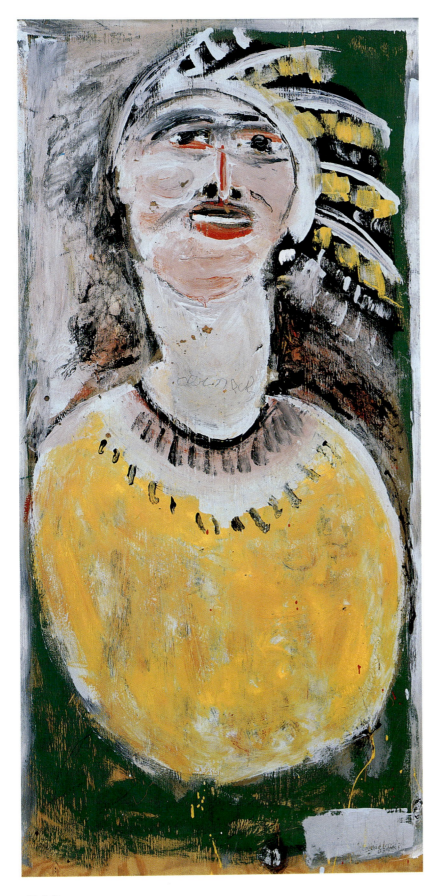

166. *Indian, c. 1990*

gonna put sugar or something in mud and see if I can do that. And that's how I started." He primarily mixes sugar with the mud, but he has also used syrup, honey, even Coca-Cola—anything sweet will make the mixture stick, he says. Once it dries, "it's just like a brick."

Natural materials are important to Sudduth. He grew up on a farm, as a young man worked as a farmhand, and has never been without a garden to tend. In conversation he proudly emphasizes that paint is not essential to his art. Grasping a clump of ivy between his thumb and forefingers, he rubs it vigorously across the board, exclaiming over the resulting color, "There is no paint in this picture." However, beginning in the 1960s, Sudduth began experimenting with latex house paint and incorporating it in his paintings. Paint had become the dominant material in many of his compositions by the mid-1980s, when his numerous patrons began bringing paint for his use. Cans of paint on his front porch testify to his increased use of non-natural materials. In fact, some of his current works are created exclusively with paint, with no mud at all.

In spite of the availability of these conventional artist's supplies, Sudduth prefers to rely on his own resourcefulness with natural materials. He claims to have found thirty-six shades of mud, and also uses leaves, pine needles, and other foliage to get a wider range of colors. He says, "I can scrub leaves on wet paper to get green. [He also rubs leaves and grass directly on plywood.] Sometimes I hammer green tree buds when they first come out in the spring to get green color, and sometimes I hammer green pine needles on wet paper." He often uses the husks of walnut shells to obtain a dark stain and gathers pokeberries and elderberries for red-purple colors.

Sudduth supplements these natural pigments with other materials: egg coloring, carpenter's chalk, axle grease, coffee grounds, and soot, increasing the range of his palette by mixing these

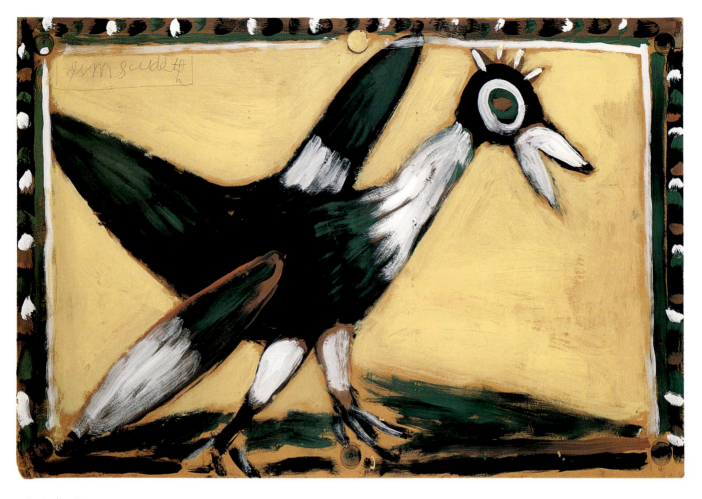

168. *Bird, 1988*

nonnatural coloring agents with clays. Mud and sand also blend effectively with paint, creating rich, tactile surfaces. Sudduth has even used red crepe paper to turn mud pink and directed exhaust from his lawn mower onto a painted scene to cause it to fade into darkness. Jack Black, director of the Fayette Art Museum, recalls a portrait of John F. Kennedy in which Sudduth carefully dabbed dampened red crepe paper on the mud to achieve the desired skin tone. It was a rare instance when Sudduth, who normally is oblivious to the color of anyone's skin, real or in a painting, concerned himself with skin tone.

Sudduth has used almost any flat surface for his paintings—cardboard, plywood, Sheetrock, metal—although now he works almost exclusively on plywood. Some of his paintings are in the form of murals adorning the sides of houses and outbuildings in Fayette County. He painted the side of his previous house in trompe l'oeil fashion so that it appeared to be constructed of stone, rather than concrete blocks,[2] and he painted the metal toolshed by this house with an eight-foot-high picture of a cow. The trunk of a tree in the yard of his current home is painted with a portrait of an Indian, a visible reminder of his first successful efforts with mud and sugar. He uses his index finger and thumb instead of a brush to apply the clays and other colors; he says they give him a better line than a brush does. He sometimes employs a nail, pocketknife, or other sharp tool to incise areas of the scene. This technique is especially effective for delineating the mortared joints of brick buildings.

Sudduth has also populated his front yard with representations of people and animals. Once, when he found a piece of phosphorus wood, Sudduth carved it to resemble a deer, creating an eerie, almost surreal sculpture. The carvings did not sell well, nor do they serve as the best vehicle for images Sudduth wishes to represent. More typical than his carvings were large figures he cut from plywood for elaborate Christmas displays he created for his yard.

Rather than painting sentimental remembrances from his youth, Sudduth paints what is familiar and what impresses him now. Architecture appeals to him, and he enjoys depicting buildings he has seen in person or in photographs. Postcards from friends also become excellent sources, and many people have commissioned him to paint their houses

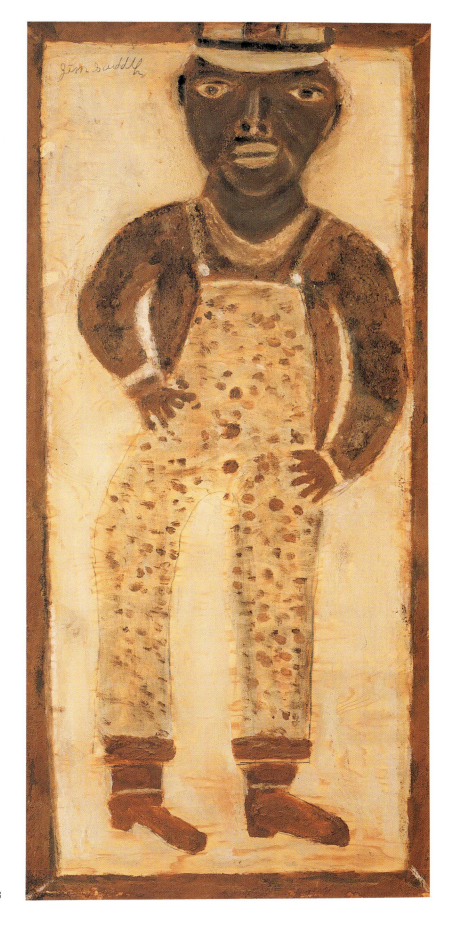

169. *Self-Portrait,* c. 1988

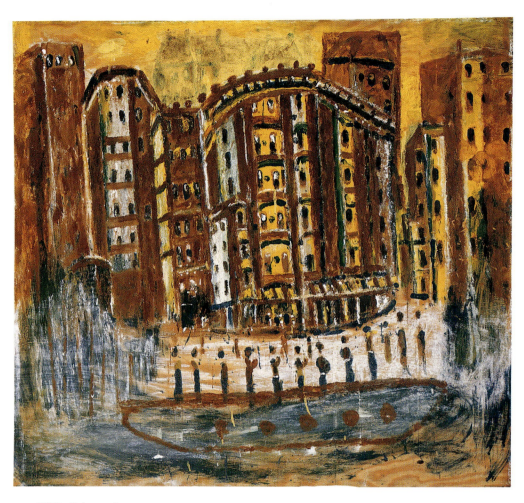

170. *Old New York*, c. 1989

or places of business. Depicting buildings in clay has obvious advantages. Clay imparts textural qualities not achievable with paint alone and thus easily translates the rough surfaces of stone or brick or the thick beams of a log cabin.

Although Sudduth enjoys looking at and studying buildings, he often sacrifices architectural accuracy for a pleasing picture, sometimes by moving stationary elements in order to include the most interesting of a structure's decorative features. He is not a chronicler in the strict sense, but he always captures the spirit of a particular location. When Sudduth drew the First United Methodist Church in Fayette (cat. no. 167), he moved the bell tower and eliminated two of the arched openings at the entrance at the top of the steps. In doing

so, he illustrated essential elements and clarified the presentation. His paintings of buildings generally fill the picture plane, giving even modest structures an aura of grandeur.

In *The Capitol, Washington, D.C.,* 1988 (cat. no. 171), Sudduth deftly uses the long, narrow proportions of the board to construct the central dome and wings. His strength as a colorist is seen in his successful blending of mud and leaf pigment, creating the muted tones of green and brown for the atmospheric background. The gritty and textured surface of *The Capitol,* set against this soft, ethereal background, highlights the individual qualities of the natural materials, which strengthen one another and create an artistic whole. While experimenting and working over the last decade, he has

been able to transfer his skills in blending and shading natural materials to achieving similar effects in paint, making his painted works more successful and more representative of his style.

Backgrounds in Sudduth's portraits are usually monochromatic, and the emphasis is on the figure or head. An exception in this exhibition is the dramatic portrait *Indian,* c. 1990 (cat. no. 166), the background of which is a lively mixture of green, black, red, and white paints. Pokeberries mixed with kaolin give a cocoa color to the skin, while another coloring agent, probably charcoal, outlines brows and other facial features, charging the portrait with an expressionist bravura. The modeling of colors on the face illustrates Sudduth's energetic approach to his work. As in

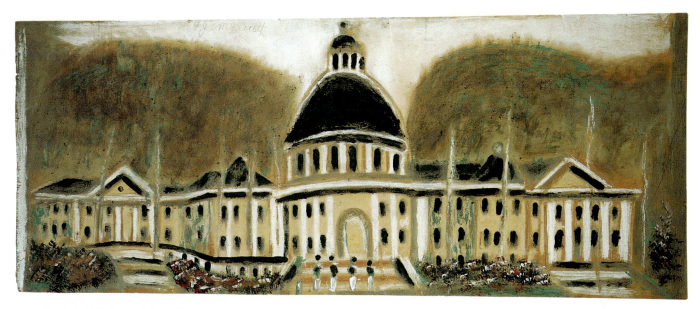

171 . *The Capitol, Washington, D.C., 1988*

most of his paintings, one senses a strong physical presence in the artist's gesture. Indeed, watching him paint, one sees his hand dive suddenly into a bucket of mud and his fingers work rapidly to create the image on the board. In this way the artist participates fully in the interaction between subject and materials.

While Sudduth's *Indian* indicates the type of individual he often paints, the *Portrait of Elbert,* 1988 (cat. no. 172), best illustrates his ability to depict a specific individual. Sudduth says that Elbert was his half brother and that this portrait was painted after Elbert's death: "A fellow killed him, arguing about the time of day." The heart-shaped face, made pale in areas by additions of yellow dirt and chalk, is surrounded by a halo of dark hair. A tremendous sadness fills the eyes, recalling depictions of Christ or other martyrs.

Sudduth uses the same direct, frontal approach in depicting himself. He has made many self-portraits, but the example in this exhibition (cat. no. 169) is especially fine. It is a full-length portrait showing Sudduth in his usual overalls and cap, but he has taken time to detail his hat and shirt, to create a decorative pattern for the overalls, and to give the shirt and overalls cuffs and buttons. Greater time, too, was taken with the hands (in many versions they are simply shoved in pockets) and the carefully modeled face. The shaped contours of cheek, nose, and chin are effectively highlighted in white.

Sudduth's affinity with nature is evident not only in his choice of materials but also in his choice of subject. He paints birds, fish, snakes, and alligators as well as a variety of farm animals (cat. nos. 168, 174), often with great humor and invention.

Sudduth was one of the artists included in the 1976 Smithsonian Folklife Festival. Only two folk artists from each of the fifty states were invited, and he was one of the two chosen to represent Alabama. He returned full of new ideas for subjects and with a cache of stories about this special event in his life. Several paintings since that trip show the Washington Monument, the Capitol, and individuals at the festival, especially the African and Brazilian dance groups. Recollections about officials he saw and met vary with each telling. He has several times recounted one story about President Gerald Ford, whom he says did not come out to see him: "Afraid he'd get some of Mr. Wallace's dirt on him!" The story is always followed with a hearty chuckle.

Among the many national monuments Sudduth celebrates, the Statue of Liberty is one of his favorites. The Gitter-

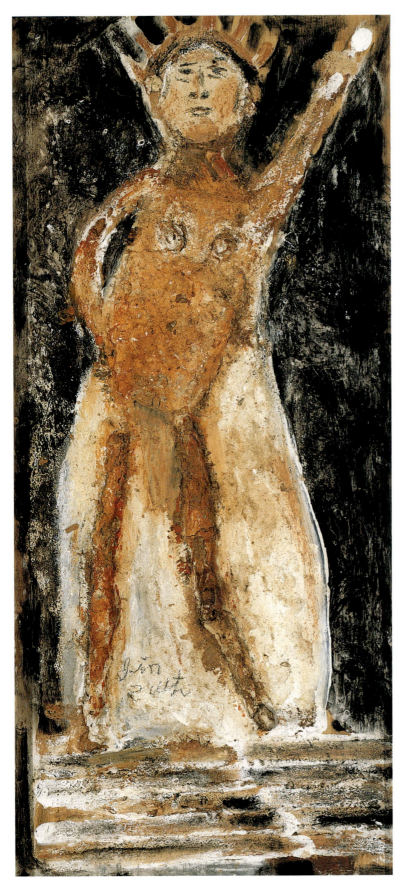

173. *Statue of Liberty*, 1986

Yelen painting (cat. no. 173) is of mud, with coffee grounds mixed in to create a richer brown and with chewing gum for the breasts. The mud mixture is heavily applied to the legs and torso, the face is defined with pencil, and the torch is painted white. In some areas the pencil lines Sudduth uses to outline most of his compositions before he applies dirt or paint are also visible. The long, slender legs, tilted torso, hand on hip, and outstretched left arm give the figure a rakish pose, more like that of a popular singer than of the symbol of freedom and justice.

Jimmy Lee Sudduth paints every day, in spite of failing health and warnings not to exert himself. But Sudduth's soul is in his painting and his harmonica playing, and to stop either one would surely dull his spirit. The joy he takes from these creative expressions is evident in his art, which is confident and optimistic. He enjoys "blowing his harp" for the steady stream of visitors who travel to Fayette to meet him as much as he enjoys demonstrating his approach to making a painting. He has stories about each painting, specifics about the image and the materials. After transforming nature's most prosaic materials into compelling visual statements, he can also travel, via the clays used in his paintings, back to the bank or yard where it came from, and through the image, as he says, to "anywhere my imagination goes."

—G.A.T.

NOTES

1. All quotations are from interviews with Jimmy Lee Sudduth conducted by the author between 1977 and 1995. The author is grateful to Jack Black, director of the Fayette Art Museum, for assisting with information about the artist's background and artistic production.

2. This is the house where Jimmy Lee Sudduth and his wife, Ethel, lived from 1950 to April 15, 1984. After it burned, they moved to Sudduth's present house at the edge of downtown Fayette.

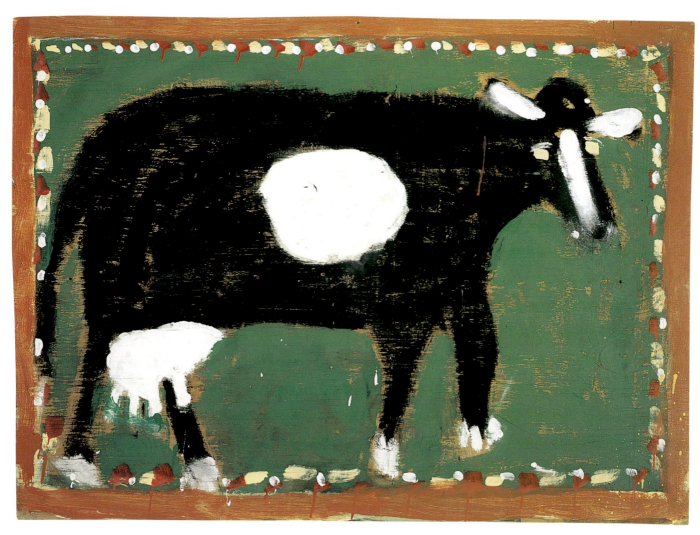

174. Black Cow, 1989

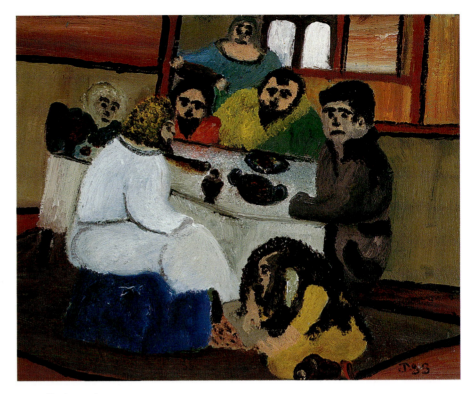

175. *Biblical Scene, late 1970s*

Rev. Johnnie Swearingen

A full-page, black-and-white photograph of the Reverend Johnnie Swearingen appears in the exhibition catalog *Black History/Black Vision*.[1] It is an image of considerable strength: A large, heavy, powerful-looking man dressed in a white T-shirt and dark trousers, a light-colored cowboy hat perched on his head, he sits on a simple stool drawn up on what appears to be a porch. Behind him are a lawn mower and other objects suggesting the informal clutter of his surroundings. Relaxed, a drink in his right hand, Swearingen stares straight at the camera. The modesty of his surroundings, the unpretentious directness of his pose, and the confidence of his expression find parallels in his impressive paintings—the products of a rich personal history.

A painting that Gitter and Yellen call simply *Biblical Scene*, late 1970s (cat. no. 175), depicts a group of seven figures.

One stands at the back of the composition. In front of him, five others are gathered around a table set for a meal. The most prominent figure, clad in a voluminous white robe, sits on a brilliant blue bench or stand at the near side of the table, in the left center foreground. This person is being ministered to by a figure who kneels before him, washing his feet.

According to the New Testament, six days before Passover, Jesus traveled with some of his disciples to Bethany, home of Lazarus, whom Jesus had raised from the dead. In Jesus' honor, a banquet was prepared, and the group was served by Mary, Lazarus's sister. To pay respect to Jesus, Mary took an expensive perfume and anointed his feet, wiping them with her hair. Judas Iscariot, one of those present, complained that the perfume was too dear to be used that way, but Jesus approved the act, announcing that it was done in anticipation of his immi-

nent death and burial. *Biblical Scene*, examined closely, clearly depicts this event from the Gospel of John. Mary is the yellow-clad figure crouching in the foreground, her long, thick, black tresses spilling over her face as she uses her hair to dry Jesus' feet.

Swearingen presents this parable of humility and respect in an interesting manner. His setting has all the elements of an academic composition. It has a compelling, even sophisticated, variety and arrangement of forms. Its varied colors are used to identify the principals. And because the table, the room, and what appears to be a carpet are all set at an angle to the picture plane, the space within which the drama unfolds is visually consistent and loosely follows the principles of formal perspective. At the same time, the painting possesses an ingenuousness not seen in schooled artists' productions.

My first impression of these features was that Swearingen must have patterned *Biblical Scene* on an illustration. Having become interested in—in fact, almost possessed by—this quality in the work, I began distinguishing similar characteristics in other Swearingen paintings. I wondered what, if anything, could be proved about my speculation. Perhaps commentaries written on the artist would reveal whether or not Swearingen employed printed illustrations to guide him. It seemed to me that among those who had interviewed this prolific and well-known artist, someone would have known how he worked. I realize that my thinking may have contained a trace of condescension. It was as though I could not accept the possibility that someone who lacked fine arts training could assemble compositions of the organizational strength and sophistication that distinguish much of Swearingen's work. I wonder how many of us who are enthusiastic about "nonacademic art" inadvertently bring to it this kind—as well as other kinds—of prejudice. After all, to an extent greater than we understand or care to admit, eyes and minds accustomed to the imagery celebrated by art history are so conditioned by its conventions that we approach any kind of art with a full array of subtle and not-so-subtle expectations.

In any case, while looking through the materials I had accumulated, I could find no mention of such a practice. In order to push ahead, I felt compelled to accept that, after all, Swearingen worked without directly referring to printed illustrations. I concluded that he possessed a remarkable imagination and a gift of recall that enabled him to "image" his subjects as though he were a witness to them. This was indeed the case in his many secular paintings. If Swearingen did not work from printed illustrations, he may have gathered, from his studies of the Bible and an adventurous lifetime of travel and intensely felt preaching, a mental store not only of popular printed illustrations but also of actual events. All of this conjecture hardly solved what had become a genuine "puzzler" for me. I decided that, to set the record straight, I must make other efforts to find out just how Swearingen worked.

On the advice of Lynne Adele, whose essay on Swearingen in *Black Vision/Black History* was the most authoritative I had found,[2] I contacted Julie and Bruce Webb of Webb Folk Art Gallery, Waxahachie, Texas. The Webbs sent me a copy of an essay Bruce had written to accompany an exhibition of Swearingen's paintings at their gallery.[3] The second to last paragraph refers to "Swearingen's worn copy of *The Children's Bible* that the artist had apparently used for biblical paintings such as *The Tower of Babel, Adam and Eve,* and *Noah's Ark.*"[4] Nothing more specific was cited concerning the use of the illustrations, but for me this bit of information opened the doors for a more inclusive appreciation of Swearingen's artistic accomplishments.

In *Biblical Scene*, Swearingen's use of color and line is somewhat arbitrary. Some forms are rendered in colors that appear to have been applied directly from the tube, flat and without mixing, while

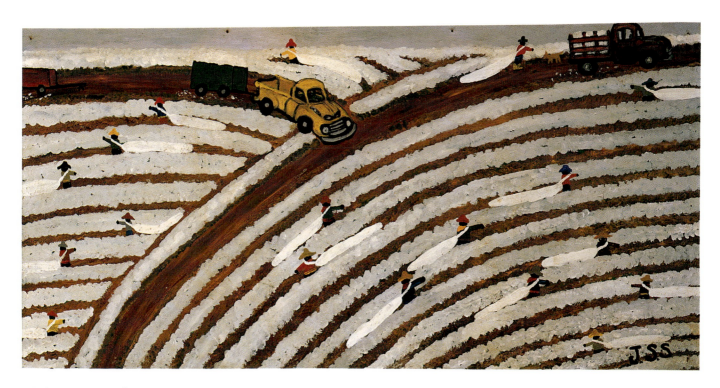

176. *Cotton Farming*, mid-1970s–1980s

other forms suggest that more attention was paid to the subtleties of the "original," for rudimentary modeling was applied to give the figures the illusion of greater solidity. Swearingen also used line in an arbitrary fashion: It appears in strength where clarity might otherwise be lost, and little if at all where color against color and shape against shape differentiate adequately. I attribute this "inconsistency" not to amateurism but to what I believe was Swearingen's subjective response to the subject. It seems obvious that he was so engaged with his biblical narrative that, no matter how much verisimilitude could have been achieved by a more direct rendering of a commercial illustration, he felt compelled to forsake mimesis to arrive at a more personal form of artistic expressionism.

Using the familiar art history term "expressionism" seems appropriate to a discussion of Johnnie Swearingen's work. This quality describes my most immediate impression when I first saw his work

in Gitter and Yelen's collection. In fact, it seemed to me that in some of his paintings Swearingen developed an expressionistic technique that could almost pass for that of an academically trained artist. This observation is not intended to "elevate" Swearingen's work by comparing it favorably with academic art. If anything, it raises the question why certain writers still bother to differentiate "academic" from "self-taught" idioms.

Cotton Farming (cat. no. 176), dating from the mid-1970s to the early 1980s, represents a dramatic stylistic shift in Swearingen's work. Instead of the labored attempt to interpret a commercially prepared image such as that in *Biblical Scene, Cotton Farming* is a bold composition of forms and lines reduced to the simplest of pictorial schemes and repeated patterns created by curving rows of white cotton and the dark brown strips of earth between them (I immediately thought of the work of Roger Brown when I studied this painting). *Cotton Farming* is punctuated by un-

differentiated field hands who, dwarfed by the vastness of the cotton crop, drag their sacks behind them as they labor. At the conjunction of the two dirt roads that separate the fields is a pickup truck, carefully rendered in bright yellow, pulling a dark green wagon. This bright accent serves as a pilot for the composition. It is significant that the fields press upward against a slender thread of blue sky that stretches across the horizon— there is cotton, more cotton, and still more cotton to be picked.

A painting modestly entitled *Farming,* mid-1980s (cat. no. 177), makes an interesting comparison with *Cotton Farming. Farming* represents yet another stylistic shift in Swearingen's work. Spatially, it is more naturalistically developed than the earlier work. Its uncomplicated landscape setting "layers" foreground to middle ground to background. Figures are apparently scaled in order of their importance to Swearingen; they do not consistently diminish in size according to the techniques of linear perspective.

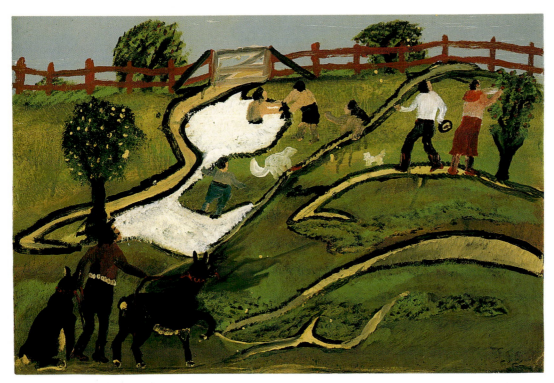

177. *Farming,* mid-1980s

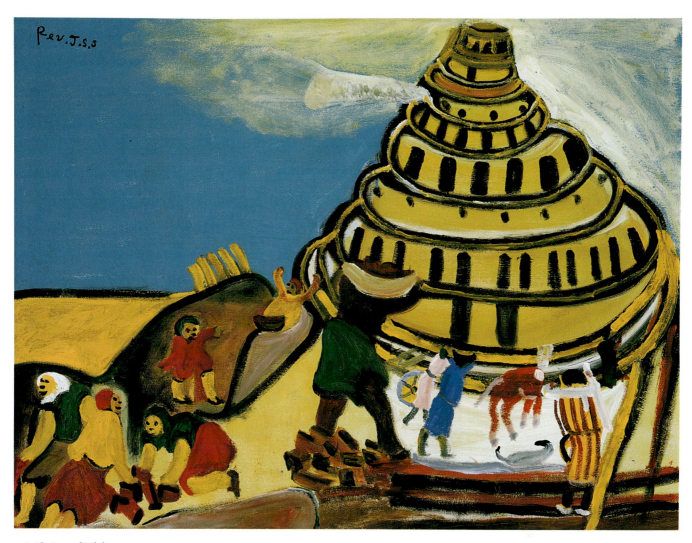

178. *The Tower of Babel*, 1992

Color is more localized; that is, Swear-ingen attempts to convey the lushness of the grass and the brightness of the clear blue sky he envisions. The poses of the animals in the lower left foreground are worked out knowledgeably; they are perhaps more "alive" than are the figures that accompany them. The artist clearly feels differently about the subjects of *Farming* and *Cotton Farming* than he does about the event depicted in *Biblical Scene*. All three are painted with great convic-tion and interest. The two more recent pictures, however, deal with subjects that Swearingen had not only seen himself numerous times but engaged in as well —he had worked close to the land for most of his life.[5] Clearly, inspiration for

Biblical Scene came from a different, per-haps more transcendent, impulse.

There are some other qualities of *Farming* and *Cotton Farming* that distinguish them from earlier works such as *Biblical Scene*. As Swearingen continued painting and receiving enthusiastic support for his work, his palette became brighter and his compositions less dense.[6] These fea-tures are also present in four other paint-ings collected by Gitter and Yelen: *Garden of Eden* (not included in this exhibition), *The Tower of Babel* (cat. no. 178), *Noah's Ark* (cat. no. 179), and *Baseball* (cat. no. 180). All are subjects that Swearingen had painted many times before, since they were among his favorites and were often requested by his patrons.[7] All these ver-

sions were completed in 1992, shortly before the artist's death in January 1993.

It is one of the traditional goals of art historical analysis to arrange artists' works in chronological order. In the case of these four paintings, I have no infor-mation establishing the sequence in which Swearingen painted them. How-ever, it seems that *Garden of Eden* might be the earliest. It is comparable to *Farming* in its space, bright color, and careful definition of forms. However, it is im-possible for me to propose a sequence for the three remaining paintings. All retain the brilliant, glowing palette typi-cal of most of Swearingen's work, but these are painted more loosely—more "expressionistically"—than the others.

Bruce Webb notes that during the 1990s Swearingen's paintings "began to take on a flowing, almost liquid appearance as his eyesight weakened."[8] One can imagine the kind of anxiety that sets in when an artist becomes aware that his or her powers are changing due to conditions that cannot be controlled. Yet there appears to be nothing feverish about these paintings. They are still very much under control. In fact, if Swearingen was working more hastily than before—for whatever reason, including failing health or the wish to meet the increasing demands for his art—this has to some extent worked in his favor. Earlier paintings appear deliberate or measured, while these later works appear to be the result of a state of exhilaration. Thus nothing is really lost; it's just that some form of artistic exchange has taken place, a process that most artists, academic or otherwise, undergo in one form or another if their careers are sufficiently long.

These four paintings possess other curious features. The theme of *Garden of Eden* is, of course, one of the most potent of the Old Testament, indeed of the entire Christian Bible. Most artistic treatments of the theme focus on Adam, Eve, the serpent, and the Tree of Knowledge. Yet Swearingen's version includes only one human. The diminutive figure with dark, cropped hair—apparently a male—is on the far side of the horse he is leading off the lower right side of the composition. Where is Eve? Furthermore, one must search to locate the serpent. The Arch Seducer, found in the upper right middle ground of the painting, is a sorry-looking specimen entwined in a branch of a large tree. He seems to be haranguing a cluster of animals gathered beneath him, but their stolid poses and strong colors suggest that they are unmoved by the serpent's words. In fact, the main subject of Swearingen's *Garden of Eden* seems to be the landscape populated by a variety of exotic and domestic animals. Strewn around the composition, singly, in pairs, and in groups, they represent Swearingen's knowledge of

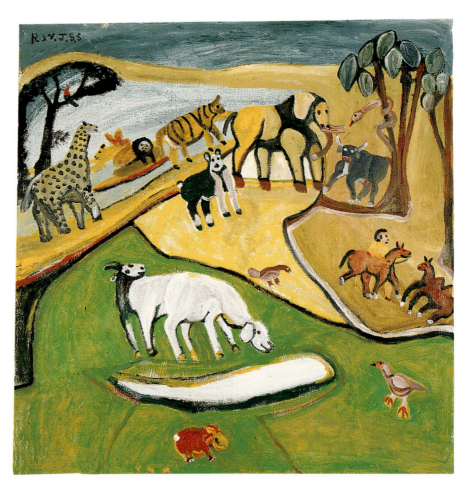

179. *Noah's Ark*, 1992

and interest in animal life. There is also something of the mood and message of Edward Hicks's Peaceable Kingdom paintings.

Swearingen's version of *The Tower of Babel* chronicles the incident in Genesis, chapter 11, which describes the feverish activities of those who desire to create a "temple tower" that will reach to the skies—an arrogant, eternal monument to themselves. It is tempting to see Swearingen's tower as a spacecraft, with which the heavens, the exclusive realm of God, can be breached and possessed.

Noah's Ark is, for me, the most exotic painting of this group. It is a simple matter to distinguish the animals and the great vessel, but the landscape that moves upward, outward, and to the sides in nervous curves around the entire composition gives to the whole a

restlessness, a hallucinatory atmosphere. Pictorial instability is underscored by the colors, some of which seem to press out away from the canvas, while others, depending on the colors around them, seem poised to suggest recession or forward projection. Swearingen's *Noah's Ark* seems to address artistic strategies rather than a specific narrative. This is a "painter's painting."

Bruce Webb observed that Swearingen "painted many baseball games, always painting himself on first base, the position he played as a younger man."[9] In this *Baseball* we are treated to a setting predominantly of bright, glowing yellow within which spectators and players act out the communal drama of the great American game. One can almost feel the brilliance and the heat of the summer days when these games are typically

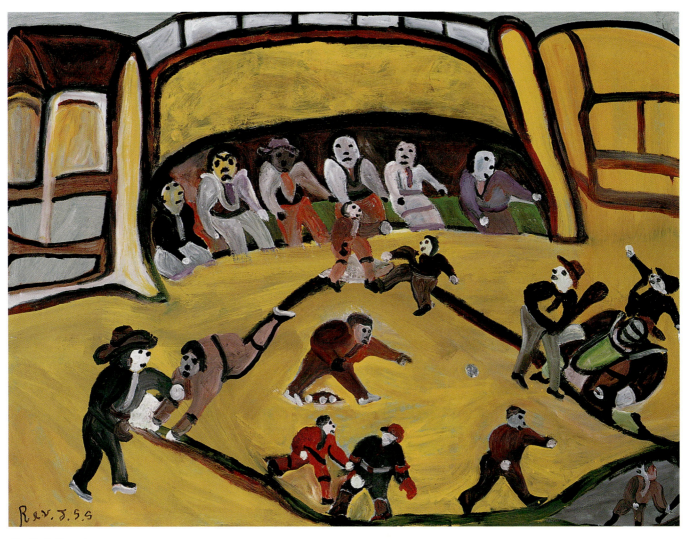

180. *Baseball*, 1992

played. Although a strong case can be made that for his secular paintings Swearingen drew upon his ability to vividly recall events from his own experience, *Baseball* suggests an exception to that oversimplification. In this painting Swearingen depicted a ballpark so convincingly —most notably in the multitiered stands that form the background of the upper half of the composition—that I suspect the picture was based on a photograph of a ball game. Once again, however, his own passion for the event and his artistic imagination transform the highly ritualized game into the transcendent experience that every fan will understand.

Swearingen's vivid evocations of sacred and secular themes are in a class

by themselves. They are unmistakably the work of an artist whose skills are self-acquired and whose vision is highly personal and charged with feeling. Nonetheless, there are fascinating connections that can be made between Swearingen's work and certain paintings by such "mainstream" artists as Matisse, Derain, and Gauguin—connections suggesting that the line often drawn between academic and self-taught artists is less significant than it at first appears. —G.J.S.

NOTES

1. *Black History/Black Vision: The Visionary Image in Texas* (Austin, Tex.: Archer M. Huntington Gallery, University of Texas, Austin, 1989), p. 64.

2. Conversation with Lynne Adele, curator of *Black History/Black Vision*, on January 17, 1995. I am grateful to Lynne Adele for her help in this matter.

3. I am grateful to the Webbs for providing the essay by Bruce per my conversation with Julie on January 19, 1995.

4. Bruce Webb, "Rev. Johnnie Swearingen," handout, January 14, 1995; prepared for the Webb Folk Art Gallery's 1995 exhibition of Johnnie Swearingen's work.

5. *Black History/Black Vision*, p. 65; also Webb, "Rev. Johnnie Swearingen."

6. A more intense palette and greater scale in Swearingen's later work is noted in Webb, "Rev. Johnnie Swearingen."

7. Ibid.

8. Ibid.

9. Ibid.

Mose Earnest Tolliver

Mose (or possibly Moses) Tolliver, one of the most highly respected of American self-taught artists, was born on the Rittenour farm in the Pike Road community of Montgomery County, Alabama. Born into a sharecropping family, he was the youngest of Ike and Laney Tolliver's eight sons and four daughters. He attended nearby Mount Olive School through the third grade, much preferring outdoor activities to classroom work. After working for a tenant farmer, he moved to nearby Montgomery in the late 1930s and began caring for people's yards and working a variety of other jobs, including painting, plumbing, and carpentry. Eventually, he was employed at the McClendon Furniture Company.

In the 1940s, Tolliver married Willie Mae Thomas, with whom he had eleven children—seven sons and four daughters. In the late 1960s, an accident at work changed his life. A crate of marble fell from a forklift, crushing his left ankle and damaging leg tendons and muscles. Since then he has been unable to work and has had to use crutches to walk. During a period of depression, he was encouraged to take up painting by one of his former employers, Raymond McClendon, who was an amateur painter himself. Experimenting and without taking lessons, Tolliver began to paint vigorously, often staying up all night creating pictures of birds, flowers, people, and animals, both realistic and fanciful. Painting has been and continues to be Tolliver's most potent strategy for healing.

Tolliver's subject matter covers a wide range, and his painting style is unique. He favors single images, although he has created a few narrative, multifigured paintings. He paints on many different surfaces, including cardboard, scraps of wood, Masonite, metal trays, and old furniture. He has also devised different hangers for his paint-

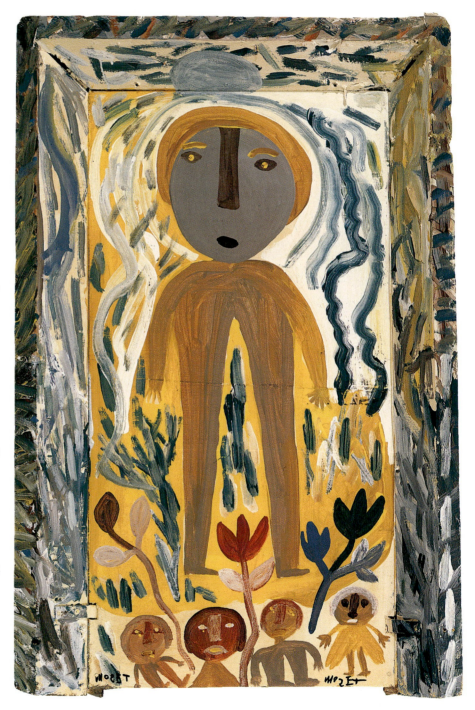

181. *Coffin*, 1988

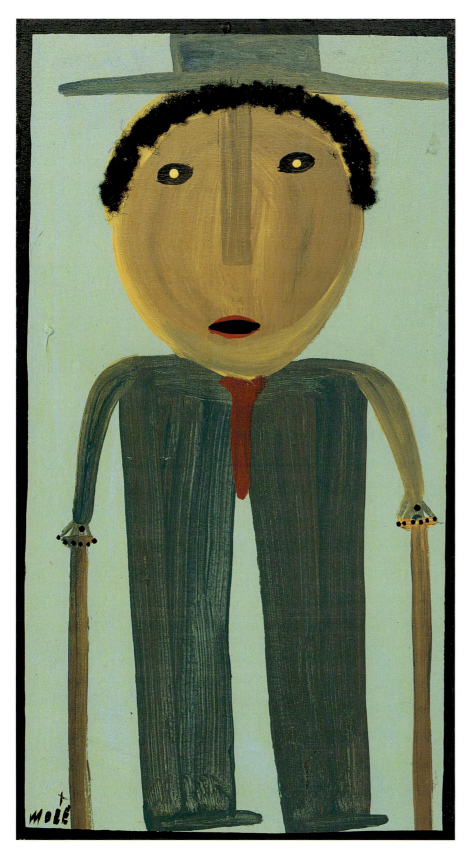

183. *Self-Portrait*, 1989

ings, most recently tab openers from aluminum cans.

The paintings *Tree of Life*, 1987 (cat. no. 186), and *Catch a Dog*, c. 1987–89 (cat. no. 185, not illus.), relate to his continuing interest in gardening. Tree, plant, and flower forms have been recurrent subjects of Mose Tolliver's paintings since the 1970s. During his working life as an employee of the McClendon Furniture Company, Tolliver had gardened as a hobby and as a secondary job. In spite of his physical problems, Tolliver to this day maintains a flower garden and vegetable plot in front of his Sayre Street house; on the adjacent lot, tulips, verbena, irises, lilies, tomatoes, cucumbers, cabbage, and collard greens bloom and ripen each season.

Both *Tree of Life* and *Catch a Dog* have a central branch emanating from a rocky mound. This compositional form calls to mind the flowering tree or tree-of-life motif in Indian, Persian, Chinese, and European art, which was a model for many of the designs for cotton textiles generally called chintz. For centuries, importers requested that these designs include blossoms and foliage growing from a single branch and that they be interspersed with other elements, such as birds, butterflies, animals, and human figures. By the time he began painting, Tolliver had worked in and around the homes of wealthy Montgomery residents for decades and had been exposed to the fine furniture, carpets, and textiles that were common home furnishings of prominent families. It is possible that some of these designs remained in his memory and later inspired his artwork.

Tree of Life shows Tolliver's preference for materials at hand, in this case what appears to be a headboard for a single bed. His exuberant tree on a rocky mound comfortably fills the surface space. A generalized four-petaled, poppylike flower combines with several thistlelike blooms. Folk artists often take

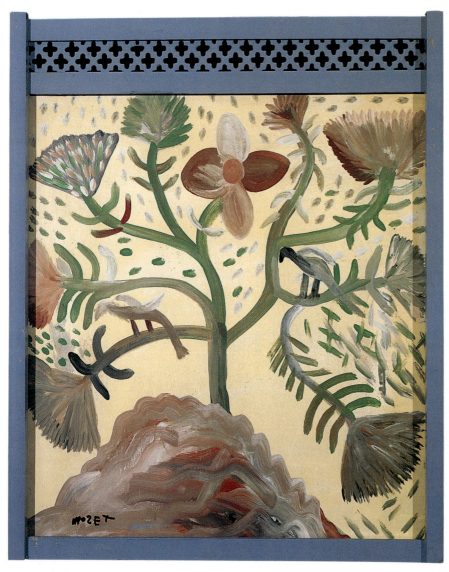

186. *Tree of Life*, 1987

be dancing. Visually, the dark blue plant forms move the lighter plant forms forward, and as in *Tree of Life* the cream background enhances the forward thrust.

In *Catch a Dog*, as in other recent paintings, Tolliver uses what he calls "pure" paint—that is, house paint (currently, water-based latex). He paints a frame around his finished painting and completes it by nailing a metal can ring to the back for hanging.

In *Self-Portrait*, 1989 (cat. no. 183), Tolliver appears close to the picture plane and stares directly at the viewer. His large, ovoid head is proportionately larger than his abstract though representational body. With his disproportionately short, thin arms and tiny hands he supports himself with two canes—a reference to the accident that brought an end to his employment at the furniture company. His body is outlined by two sweeps of the brush which extend from his legs to his shoulders. An ambiguous penile form might be interpreted as a tie. Though his figure is presented frontally, his shoes are depicted in profile, bringing to mind Egyptian wall paintings. His large head is planted directly on his neckless body and topped by a ring of very curly hair, and he wears a gray hat. As in Thornton Dial's *Chair Man*, the hat may signify the many freedoms achieved by the emancipated African American, including so simple but so potent a freedom as that of wearing hats like those worn by white men. This figure appears confident and sturdy. The iconic eyes straddle a flattened, rectangular nose that begins at the forehead, and the small mouth is similar to that found on figures depicted in many cultures, including African American and Native American. The gaze is direct but nonconfrontational. The palette of gray and yellow with a light bluish green background is enlivened by the textured hair, the red accents of the mouth and tie, and the marvelous subtle shades achieved by the artist as his wet brush followed the outlines of the face and nose.

Mother and Child, 1989 (cat. no. 184), seems to be a variation of *Woman Seeking Food for Her Baby in North Africa* (Arnett

liberties with perspective and scale, and in this composition the flatly rendered images are made all the stronger by the inclusion of two diminutive birds peeping out from the lower branches on each side of the central stem. Tolliver's common practice of using only two or three hues for his palette is also apparent in *Tree of Life*, where he uses primarily green and rust on a bright creamy background. His technique of wet-on-wet paint application results in a myriad of shades, as his confident brushstrokes create basic shapes over a previously prepared and solid ground surface. With an economy of line and color, he creates graceful, delicate birds that are effectively juxta-

posed against the organic form of the base. The enlivening dotting among the foliage and blossoms appears to be the handiwork of a family member, several of whom have collaborated with Tolliver, following a workshop tradition that has a strong and continuing historical basis. *Coffin*, 1988 (cat. no. 181), is also a product of collaborative effort.

Catch a Dog is a variation of the tree-of-life motif, with small, clustered blooms resembling cherry blossoms interspersed with balloonlike or breast-like forms emanating from a central stem that in turn grows from a large, solid form. The multicolored blossoms atop sinewy, graceful stems almost seem to

182. George Washington, 1988

182. George Washington, 1988

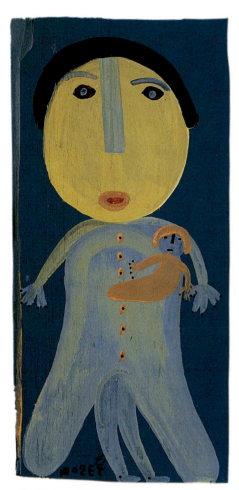

184. Mother and Child, 1989

Collection),[1] a work inspired by a television program showing some of the horrors of war and its aftermath. All the elements of this subject—which Tolliver has explored many times—are present in the Gitter-Yelen work. The woman, baby, and spear are included, but the African setting is universalized and transformed by Tolliver's unique style. The glowing, golden face of the figure moves forward like a sun against the dark gray background. As in *Self-Portrait*, the neckless head is planted solidly on the body. Its features include brightly painted, small eyes; a flattened, rectangular nose near the top of the head; and a small mouth. The graceful, abstracted dress allows room for curved legs that end in feet planted on the ground; the feet are again shown in profile, both oriented in the same direction. Hands and feet are tiny in comparison to the rest of the body,

and the small baby, which is supposed to be in the mother's arms, seems to hang precariously in space. The baby's placement adds a feeling of movement, as do the swing of the baby's body in one direction and the curve of the mother's legs in the opposite direction.

Another subject that Tolliver visited many times was that of George Washington (cat. no. 182). In 1982, when Tolliver went to the Corcoran Gallery in Washington, D.C., for the first time (as an exhibiting artist, he was an honored guest at the opening of *Black Folk Art in America, 1930–1980*), he was photographed by his Montgomery friend Anton Haardt under the famous Gilbert Stuart portrait of George Washington. Both the Stuart portrait and the picture on the dollar bill were excellent references for Tolliver, who—like the many trained artists who painted several versions of one subject —painted the heroic visage of George Washington many times through the years. In the early 1980s, Tolliver's Washington pictures were abstract but fairly realistic in configuration. By the mid-1980s, the portraits took on a different look. The face widened in the upper portions, and hair simulating a wig circled the large head. In one of these later Washington paintings the tan and brown face and ring of wavy green hair stands out

from the pea-green background. The head is solidly anchored on the brown upper body, which is invigorated by brown and green dabs of paint, a trademark of Tolliver's style. The figure's tiny eyes and tiny mouth give this personalized Washington a look of surprise and wonder, suggesting to this viewer that our first president is perhaps considering the nation's current complex problems. Unifying the painting is a dark brown border which the artist painted freehand. The frame is also personalized by two arching mounds of paint, which Tolliver says he sometimes applies as a decoration when his hand veers from the straight line that he had originally sought. His "mistake" becomes a frame design that enhances his composition.

Today, Tolliver continues to paint pictures for his admiring patrons. He is one of the few remaining living artists from the seminal Corcoran exhibition of 1982, which launched an interest in and recognition of this important genre of American art. —L.K.

NOTE

1. Illustrated in Lee Kogan, "Mose Tolliver, Picture Maker," *Folk Art Magazine* 18, no. 3 (fall 1993): 51.

Bill Traylor

First, two personal statements, in no particular order: 1) When it comes to looking at art, I consider myself something of an unapologetic, unreconstructible skeptic, especially suspicious of and deeply disappointed in the bombast and pretentions of so much of what appears on the contemporary scene, what I often refer to as "high impact/low yield art," and 2) If after a lifetime of looking at art I had to select one artist whose work consistently satisfied my aesthetic sensibilities in every way, it would be Bill Traylor.

"Suggesting kinship with the mesolithic drawings found at such sites as Castellón de la Plana in Spain, or Tassili in North Africa, Bill Traylor's pictures compel interest through their reductive morphology, spatial ambiguity, graphic intensity, and unique, sustained, readily identifiable style." This is how I had intended to begin this commentary on two works by Traylor from Alice Yelen and Kurt Gitter's collection: *Man Talking to a Bird* (cat. no. 188) and *Chicken atop a Speckled House* (cat. no. 187), both from the years 1939 to 1942. I'm not dissatisfied with my rhetoric, but it only begins to present the importance and achievements of Traylor's art.

Considering the limitations of space here, I want to concentrate on two aspects of the works. Certainly of great interest to me is the way in which Traylor places his subjects on the support. One can sense that every interval of space between the subjects and the edges of the support has been calculated to impart maximum visual tension. At the same time, the intervals establish for Traylor's subjects an architectural stability—a "rootedness" of design that seems to admit the likelihood of no other equally satisfying placement.

For example, the uppermost elements of both *Man Talking to a Bird* and *Chicken atop a Speckled House* press so close to

187. *Chicken atop a Speckled House*, c. 1939–42

the top edges of the compositions that they risk becoming visually crowded—poorly thought out in conventional terms. However, not only are they not a design deficiency, but they in fact create a pressure that activates something greater than a routine solution to a pictorial design problem.

In *Man Talking to a Bird*, Traylor arranged seven red, four-sided shapes on the two architectural forms that dominate the picture. Three act as piers for the upper structures; just above them are two doors. Two more serve as unidentifiable elements on the outer corners of each building. With regard to size, placement, and proportion, they work brilliantly to unify the central subjects without creating monotony. Imagine this drawing without these details! The house portion of *Chicken atop a Speckled House* is formed by four triangles and three structural bars. The sizes and the proportions of each set of these shapes are varied, but together they interlock to form a powerful ensemble. This remarkable ability to situate and to construct can only have been instinctive. Ironically, it takes most formally trained artists years to become so sophisticated. Of equal importance is Traylor's creation of a highly conventionalized vocabulary of shapes—humans, animals, buildings—whose interactions with one another and with their environment are absolutely convincing as an analogue to "real" human experience. Furthermore, there is no question that Traylor regarded the world not only with great interest but with sympathy, humor, and warmth.

Traylor most certainly drew upon his own experiences when he created his pictures. However, his ability to "universalize" these experiences through his highly personal, symbolic pictorial language renders his inspiration accessible to everyone, a remarkable achievement for any artist.[1] —G.J.S.

188. *Man Talking to a Bird*, c. 1939–42

NOTE

1. Bill Traylor has been the subject of many articles and books. The following are those I found most useful, either for the information they contain or for the illustrations included: *Bill Traylor Drawings*, from the collection of Joseph H. Wilkinson and an anonymous Chicago collector (Chicago: Randolph Gallery of the Chicago Public Library Cultural Center, Chicago Office of Fine Arts, 1988) (Michael Bonesteel's essay in this book, "Bill Traylor: Creativity and the Natural Act," pp. 9ff., is one of the most perceptive commentaries on Traylor's art of which I am aware); Jane Livingston and John Beardsley, *Black Folk Art in America, 1930–1980* (Jackson: University Press of Mississippi: 1982), pp. 138–45; Frank Maresca and Roger Ricco, *Bill Traylor: His Life, His Art* (New York: Alfred A. Knopf, 1991); Chuck Rosenak and Jan Rosenak, *Museum of American Folk Art Encyclopedia of Twentieth-Century American Folk Art and Artists* (New York: Abbeville Press, 1990), pp. 305–6; Maridith Walker, "Bill Traylor: Freed Slave and Folk Artist," *Alabama Heritage* (fall 1989): 18–31; Alice Rae Yelen, *Passionate Visions of the American South: Self-Taught Artists from 1940 to the Present* (New Orleans: New Orleans Museum of Art, 1993), pp. 13, 49, 50, 56, 59, 93–94, 97, 255, 257, 332.

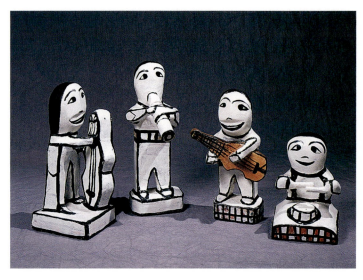

190. Group of Musicians, 1992

Hubert Walters

Hubert Walters was born on August 4, 1931, in Kingston, Jamaica. When he was two and a half years old his father died, and he went to live with his grandparents, who raised him on their farm in the Jamaican countryside. Walters credits his grandfather—a carpenter, mason, and jack-of-all-trades who carved wood and wove baskets—with teaching him how to work with his hands. In his early twenties Walters became a fisherman, and he adapted some of the skills he had learned from his grandfather to making his own nets, harpoons, and wire-mesh fish traps. He also built his own boat, and this led him to a sideline career as a fishing-boat builder and owner of a small boat-rental operation. Since he found particular enjoyment in painting his boats, he decided to try his hand at making paintings, and soon he was painting landscapes and narrative scenes inspired by his surroundings. Although he had seen work by Jamaican folk painters, he neither apprenticed nor pursued formal art studies, and he made no attempt to sell his paintings, preferring instead to give them away to friends and relatives.

At age thirty, only a few years after he took up art, Walters joined the Jehovah's Witnesses and became an active member of their congregation in Kingston. In the late 1960s a fellow church member with matchmaking intentions encouraged him to begin corresponding with Marion Greg, a young woman in Brooklyn, New York, who, like Walters, was a Jehovah's Witness and unmarried. Walters followed the suggestion and in 1970 went to New York to meet his correspondent. The friend's matchmaking efforts paid off, and by 1972 Walters and his new bride were living in a Harlem apartment and he was working in a cabinet shop. "I loved the city for all the excitement there," he says, "but I didn't like living in such tight spaces. I was used to living in open spaces."[1] So in the mid-1970s he and his wife left the city and went to Iredell County, North Carolina, where a friend from their church in New York had recently moved.

Since the move Walters has supported himself as a machine operator and assembly-line worker in textile mills and a furniture factory; he has also operated a small concession, selling ice cream. Though he has continued to make paintings over a thirty-year period, after moving to the States he began making the sculptures for which he is primarily known. First he created fanciful miniature replicas of the fishing boats he used to build in Jamaica. Then in the late 1980s he started experimenting with other three-dimensional forms and new materials. This occurred after he had temporarily returned to New York City, where he worked at a maintenance job that paid higher wages than those he had earned down South. In his spare time in New York he made sculptures using a combination of wood, metal, and Bondo —a strong, puttylike compound made for repairing automobile bodies. When he returned to North Carolina a year and a half later, he had to rent a trailer to haul home all the sculptures he had made.

Walters still paints landscapes, figures, and flowers, which he renders in a loose and highly simplified style, and he still makes slapdash fishing-boat models that range from breadbox size to ten feet long. But his most distinctive works are the smoothly contoured figural sculptures of the kind he first made during his most recent stay in New York. These generally consist of Bondo supported by concealed wood and metal armatures, most frequently painted white with minimal details and decoration in black, and occasionally in bold reds, blues, and other bright colors. He has created a variety of animals, birds, and fish from these materials as well as stylized humanoid figures. Among the last-mentioned are dozens of small musician figures like those in the Gitter-Yelen collection (cat. no. 190) and larger full-figure portraits of historical and mythological figures, such as Goliath, the

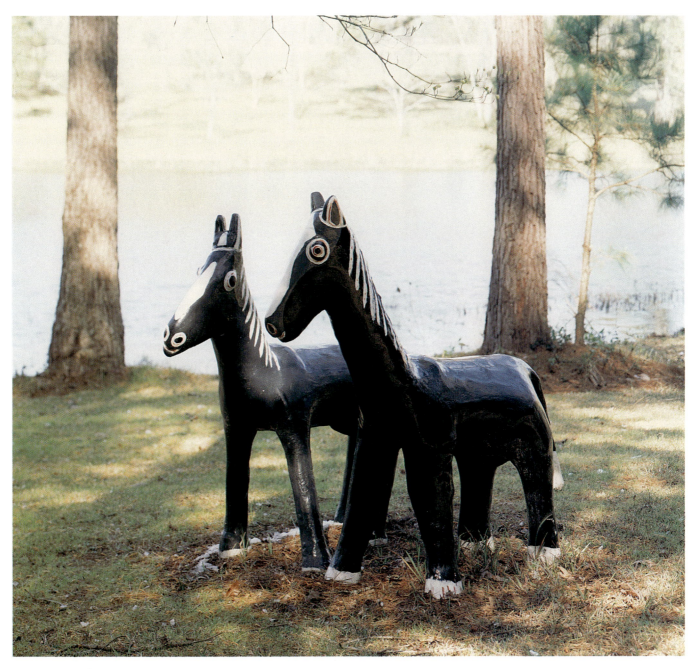

189. *Sonny Boy and Day Boy,* 1989

queen of Sheba, and the Ethiopian king Haile Selassie. He also makes unusual variations on cabinets for old-fashioned grandfather clocks, decorated with odd protuberances and loose geometric-abstract patterns. He says,

> My art is about ideas. I have an idea and then I make it. A person that takes training in art is limited by his training, but a person that is self-taught, like I am, can make anything that pops into his head.

He can start from nothing and make something out of it, because he don't have no set rule that it has to be this way or that way. When I start to make something I don't even know what I'm making at first, but then it starts to take shape and starts to take shape, and then something comes out. My work never spoils, because if it doesn't work out as one thing I can change it to something else and go.

— T.P.

NOTE

1. Quotations and other information herein are from the author's interview with the artist at the latter's home in Troutman, North Carolina, on December 29, 1994.

Philo Levi Willey

Philo Levi ("Chief") Willey, who was born September 26, 1887, in Falls Village, Connecticut, was a prolific painter. His exuberant works reflect his varied experiences, in particular those in New Orleans and its environs, where he settled in 1931.

At age twelve, with little schooling, he left the family farm with a few dollars and traveled throughout the United States, working along the way at many jobs: lumberman, storekeeper, fireman, deckhand, chauffeur, cowboy on a Wyoming ranch, wagon driver for the Barnum and Bailey Circus. He also tried his hand at boxing and worked as a service manager for the Chevrolet division of General Motors in St. Louis, Missouri. In the early 1930s, Willey left St. Louis and began to work for the New Orleans Sewerage and Water Board. He became chief of security and remained there for more than thirty years until his retirement in 1965. His nickname, "Chief," was given to him by his coworkers.

To occupy his time after retirement, Willey began to paint, having been encouraged to do so by his second wife, the artist Cecilia Seixas. (His first wife passed away in 1959.) He sold his first works in historic Jackson Square in New Orleans, where he hung them from the fence that surrounds the square. In the late 1970s, recognition by Robert Bishop,

then director of the Museum of American Folk Art, and a subsequent exhibition sponsored by the museum at the State University of New York furthered his career. His earliest works were in watercolor, colored pencil, and crayons. Later he favored acrylics on Masonite, which allowed him to achieve more brilliant color. Willey died in New Orleans on July 7, 1980. He is credited with creating more than eighteen hundred works in the fifteen years that he painted.

Friends of Wildlife, 1975 (cat. no. 191), is an exuberant painting that superbly typifies folk narrative painting, with its flattened perspective, layered composition, sectioning, nonnaturalistic size and proportion of elements, representational but highly abstracted forms, meticulous detail and decorative patterning, and bright, unmixed palette. Willey was not a typical memory painter; in much of his artwork, an element of fantasy combines with realistic details, adding to the richness of the narrative. Willey's iconography features the recurrent appearance of figures such as Preacher Bear, who became a main character in a series of paintings.

Friends of Wildlife is a portrait of a town in which twentieth-century appurtenances such as television antennas, cars, and boats are integrated with flora and

fauna. Birds and puffy white clouds share the jewel-like sky. The meticulously organized scene, in deeply saturated, gemlike colors, is an Edenic presentation of a paradise on earth. The artist's romantic, optimistic view of life elevates the everyday setting to mythic proportions.

In *Friends of Wildlife*, Willey presents a unified picture of life in a southern suburban town. The painting relates to others that were based on bucolic themes and that were different from his many works related specifically to New Orleans life. In fact, *Friends of Wildlife* is similar to *Suburb of Hill Town* a painting in the collection of the late Robert Bishop. In a letter to Bishop, Willey included a narrative about *Suburb of Hill Town* that could just as easily describe the action depicted in *Friends of Wildlife*. In it, Willey tells of a country boy who, after earning millions of dollars, builds a town on his farm and then retires:

> He first cleared all the unnecessary tree hills, trees, and bushes so that the animals and birds could roam without fear of a hunter. He then built some houses for those people he employed to work on the upkeep of the town. [There] was a river which ran through the land, where fishing was good and boats traveled to large cities, on the other side of the river. He built for himself a nine-hole golf course between the river and the state highway which offered a place to

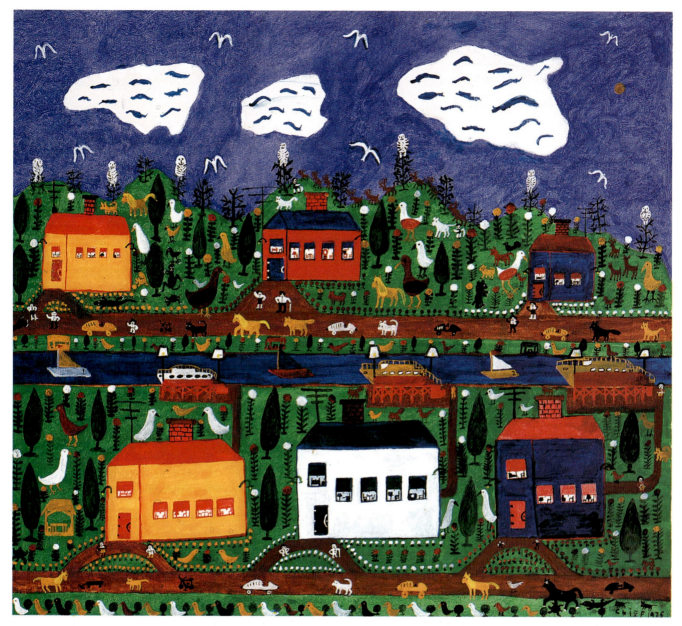

191. *Friends of Wildlife*, 1975

ride horses and motorcycles, also to walk. . . . You will notice that there are no police in this town, as all who live here are law abiding and love one another.

While his narrative contains several details not included in either *Friends of Wildlife* or *Suburb of Hill Town*, it suggests that both paintings may be part of a series. Similarities in subject matter, composition, imagery, palette, and general mood reinforce the suggestion, as does a small but winsome detail: In each of these paintings, quirky guardian owls patrol the treetops of the landscape's upper perimeter. —L.K.

Purvis Young

Only once did I drive through Miami, Florida, while on my way farther south, so I cannot claim to have visited the area of that city called Overtown, an urban disaster—another inner city ghetto that has been chronicled by its self-styled visual historian, in this case the painter Purvis Young. However, informed by the numerous news reports of urban decay and social problems, and as a witness to the recent degradation of areas of my own hometown, I can to some extent connect with Young's struggle to find a way to cope with this kind of spectacle and to seek change by exposing it to the world at large.

Purvis Young's community environment is one of burned-out buildings, vacant lots, and trash strewn everywhere. The helpless and the hopeless wander aimlessly, and the atmosphere is one of unrelieved despair. Looking for some relief from the horrors around them, or perhaps seeking escape or a moment of forgetfulness, people often resort to the hollow catharsis of violence. These struggles are endless, and change seems unlikely. Ironically, Purvis Young's expressive palette is extracted from this very chaos and human misery. He performs a marvelous feat—perhaps only artists can do this sort of thing—by taking what seems to be despair and its material consequences and, like an alchemist seeking to transform base materials into precious metals, converting these into a vision of hope and optimism, however tenuous.

Gitter and Yelen have assembled a collection of Young's work that is unparalleled in its variety and unsurpassed in artistic intensity. Because I think that many of the works speak eloquently for Young's broader aesthetic—which he developed early and has sustained in a highly innovative manner—I would like to begin with what might be described

as one of this artist's more "conventional" works, the monumental mixed-media picture entitled *Father*, 1988 (cat. no. 193).

Even before one considers its subjects and iconography, one is struck by the way the artist assembled this work. It is conventional only in the sense that it appears to be a painting on a flat support, finished with a frame. But there the comparison stops. The panel is a crude, irregular segment of cast-off wood, and around its edges are nailed a series of small, irregular, miniature frames. The result of this curious assemblage is to transform what is ordinarily a highly controlled, traditional picture plane into a space whose function and definition appear uncertain and in a state of flux.

The dominant, central feature of the painting is a rendering of a head of Christ or God the Father. Based on traditional stereotypes, the head is depicted with long hair, a mustache, and large eyes. This authoritative personage stares out at the viewer with an expression so neutral—neither admonitory nor engaging—that the viewer remains free to make his or her own interpretation. A multicolored halo surrounds this figure, around which are gathered other, more diminutive figures. In one corner is a group of rearing horses—one of Young's most frequently used motifs—and elsewhere are renderings of humans. All these subjects are executed in the nervous, calligraphic, swiftly brushed line work that is one of Young's stylistic hallmarks.

Young framed *Father* with strips of wood and panels of glass that form a series of small, irregular pictures, either rough sketches of figures or sections of vigorous brushwork. I connect these miniatures with pictorial configurations similar to those found in Russian iconostases or Spanish *reredos* (altar screens).

These illustrations accompany and give visual and spiritual support to the main images.

Father is a highly complex picture that addresses many issues of concern to Young and does so in a fairly consistent iconography. It is clear from Young's many representations of Christ or God the Father that his religious feelings are strong. The head of Christ obviously represents the primary character in Christian drama. But I would push this further and suggest that these images also refer collectively to Young's community—we are all Christ, we have all suffered, we belong to each other, we must rise together, so to speak. Young once noted, "I paint a lot of [black] saints . . . because black people [are] one of the most Christian-hearted people there [are]."[1] The looming visage in the center of *Father* establishes the preeminence of the subject's power. He is surrounded by symbols of the social ills suffered by the artist's people.

Horses are another ubiquitous theme in Young's work, where they seem to be symbols of freedom; here they rear up on their hind legs, perhaps in celebration of their natural state. Paula Harper suggests that these creatures may have been inspired by "the horses of the mounted police force" or are "perhaps purely mythological, . . . like the horses on Greek vases."[2] I would add that, besides representing unrestrained nature, horses are also regarded as animals capable of great trust and friendship, and some cultures view them as the most noble of beasts.

Young's familiarity with the history of art is clear; that he availed himself of local libraries to learn more about art and art history is well documented. An avowed admirer of Vincent van Gogh and Reginald Marsh, Young once compared himself to another famous artist:

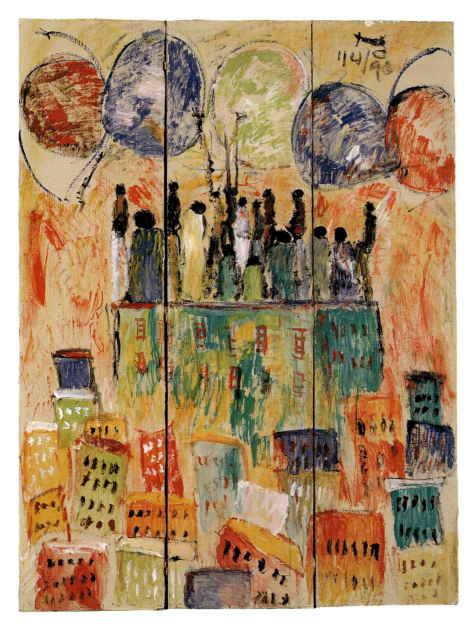

192. *Eyes over the City*, 1990

"Like Rembrandt, I'm walking among the people."[3]

Where do all these comments take us with respect to Purvis Young's *Father* in particular and his art in general? It has been my view that artists are most successful when they develop a technique that supports their expressive intentions so convincingly that one is unaware of their accomplishment until one takes time to define it. Another way of saying this is that I, like other viewers, am most interested in art that impresses me initially with its content, well before I ask how it was done. Young's work has an immediate visual impact. His artistic vocabulary is accessible, direct, and pertinent, and it pulls the viewer into the narrative quickly, efficiently, and forcefully. It cannot be claimed that Purvis Young has mastered the kind of brushwork that expresses form (the human body, for example) with conventional, academic polish. In this regard, he is an untutored artist. It is clear that he learned a great deal from studying "mainstream" artists: His brushwork, for instance, imitates expressionistic methods of drawing. There is no evidence, however, that Young really wanted to imitate others. I am convinced that he took ideas from them but ultimately accepted the responsibility for innovating his own voice, one appropriate to his subjects, which could be the only real artistic truth for him. The swift brushwork of an academic artist usually reveals a preoccupation with the significance of "correct form," learned in the years of apprenticeship; Young is not interested in that kind of correctness. Instead, he wants to inform his art with the energy and the life force that he sees around him. He mourns what is so obvious to him—that so much of this vibrant stuff is spoiled, wasted, and destroyed.

Man behind Bars (Purvis in Jail), 1989 (cat. no. 194), is another composition that uses an oversized portrait as its main subject. In this case, however, it is the artist himself who is shown—here imprisoned behind a mesh. His mouth is open, seemingly to utter a cry of outrage and frustration. Surrounded by buildings, he is accompanied by a crowd of people represented in miniature. This painting suggests at least two kinds of incarceration. Young spent time in prison, so he understands well that form of debilitating sequestration. The other is the kind that holds entire populations hostage to social and political ills—the world of the urban ghetto. Young has often spoken of his frustration with the situation in his community. He is especially concerned with the fact that joblessness and its consequent diminution of self-respect have been tearing his community apart for decades. Part of his frustration comes from others' misperception that his people have no ambition, no desire to secure employment. "Mostly I see people who want to work. *Everybody* wants to work. People aren't lazy."[4] Without a constructive direction or honorable goals, people end up imprisoned one way or another.

Mountain Landscape, 1991 (cat. no. 196), is a different sort of painting in many

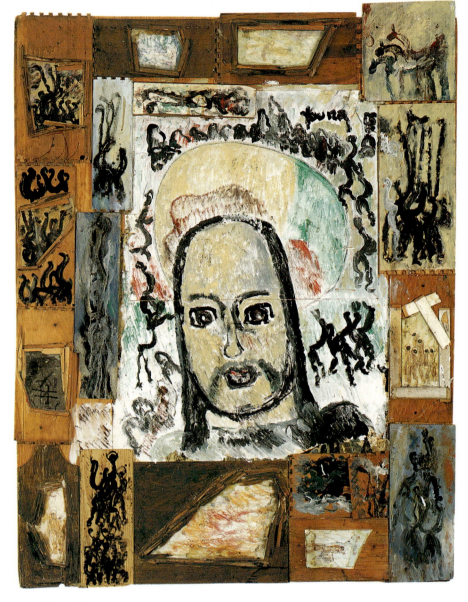

193. Father, 1988

lower part are very specific; they suggest to me the traditional Chinese and Japanese representations of the *parinirvana* of the Buddha, the traditional event in Buddhist lore when the great religious figure left his followers and the earthly realm to rejoin the state of perfect bliss beyond phenomenal existence. I suggest that Young discovered and studied this solemn theme and saw a way to use it to connect the mythical past with the experiential present; perhaps he sees himself as a disciple of the Great Teacher. I am convinced that both *Mountain Landscape* and *Burial in the City* are brilliant adaptations of artworks from a culture outside Young's own and that Young co-opted them in order to re-present a fundamental idea of destiny and spiritual unity to a new generation.

Although it's doubtful Young has been instructed in pictorial design principles, his choices of formats and his compositions are invariably correct for his messages. Thus in paintings such as *Tenements of the City*, c. 1989–90 (cat. no. 195), *Disaster in Bangladesh*, 1990 (cat. no. 197), and *Boxcars of People* (also in the Gitter-Yelen collection but not included in this exhibition), he uses elongated supports to help raise the level of compositional energy. Overcrowded, filthy, decrepit buildings are common in urban ghettos. Young's tall, slender, jerry-built panel and frame for *Tenements of the City* are as expressive of this theme as are the subjects depicted. The long, horizontal freight cars in *Boxcars of People* surely refer to the trainloads of humans shipped off for extermination by the Nazis during World War II. Young's depiction of an endless string of railroad cars—the anonymous, mechanical carriers of people to their death—that stretches to either edge of the painting suggests the extent of the misery and the magnitude of a tragedy that is beyond comprehension. *Boxcars of People* can in fact be seen as a modern pictorial mantra about the endless suffering that humans visit upon each other.

Throughout Young's work, expressions of despair are always offset by

ways. Most of Young's compositions address urban issues. Here, however, in the foreground of a mountain setting, a procession of people carries what appears to be a coffin, presumably along a path to a burial site. Scattered about are groups of people represented very simply. As in most of Young's paintings, there is virtually no perspective, so the space of the painting is flat. Possibly Young saw this image in a book and it impressed him deeply. Furthermore, it may have been inspired by a traditional Chinese landscape painting. Compared

to the artist's typically dramatic style of brushwork, this composition is delicately rendered, even poetic, so the comparison to the Chinese genre seems appropriate. Support for this idea is found in another painting, the striking *Burial in the City*, 1988 (cat. no. 200). No doubt Young had seen funerals in his neighborhood; given the troubles and the troubled people there, they surely were a common sight. However, the prominent, horizontal position of the deceased at the top of the picture and the vertical arrangement of the living figures along most of the

notes of hope and salvation, notably in his many depictions of holy figures such as Christ, God the Father, and Buddha. *Disaster in Bangladesh* is painted on a tall, vertical panel almost completely filled by the gigantic representation of a robed, tonsured, haloed figure. Around him, in miniature, are strewn the remnants of buildings destroyed by floods. On the one hand, this picture could record Young's response to news of the floods that periodically destroy the land of eastern India; in spite of this natural disaster and its attendant horrors, however, the towering presence of the Buddha, or perhaps of a Hindu priest, represents the ever-present divine spirit that transcends worldly concerns. On the other hand, the figure could easily stand for a universal conception of the Divine Spirit: This painting works just as well if it is understood as another treatment of Young's community of Overtown, with Christ or God the Father in place.

One of Young's most inventive works consists of two monumental paintings executed on opposite sides of a large, three-panel folding screen (cat. no. 192). Entitled *Horses*, 1990 (recto, not illus.), and *Eyes over the City*, 1990 (verso), the compositions epitomize the artist's boldness and sureness of vision. *Horses* features one of Young's favorite subjects, a horse and rider, sketched swiftly and with confidence. As I have suggested, there are many interpretations of the horse motif, but here Young seems to be alluding to a gathering of people that has become unruly, requiring the intervention of the mounted police. Around the main figure, groups of smaller figures, half human, half horse (suggesting that these enforcers have taken on a new and unnatural role), press upward toward the crowds of people milling across the top of the painting. Once again, Young's restless calligraphic painting technique invests the painting with a nervous energy —palpably conveying the drama of situations at once local and particular but also all too universal in our strife-torn cities. An important element of this painting— the large circles, three across the top and

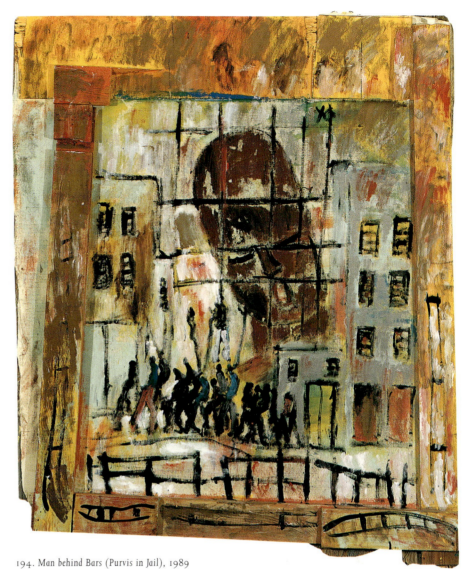

194. *Man behind Bars (Purvis in Jail)*, 1989

another in the right middle ground— represents Young's notion of "eyes over the city," also used in two other paintings in this collection: *Tenements of the City* and the painting named for this phenomenon, *Eyes over the City*. I interpret this motif as symbolic of the unnerving presence of authority in the ghetto communities: the ever-present, impersonal, implacable forces of social order that press relentlessly on people who are already at the end of their rope. The ubiquity of these "eyes over the city" is the subject of the screen's verso painting. Here are no less than five immense representations of the symbol over a cityscape whose skyline is blood red—the burning city. A cluster of

protesting citizens gathers on the rooftop of a building that stands like a king of the mountain over the ruins below.

Young's use of a folding screen for these messages is ironic and especially potent. Historically, the folding screen was a piece of furniture designed to divide a room informally, flexibly, and temporarily into areas of special function. It was also used to conceal. It allowed a person to discreetly change clothes behind it, or it blocked from view accessories not meant to be viewed during a social visit (serving trays and food, for example). Thus the folding screen represents privacy. But Young turns the tables on this old-fashioned

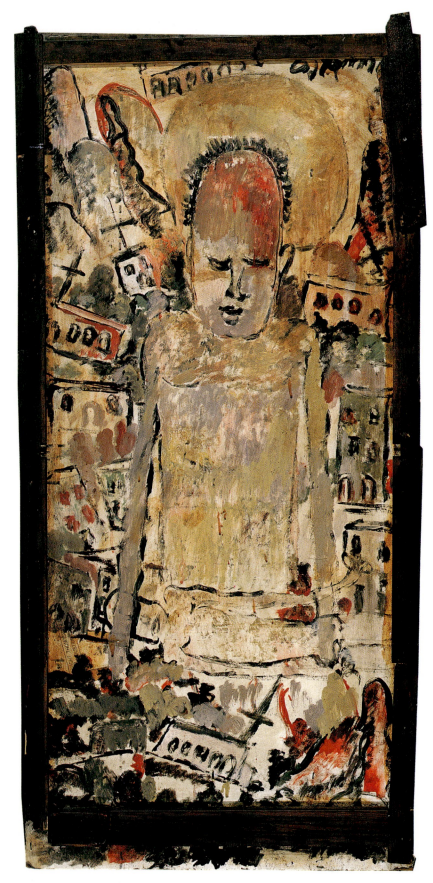

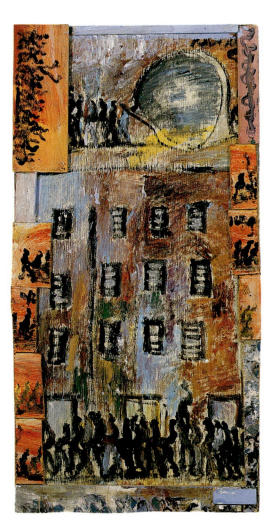

195. Tenements of the City, c. 1989–90

197. Disaster in Bangladesh, 1990

use. Instead of creating something elegant, something that will make a space more beautiful or more functional, he has turned the object into a pair of powerful statements that cannot be ignored. Or can they? A folding screen is easily collapsed on itself and put away. Is there an even more clever message for us?

When people discuss the social disintegration of our inner cities, conditions often mentioned are unemployment, crime, life on the streets, the decay of neighborhoods and businesses. But surely the most precious resource that any community possesses is the family, and Young's painting *Family*, 1991 (cat. no. 198), is a chilling commentary on a situation endemic in many of today's inner circles. This is an enormous painting, measuring eight feet high by four feet wide. Judging by its size, I would assume that Young intended the painting to be a major statement. At its center is a monumental, bold silhouette of a pregnant woman represented in a highly reductive fashion: She has no arms, she is anonymous, she is perhaps "every woman." And yet, curiously, either she has no breasts or they have shriveled to insignificance. Around and underneath this mythic figure are six other figures, their genders unclear. Are they a family, gathering around the large mother figure for support? Crowds of people are sketched in lightly throughout various sections of the painting. Is this a statement about the tragedy of families broken or incomplete?

In so many cities whose underprivileged citizens are "against the wall," it is common knowledge that it is the women who manage to preserve some semblance of family—truly the only hope for the future. Is this featureless, breastless, but fecund figure a symbol of despair or of hope? I am impressed by so much of Young's work because he seems content to point out realities—he does not cosmeticize or conceal the truth as he has experienced it. He does not editorialize. His works do not give us answers. Instead, they force us to think deeply and find the answers in ourselves. What

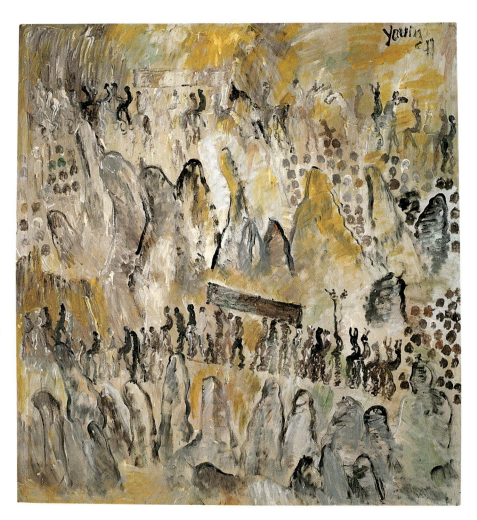

196. *Mountain Landscape*, 1991

Young does is extraordinarily difficult: He tells stories about city life without telegraphing a message, which can be accepted or rejected out of hand. He does not sentimentalize, thus risking overstatement and dilution of the narrative. And most impressive of all, he does not exaggerate. Young has been quoted many times about his goals as an artist, but I was particularly struck by two statements. An avowed activist, he went on record when he said, "I am determined to get in the world."[5] And he merely stated fact when he observed, "I look at things like this in life, you know."[6]

Purvis Young's books are among his most exciting productions. Books afford many pleasures—anticipating their con-

tent, holding them, examining them. Young's books, however, are extraordinary, for he takes an ordinary discarded ledger or directory or atlas, and by working over the pages or pasting in drawings, he jams it cover-to-cover with a most incredible array of images and ideas. When filled, the pages are so full and heavy that they fan out uncontrollably—an apt metaphor for the artist's personality. These are perhaps the most intimate and direct documents of the man's protean energies. Gitter and Yelen have a remarkable specimen of this genre (cat. no. 199, not illus.), and it is inexhaustible in its proliferation of techniques, materials, subjects, and adaptations of media. Since it appears to be chronological in arrangement, it is possible to leaf

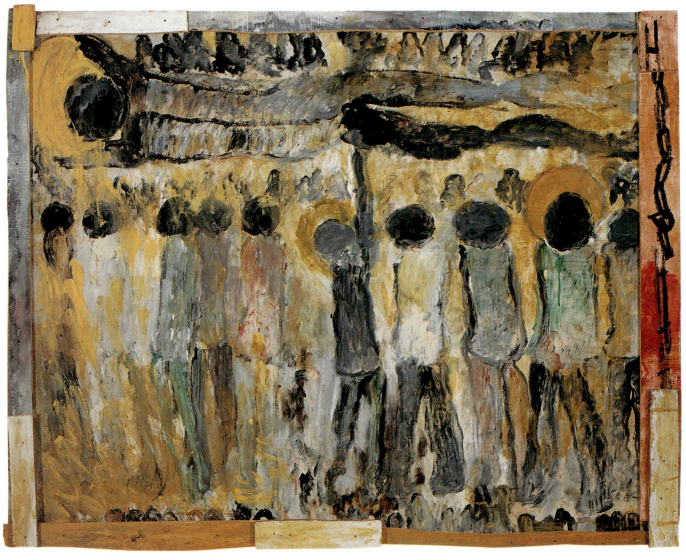

200. *Burial in the City*, 1988

through it slowly, page by page, from beginning to end, and watch the changes in the artist's mind as he moves restlessly from one idea to the next. One material works for a spell; then it is replaced by something experimental or perhaps more useful in his quest for artistic intensity. The element of time is important here. How long do Young and his people have to wait? How long before, full of anxiety and frustration, these life pages burst and fall apart? The weight of the volume is significant as well. One is literally bearing a physical mass that both embodies the artist's soul and pulls it down.

It is true that Young and his art are connected in a way that is quite different from that of many other artists. He has chosen to live in and continue to chronicle the place where he was born and reared and where he developed as an artist. His environment is his inspiration, its detritus his palette. Young is an artist, choosing this as a calling above all others: "Painting is my whole life. I go to sleep with my paintings and I wake up with my paintings."[7] —G.J.S.

NOTES

1. Larry Mahoney, *Miami Herald*, September 24, 1971, p. 1D.

2. Paula Harper, *Miami News*, April 8, 1983, p. 3D.

3. Vicki Sanders, *Miami Herald*, February 2, 1983, pp. 1B ff.

4. John Doussard, *Miami News*, February 2, 1985, p. 1A.

5. Joanne Butcher, *Art Papers* 2, no. 6 (November/December 1987): 45.

6. Sanders, *Miami Herald*.

7. Robert Becker, "Creating a Scene," *Interview* (September 1986): 78.

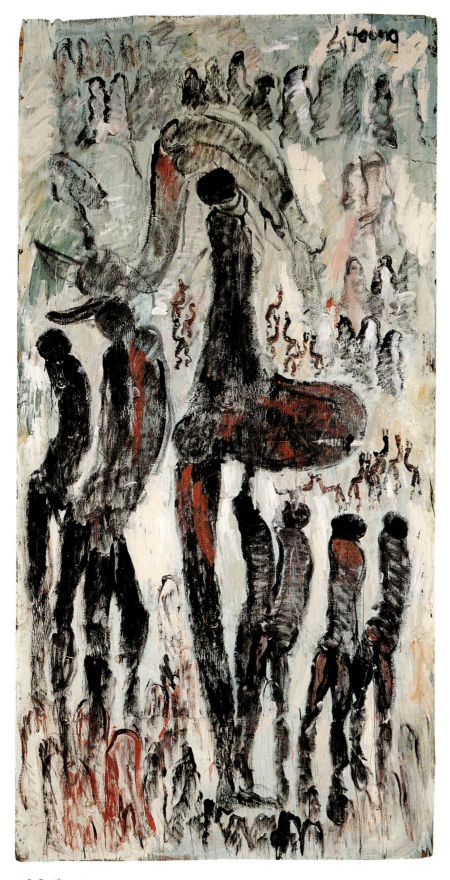

198. *Family*, 1991

Malcah Zeldis

Malcah Zeldis was born Mildred Brightman on September 22, 1931, in the Bronx, New York. Shortly after her birth, her family moved to Detroit, where her father eked out a living as a window washer. She graduated from high school with strong Zionist leanings and in 1948 went to live on a kibbutz in Israel. She met and married Hiram Zeldis, a writer who was also from Detroit. The couple were married in Detroit and returned to Israel. She was encouraged to paint by Aaron Giladi, an Israeli artist who saw her artwork during a visit to the kibbutz.

In 1958 Zeldis left Israel with her family and settled in New York. For more than ten years, she was a mother and housewife. Neither her father nor her husband encouraged her to paint, and although she thought about painting during this time, she did not have enough confidence to pursue it. During the early 1970s, as her children grew older and her marriage floundered, she was admitted to Brooklyn College. She graduated in 1974, worked as a teacher's aide, obtained a divorce, and began to paint seriously.

Zeldis's interests are wide and the subjects of her paintings are varied. Her artworks encompass social themes, celebrations, everyday events, religious events and practices, fairy tales, and portraits of her heroes and heroines. She

often rapidly sketches her design and then paints in oil on canvas or board or in gouache or tempera on paper. Her paintings have been widely collected and exhibited, and she has recently illustrated several children's books.

In *Bloomingdale's*, 1972 (cat. no. 201), a deeply saturated, animated painting of the flagship store that is as much a symbol of sophisticated New York as it is a retail mecca, Zeldis captures the essence of the urban life with which she is so familiar. She depicts the crowd outside the landmark on the corner of 59th Street and Lexington Avenue. For verisimilitude, Zeldis includes signs for Wig City, Howard Johnson's, and Argosy Books in addition to that for Bloomingdale's. Throngs of people—many involved in their own thoughts and activities, others momentarily looking up to the viewer for an instant of recognition —crowd the street. Although no snow is on the ground, the presence of Santa Claus, with his arm extended in friendship, places the time of the scene between Thanksgiving and Christmas.

The compositional space is compressed, and the layering of elements creates a highly personalized perspective. The stacking of planal elements, without the use of shading or traditional perspective, gives the impression of illusionary space. Several points of perspective are

introduced simultaneously, and that, along with the compression of elements in the larger design, charges the atmosphere. The asymmetrical arrangement of architectural details and the introduction of a strong diagonal (representing the street filled with an unending procession of automobiles) further enhance the energy Zeldis elicits from this tumultuous scene. The feeling of excitement is increased by a palette of bold, clear, unmixed colors, especially the electric blues, greens, yellows, and oranges.

While the scene is crowded with detail, the composition is never out of control. Zeldis has a strong design sense, which is exemplified through her balanced use of line and color and her innate sense of the principles of repetition and variation. Angular building and window shapes are balanced by the rounded heads of people and the tops of cars. The dazzling yellow display window is echoed in smaller patches in the other illuminated windows and in the hair and clothing of the throng.

The artist frequently incorporates images of herself in her works. In *Bloomingdale's*, the attractive, dark-haired artist is standing next to a blonde model strongly resembling Marilyn Monroe, one of Zeldis's recurrent heroines; they are inside the main display window and are fashionably dressed for a holiday

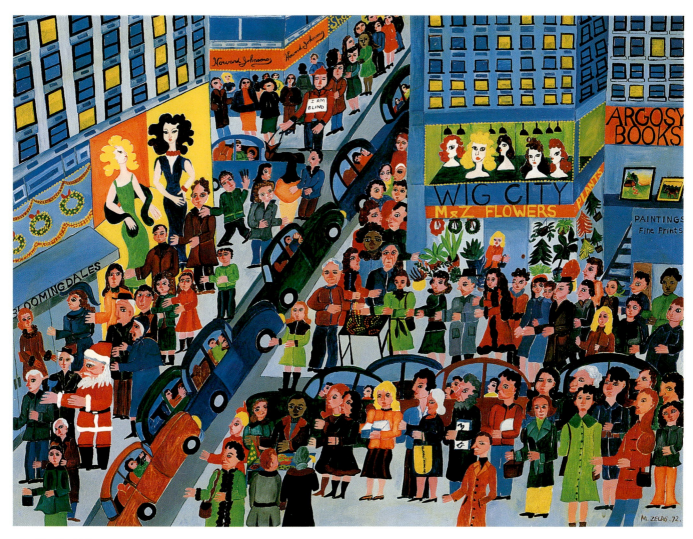

201. *Bloomingdale's*, 1972

evening's festivities. The model's dark, wavy hair and formfitting, sleeveless gown with red trim stand out boldly inside a lighted window. While Zeldis as the model is compositionally large and placed almost at the front and center in the show window, the crowd's attention is mostly elsewhere. A few people appear to be glancing up at the artist who has painted them, but most are painted in profile and appear to be preoccupied with their own thoughts. Another autobiographical touch is the landscape painting in the Argosy Books window: According to Zeldis, the artwork is reminiscent of the colored-pencil and chalk sketches created by her father, Morris Brightman, a Sunday painter.

Celebration, 1988 (cat. no. 202), a work of gouache on paper, expresses the artist's deep attraction to the weekly Sabbath services practiced by Orthodox Jews. The setting is a synagogue interior. The narrative depicts a moment following the Torah's removal from the arks seen on the back wall, just before the weekly Sabbath reading from the sacred scripture. The male congregants—separated from the females, according to custom—stand with their arms outstretched, ready to touch the Torah reverentially as bearers walk through the aisles chanting familiar prayers and blessings. Their heads covered respectfully with hats or *tallezim* (prayer shawls), they await the experience of personal closeness with

the Torah, the book of laws and the moral codes that have unified the Jewish people for centuries.

Zeldis, who is not an Orthodox Jew, is nevertheless tremendously moved by the beauty of people who reify the Torah, treating it with respect and love. Throughout their tortured history, the Jews have looked to the Torah as a constant source of inspiration and guidance, and it remains a testament of their faith and a symbol of their reverence for God.

In *Celebration*, the artist captures this profound love and anticipation of a feeling of closeness with God, objectified by the Torah scrolls. Zeldis paints what she describes as a moment of "elevation, one governed by a unifying beauty and

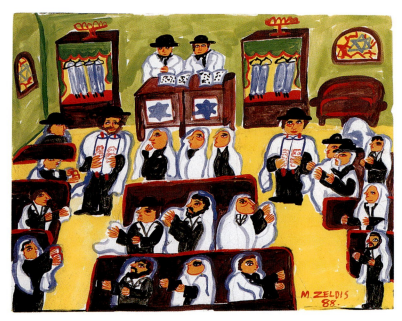

202. *Celebration*, 1988

respect for a moral prescription based on ethical and humane principles."[1]

Zeldis takes a few compositional liberties to show both the congregants and the Torah scrolls with an unobstructed view. Realistic placement of the *bimah*, or lectern, from which the Torah is read would be in the foreground, not on the back wall. Placing the *bimah* there would change the compositional focus, yet leaving out the elevated Torah stand would be a serious omission. Zeldis's choice balances the form and keeps the painting's full content intact. The formal design is well balanced, the colors strong. The blue outlines, reminiscent of the blue and white Israeli flag, stand out from the white prayer shawls and brown and maroon pews. Set against the cool green wall, its decorated windows featuring the modern star of David, is the warm golden yellow floor, which radiates an interior heavenly light yet does not overpower the devotions taking place. Zeldis's masterful use of curved shapes adds to the emotional intensity of the scene.

Hebrews Lesson (in the Gitter-Yelen collection but not in this exhibition), an autobiographical scene painted in gouache on paper, depicts Zeldis's brother, Yaakov, at the kitchen table in Detroit with his Hebrew teacher, Mr. Auslander. Yaakov, or Jack, as he was called, contracted rheumatic fever when he was ten years old and was consequently unable to attend Hebrew school. So that Jack would not fall behind in his studies for his bar mitzvah in his thirteenth year, his Hebrew teacher came to the house to instruct him. His baseball cap to one side, Jack sits with his black-hatted, bearded teacher, with open books on the green table before them. The white stove, sink, and cabinet punctuate the glowing yellow wall and floor. An observer, Zeldis stands on the sidelines with her doll, as her cat, Kutsick, scampers across the floor.

I Have a Dream (Martin Luther King), 1976 (cat. no. 203), honors one of Zeldis's heroes. Zeldis had admired Martin Luther King from the first time she saw him on television, August 28, 1963, delivering the famous "I Have a Dream" speech to a crowd of 250,000 people. Highlighting one of the most famous marches on Washington, the civil rights leader called for all people to come together and live in harmony and peace. The talk was delivered in front of a statue of another Zeldis hero, Abraham Lincoln. The artist documents the event, focusing on King in front of the Lincoln Memo-

rial and flanked on either side by self-portraits of the artist carrying flowers as offerings to her spiritual hero. Zeldis comments, "It is as if King with his lofty thoughts and eloquence made one feel uplifted. His raised arms suggest spiritual ascension and nobility." Because Zeldis believes that King was a great American and human being, she has painted him many times.

Malcah Zeldis, one of the leading self-taught contemporary artists, is best known for her paintings depicting urban life, historical and religious events, her heroes, and her own life. Her spirited narrative style expresses an optimistic life view and a strong social commitment, and her paintings have been widely exhibited. Of special note is the one-person show presented by the Museum of American Folk Art at New York University in 1988. It was the first time the museum had presented a one-person exhibition of the work of a living folk artist. — L.K.

NOTE

1. Quotations are from a telephone interview with the artist conducted by the author, July 1995.

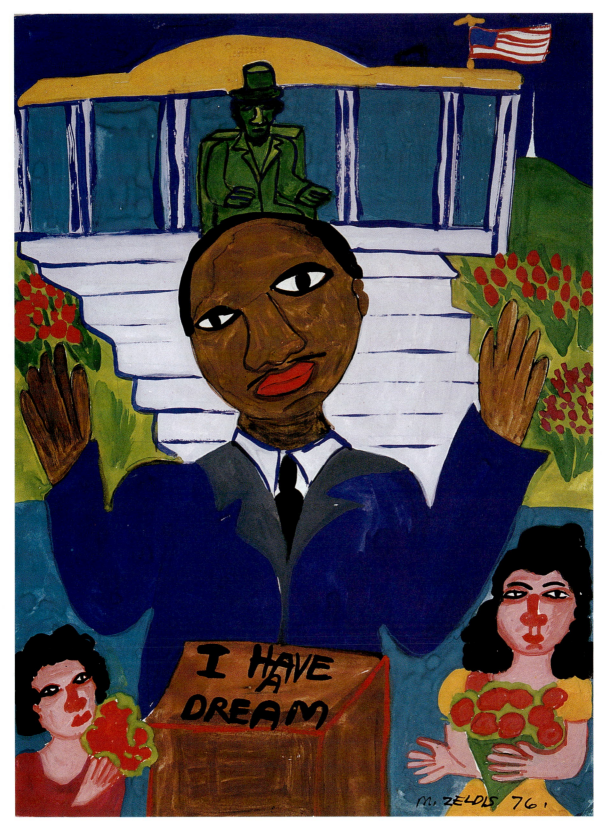

203. I Have a Dream (Martin Luther King), 1976

Exhibition Checklist

Dimensions are in inches, height preceding width and depth. In the case of some three-dimensional works only the principal dimension or dimensions are given: height (H.), width (W.), depth (D.), diameter (DIAM.), or length (L.). All works are illustrated unless otherwise noted.

MINNIE ADKINS, B. 1934

1. *The Entangled Wood no. 1*, 1989
 enamel on fabric window shade
 38½ × 96½
 Inscribed on verso: M.E.A. / 1989 / By Minnie Adkins / The Entangled Wood no.1

STEVEN ASHBY, 1904–1980

2. *Standing Woman with Purse*, 1972
 wood, cloth, paint, beads, seed, pearls, paper
 25 × 9¼ × 4¼

AARON BIRNBAUM, B. 1895

3. *Untitled (Landscape)*, 1993
 acrylic with varnish on cardboard
 18 × 50
 Signed: A. Birnbaum

MINNIE BLACK, B. 1899

4. *Critter*, 1990
 gourds, paint, with additions such as feathers, velvet, plastic
 12½ × 25½ × 17
 Signed on underside: Minnie L. Black

DAVID BUTLER, B. 1898

5. *Whirligig*, 1975
 paint on tin and wood
 H. 29, L. 39

ARCHIE BYRON, B. 1928

6. *Man in Overalls*, c. 1992–93
 sawdust, glue, paint
 60 × 23 × 9

RAYMOND COINS, B. 1904

7. *Ruby and Raymond*, 1982
 cedar and cloth
 Ruby: 55 × 24 × 15
 Raymond: 60 × 27 × 17

8. *Stele Commemorating the Founding of a Church*, c. 1975
 soapstone
 44½ × 22 × 6½

9. *Dream Stone: Dry Bones*, 1988
 soapstone
 H. 41, L. 45

10. *Deer*, c. 1982
 cedar
 41½ × 34 × 44

11. *Adam and Eve (recto)*, c. 1982
 The Devil (verso), c. 1982
 soapstone
 20¾ × 14¼
 Incised verso: The Devil / W. R. Coins

12. *Angel*, c. 1982
 soapstone
 20¾ × 18
 Incised near center: R. Coins

13. *Buffalo*, c. 1978
 wood
 37½ × 70 × 49

14. *Crucifixion*, c. 1988
 soapstone
 H. 17, W. 11
 Incised on back: W. R. Coins

JOHN WILLIAM DEY, 1912–1978

15. *Charlie Chaplin Inspecting Country Real Estate*, c. 1974
 model airplane paint on board
 30½ × 36
 Signed lower right: Uncle Jack

THORNTON DIAL, SR., B. 1928

16. *Lady and Rooster*, 1991
 watercolor, pencil on paper
 22½ × 30
 Signed lower left: TD

17. *Lady Tiger Fish*, 1991
 acrylic and industrial sealing compound on paper
 22 × 30
 Signed upper left: TD

18. *Street People*, 1987
 concrete base and painted tin figures
 various sizes, from H. 9½ to H. 15½

19. *Keeping the Pigs from Rooting*, 1988
 painted carpet and wood
 79½ × 96

20. *Chair Man*, 1987
 metal, hat, painted packing tape for head and hands
 60 × 37 × 44

21. *Atlanta Convention*, 1988
 mixed media construction
 buildings: H. 54
 plane: L. 104

22. *Schoolteachers*, 1988
 acrylic on board
 48 × 49

23. *Demolition*, 1987
panels: paint, applied painted canvas "leaves"
25½ × 48; 23½ × 48½
bulldozer: wood, metal, wire
26½ × 66

SAM DOYLE, 1906–1985

24. *First Passenger Line from Frogmore to Savannah*, c. 1975
oil on metal and wood
57¾ × 90

25. *WA DA*, c. 1975
paint on metal
56½ × 27
Signed lower right: S. D.

26. *Rocking Mary*, c. 1980
paint on metal
37½ × 26¼
Signed: S. D.

27. *No More We Fear*, c. 1982
paint on metal
29¼ × 53¾

28. *Dr. Buz*, c. 1980
paint on metal
45 × 27
Signed bottom center: S. D.

29. *Joe Louis*, c. 1980
paint on metal
48 × 27
Signed bottom right: S. D.

30. *Nurse Midwife*, c. 1980
paint on metal
40 × 25½
Signed: Sam Doyle / S. D.

31. *Try Me*, c. 1978
paint on metal
48½ × 27

WILLIAM EDMONDSON, C. 1870–1951

32. *Nurse*, c. 1935
limestone
12½ × 4 × 7

HOWARD FINSTER, B. 1915

33. *Cathedral in Heaven*, 1979
painted plywood, mirrors, wired with light bulb
37 × 19½ × 9½
Signed: By Howard March 1979 / Howard Finster

34. *Noah Being Warned*, 1976
oil on fiberboard
17¾ × 36½

35. *George Washington in Another World*, 1987
oil on panel
58½ × 47

36. *Concentration Camp (Gas Pit / Silent Death)*, 1990
oil on panel
7¾ × 10¾
Signed: Howard Finster

37. *Wipe Rags (Captured Visions)*, 1989
oil and felt-tip markers on cloth
Two rags: 24 × 15½; 24 × 20
Signed bottom center: Howard Finster

38. *Roosevelt and Wilson*, c. 1977
oil on metal table top
23 × 40

39. *200-Foot Tidal Wave*, c. 1976
enamel on fiberboard
29½ × 11¾ (31 × 13¼ with frame)
Signed lower right: Howard 3-HRS
Inscribed on verso: 200 Foot Title [sic] WAVE / One way of Excape / Raise Your / Ship Set it Over the / Title wave

40. *Mailbox*, 1989
enamel on aluminum mailbox
9½ × 19 × 6¾
Signed bottom right: Howard Finster

VICTOR JOSEPH GATTO, 1893–1965

41. *Circus*, c. 1950
oil on canvas
19 × 30
Signed lower left: Victor Joseph Gatto

42. *Johnstown Flood*, 1955
oil on fiberboard
9 × 18
Signed lower left: Victor Joseph Gatto
Inscribed on back: Title August 1955 / Artist Victor Joseph Gatto / Collection Mr. and Mrs. Strauser

43. *Poppies*, c. 1950
oil on canvas panel
15¾ × 19¾
Signed lower right: Victor Joseph Gatto

44. *Jungle*, c. 1946
oil on canvas panel
15¾ × 19¾
Signed lower left: Victor Joseph Gatto

RALPH GRIFFIN, 1925–1992

45. *Wizard*, 1988
painted driftwood with nails
12¾ × 7½

46. *Man in Airplane*, 1990
painted driftwood, nails, wheels
8½ × 18 × 13
Signed: RG

47. *Grimacing Figure*, c. 1988–89
painted driftwood, plastic, nails
32 × 16 × 12

48. *Dwarf*, 1989
painted driftwood, nails
30½ × 15 × 21

49. *Inverted Bush (Monster)*, 1989
tree limb, wire
39 × 19 (approx.)

50. *Angel*, 1991
painted driftwood, nails
13 × 12 × 4½
Signed on back: RG

JOSEPH CHARLES HARDIN, 1921–1989

51. *Red Woman*, 1988
acrylic on cardboard
33 × 13

BESSIE HARVEY, 1929–1994

52. *Mask*, 1988
painted wood, jewelry, seeds
14½ × 9½ × 8

53. *Mask*, 1988
wicker cornucopia, shells, yarn, plastic, aluminum foil
H. 13, DIAM. 9½

54. *Mask*, 1988
foil, feathers, pine straw, paint, wire mesh
18 × 13 × 10

WILLIAM LAWRENCE HAWKINS, 1895–1990

55. *Neil House No. 1 (recto)*, 1979
Rhinoceros (verso), 1979
enamel on paper
22½ × 28
Signed at top: William L. Hawkins

56. *Union Station*, c. 1982–83
enamel on fiberboard
24 × 36
Signed at bottom: William L. Hawkins

57. *Buffalo Hunter No. 2*, 1985
enamel on fiberboard
48 × 60
Signed at bottom: William L. Hawkins

58. *Swords into Plowshares*, 1985
enamel on fiberboard
38 × 48
Signed at bottom: William L. Hawkins

59. *Peco Food Bar No. 2*, 1985
enamel on fiberboard
48 × 48
Signed at bottom: William L. Hawkins

60. *Alligator and Lovers No. 2*, 1985
enamel on fiberboard
46½ × 56½
Signed at bottom: William L. Hawkins

61. *Puma Kitten*, c. 1985–86
enamel, glitter, cornmeal modeling paste on board, paint
43½ × 31½
Signed at top: William L. Hawkins

62. *San Francisco Golden Gate Bridge*, 1986
enamel on fiberboard
39¼ × 48
Signed lower left border: William L. Hawkins

63. *Last Supper No. 9*, 1987
oil, collage, cornmeal modeling paste on fiberboard
43 × 48
Signed at bottom: William L. Hawkins

64. *Elephant*, c. 1988–89
enamel, cornmeal modeling paste
48 × 48
Signed at bottom: William L. Hawkins

CLEMENTINE HUNTER, 1886/87–1988

65. *Gourd Harvest*, 1955
oil on wood panel
70½ × 46½

66. *Quilt, Melrose Plantation*, c. 1960
appliquéd and pieced cotton on paper
69 × 54½
Signed lower left: ƆH

REV. JOHN L. HUNTER, B. 1905

67. *Standing Figure of Man*, 1990
wood, house paint, plastic
53½ × 14 × 10

CLYDE JONES, B. 1938

68. *Two Guys on a Car*, 1988
wood sculpture with nails, bottle caps, hats, traces of paint
62 × 29 × 30

69. *Two Dinosaurs*, 1990
oil on board
13¾ × 38¼

SHIELDS LANDON JONES, B. 1901

70. *Three Musicians*, c. 1975–78
painted wood
Banjo player: 43 × 13½ × 19
Guitarist: 31½ × 11½ × 13½. Signed: S. L. Jones
Fiddler: 27¼ × 8 × 10. Signed: S. L. Jones Hinton WVA

EDDIE KENDRICK, 1928–1992

71. *Garden of Eden*, c. 1988–89
pencil, crayon on paper
19 × 24
Signed: Eddie Kendrick

72. *Ascension to Heaven*, c. 1991–92
colored pencil, ink, crayon, watercolor on poster board
19 × 24
Signed lower right: By E. Kendrick

CHARLES KINNEY, 1906–1991

73. *Old Devil Burning People*, c. 1989–90
tempera and pencil on poster board
22 × 28
Signed lower left: Charly Kinny

74. *Hoot Owl*, c. 1989–90
watercolor, pencil, charcoal on poster board
22 × 28
Signed lower right: Charly Kinny

75. *Dear*, c. 1989–90
tempera and pencil on poster board
22 × 28
Signed lower right: Charly Kinny

76. *BAREants*, c. 1989–90
tempera and pencil on poster board
22 × 28
Signed center: Charly Kinny

77. *Tornado*, c. 1989–90
tempera, pencil, ink on poster board
22 × 28

78. *Charly Kinny in Wilde Wilinis*, c. 1989–90
tempera and pencil on poster board
22 × 28
Signed lower left: Charly Kinny

JOE LOUIS LIGHT, B. 1934

79. *Freeman*, 1989
enamel on panel
11½ × 33½
Inscribed on verso: FREEMAN
Signed lower right: J. Light

80. *Flower Diptych*, 1989
enamel on two panels
51½ × 17 (each panel)
Signed lower right each panel: Joe Light

81. *Inscription*, 1992
enamel on panel
7½ × 81
Signed lower right: Joe Light

82. *Rocks and Water*, 1991
enamel on panel
24 × 48
Signed lower right: Joe Light

83. *Earth and Sky*, 1991
enamel on panel
24 × 48
Signed lower right: Joe Light

CHARLIE LUCAS, B. 1951

84. *Mr. Charlie*, 1992
metal, found objects
H. 81

85. *Mask*, 1988
lawn mower cover, other found metal objects
30¼ × 21½

86. *Don't Drive Drunk (Man on Bicycle)*, 1987
found metal objects
H. 59, L. 79

87. *Camels*, 1988
railroad spikes welded with other metal objects
H. 10 (average)

88. *Dinosaur*, c. 1987–88
wire, colored telephone wire
H. 27

89. *Crossing the Line*, 1988
acrylic on board, garden-hose frame
20¼ × 96
Signed lower left: CL

90. *Dinosaur*, 1990
acrylic on board
21½ × 27½
Signed lower left: C. L. / Tin Man

91. *Man with Lantern*, c. 1987–88
assembled from found metal objects including a muffler, exhaust pipes, cooking pot, and lantern
H. 70

JUSTIN MCCARTHY, 1892–1977

92. *Christ Entering Jerusalem*, c. 1960s
oil on board
24 × 32
Signed lower center: J. McCarthy

93. *Two Women in the Snow*, c. 1920
watercolor, pencil on paper
10½ × 8¼
Signed in pencil lower left: J. McCarthy
Signed lower right: By Prince Dashing [pseudonym]

94. *Cartoon Series*, c. 1930s
pen and ink on paper
14 × 22
Signed lower left: J. McCarthy

95. *Cherries*, 1920
watercolor on paper
10 × 8
Dated upper right: 1920

96. *Lion and Cub*, c. 1962
oil on panel
18¼ × 18
Signed and dated lower right:
62 J. McCarthy

97. *Jim Thorpe Highway*, c. 1962
oil on fiberboard
24 × 36
Signed lower right: J. McCarthy

98. *Fashion*, 1967
oil on fiberboard
24 × 25½
Signed and dated lower right:
1967 J. McCarthy

99. *Noah's Ark*, c. 1966
 oil on fiberboard
 21 × 26¾
 Signed lower right: J. McCarthy

WILLIE MASSEY, C. 1908–1990
100. *Birdhouse (orange, black, green)*,
 c. 1988–89
 painted wood, foil, tape
 22 × 16¼ × 12½

101. *Birdhouse (red, white, blue)*, c. 1988–89
 painted wood, foil, buttons
 17 × 18½ × 18

102. *Alligator and Snake*, 1989
 oil on cardboard
 11½ × 15¼

103. *Sailboat*, c. 1988–89
 painted wood with buttons
 H. 13, W. 7

104. *Rocking Chair (orange, green)*, 1989
 painted wood
 9¾ × 6¾ × 8½

REGINALD MITCHELL, B. 1961
105. *Riverboat Gambler*, 1993
 acrylic on canvas
 48 × 32

SISTER GERTRUDE MORGAN, 1900–1980
106. *Ship of Zion*, c. 1970–75
 acrylic and ink on paper
 11½ × 16½
 Signed in ink lower right: Sister Gertrude
 Morgan Missionary

107. *God the Light of the City (Sister Gertrude with Black Dog)*, c. 1970–75
 acrylic and ink on polystyrene plastic
 6 × 8¾
 Signed lower right: Sister Gertrude Morgan

108. *John the Revelator (Revelations)*, c. 1970–75
 acrylic and ink on paper
 22 × 28
 Signed lower right: Sister Gertrude Morgan

109. *Precious Lord*, c. 1970–75
 acrylic on paper
 13 × 40
 Signed lower left: Sister Gertrude Morgan

110. *Self-Portrait*, c. 1970–75
 acrylic on tagboard
 6½ × 4
 Signed upper left: Sister Gertrude Morgan

111. *New Jerusalem*, 1972
 acrylic and ink on paper
 22 × 28
 Signed and dated in ink upper left: Sister
 Gertrude Morgan 5/72

112. *Fan ("The Sun Set Hour")*, c. 1970–75
 acrylic and ink on eight tagboard panels,
 sewn with string
 12½ × 17
 Label on back: Corcoran Gallery of Art

113. *Jesus Is My Airplane*, c. 1970–75
 acrylic and ink on paper
 9¼ × 12
 Signed upper left: Sister Gertrude Morgan

114. *Christ before the Multitudes, Christ at the Door, and the Raising of Lazarus*, c. 1970–75
 acrylic and ink on paper
 12½ × 26⅜
 Signed in ink upper right: Sister Gertrude
 Morgan

MARK ANTHONY MULLIGAN, B. 1962
115. *Is This Paradise?* 1993
 oil on panel
 36 × 44¼
 Signed lower right: Mark Mulligan

EDWARD MUMMA, 1908–1986
116. *Untitled*, c. 1970–80
 oil on canvas board
 13½ × 11

JOHN B. MURRY, 1908–1988
117. *House*, c. 1980
 watercolor, marker on panel
 23 × 23

118. *Gray, White, Black, and Blue and Script Abstraction*, c. 1987–88
 watercolor, marker on paper
 24 × 18

119. *Purple and Script Abstraction*, c. 1987–88
 mixed media on paper
 24 × 18
 (not illus.)

120. *Pink and Yellow*, c. 1987–88
 watercolor and marker on paper
 24 × 18

121. *Red and Black Script Abstraction*, c. 1987–88
 ink, marker on paper
 24 × 18

122. *Untitled*, c. 1987–88
 watercolor, pen, pencil on paper
 23¾ × 17¾
 Note: Chosen as the cover illustration
 for the invitation to the opening of the
 41st Biennial Exhibition of Contemporary American Painting, Corcoran Gallery of Art, April 5–
 June 4, 1989.

MORRIS BEN NEWMAN, C. 1883–1980
123. *Landscape with New Flowers*, c. 1977–79
 oil on fabric window shade
 42 × 50½

ELIJAH PIERCE, 1892–1984
124. *The Resurrection of Christ*, 1965
 painted wood relief, glitter
 20 × 28

LAMONT ALFRED PRY, 1921–1987
125. *Ringling Brothers Barnum and Bailey Circus*,
 c. 1970–75
 acrylic and marker on cardboard
 28¾ × 53¼

NELLIE MAE ROWE, 1900–1982
126. *Mean Bird*, 1980
 pastel, colored pencil on paper
 18 × 24
 Signed lower right: Nellie Mae Rowe 1980

JOHN SAVITSKY, 1910–1991
127. *Pocono Farms*, 1962
 oil on panel
 8¾ × 37½
 Signed on right edge: Savitsky

128. *Funeral Train*, c. 1975
 oil on fiberboard
 13 × 27¾
 Signed lower right: Savitsky

129. *Miners' Train*, c. 1975
 pencil, paint on board
 12½ × 20½
 Signed on right edge: Savitsky

130. *Landscape of Town*, c. 1961
 oil on fiberboard
 8¾ × 11
 Signed lower right: Savitsky

131. *God Bless America*, c. 1976
 oil on fiberboard
 15¾ × 30
 Signed lower right: SAVITSKY
 Inscribed on back: Title: God Bless America
 By Coal Miner Jack Savitsky Lansford PA
 18232. Jack Savitsky worked in and around
 the coal mines for 35 years / Never took a
 art lesson. He paints in oil charcoal pencil,
 watercolar [sic] crayon ink.

132. *Adam and Eve*, c. 1975
 oil on canvas panel
 12 × 16
 Signed lower right: SAVITSKY

133. *Reading Railroad*, 1964
 pencil, colored pencil
 17 × 23½
 Signed lower right: SAVITSKY/64

134. *Breaker Boys Picking Slate 1925*, 1964
 pencil on paper
 13½ × 16½
 Signed lower right: Savitsky

JAMES P. SCOTT, B. 1922

135. *Houseboat*, 1987
painted wood, linoleum, metal, plastic
32½ × 35 × 27

136. *Mrs. Lafitte*, 1986
painted wood, mixed media
L. 60

137. *Church*, 1991
painted wood, mixed media
19 × 17½ × 23½

138. *Oyster Queen*, 1988
painted wood, mixed media
30½ × 64 × 18½
Inscribed on canopy: Dr. Kurt Gitter

JON SERL, C. 1894–1993

139. *Blind Chemist*, 1977
oil on canvas
40 × 28½
Signed lower center: Jon
Inscribed on back: Blind Chemist/Green/
rust/offwhite

140. *Woman Strolling with Birdcage*, c. 1975–80
oil on canvas
23½ × 29½
Signed lower right: Jon
Inscribed on back: Moving from brush fire

141. *Nuns*, 1980
oil on particleboard
60 × 26½

142. *Church Scene*, c. 1970
oil on board
30 × 40

143. *Mother and Child*, c. 1975
oil on board
30¼ × 16¼
Signed lower right: Jon

144. *Prodigals Return*, c. 1975–80
oil on canvas
19½ × 15½
Signed lower left: Jon
Inscribed on back: Prodigals Return
and How!

145. *Athlete*, 1988
oil on board
47½ × 31½
Inscribed on back: Aug 23 '88

HERBERT SINGLETON, B. 1945

146. *Club 27*, 1989
painted door
72 × 32

147. *KKK—The Lynch*, 1990
painted panel
48½ × 20

148. *Schoolroom*, 1990
painted panel
16½ × 56

149. *Killer Stick*, 1990
wood, paint
L. 36

150. *Second Line—Funeral March*, 1994
painted board
48 × 14½

151. *Marcello-Joe U Grocery*, 1991
painted panel
18¼ × 60

ISAAC SMITH, B. 1944

152. *Polar Bear*, 1994
painted wood, plaster
22 × 49 × 22

MARY TILLMAN SMITH, 1904–1995

153. *Three Faces*, 1988
oil on board
24 × 48
Signed on verso: Mary T. Smith

154. *Faces with Calligraphy*, c. 1980–85
paint on panel
24 × 24 (each panel)

155. *Single Black Figure on Red with Yellow*, c. 1985
paint on particleboard
37½ × 29½

156. *Five Figures of Blue and Red on Yellow*, c. 1985
painted tin
22 × 59½

157. *Single White Figure on Black with Red*, c. 1980–85
painted tin
64¼ × 26½

ROBERT E. SMITH, B. 1927

158. *Alcatraz Island*, 1990
acrylic, oil, markers, pencil, pen on paper
22 × 28
Signed and dated: Robert E. Smith March
19, 1990

159. *New Orleans Table*, c. 1988–89
enamel on wood construction
23 × 18 × 18
Signed on top: Robert E. Smith

QUINLAN J. STEPHENSON, B. 1920

160. *Eagle*, 1992
concrete, paint, shells
26¾ × 34 × 3

DAVID STRICKLAND, B. 1955

161. *Mr. Oliver*, 1991
found metal objects, including a tractor
grille
85 × 70½ × 30

162. *Dinosaur*, 1991
found metal objects, including gas tank,
soil aerator, and tiller
67 × 122½ × 32½

163. *Red Snapper*, 1994
found metal objects
29½ × 70

164. *Radiator Man*, c. 1993–94
found metal objects including a steel
drum, radiator, rubber gloves
84 × 33 × 24

165. *Giant Horned Toad*, 1992
tin and sickle blades
25 × 62

JIMMY LEE SUDDUTH, B. 1910

166. *Indian*, c. 1990
paint and natural vegetable materials
on board
48 × 23½
Signed on neck: Jim Sudduth

167. *Church*, 1976
mud and paint, kaolin, pencil on board
23½ × 32
Signed in pencil in middle: Jim Sudduth

168. *Bird*, 1988
paint on pressboard and suction cups
32¼ × 48¼
Signed upper left: Jim Sudduth

169. *Self-Portrait*, c. 1988
mud on board
48¼ × 24
Signed upper left: Jim Sudduth

170. *Old New York*, c. 1989
mud with paint on board
48 × 53

171. *The Capitol, Washington, D.C.*, 1988
mud with paint on board
27½ × 69½

172. *Portrait of Elbert*, 1988
mud and white chalk on board
23½ × 21½
Signed in pencil, middle right: Jim
Sudduth

173. *Statue of Liberty*, 1986
mud, kaolin, paint, chewing gum, pencil
28½ × 13
Signed lower left: Jim Sudduth

174. *Black Cow*, 1989
mud on board
42½ × 59
Signed above center: Jim Sudduth

REV. JOHNNIE SWEARINGEN, 1908–1993

175. *Biblical Scene,* late 1970s
oil on canvas
16 × 20
Signed lower right: J. S. S.

176. *Cotton Farming,* mid-1970s–1980s
oil on canvas
24 × 28
Signed lower right: J. S. S.

177. *Farming,* mid-1980s
oil on panel
16 × 24

178. *The Tower of Babel,* 1992
oil on canvas
30 × 40
Signed upper left: Rev. J. S. S.

179. *Noah's Ark,* 1992
oil on canvas
30 × 40
Signed upper left: Rev. J. S. S.

180. *Baseball,* 1992
oil on canvas
36 × 48
Signed lower left: Rev. J. S. S.

MOSE EARNEST TOLLIVER, B. 1919

181. *Coffin,* 1988
house paint on coffin
42 × 27½
Signed lower left and lower right: Mose T
Note: Attributed, in addition, to other
family members.

182. *George Washington,* 1988
house paint on board
23¾ × 23¾
Signed lower left: Mose T

183. *Self-Portrait,* 1989
house paint on board, applied hair
25 × 14
Signed lower left: Mose T

184. *Mother and Child,* 1989
house paint on board
31½ × 16
Signed lower left: Mose T

185. *Catch a Dog,* c. 1987–89
house paint on board
18 × 35½
Signed lower left: Mose T
Inscribed on back: Catch a Dog
(not illus.)

186. *Tree of Life,* 1987
house paint on board
36 × 29½
Signed lower left: Mose T
Note: Attributed, in addition, to other
family members.

BILL TRAYLOR, 1854–1947

187. *Chicken atop a Speckled House,* c. 1939–42
poster paint and pencil on cardboard
26¼ × 13

188. *Man Talking to a Bird,* c. 1939–42
poster paint and pencil on cardboard
16½ × 13½

HUBERT WALTERS, B. 1931

189. *Sonny Boy and Day Boy,* 1989
wood, auto body filler, paint
32½ × 53

190. *Group of Musicians,* 1992
wood, auto body filler, paint
bass player: H. 12
horn player: H. 14½
bass guitar player: H. 11½
drummer: H. 8½

PHILO LEVI WILLEY, 1887–1980

191. *Friends of Wildlife,* 1975
oil on canvas
36 × 40
Signed and dated lower right: Chief 1975

PURVIS YOUNG, B. 1943

192. *Horses* (recto), 1990
Eyes over the City (verso), 1990
oils, enamel, mixed media on a variety
of supports
68½ × 17¼ (each panel)
Signed and dated upper right on verso:
Young 1/4/90
(*Horses* not illus.)

193. *Father,* 1988
oils, enamel, mixed media on a variety
of supports
60 × 50

194. *Man behind Bars (Purvis in Jail),* 1989
oils, enamel, mixed media on a variety
of supports
60 × 40

195. *Tenements of the City,* c. 1989–90
oils, enamel, mixed media on a variety
of supports
46½ × 24

196. *Mountain Landscape,* 1991
oils, enamel, mixed media on a variety
of supports
50 × 47½
Signed and dated upper right: Young 91

197. *Disaster in Bangladesh,* 1991
oils, enamel, mixed media on a variety
of supports
53 × 26

198. *Family,* 1991
oils, enamel, mixed media on a variety
of supports
96 × 48
Signed upper right: Young

199. *Book,* early 1970s–late 1980s (about 18 years)
discarded atlas with several hundred
collaged drawings in various media
14½ × 10 × 2½
(not illus.)

200. *Burial in the City,* 1988
oils, enamel, mixed media on a variety
of supports
48 × 48

MALCAH ZELDIS, B. 1931

201. *Bloomingdale's,* 1972
acrylic on canvas
24 × 32
Signed and dated lower right: M. Zeldis 72

202. *Celebration,* 1988
gouache on paper
9 × 11¾
Signed and dated lower right: M Zeldis 88

203. *I Have a Dream (Martin Luther King),* 1976
gouache on paper
16 × 20
Signed and dated: M Zeldis 76

Selected Bibliography

Alabama State Council on the Arts. *Outsider Artists in Alabama*. Montgomery, 1991.

Alexander, Judith. *Nellie Mae Rowe, Visionary Artist: 1900–1982*. Atlanta: The Southern Arts Federation, 1983.

Another Face of the Diamond: Pathways through the Black Atlantic South. New York: INTAR Latin American Gallery, 1988.

Ardery, Julie, and Tom Patterson. *Generations of Kentucky*. Louisville: Kentucky Art and Craft Foundation, 1994.

Artists' Alliance. *It'll Come True: Eleven Folk Artists First and Last*. Lafayette, La., 1992.

Baraka, Imamu Amira [LeRoi Jones], and Thomas McEvilley. *Thornton Dial: Image of the Tiger*. New York: Harry N. Abrams, 1993.

Bill Traylor Drawings, from the collection of Joseph H. Wilkinson and an anonymous Chicago collector. Chicago: Chicago Public Library Cultural Center, 1988.

Bowman, Russell. *American Folk Art: The Herbert Waide Hemphill, Jr., Collection*. Milwaukee: Milwaukee Art Museum, 1981.

Bowman, Russell, and Jeffrey R. Hayes. *Common Ground / Uncommon Vision, The Michael and Julie Hall Collection of American Folk Art*. Milwaukee: Milwaukee Art Museum, 1993.

Bronner, Simon J., and John Michael Vlach, eds. *Folk Art and Folk Art Worlds*. Ann Arbor: UMI Research Press, 1986.

Cardinal, Roger. *Outsider Art*. New York: Praeger, 1972.

————. *Outsiders*. Westport, Conn.: Praeger, 1979.

————. *Primitive Painters*. Westport, Conn.: Praeger, 1979.

Carter, Curtis L. *Contemporary American Folk Art, The Balsley Collection*. Milwaukee: Patrick and Beatrice Haggerty Museum of Art, Marquette University, 1992.

Columbus Museum of Art. *Elijah Pierce, Woodcarver*. Columbus, Ohio, 1992.

Fagaly, William A. *David Butler*. New Orleans: New Orleans Museum of Art, 1976.

Ferris, William R., Jr., ed. *Afro-American Folk Art and Crafts*. Jackson: University Press of Mississippi, 1983.

Finster, Howard. *Howard Finster's Vision of 1982. Vision of 200 Light Years Space Born of Three Generations. From Earth to the Heaven of Heavens*. Summerville, Ga.: privately published, 1982.

Fletcher, Georganne, ed. *William Edmondson: A Retrospective*. Nashville: Tennessee Arts Commission, 1981.

Florida State University Gallery and Museum. *Unsigned, Unsung . . . Whereabouts Unknown, Make-Do Art of the American Outlands*. Tallahassee, 1993.

Fuller, Edmund L. *Visions in Stone: The Sculpture of William Edmondson*. Pittsburgh: University of Pittsburgh Press, 1973.

Hartigan, Lynda Roscoe. *Made with Passion: The Hemphill Folk Art Collection*. Washington, D.C., and London: Smithsonian Institution Press, 1990.

Hemphill, Herbert W., Jr. *Folk Sculpture USA*. Brooklyn: Brooklyn Museum, 1976.

Hemphill, Herbert W., Jr., and Julia Weissman. *Twentieth-Century American Folk Art and Artists*. New York: E. P. Dutton, 1974.

Kahan, Mitchell D. *Mose Tolliver*. Montgomery, Ala.: Montgomery Museum of Fine Art, 1981.

Kemp, Kathy, and Keith Boyer. *Alabama's Visionary Folk Artists*. Birmingham: Crane Hill Publishers, 1994.

Knott, Robert. *Diving in the Spirit*. Winston-Salem, N.C.: Wake Forest University Fine Arts Gallery, 1992.

Lampell, Ramona, Millard Lampell, and David Larkin. *O, Appalachia: Artists of the Southern Mountains*. New York: Stewart, Tabori, and Chang, 1989.

Larsen, Martin, Susan Larsen, Lauri Larsen, and Robert Martin. *Pioneers in Paradise: Folk and Outsider Artists of the West Coast*. Long Beach, Calif.: Long Beach Museum of Art, 1984.

Lippard, Lucy. *Mixed Blessings: New Art in a Multi-Cultural America*. New York: Pantheon Books, 1990.

Livingston, Jane, and John Beardsley. *Black Folk Art in America, 1930–1980*. Jackson: University Press of Mississippi, 1982.

Manley, Roger. *Signs and Wonders: Outsider Art inside North Carolina*. Raleigh: North Carolina Museum of Art, 1989.

Maresca, Frank, and Roger Ricco. *Bill Traylor: His Art, His Life*. New York: Alfred A. Knopf, 1991.

Maresca, Frank, and Roger Ricco with Lyle Rexer. *American Self-Taught, Paintings and Drawings by Outsider Artists*. New York: Alfred A. Knopf, 1993.

Metcalf, Eugene W., and Michael Hall. *The Ties that Bind: Folk Art in Contemporary American Culture*. Cincinnati: Contemporary Arts Center, 1986.

———, eds. *The Artist Outsider: Creativity and the Boundaries of Culture*. Washington, D.C. and London: Smithsonian Institution Press, 1994.

Miami University Art Museum. *Two Black Folk Artists: Clementine Hunter, Nellie Mae Rowe*. Oxford, Ohio, 1987.

———. *Contemporary American Folk, Naive, and Outsider Art: Into the Mainstream?* Oxford, Ohio, 1990.

Milwaukee Art Museum. *Driven to Create: The Anthony Petullo Collection of Self-Taught and Outsider Art*. Milwaukee, 1993.

Montgomery Museum of Fine Arts. *In/Outsiders from the American South*. Montgomery, Ala., 1992.

Ollman, John E. *Howard Finster: Man of Visions*. Philadelphia: Philadelphia Art Alliance, 1984.

Patterson, Tom. *Southern Visionary Folk Artists*. Winston-Salem, N.C.: The Jargon Society, 1984.

———. *Ashe: Improvisation and Recycling in African-American Visionary Art*. Winston-Salem, N.C.: Diggs Gallery, Winston-Salem State University, 1993.

———, ed. *Howard Finster: Stranger from Another World*. New York: Abbeville Press, 1989.

Perry, Regenia. *What It Is: Black American Folk Art from the Collection of Regenia Perry*. Richmond: Anderson Gallery, Virginia Commonwealth University, 1982.

Philadelphia College of Art. *Transmitters: The Isolated Artist in America*. Philadelphia, 1981.

Pierce, James Smith. *God, Man and the Devil: Religion in Recent Kentucky Folk Art*. Lexington, Ky.: Folk Art Society of Kentucky, 1984.

Quimby, Ian M.G., and Scott T. Swank, eds. *Perspectives on American Folk Art*. New York: W. W. Norton, 1980.

Rosenak, Chuck, and Jan Rosenak. *Museum of American Folk Art Encyclopedia of Twentieth-Century American Folk Art and Artists*. New York: Abbeville Press, 1990.

Selen, Betty Carol, with Cynthia J. Johnson. *Twentieth-Century American Folk, Self-Taught, and Outsider Art*. New York: Neal-Suman Publishers, 1993.

South Queens Park Association. *Thornton Dial, Sr.: Strategy of the World*. Jamaica, N.Y., 1990.

Southeastern Center for Contemporary Art. *Next Generation: Southern Black Aesthetic*. Winston-Salem, N.C., 1990.

Schwindler, Gary J. *Popular Images/Personal Visions, The Art of William Hawkins 1895–1990*. Columbus, Ohio: Columbus Museum of Art, 1990.

Swain, Adrian. *Local Visions: Folk Art from Northeast Kentucky*. Morehead, Ky.: Morehead State University, 1990.

Taylor, Ellsworth. *Folk Art of Kentucky*. Lexington: University of Kentucky Fine Arts Gallery, 1975.

Tennessee Fine Arts Center at Cheekwood. *Will Edmondson's "Mirkels."* Nashville, 1964.

Thompson, Robert Farris. *Flash of the Spirit: African and Afro-American Art and Philosophy*. New York: Random House, 1983.

Tuchman, Maurice, and Carol S. Eliel. *Parallel Visions: Modern Artists and Outsider Art*. Princeton and Los Angeles: Princeton University Press, Los Angeles County Museum of Art, 1992.

Turner, John F. *Howard Finster, Man of Visions: The Life and Work of a Self-Taught Artist*. New York: Alfred A. Knopf, 1989.

University Art Museum, University of Southwestern Louisiana. *Baking in the Sun: Visionary Images from the South*. Lafayette, La., 1987.

Vlach, John Michael. *Plain Painters: Making Sense of American Folk Art*. Washington, D.C., and London: Smithsonian Institution Press, 1988.

Volkersz, Willem. *Word and Image in American Folk Art*. Kansas City, Mo.: Mid-America Arts Alliance, 1986.

Walker Art Center. *Naives and Visionaries*. Minneapolis and New York: E. P. Dutton, 1974.

Weld, Allison. *Dream Singers, Story Tellers: An African-American Presence*. Fukui, Japan, and Trenton, N.J.: Yoshida Kinbundo Co., Fukui Fine Arts Museum, and New Jersey State Museum, 1992.

Westmacott, Richard. *African-American Gardens and Yards in the Rural South*. Knoxville: University of Tennessee Press, 1992.

Wilson, James L. *Clementine Hunter: American Folk Artist*. Gretna, La.: Pelican Publishing, 1988.

Yelen, Alice Rae. *Passionate Visions of the American South: Self-Taught Artists from 1940 to the Present*. New Orleans: New Orleans Museum of Art, 1993.

In addition to the works cited above, *Folk Art Magazine* (The Museum of American Folk Art), *Folk Art Messenger* (The Folk Art Society of America), *Folk Art Finder* and *Raw Vision* are excellent sources of information on individual artists and self-taught art.

Contributors

ROGER CARDINAL is professor of literary and visual studies, University of Kent, Keynes College, Canterbury, England. He is the author of numerous books and articles on self-taught or outsider art, including the influential *Outsider Art* (1972), *Primitive Painters* (1979), and the major essay for the catalog *Outsiders* (1979); he is coeditor of *Cultures of Collecting* (1993).

LEE KOGAN is associate director of the Folk Art Institute, Museum of American Folk Art. She received her master's degree from New York University, Folk Art Studies Program, and is the author and curator of several publications and exhibitions on self-taught art. She served as research coordinator for *The Museum of American Folk Art Encyclopedia of Twentieth-Century American Folk Art and Artists* and as project coordinator for *Fearful Symmetry: The Art of Thornton Dial.*

SUSAN C. LARSEN is professor of art history at the University of Southern California in Los Angeles. She received her Ph.D. in the history of art from Northwestern University; her dissertation was entitled "The American Abstract Artists Group: A History and Evaluation of Its Impact Upon American Art, 1927–74." Her previous positions include curator of the permanent collection, Whitney Museum of American Art. She has organized many exhibitions, including *Pioneers in Paradise: Folk and Outsider Artists of the West Coast, 1844–1984.*

TOM PATTERSON is a freelance writer and critic who frequently lectures and organizes exhibitions on self-taught artists. His writings include *St. EOM: In the Land of Pasaqquan*, an illustrated biography of Eddie Owens Martin; *Howard Finster: Stranger from Another World*; and *Recla-* mation and Transformation: Three Self-Taught Chicago Artists.*

REGENIA PERRY taught art history at Virginia Commonwealth University for more than twenty years. She has lectured on African and African American art, has served as guest curator for several institutions, and has contributed to many publications, including *Black Folk Art in America, 1930–1980*. She is the author of *Free Within Ourselves: African American Artists in the Collection of the National Museum of American Art.*

DEBORAH GILMAN RITCHEY is on the staff of the Rock and Roll Hall of Fame, Cleveland, Ohio. She has served as curator of folk art at the African American Museum, Dallas, Texas, where she curated a traveling exhibition, *Texas Black Folk Artists*, in 1993. She has a master's degree in art history from Louisiana State University, and her research and writing have focused on the work of Louisiana and Texas self-taught artists.

GARY J. SCHWINDLER is professor of art history, Ohio University at Athens. He received an M.F.A. in painting from the Cranbrook Academy of Art, Bloomfield Hills, Michigan, and received his Ph.D. from the University of California, Los Angeles. His doctoral dissertation was entitled "The Dating of Medieval South Indian Metal Sculptures." He has published extensively on Asian and contemporary art, and on self-taught art in particular. He has organized many exhibitions, including *Interface: Outsiders and Insiders* and *Popular Images/Personal Visions: The Art of William Hawkins, 1895–1990.*

THOMAS ADRIAN SWAIN is artistic director and curator for the Kentucky Folk Art Center, Morehead, Kentucky. He has organized a number of exhibitions on self-taught artists, including *Slow Time: The Art of Charley, Noah and Hazel Kinney; Oh My Gourd: Folk Art by Minnie Black*; and *Local Visions: Folk Art from Northeast Kentucky.*

GAIL ANDREWS TRECHSEL is assistant director, Birmingham Museum of Art. She received her master's degree from the Cooperstown Graduate Programs and worked at the Abby Aldrich Rockefeller Folk Art Center, Williamsburg, Virginia, before joining the staff of the Birmingham Museum of Art. She has organized several exhibitions of Alabama self-taught artists and is author of the introduction for *Revelations: Alabama's Visionary Folk Artists.*